Brian Skerry **Ocean Soul**

Red pigfish and blue maomao. New Zealand, 2006

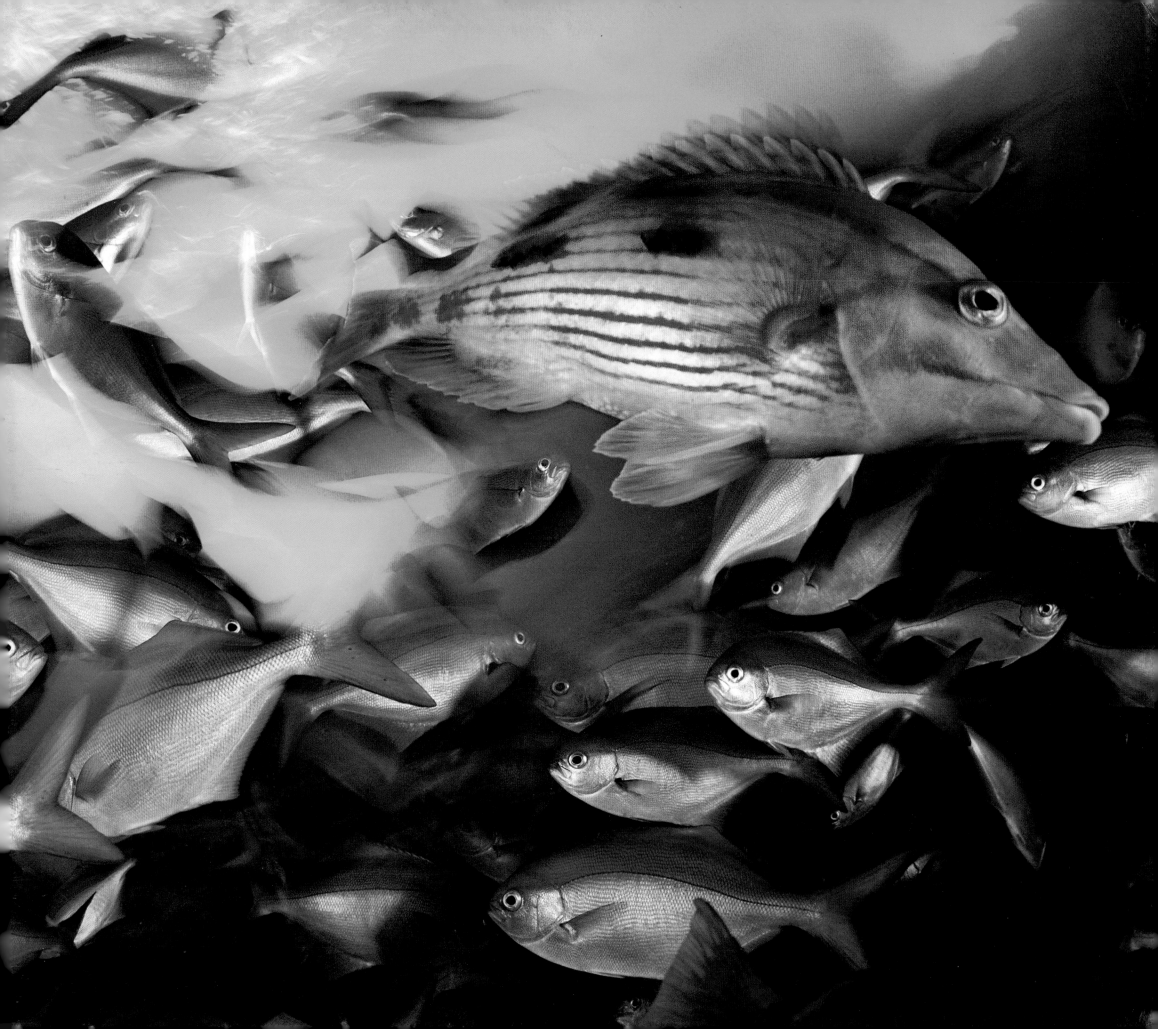

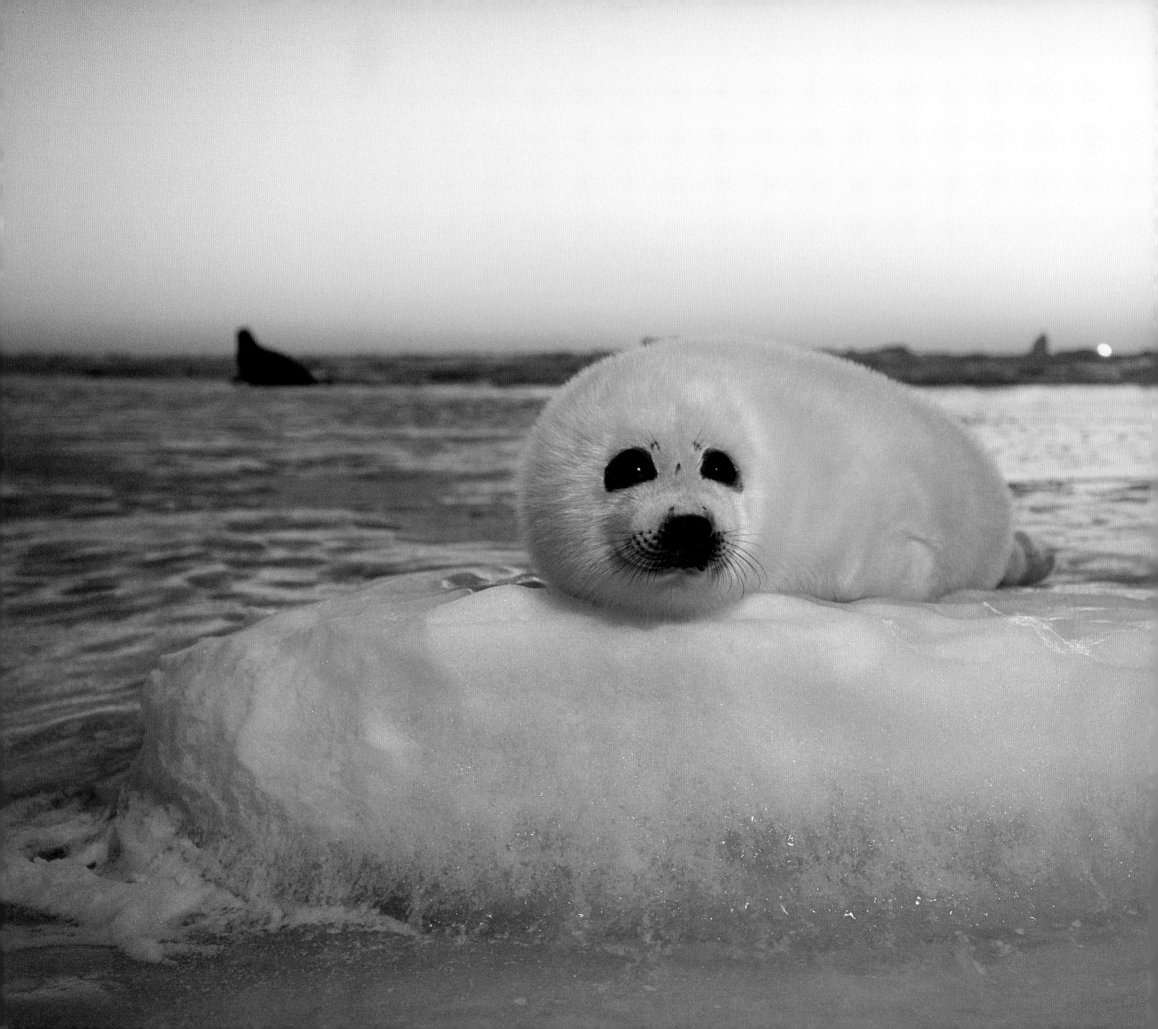

Harp seal pup. Canada, 2002

Oceanic whitetip shark. Bahamas, 2005

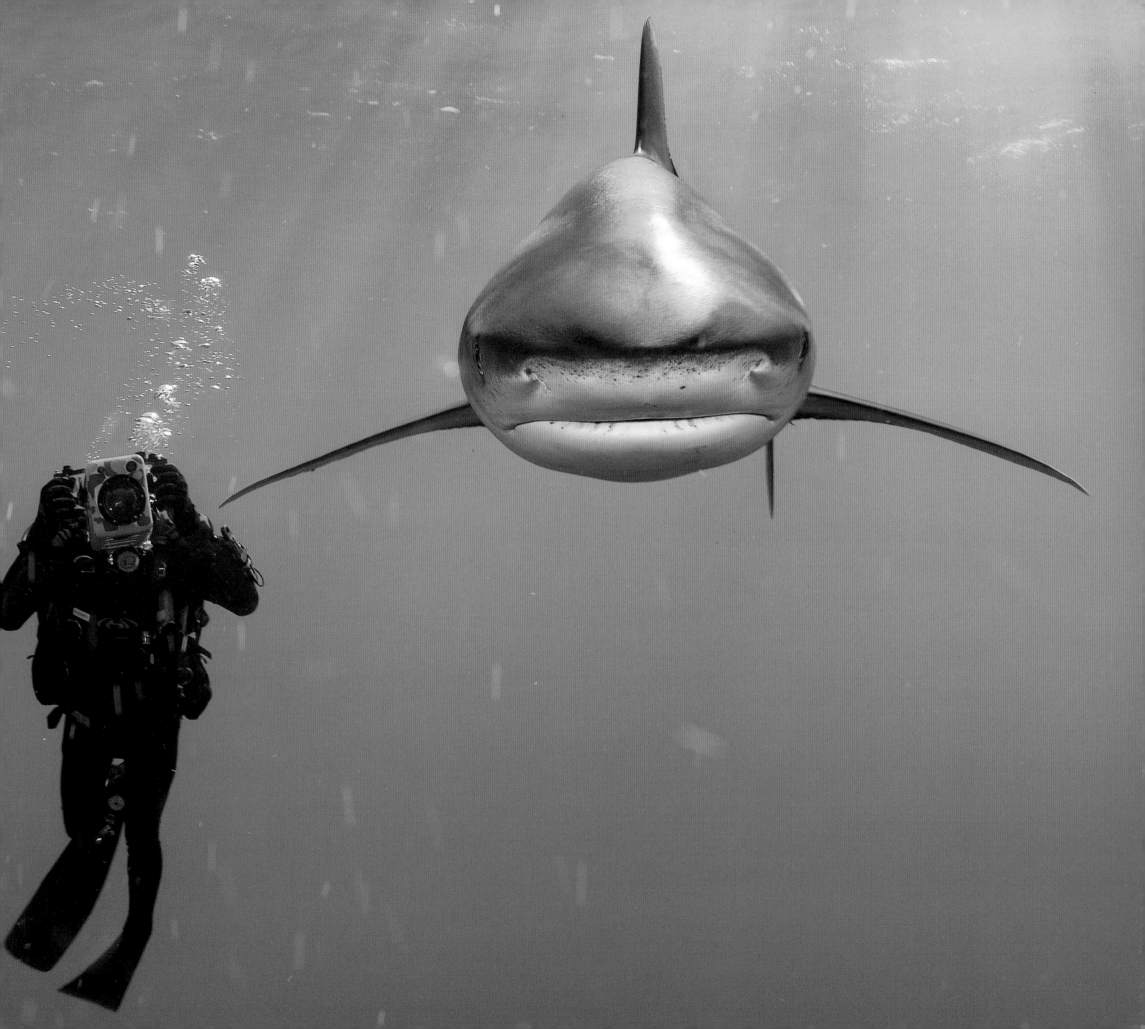

Achilles tang. Vostok Island, 2009

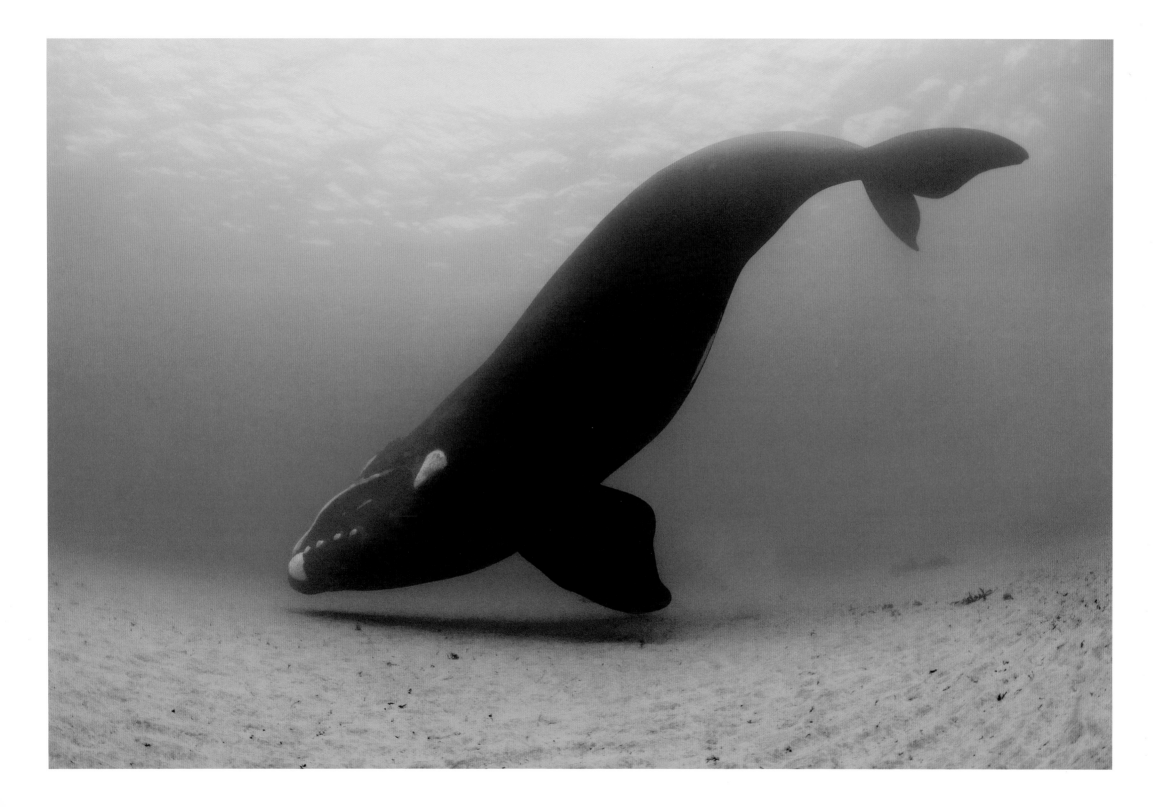

Southern right whale. New Zealand, 2007

Brian Skerry Ocean Soul

National Geographic

Washington, DC

Conservation International

Washington, DC

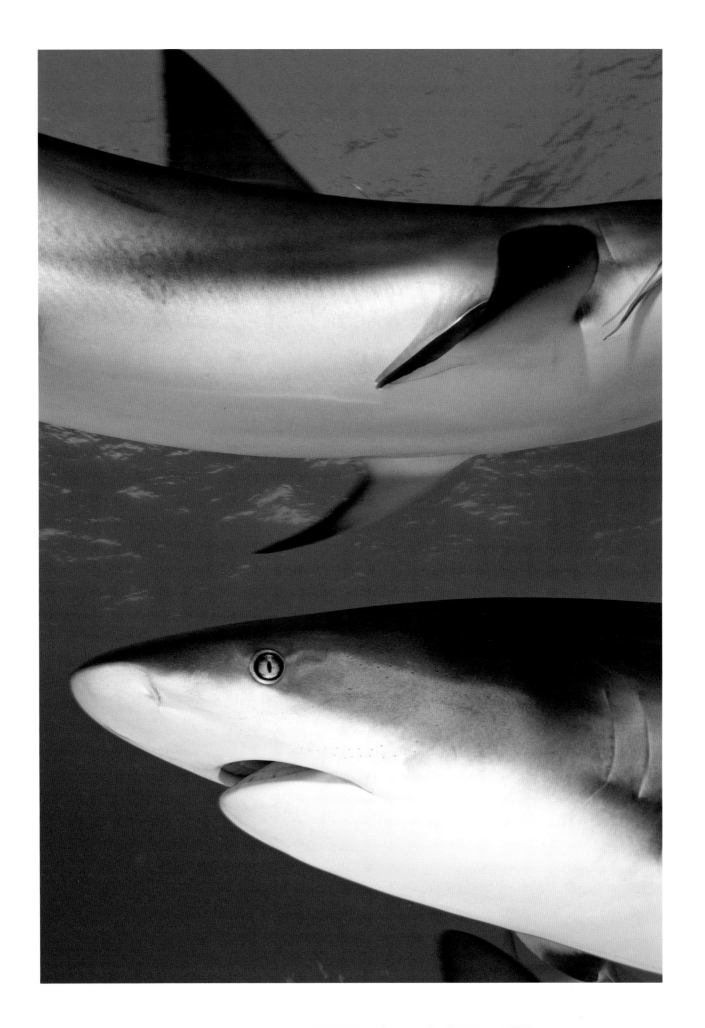

For Marcia, whose love and understanding made everything possible

Caribbean reef sharks. Bahamas, 2005

Foreword Gregory Stone

Images are powerful. They communicate so much in a matter of seconds because humans are visual creatures. Millions of years ago we inherited remarkable stereoscopic eyesight from our primate ancestors, who needed to swing rapidly and accurately from tree branch to tree branch. Then our ability to see and hunt animals on the ground emerged, and some 40,000 years ago prehistoric cavemen became the first to leave records of the wildlife that so preoccupied their daily concerns on the walls of caves in what is now France.

Today the importance of our visual sense is all around us—billboards, magazines, TV, movies, and books, upon which most popular culture and communication is based. It is hard to advance any idea without a powerful image behind it. And that is why photography is an important part of human communication, the one thing that enables us to fully understand and feel something, instantaneously, beyond the slower acting power of words. Even now, I am attempting to tell you something that a good picture would show you in an instant. Jacques Cousteau said, "We only protect what we love, we only love what we understand, and we only understand what we are taught." I would argue that his postulate is correct but incomplete: We understand only what we see, and for the majority of people, seeing is believing. That is why photography is essential.

Brian Skerry possesses a remarkable combination of talents. He is a world-class ocean explorer. He dives in places no one has ever gone before—places variously dangerous, cold, warm, deep,

beautiful, polluted, ugly, and remote but always important and always in the ocean. He has lived underwater with me for ten days; dived under the ice in the Arctic and Antarctic; worked in cramped submarines thousands of feet underwater; and slept on hot, dirty Indonesian beaches swarming with malaria-infected mosquitoes, to name just a few of the places and situations he endured to bring you *Ocean Soul.* Into this body of work Brian has put his soul, his passion, in every image.

Brian is the most talented ocean journalist I know. He gets the story right. I have had the great pleasure and privilege of working with him on a number of projects and several *National Geographic* magazine stories, some of which are represented in this book, where I was the writer and he was the photographer (or, in the common parlance of this business, the "shooter"). While "shooter" is a clever shorthand for a photographer, it diminishes the complexity of what he does.

Months, and sometimes years, before Brian even thinks about picking up a camera or donning his dive gear, he is on the phone, reading books or papers in science journals, scoping out locations, talking to everyone he can find, and studying every aspect of the story's background so that he can plan to make a series of very specific images. Only then will he look to the tools of his trade, what he needs to create images that will tell you the story: dozens of cameras, silver and black underwater housings, underwater lights with names like Hydrargyrum medium-arc iodide, filters, wet suits, dry suits, submarines, Remotely Operated Vehicles, ultralights, balloons, emergency locating devices, and gear of all kinds. Believe me, it is hard enough to tell a good story, and even harder to get a picture of it. To do it all underwater with a journalist's precision and accuracy is truly amazing.

Finally, Brian is an artist. Merely documenting a subject is fairly easy. There are thousands of photographers who take pretty underwater pictures. Brian has that rare ability to make pictures that interpret subjects in new ways—pictures that show far more than simply where and what was happening, also including the true nature of the moment, the ethereal, almost spiritual, aspect of his subject.

Some of Brian's images remind me of the Impressionist artists from the turn of the century Cézanne and Monet, who could also share and take us into their dreams with images that revealed a deeper meaning—shimmering sea turtles; immersive walls of moving fish; amid clouds of spawning fish; inches from the sharp teeth of crocodiles and sharks; or above luxuriant carpets of yellow-green, auburn, and purple corals. Whether it is an Impressionist interpretation or the bare, compelling, and sometimes brutal fact of overfishing or habitat destruction, Brian's images stay with you. By reading this book, you are about to start a lifelong relationship with the ocean and with Brian's work.

Wes Skiles, a late and great underwater photographer and friend of both Brian's and mine, summed it up when he said to me once, "We National Geographic photographers are in the business of making pictures that people remember for the rest of their lives." Brian is one of the world's great photographers, whose pictures will stay with you for the rest of your life. Brian has dedicated his life to the ocean as a journalist, explorer, and ocean conservationist. The ocean is the main life support system of Earth and the substance from which life itself originated. It regulates the climate we enjoy, the water we drink, and much of the food the world needs. The ocean needs us now more than ever, and Brian Skerry helps us understand that fact through his impressive life's work, partly represented in the following pages.

Enjoy this book and its remarkable photographs. After you view these images, they will stay with you for the rest of your life, and you will never look at the ocean the same way again. ∽

Gregory S. Stone, Ph.D., is Senior Vice President for Marine Conservation, Chief Scientist for Oceans at Conservation International.

Introduction Brian Skerry

I am certain it was love at first sight. Though I honestly cannot remember the first time I saw her, I fell in love with the sea as a child, and from that early age my course was set for a lifelong voyage more wondrous than even my wildest childhood dreams.

My small, working-class hometown in Massachusetts, about an hour's drive from the ocean, was not a place that would seem to inspire such passion. But days spent on the beaches of Rhode Island, Cape Cod, and New Hampshire were a taste of something magical, an unusual blend of adventure, mystery, and calm that stirred my soul and sealed my fate.

I think that, for those who are drawn to the sea, the attraction cannot be explained easily. It is an unseen force, a siren's song that lures us to the water. As a boy I knew exactly what I wanted to do with my life. I dreamed of swimming with dolphins, whales, and sharks; exploring sunken shipwrecks; and traveling to faraway places. Lying on the living room floor of my home, I watched Jacques Cousteau documentaries and read books about life in the ocean. I spent countless hours flipping through the pages of *National Geographic* magazine and studying pictures of undersea animals and divers.

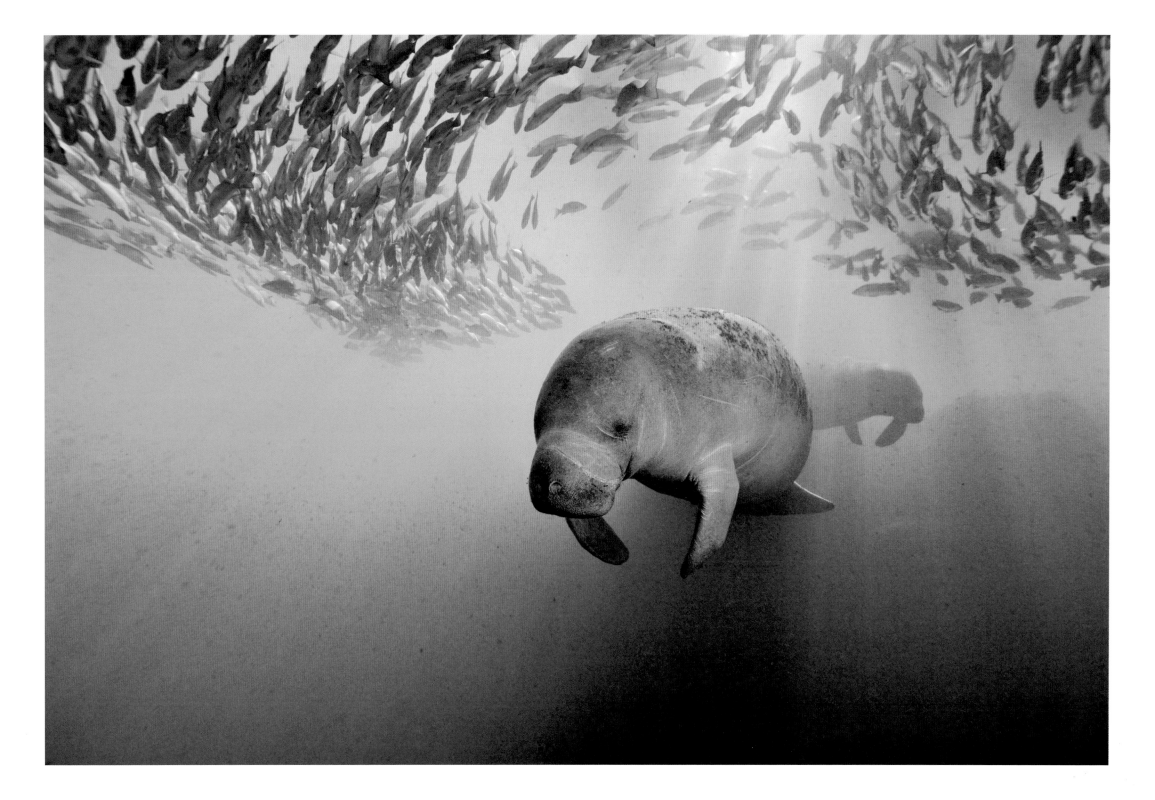

Florida manatee. Florida, 2009

Introduction

With a toy mask and fins in my backyard swimming pool, I pretended to be the explorers I saw in magazines and on television. I spent endless summers swimming from one end of the pool to the other, imagining that I was on some exotic coral reef or leading an expedition in search of some elusive creature under the sea.

Although the dreams of children often vanish with age, my desire to become a diver only grew stronger. When I was about 15, I tried scuba for the first time. Once again, it was in my pool, but I remember vividly the incredible sensation of breathing underwater. Sitting in the pool's shallow end, I tentatively took my first breath from the regulator and, by the third breath, had two simultaneous thoughts: "I can't really be breathing underwater, can I?" and "Wow, I have discovered a whole new world!" That summer I explored local lakes, quarries, and reservoirs with a friend from school, and by the following summer I was exploring the ocean as a certified scuba diver.

Those first ocean dives in New England waters were exhilarating. There was something that just felt right to me about being in the sea. I was completely in my element underwater and was happy just kneeling on the bottom off a sandy beach and swaying with the surge. Having spent years standing at the water's edge, I was finally immersed. As I moved through dimly lit green water, I saw orange *Metridium* anemones clinging to rocks and silvery schools of pollack swimming by my mask. Shining my light under rocky crevasses, I discovered lobsters and crabs and eels. Clusters of blue mussels hung from pilings, and sand-covered flounder hoping not to be seen shot off like a rocket when I approached too near and left a cloud of silt in their wake. The water was cold and my equipment cumbersome, but none of that really mattered. It was a small price to pay for the treasure trove I was getting in return. Exiting the water on those days, I felt a sense of contentment unlike any I had experienced

before. I was tired, salty, and sometimes sunburned but completely relaxed and very, very happy.

Within about a year of becoming a certified diver, I attended a diving conference called the Boston Sea Rovers Clinic. Billed as the longest-running dive show on the planet, the daylong event featured speakers on all aspects of the underwater world. The presentations by underwater photographers and filmmakers interested me most. As I sat in the dark and watched these image makers show their work and tell tales of their adventures, I had an epiphany. I had always wanted to explore the oceans, but I now understood how I would do this. I would do it with a camera.

It made perfect sense. I considered myself a visual person, and becoming an underwater photographer would allow me to do it all—explore the oceans and be visually creative. And, as I was drawn to the sea itself, there was something mysteriously appealing to me about the notion of being an underwater cameraman, traveling to remote locales, diving beneath the waves, and returning with photos from a world few might ever see. Knowing the ocean was an endless source of fascinating subjects and tales, I was especially interested in photojournalism. Within weeks I had bought my first camera. It was a used Nikonos II, an amphibious camera made specifically for underwater photography. Without a clue as to how to actually use it, I was soon diving with camera in hand and making pictures. They were not very good pictures—in fact, they were quite terrible—but with unbridled enthusiasm off I went week after week. Knowing I had an awful lot to learn, I worked to perfect my craft.

Around this time I was also headed off to college. I decided to major in communications media in the hope of learning the intricacies of image making and then using that knowledge underwater. My curriculum included courses in photography, television production,

film animation, photojournalism, and other photo-related subjects. Although I was learning the fundamentals of photography in school, most of what I was doing underwater was self-taught.

Shooting underwater was working in a completely different world. Light reacted very differently from the way it did on land, and I needed to hunt to find elusive subjects, stealthily approach within feet or inches, and then make pictures—all within the limits of my air supply. I could not change lenses underwater and was limited to 36 frames on a roll of film in those days, long before digital cameras. To make great pictures, I realized, I needed to be totally focused and not distracted by anything that would use up precious time underwater. Being a good photographer meant being completely comfortable with my equipment, both diving gear and photo gear, and being able to handle whatever the ocean handed out, from rough seas and strong currents to cold and dark conditions. In order just to get out to offshore sites, I also had to learn about boats, navigation, and weather. Before long, my pursuit of underwater images was consuming all of my time, but despite my spending nearly every waking moment on some aspect of photography or diving, it never seemed like work.

Underwater photography has been a career quite unlike any other. Despite the fact that I had a degree and several years of underwater experience, and although I lived and breathed this stuff, jobs were almost nonexistent. My dream had always been to become a *National Geographic* magazine photographer, though I began to realize that my odds of actually achieving this were about one in a billion. Energized with the optimism of youth, I slowly developed a plan. I knew that if I were ever to get a shot at working for *National Geographic* I would need to be a great photographer, which meant having the experience and portfolio to prove I could handle an assignment. Producing a portfolio of subjects from

around the globe required resources, however, and I had barely enough money to buy a used underwater camera. So step one in the plan was to dive and to shoot close to home.

With its long maritime tradition, New England has some of the world's richest waters, and it was a perfect place to continue honing my skills as an undersea photographer. Working a variety of jobs to pay the bills, I dived and made pictures whenever I could. I always wanted to see and do more. For more than a decade I worked on a wreck-diving charter boat, which allowed me to dive for free. With access to these dive sites, I began to specialize in shipwreck photography. I made pictures of sunken freighters, passenger liners, and submarines. I loved history, and exploring shipwrecks was a perfect way to create a niche within underwater photography and to gain valuable experience. Many of these lost ships were in deep, dark, cold water, and I knew that if I could dive and shoot in these conditions I could do it anywhere in the world.

I was also expanding my body of work with wildlife during this time, both in New England and internationally, as I began to make some money and assignments began to trickle in. Traveling as much as possible, I photographed great white sharks, sperm whales, orcas, and seals. I spent weeks on tropical reefs and dived beneath frozen bays. But it was my shipwreck work that landed me my first assignment with *National Geographic* magazine: to photograph a pirate shipwreck called the *Whydah,* which came to me as a referral from NGM photographer Bill Curtsinger. I had been a longtime admirer of Bill's work, and in the mid-1990s we had become friends and dived together worldwide. He called one day to say NGM wanted him to return to the *Whydah* site for more coverage of a story he had started the previous year, but he was working on a second story at the time and could not do both. So he offered to recommend me for the *Whydah* assignment but warned that it

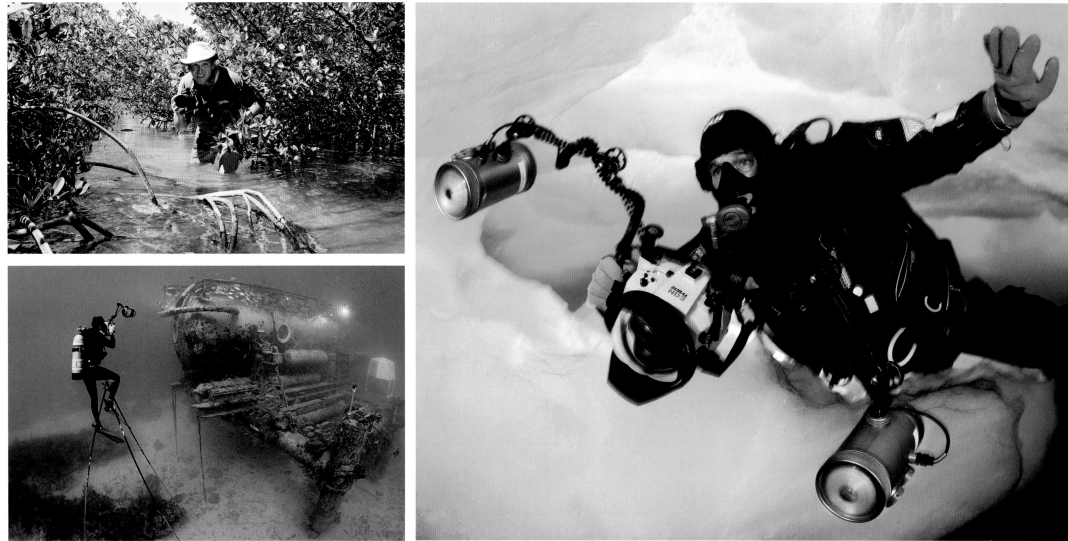

would be difficult. He explained that the visibility on-site was terrible and that there was practically nothing to photograph, since the ship had sunk in the 1700s and what remained was buried deep under mountains of sand. According to Bill, there was a 98 percent chance of failure on this assignment, and with *National Geographic* a new photographer would have only one chance. "You might want to wait for a better opportunity to come down the pike," Bill said. After thinking about it for a very short time, I told Bill I wanted it. I figured that a better opportunity might never come and believed that with my years of shipwreck shooting, I had what was needed to pull it off.

Everything Bill said was true, but I worked like a madman, using every possible technique to get the pictures. Since the wreck site was only a couple hours from my home, I spent as much time out there as possible, too. The *Whydah* divers were beginning to uncover sections of the wooden hull and some of the pirate treasure, Spanish doubloons. I brought in movie lights to overcome the turbid waters and made macro pictures of the artifacts and coins. When all was said and done, the magazine's staff was pleased with my work. Thanks to Susan Smith and Kent Kobersteen, NGM's assistant director and director of photography respectively, the

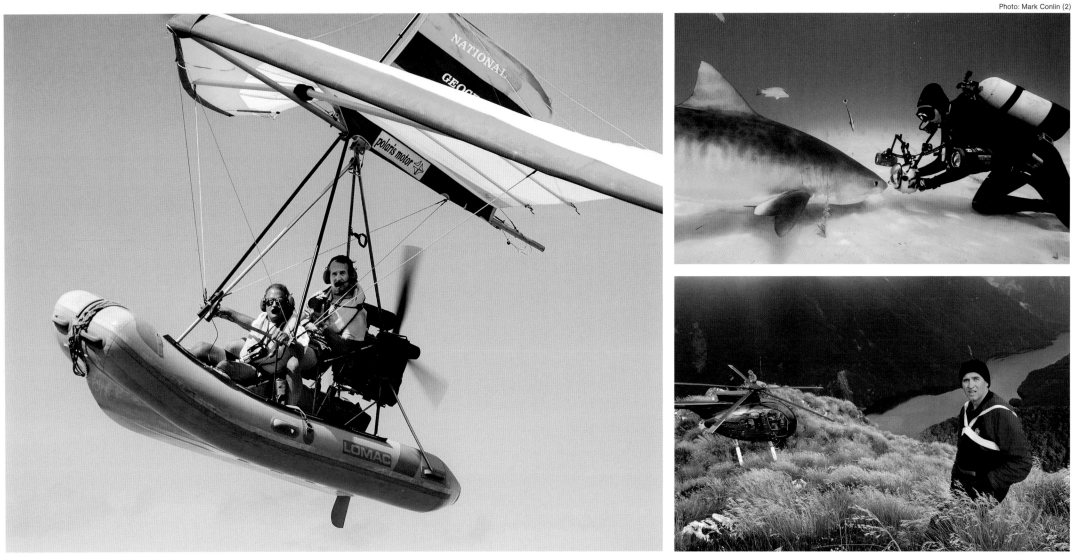

magazine began to "develop" me as a regular shooter. Spending time in various departments at headquarters, such as photographic, illustrations, layout, and photo engineering, I learned about the magazine's inner workings and specific photographic needs. In the field with veteran photographer David Doubilet, I learned valuable techniques as I watched him work.

Although my nautical archaeology assignments were fascinating, I was most passionate about natural history and desperately wanted to shoot wildlife stories. Imagining encounters with undersea animals was what stirred my soul, and I longed to produce

Brian Skerry in mangrove. Bimini, 2005 (opposite, upper left) ~ **Skerry, Aquarius habitat.** Florida, 2002 (opposite, lower left) ~ **Skerry ice diving.** Japan, 2008 (opposite, right) **Skerry flying in ultralight aircraft.** Bahamas, 2005 (above, left) ~ **Skerry with tiger shark.** Bahamas, 2005 (top, right) ~ **Skerry, Fiordland.** New Zealand, 2006

images that would shed light on their elusive lives. With the help of legendary illustrations editor Kathy Moran, I finally made my transition from archaeology stories to natural history. I have now spent more than a decade living among marine wildlife, learning from them, and telling their stories.

The title for this book came to me years ago as I reflected on what it is I photograph. When asked what my favorite subjects are, I have a hard time answering since I am fascinated by all underwater animals and ecosystems. Some photographers specialize in big animals or in macro creatures; some shoot only in warm waters, while others prefer the cold. I have never been able to pick an absolute favorite because I truly love it all. What I enjoy more than anything, however, is making pictures that evoke the true essence of an animal. I often feel a life force emanating from creatures, a tangible energy that defines an individual animal. I try to use that energy to make pictures that do more than simply record—that preserve a moment in time, an instant when a creature's spirit is captured in a blend of light, gesture, and grace. "Ocean soul" describes this life force that exists within animals and places in the sea and that emanates from the ocean as a whole. And I suppose it is also how I see myself, as an ocean soul, having spent the majority of my life chasing that dream and being drawn by that tidal force of the sea.

As with most photographers, my interest has always been to make beautiful pictures of subjects that inspire me. The creative process has been my strongest motivator; I want to spend time in nature and to interpret what is before my eyes with a camera. My greatest joy comes from producing photographs that celebrate nature and reveal magical, natural moments. Over the years, there has been an evolution in my work, a path that has led from an exclusive focus on capturing nature's beauty to a broader journalistic interest in recording the many threats facing our oceans and marine wildlife.

We live on a water planet, yet I wonder how many of us actually see it that way. The ocean covers 71 percent of the planet's surface, represents nearly 98 percent of Earth's livable volume, and produces the majority of the air we breathe. A logical conclusion would be that humankind must do everything possible to protect this vital component of our home, when our own survival clearly depends on it. Instead, we have treated our precious waters like a sewer, a place to throw chemicals and trash. For centuries we have removed wildlife from the sea and destroyed entire ecosystems while conserving very little. I have always believed that the sea suffers the fate of being regarded as vast and deep with endless resources and bounty, yet I know that the reality is far different. She is resilient, indeed, but will die a death from a thousand cuts unless we take bold steps to protect her.

I have been blessed to realize my dream of becoming an underwater photojournalist, but with that I feel an obligation and sense of urgency to share what I have seen with others. It would be fun to pursue only celebratory pictures of nature, but it is because of my love for the sea that I photograph the disturbing scenes as well, in hopes of raising awareness. Photography can be a powerful instrument for change, and photojournalists can tell stories that make a difference.

Within this book are elements of all that I have seen and learned in more than three decades of exploring the sea—my passion and dreams, the life force of the sea, and the wounds she suffers. Together they represent ocean soul. ~

Blue shark with parasitic copepod. Rhode Island, 1995

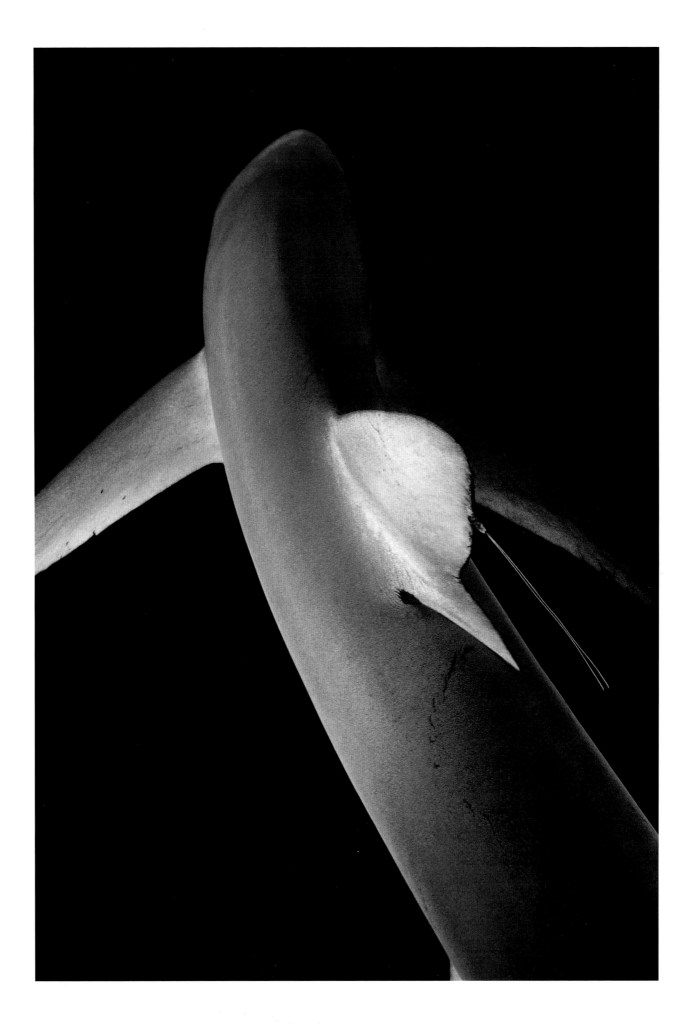

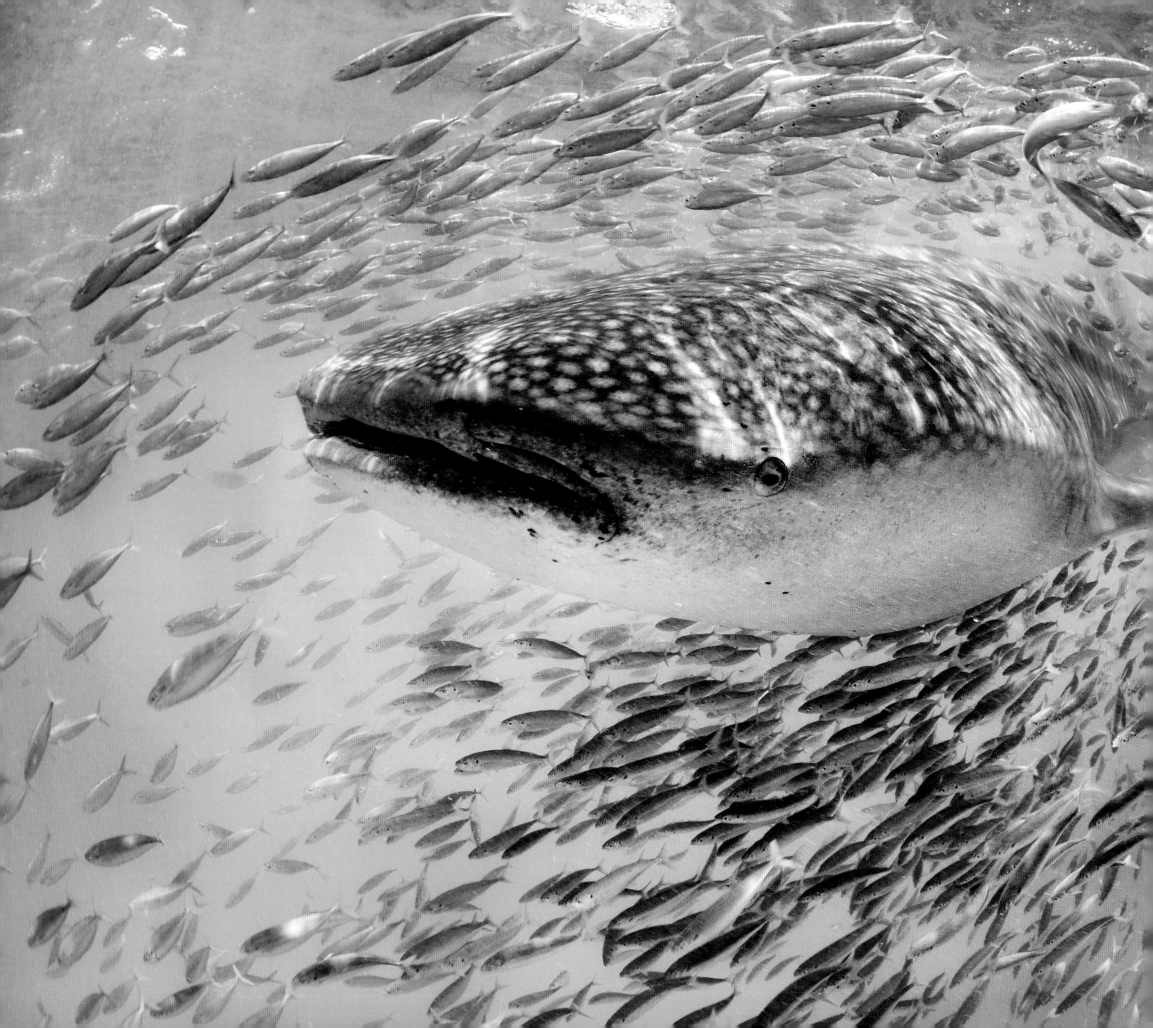

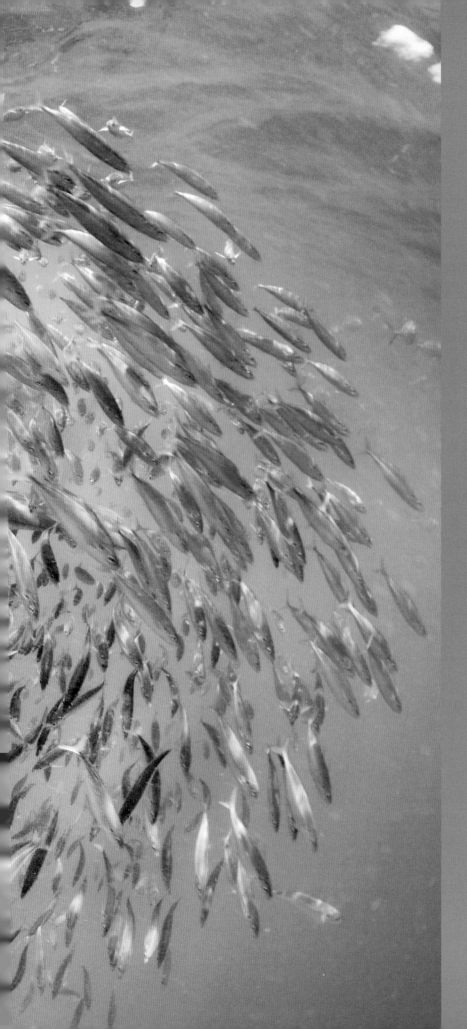

Warm Waters

Whale shark. Mexico, 2009

Warm Waters

I often think of the ocean as a living kaleidoscope, because every time I look inside I see something different. It's always changing, alive with color, movement, and light. And while we sometimes think of the ocean as a single place, it is in reality a complex series of dynamic, interconnected ecosystems that are home to the greatest biodiversity on the planet. For me, the oceans represent the last truly wild place on Earth. There are no artificial fences or boundaries that restrict animal migrations. Upon entering the sea on any given day, you never know what you will find. With only a tiny fraction of the underwater world having been explored, endless discovery awaits. It is the ideal province for a lifelong wanderer in love with natural wonders and the thrill of learning answers to hidden secrets.

In this book we journey into many wild realms, and for the sake of narrative these places have been gathered into chapters defined by temperature, with the final chapter revealing some of the most remote marine locales and those most untouched by civilization. *Warm*, *cool*, and *cold* are relative terms, however. One diver might think California waters are cool, while another might think they are downright cold. Many species of marine animals do not fit neatly into such categories, either. A leatherback turtle begins its life on tropical beaches but migrates through many waters of varying temperatures during its decades of travel. But tidy categories are not especially important. I prefer to be like that leatherback, swimming through this three-dimensional kaleidoscope, enjoying it all and figuring it out as I go.

Warm waters are inviting waters. They are the tropical seas we think of when imagining exotic, romantic places, where shores are lined with palm tress and the air and water soothe the body. For me, tropical waters are the places I feel most free, where I am unencumbered by bulky layers of thermal protection and can move easily through the sea. In warm water I can also spend more time just looking and seeing. Being able to spend time underwater is a luxury given the range of restrictions that limit divers and underwater photographers. We can stay underwater only as long as our air supply lasts or we remain warm enough. We cannot use telephoto lenses like those of our terrestrial counterparts because even in the clearest of water, colors quickly fade with depth or distance, and water wreaks havoc on light, which gets scattered and refracted in ways unfavorable to photography. Time is, therefore, what I desire—time to learn, time to get close, and time to work my craft.

When conditions are warm, I can stay in the water all day. Wearing only a thin wetsuit, I can dive and snorkel for hours on end. This allows animals to acclimate to me and to get close enough for me to make compelling images. I have spent some of my best days in the field simply diving for hours in the shallows or free diving in warm, clear water. While photographing manatees in the rivers and springs of Florida, I began my days early and ended late, as most fieldwork days go, but here I could emulate my subjects—I could swim for hour after hour like a manatee myself. Days like this are Zen-like. Lying on the water's surface and listening to the sound of my breathing, I effortlessly submerge and then gently kick my fins. I glide over the sand or muddy bottom, over sunken logs and weeds, and look for distant shapes that will materialize into manatees. Late in the day I often cruise through narrow channels that emerge into primordial pools, natural springs where these creatures rest overnight. In crystal clear water I move alone near dusk, as I make frames and watch wild animals on their own terms.

To make great pictures, a photographer must observe and truly see, and in warm-water places that is exactly what I am able to do. As a new diver, I often swam long distances with the belief that I would see the most if I covered lots of territory. Over time I learned that the real value is in being patient, slowing down, and watching

the world around me. When I visit an underwater ecosystem for the first time, my initial perception is usually chaos. There are animals swimming around in all different directions, and none of it seems to make sense. Trying to photograph a scene like this is nearly impossible. Just chasing subjects around only leads to frustration. After I sit in one place and watch, however, things begin to make sense. I start to see behaviors and relationships reveal themselves as if I am passing into a different dimension where chaos becomes order. I certainly don't understand all of it—or even most of it—but I do understand some of it, and this is where I focus my lens.

I found this process to be especially true while on assignment in the warm waters of Japan's Ogasawara Islands. As part of a broader story about Japan's ocean wildlife, I dived for several weeks off Chichi Jima and its surrounding islands, located more than 620 miles from Tokyo. My helpful guides showed me an exotic array of creatures in a perpetual state of motion, like an underwater marine life mobile. To make sense of this world and to tell a story with pictures, I zeroed in on specific animals that interested me and spent hours watching and learning. Swimming over a field of coral one afternoon, I spied a fish just floating up in the water column. Drawing closer, I saw that it was a wrought iron butterfly fish, an endemic species known locally as the You Zen, which has markings identical to an ancient Japanese kimono. Darting around the butterfly fish was a small wrasse that was "cleaning" the You Zen by picking off parasites and dead skin. Remaining at a safe distance so as not to disturb the moment, I composed the scene in my viewfinder and began making pictures. I was privileged to watch this delicately choreographed dance of two species.

Another dive found me perched atop the rusting, old engine of a World War II shipwreck. The massive machine was covered in sea growth, including a colony of coral whose polyps fed in the currents that washed over the top. Within the coral, in certain holes once occupied by tube worms, lived tiny coral hermit crabs. These little crustaceans were brilliantly colored, with blue legs, orange- and white-striped claws, and eyes on the ends of stalks that were patterned with stars and stripes. About the size of two grains of rice, these critters would slowly emerge from their holes and feed with their antennae raised up into the water. I sat there for hours just waiting for those precious few seconds when the crab would pop out and I could frame a portrait.

The gift of time that warm water offers is a chance not only to see and to learn but also to really work a scene or subject in a way that I am rarely permitted elsewhere. In deep, dark, or cold water I am greatly limited and must often work quickly. In warm water I can experiment more, paint with light, and create images that offer layers of interest.

After a late day dive off Chichi Jima, I climbed aboard the boat and was packing up for the ride back to shore, ready to call it a day. Looking over the side of the boat, I noticed that a large school of batfish had moved in and were feeding on plankton near the surface. I strapped on another tank, slipped back into the water, and spent at least two more hours working this scene. Low in the sky, the sun created a lovely backlight, and the water had a jewel-like quality, glowing in hues of green and blue. Since I was not cold, even after hours in the water, I could relax and get in "the zone," where I could completely take in every nuance and make pictures that evoked emotion. With the benefit of time, I watched as the school pulsed with an ancient rhythm. Over and over again I'd move in for a few frames and then gently back away until the image was right.

A desire to understand the relationships of wildlife in the sea is a very big part of the motivation for my work. I want to understand

the behaviors of individual animals, but I also want to know how animals and ecosystems interrelate. The stories I most like to tell photographically are those in which habitats overlap and we begin to see how the tapestry of undersea life is woven together. Nowhere am I better able to see these relationships than in warm waters. Coral reefs are perhaps the warm-water ecosystem most often associated with tropical waters, but stunning reefs are often only part of the story. The more complete story often includes neighboring ecosystems that work in harmony with reefs and keep them healthy and replenished.

Driven by an interest in telling such a story, I pitched the editors of *National Geographic* magazine on a feature about the Mesoamerican Reef, the world's second largest barrier reef system and one in which the connectivity of ecosystems is crucial. This reef system stretches from Mexico's Yucatán Peninsula in the north through the countries of Belize, Honduras, and Guatemala. But the name *reef* is somewhat of a misnomer, since this region is more accurately a series of interconnected habitats of mangroves, sea-grass beds, and coral reefs, each one critically dependent on the other.

Shooting a story of this scope is a substantial undertaking. I typically spend months and sometime years researching all the various components to understand fully how my coverage will take shape. I want to know exactly where I will go and what I will see once I get there. At the outset of such an assignment I have far more questions than answers. Standard questions include, What is the best time of year to see specific species? Will the visibility be good? What boats will I use, and where will I stay? As information is gathered and dates are scheduled, I must prep and pack equipment for what usually amounts to months of work in the field.

Underwater photography is an equipment-intensive business. It requires all the equipment used by land photographers, plus so much more. Cameras must be placed inside underwater housings, and special strobes, strobe arms, cords, housing ports, and extension rings are needed as well. Then there is all the diving gear—wet suits of varying thicknesses, masks, snorkels, fins, regulators, buoyancy compensators, and more. Because I often work in remote locations where I cannot buy specialized items I might need or get equipment repaired, I must bring backups of everything, plus tools. I often head off on assignment with 30 cases of equipment in tow. How I envy my street-shooting colleagues who travel with only two or three camera bodies and a handful of lenses. But then again, they don't get to spend months with sharks or sea turtles.

Spending months in the company of inspiring marine animals is precisely what my work on the Mesoamerican Reef entailed. For much of this assignment I chartered my own sailboat, which served as my home and dive platform for weeks on end in Belize. Each long day began when my assistant, Jeff Wildermuth, and I left the catamaran and motored off in a small boat to mangroves, reefs, or sea-grass beds to spend as much time as possible immersed within them. My hope was to highlight this visually rich region as a showcase for marine connections, to illustrate with photographs how each habitat is crucial to the other.

One of the most dramatic examples of the interdependence of habitats can be seen with an event that combines astronomy, biology, oceanography, and geography in a cosmic recipe that results in creation of new oceanic life. Off the coast of Belize, these forces of the heavens and Earth mesh with precise timing, producing epic spawning aggregations of fish. I had seen various species of fish spawn over the years, but they were nothing like what I saw at Gladden Spit. In this specific location, during the full moon in springtime, various species of fish called snapper gather to spawn. On these few precious evenings I traveled out to the

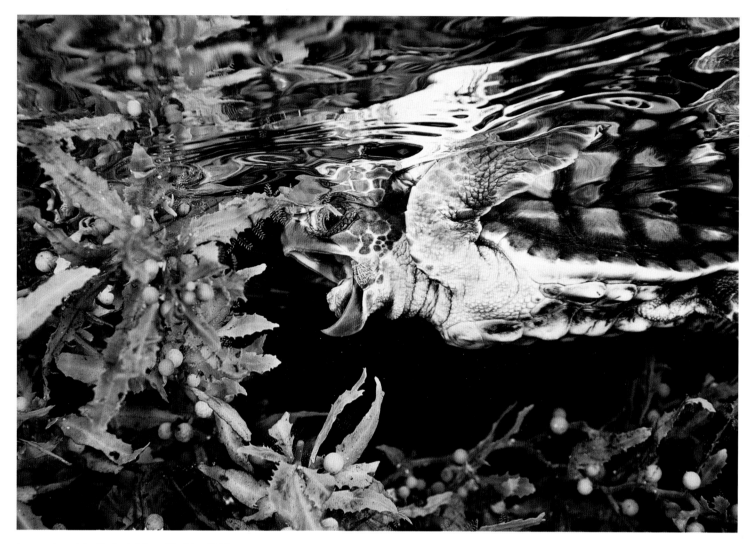

Loggerhead turtle hatchling. Florida, 2003

How I envy my street-shooting colleagues who travel with only two or three camera bodies and a handful of lenses. But then again, they don't get to spend months with sharks or sea turtles.

deep water with my local guide and expert Dan Castellanos. With knowledge garnered from years of experience, Dan would position our small boat in the spot where he thought we would likely find the fish, and then over the side we'd go. Though visibility was often good, we were diving near dusk and light levels were extremely low. As our eyes became adjusted to the dark, we could make out a massive school shimmering far below in the deep. The snapper stay at depths of more than 200 feet during the day but begin to move to shallower water as spawning nears. Swimming continuously through the dark, blue, featureless void of water, we kept up with the school that was always moving and waited for the frenzy that would eventually ensue.

Like a living volcano materializing before my eyes, the snapper erupted from the depths and formed a massive, gyrating pyramid. There were more than 10,000 fish rising upward in a 100-foot-long column. Their urge to mate was triggered by some celestial signal to which they were tuned. Near the top, female snapper would split off, and several male suitors would follow them aggressively. Clouds of spawn and milt mixed together from dozens of individual events until the entire ocean turned white, and we were lost in a cloud in which we could barely see each other. In the haze, whale sharks appeared as giant silhouettes feeding on the spawn, while bull sharks rocketed up from below to predate on the snapper. By the time I broke free of the cloud, the snapper were long gone, having retreated to the bottom. Then, in the distance, another column formed and the event repeated.

Spawning aggregations like this one are among the most breathtaking scenes I have witnessed in the sea. But the connections that follow, while not nearly as dramatic, are equally fascinating. Somehow the snapper have learned to spawn at a very special location, where ocean currents carry their fertilized eggs to safety.

Lying inshore of the spawning ground are mangroves, directly in the path of currents carrying the eggs. It is in these mangroves that the baby fish are born, safe from open-water predators. Growing in dense thickets near islands or on their own, mangroves are the ocean's nurseries, giving protection to a wide range of species. On the mornings after my dives to photograph spawning snapper, I would spend hours diving in mangroves and watching juvenile fish, from baby barracuda to tiny cubera snapper, hiding among the network of tree roots. Once big enough, these fish move to the reefs offshore and bring their lives' events full circle.

On these sojourns, I often bring several cameras underwater, stage them on the bottom in safe places, and then swim back and forth between mangroves and sea-grass beds as I shoot seascapes, behavior, and portraits. In fields of sea grass I saw loggerhead and green sea turtles lazily grazing and conch crawling along the bottom with eyes peering out from their dusty shells. Stoplight parrotfish, stingrays, nurse sharks, and tarpon cruised past millions of tiny, silver fish whose reflections were mirrored in the calm surface water above. As I lived in these environments day after day, it all began to make sense. I was far from understanding all of the mysteries of these animals and their relationships, but the overall picture was one of harmony. It was a perfectly designed machine that relied on balance. Remove or damage a piece of the machine, and the whole thing suffers or falls apart.

For decades I have tried to peel back the layers of mystery surrounding many marine creatures, though most have held tightly to their secrets. One animal that keeps me pondering is the shark. Spellbound by these enigmatic animals since I first encountered them in New England, I never tire of watching their special blend of power and grace. Despite much observation, we know so little about their lives. I have photographed sharks in waters around the globe,

and I always want more and yearn to peer deeper into their world. To feed my passion and to raise awareness, I developed a story about sharks for *National Geographic* magazine. Although there are great places in the world to see specific species, the Bahamas was a place where I could photograph many species in a variety of habitats that would provide a broader view of these animals. The Bahamas has mangrove nurseries, coral reefs, shallow sea grass beds, and deep oceanic trenches—all perfect ecosystems for sharks. Photographing multiple shark species in exquisite water was the assignment I had dreamed about from the start.

My goal was to make intimate pictures of sharks, but I didn't want to perpetuate the myth of sharks as monsters. Rather, I wanted to portray them as an elegant and important part of each ecosystem in which they lived. The pictures needed to be respectful, so that old beliefs would fade and a new view might take hold. Early in this project I made a photograph that helped set the tone. Kneeling on the sea bottom in a place known as Tiger Beach, I watched a 12-foot-long female tiger shark cruise over the turtle grass with three silver bar jacks swimming in front of her nose. The shark ascended toward the surface, so I did the same, hoping to fill the frame with this regal animal but unsure of what might actually happen. As I drew near, I released the shutter just as the tiger shark turned. The result was an image that offers a gentle view of this apex predator, one in which shadows of tiny fish are painted on her face and her appearance is anything but threatening.

I had an equally memorable experience with a shark species whose stocks have plummeted worldwide in recent times, a species that commercial fisheries target for its large fins. I hadn't heard of anyone seeing oceanic whitetip sharks underwater in decades, although they were once commonly seen offshore in the Bahamas. But, after hearing tales from sport fishermen claiming sightings near a place called Cat Island, I trekked off with dive operator Jim Abernethy and biologist Wes Pratt on a highly speculative, 16-day search.

Because we would be working up in the water column and not on the bottom, I brought along a shark cage as a safe haven in case we needed it. We spent day after day cruising and diving and searching with no luck. But then one afternoon, we struck gold. It was late in the day, and we had positioned the dive boat over a deep drop-off and throttled back the engine, when a large dorsal appeared off our stern—a fin splashed on top with white!

A few moments later I was floating within the crystal blue water when she materialized in the distance, a female oceanic whitetip about nine feet in length moving directly toward me. She reached me in seconds and, highly curious, bounced her nose off my dome port repeatedly. The shark eventually settled into swimming large, lazy circles around the cage. She often moved in close to check me out and then returned to her orbital path. In that late afternoon light, she was stunning—her long pectorals, perfectly sculpted dorsal, and golden-colored back glowed against the blue backdrop. It was an experience I didn't want to end. I was light-years away from everything else, just drifting in the ocean with this beautiful shark. After a couple hours the sun was low on the horizon and light levels underwater were falling quickly, so I reluctantly exited the water.

I have had many magical shark encounters in warm waters, and I believe that I am better for having had such experiences. It's been said that sharks have remained unchanged for hundreds of millions of years because they are perfect and no further evolutionary changes are necessary. Perhaps in time we will peel back more of the layers of mystery that shroud sharks and other inhabitants of the ocean, as we gain a larger appreciation for them and evolve further ourselves. ～

Ogasawara Islands

Far from the frenetic activity of mainland Japan, marine life surrounding the Ogasawara Islands moves to its own rhythm. The undersea terrain here morphs from boulder-strewn shallows to coral reefs, each with its own cast of characters. In these waters the ocean has also transformed shipwrecks from bygone wars into lush gardens of life, and oceanic caves hide species not yet described by science. The gift that warm water provides is the gift of time, being able to spend prolonged periods in the water so that we can begin to make sense of all that we see. As we move slowly through these places, patterns begin to emerge and behaviors are revealed. In time, order is created from chaos.

Batfish. Japan, 2008

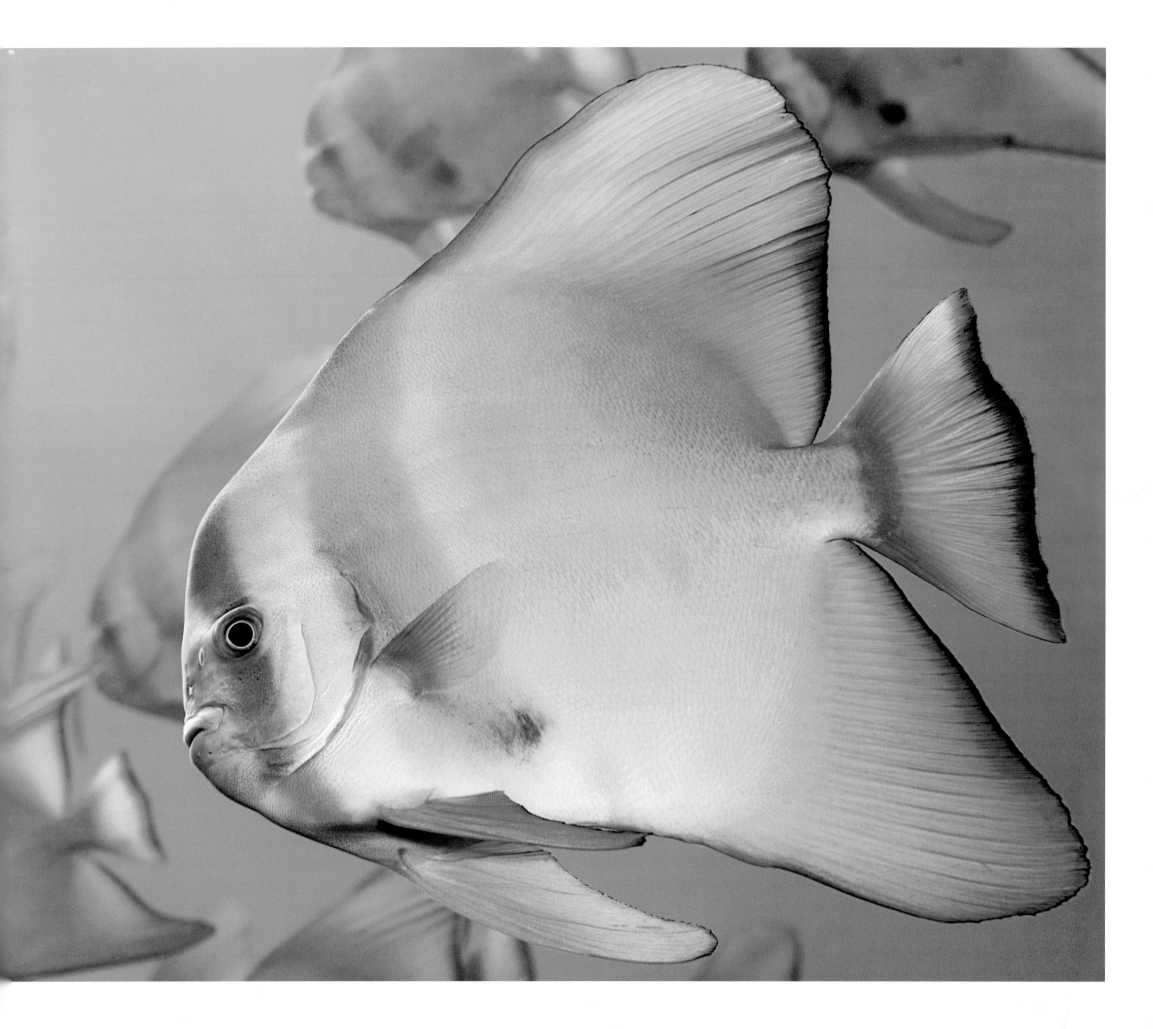

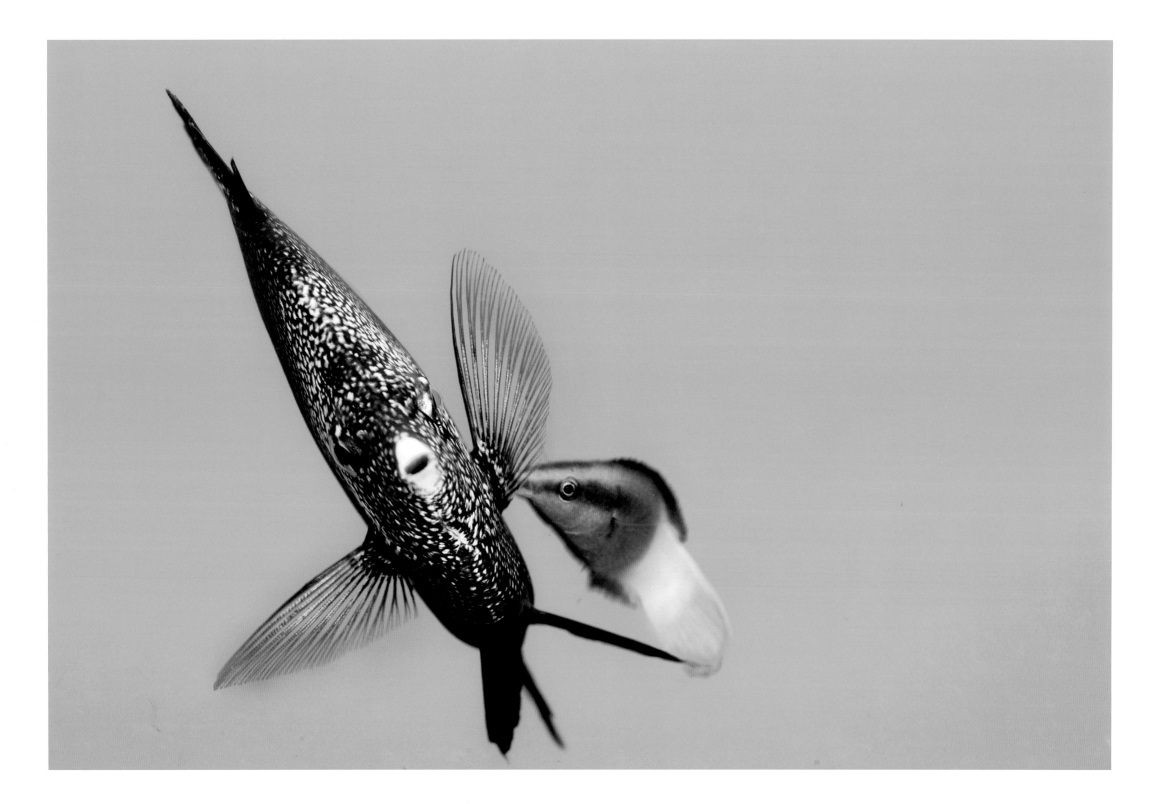

Wrought iron butterfly fish and wrasse. Japan, 2008

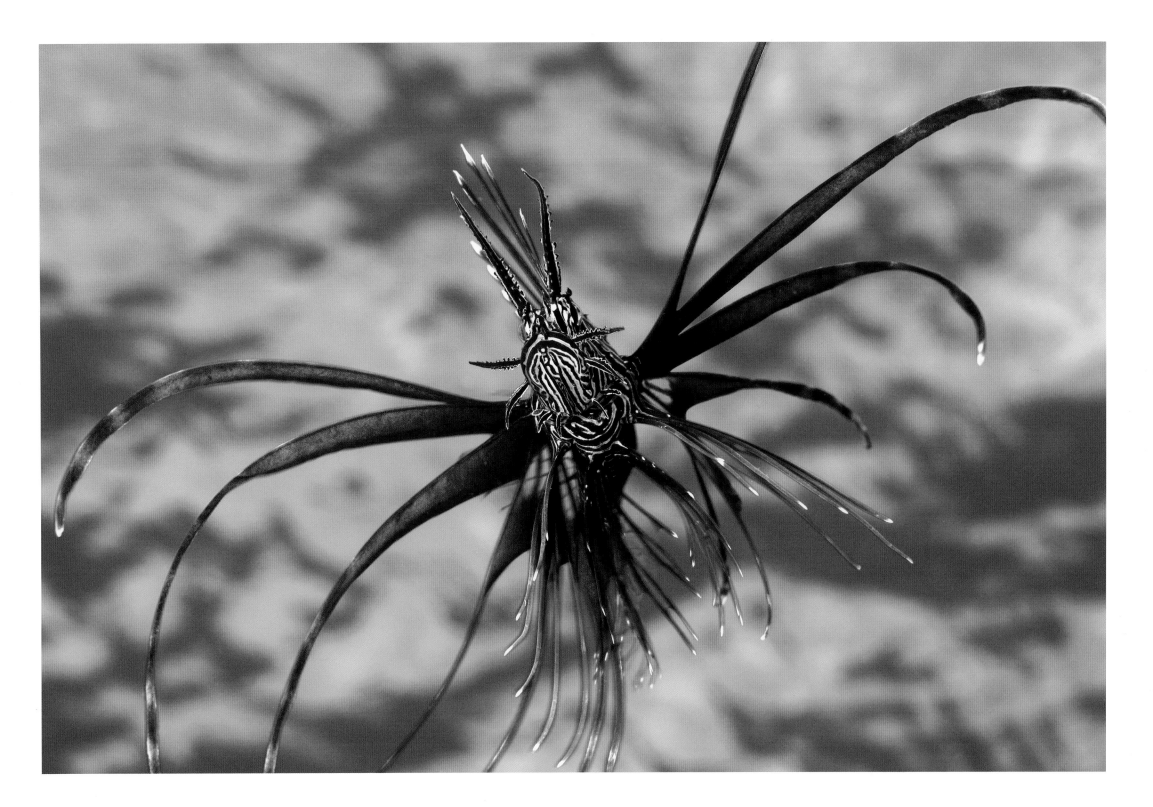

Lionfish. Japan, 2008

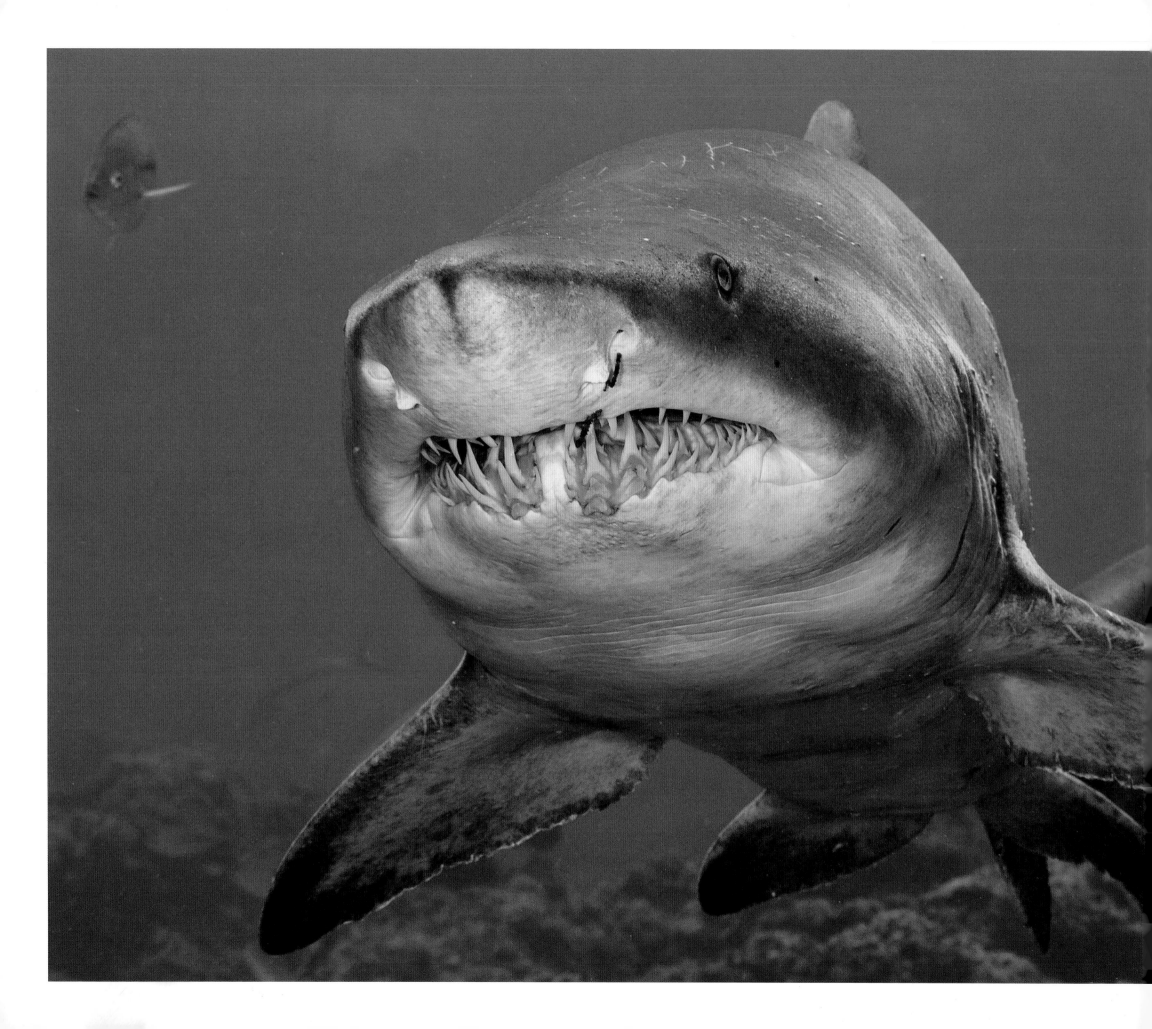

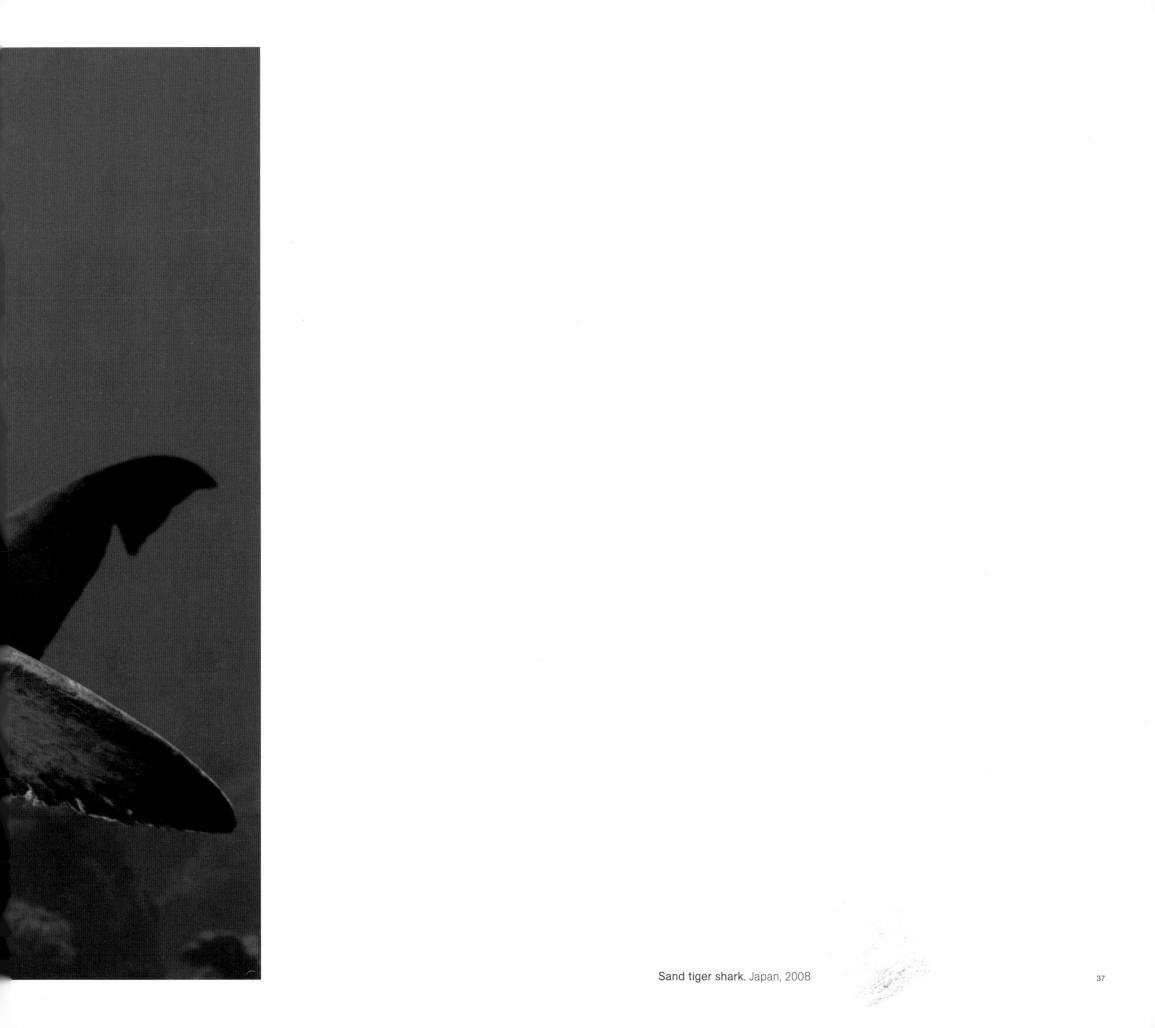

Sand tiger shark. Japan, 2008

A desire to understand the relationships of wildlife in the sea is a very big part of the motivation for my work. I want to understand the behaviors of individual animals but also want to know how animals and ecosystems interrelate.

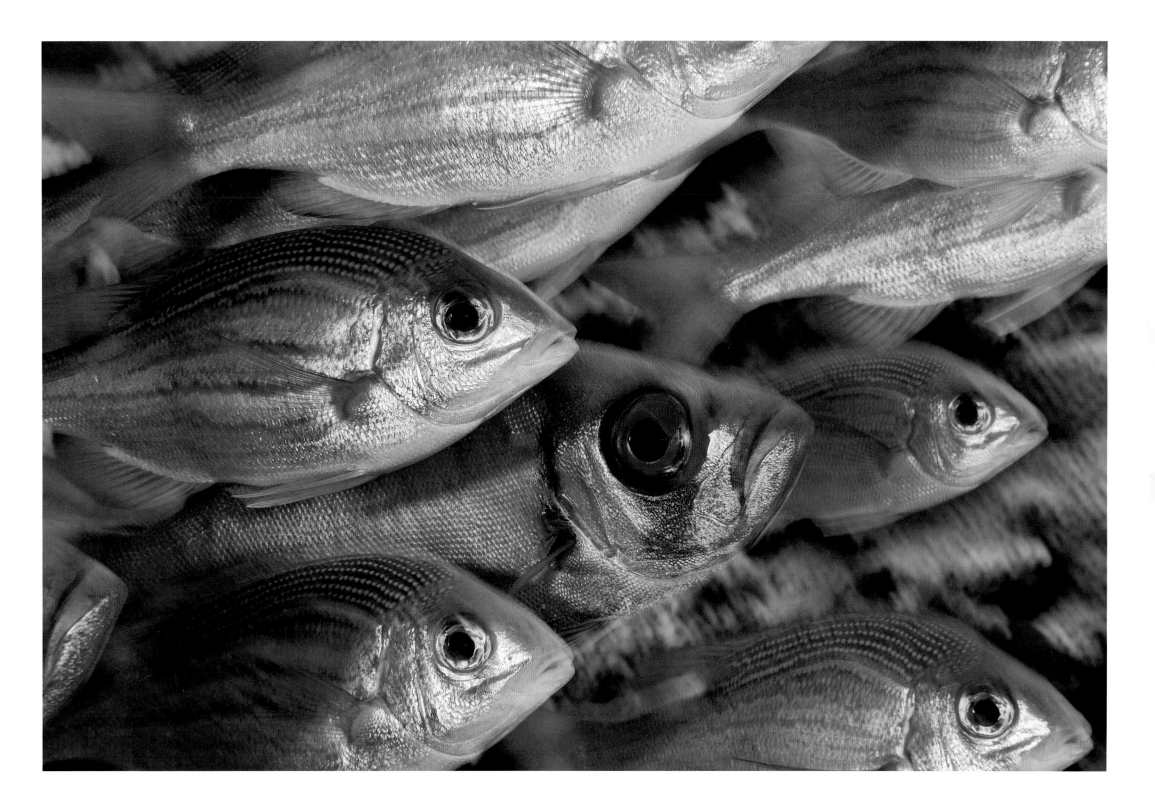

Gold-lined sea bream and glass eye. Japan, 2008

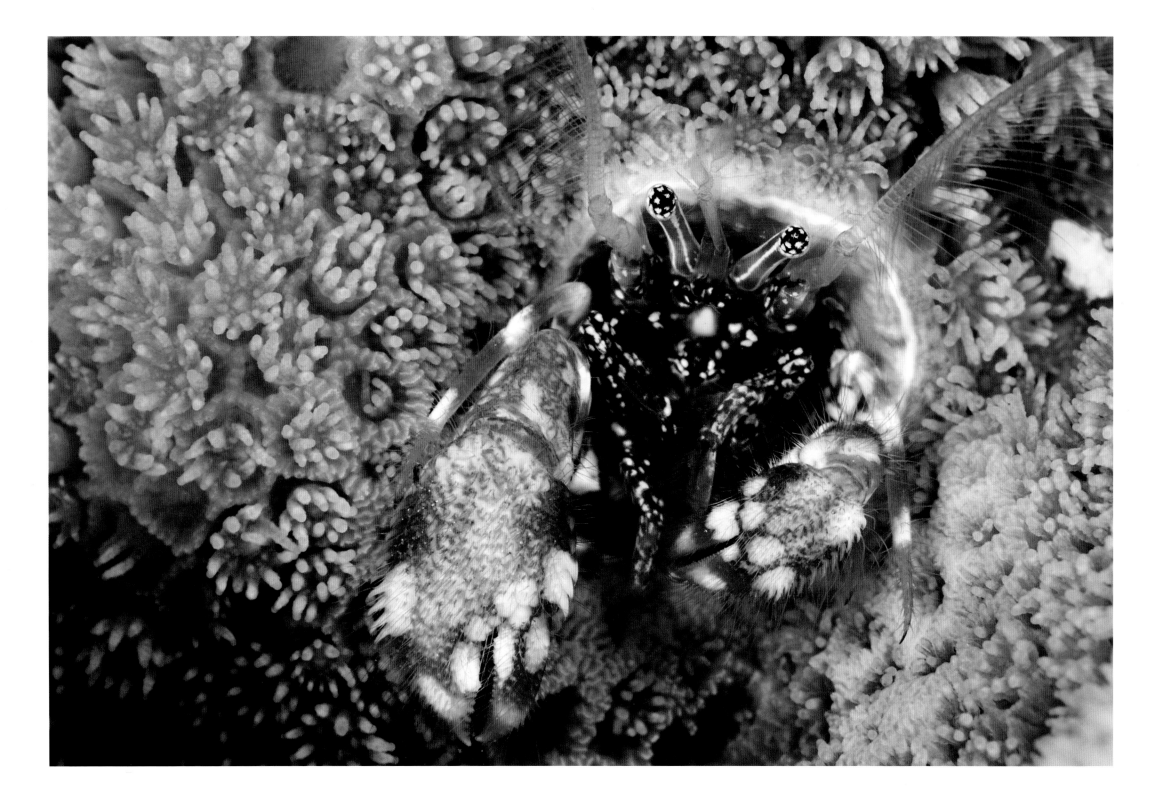

Hermit crab in coral. Japan, 2008

Undescribed tunicates. Japan, 2008

Mesoamerican Seas

Stretching through four countries, the
Mesoamerican Reef system is a complex
series of interrelated ecosystems. In these
tropical seas, mangroves, coral reefs, and
sea grass beds are woven together intri-
cately like a living tapestry, each depen-
dent on the other for its own survival.
The connectivity between the oceans and
the heavens is seen here as well, when
on certain nights during specific moon
phases, fish spawning occurs in mas-
sive aggregations. Exploring beneath the
surface, we encounter animals great and
small, from giant whale sharks feeding in
blue water to tiny blennies living inside
coral, and it becomes clear that everything
here works in harmony, like a precision
machine with each part playing a vital role.

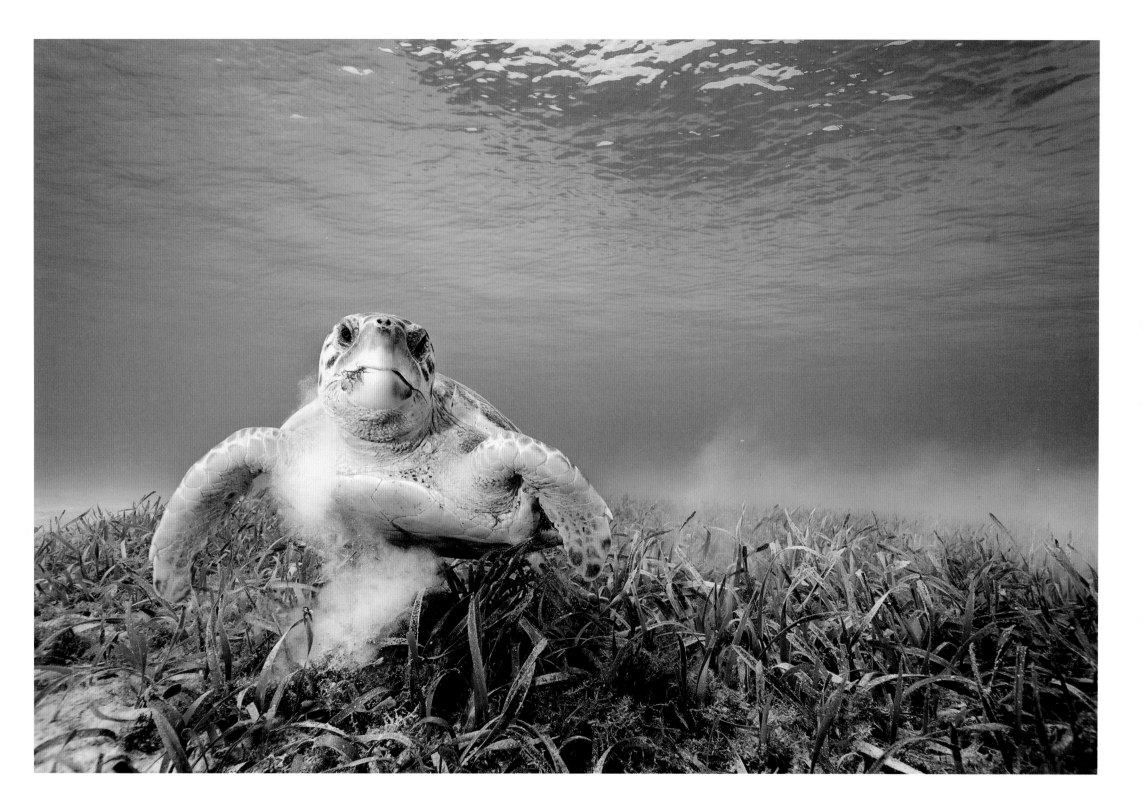

Loggerhead turtle. Belize, 2010

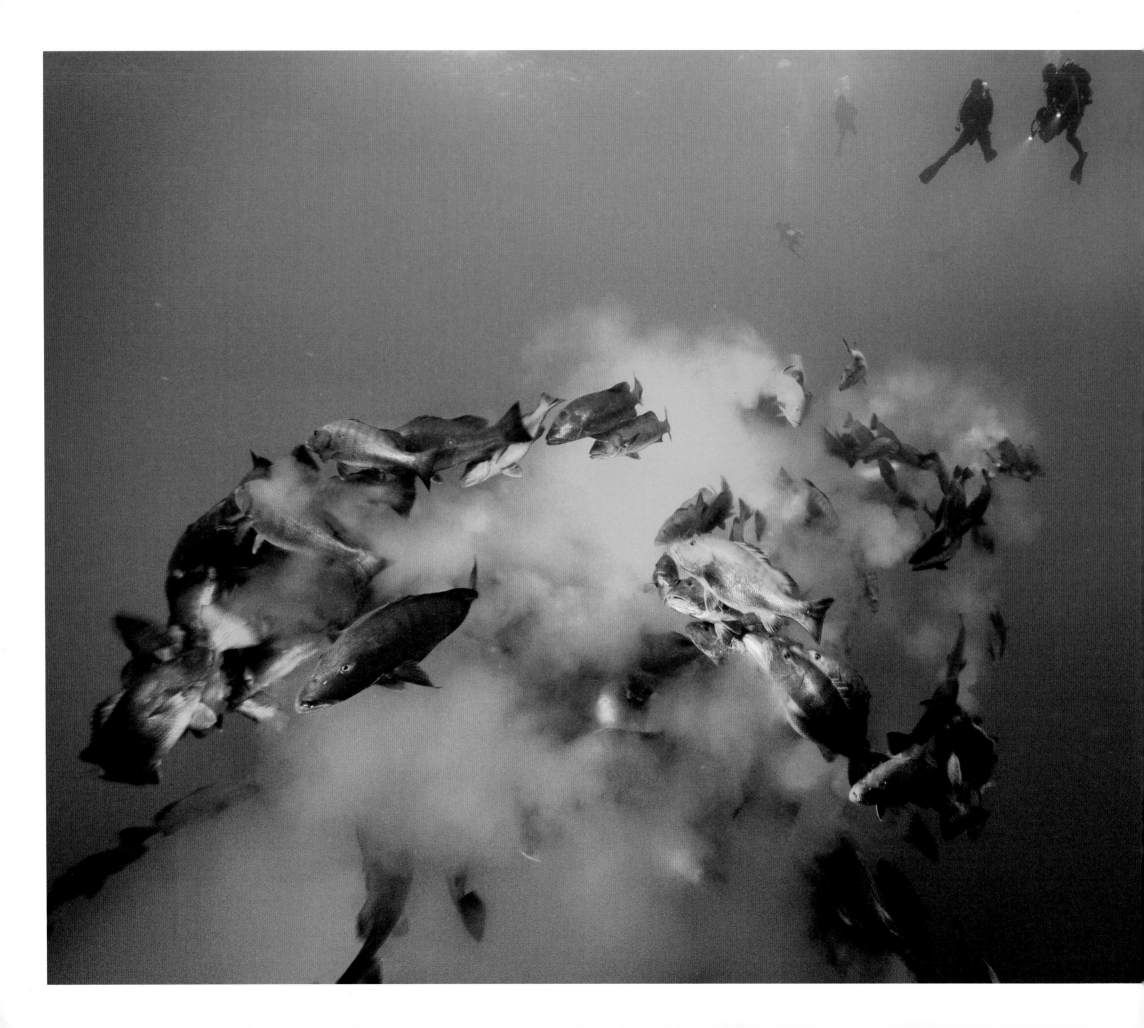

Spawning cubera snapper. Belize, 2010

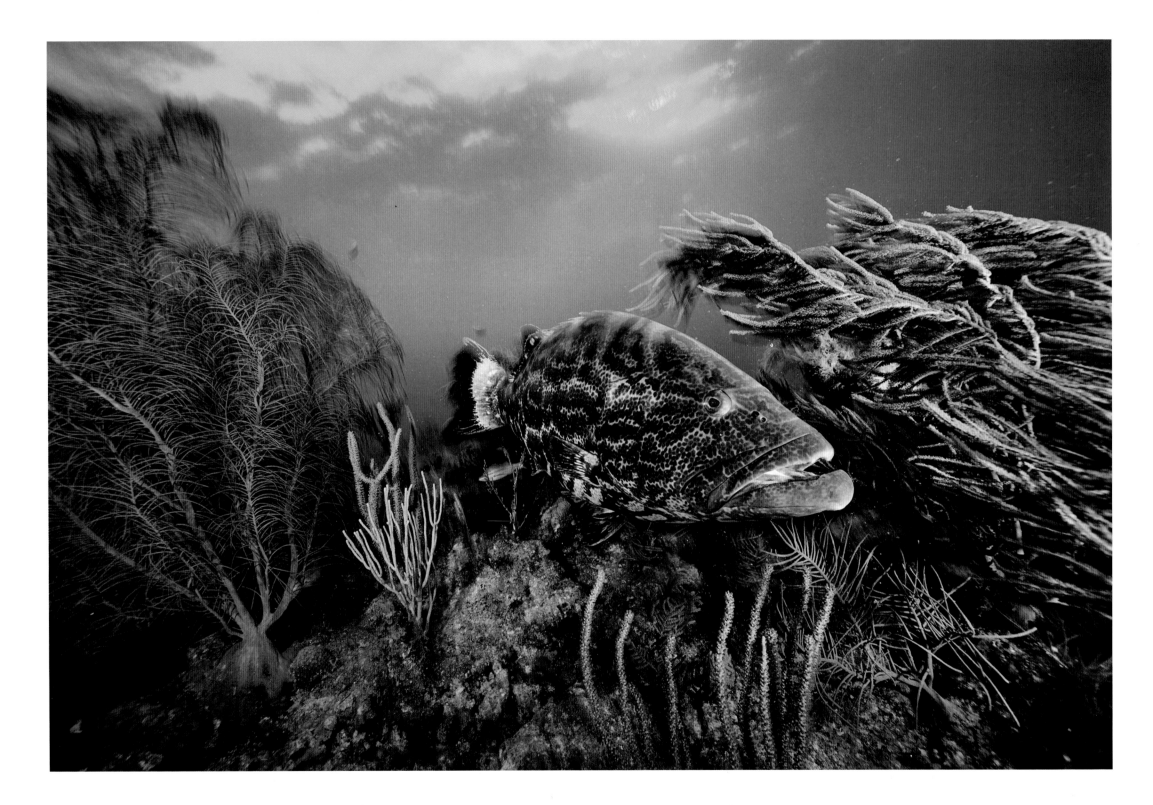

Black grouper. Belize, 2010 ~ **Black margate.** Belize, 2010 (opposite)

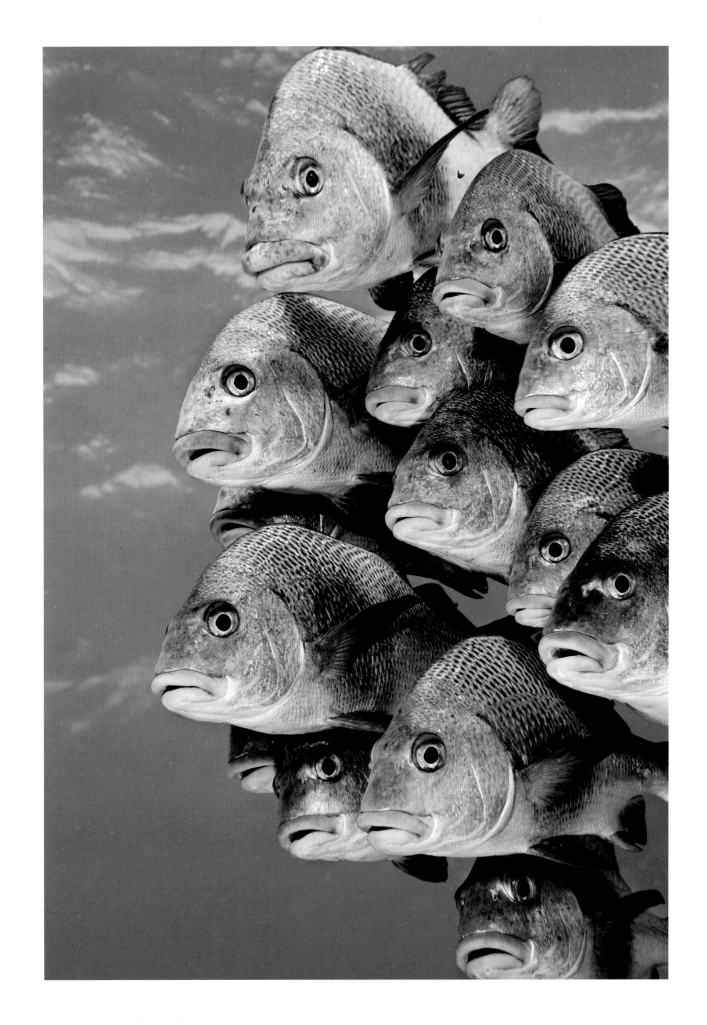

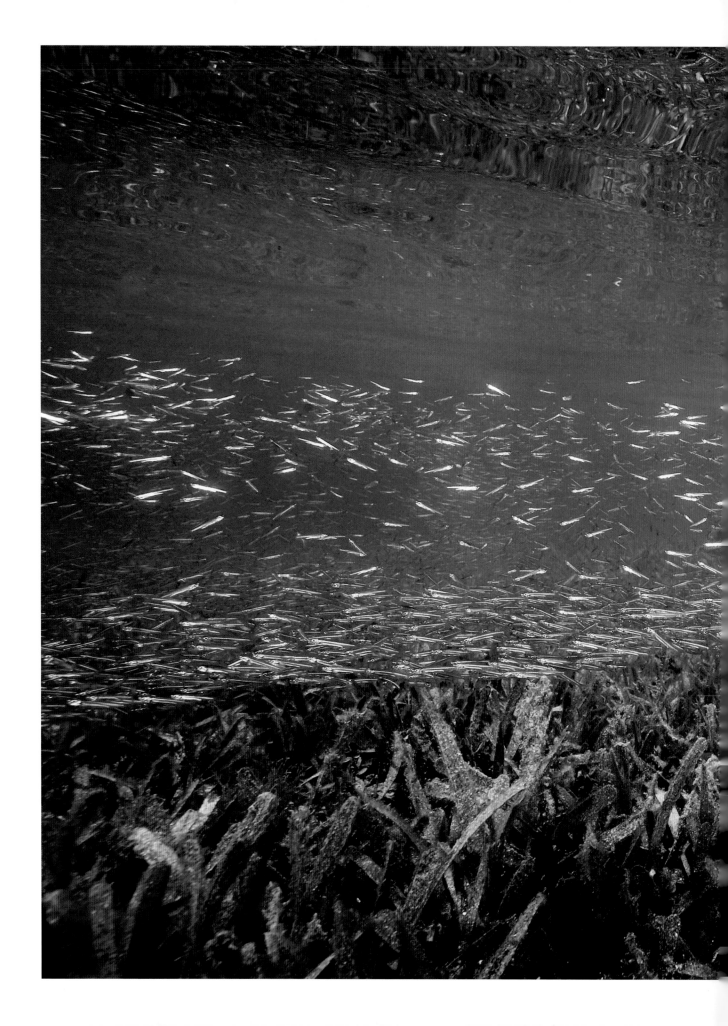

Sea grass. Belize, 2010

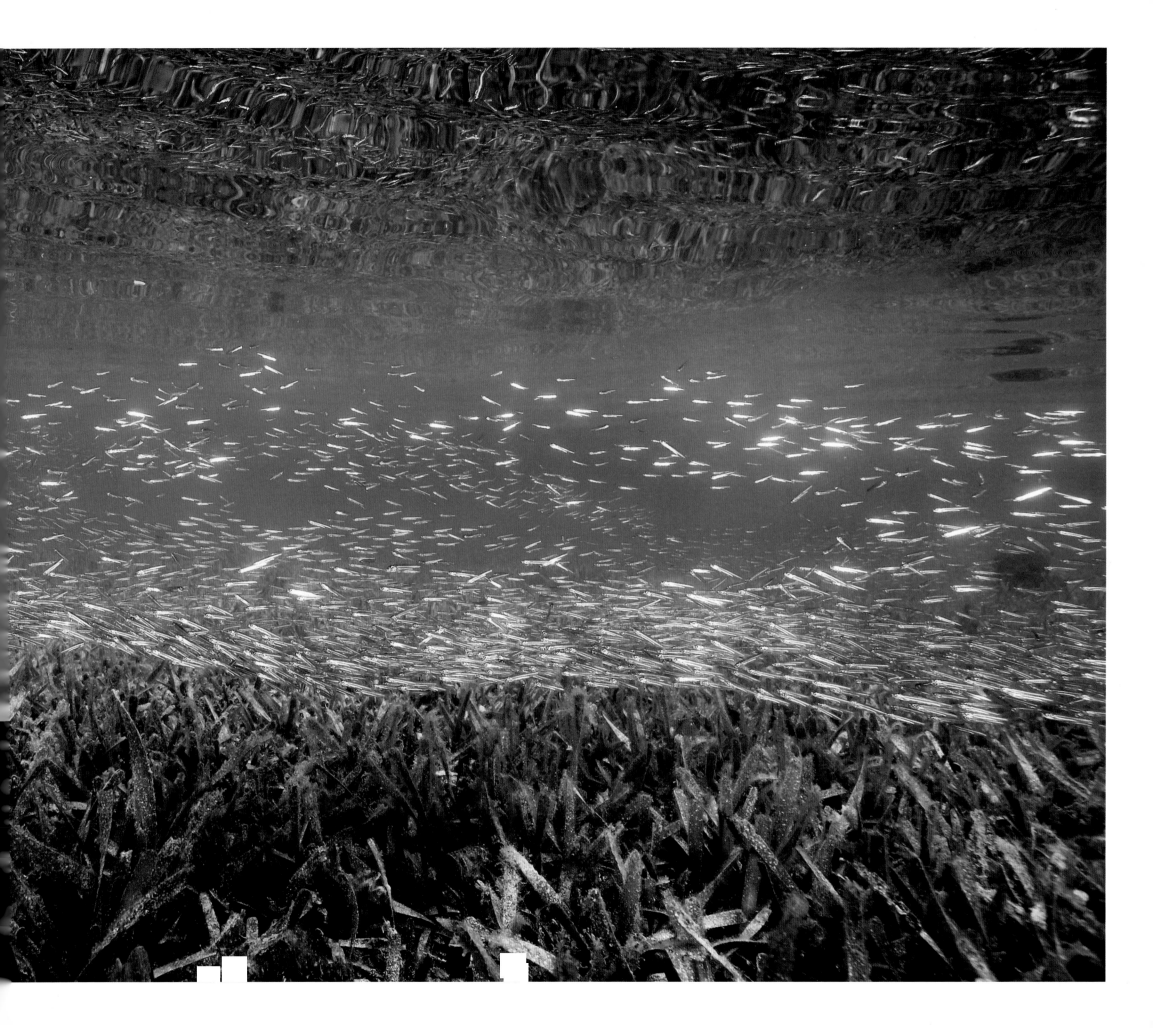

Trumpetfish. Belize, 2010

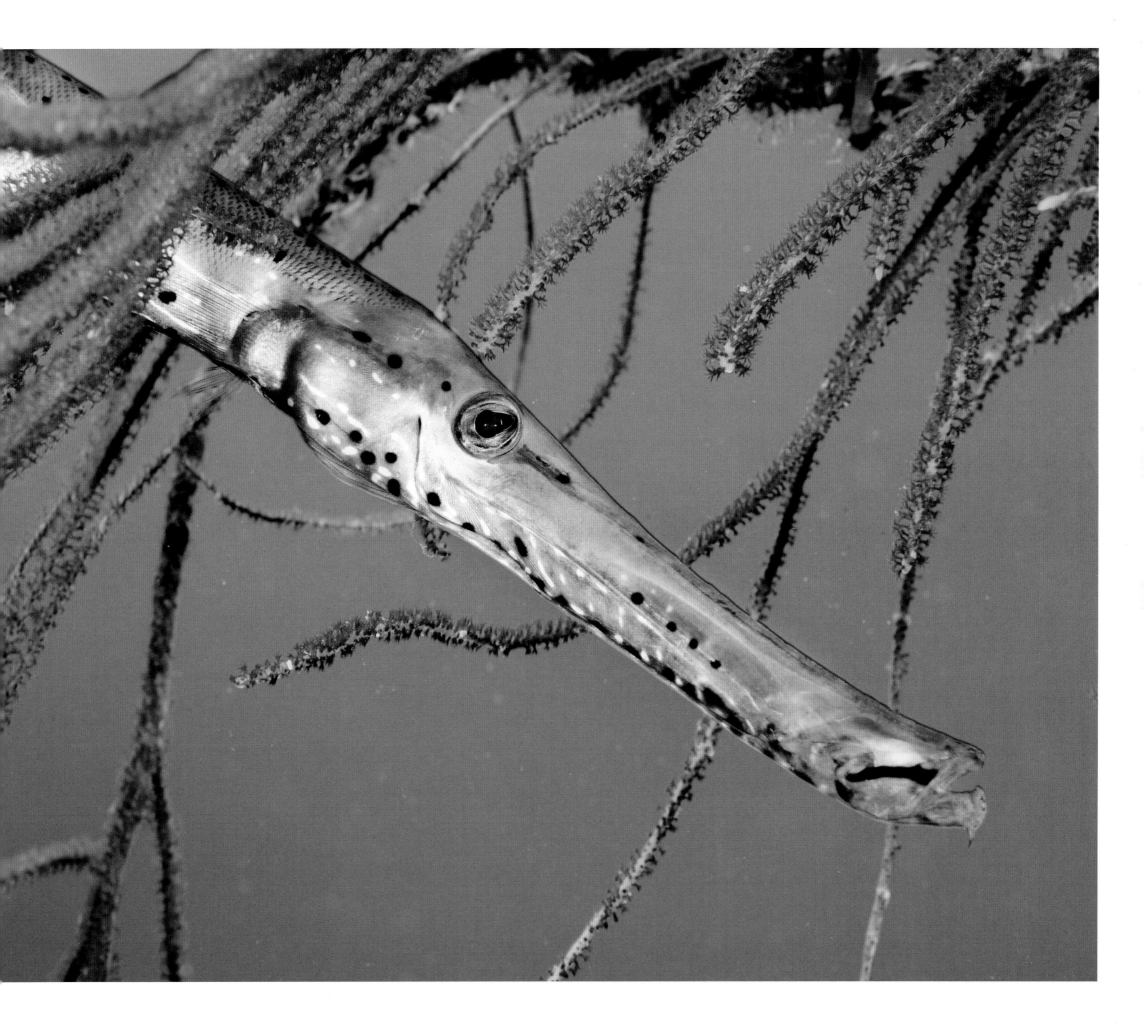

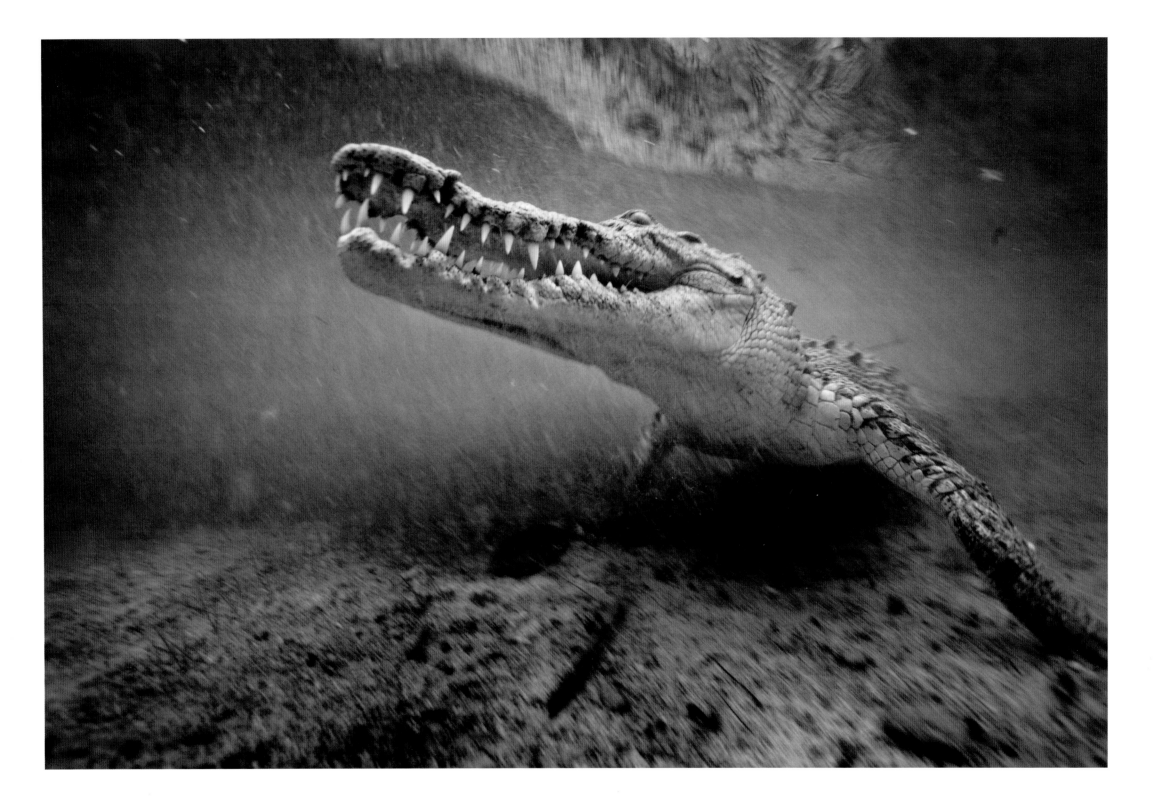

American crocodile. Mexico, 2009

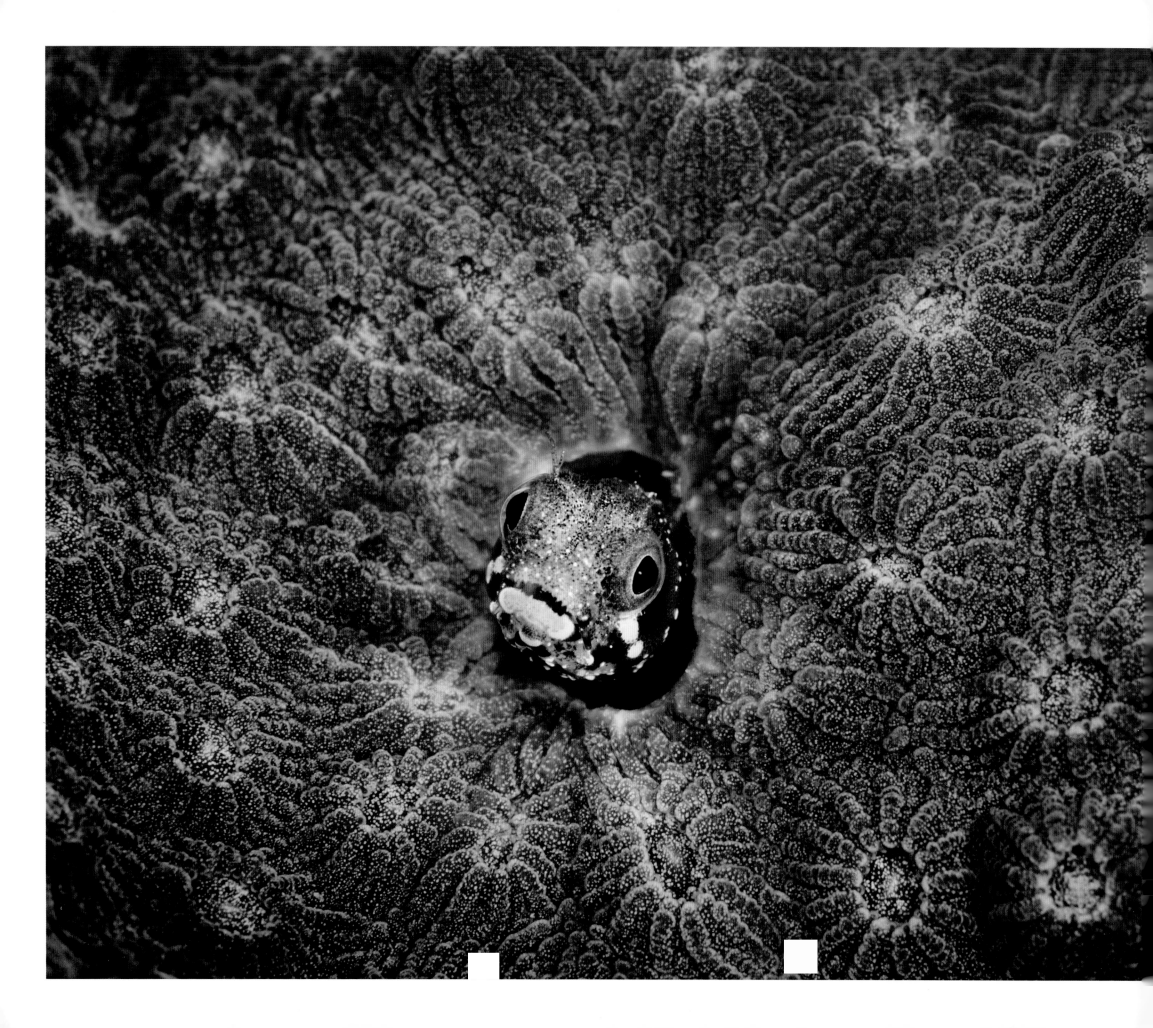

Spinyhead blenny in coral. Belize, 2010

Sea Monsters

Traveling in schools of thousands, they grow to lengths of more than 12 feet, have a beak for a mouth, and sport tentacles and arms that possess teeth-lined sucker disks. It would be hard to imagine a more fearsome sea monster than the Humboldt squid. Known to eat "anything that moves," these deepwater cephalopods are also cannibalistic, predating on each other when offered the chance. Other species of tropical squid are far less menacing, although encounters with any species offer fascinating observations of behaviors that seem otherworldly. Communicating with skin that forms patterns, and using ink as a defensive mechanism, squid typically live less than 18 months. Highly evolved invertebrates, these jet-propelled James Deans of the sea live fast and die young.

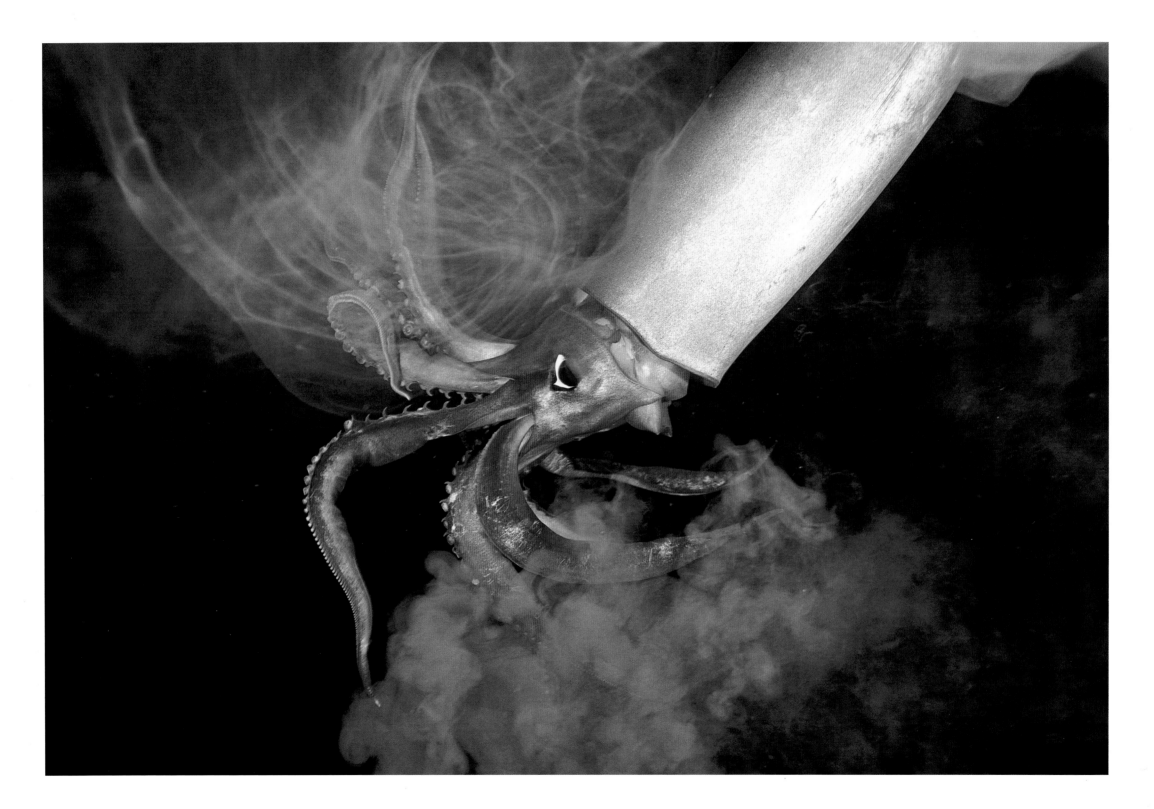

Humboldt squid. Mexico, 2002

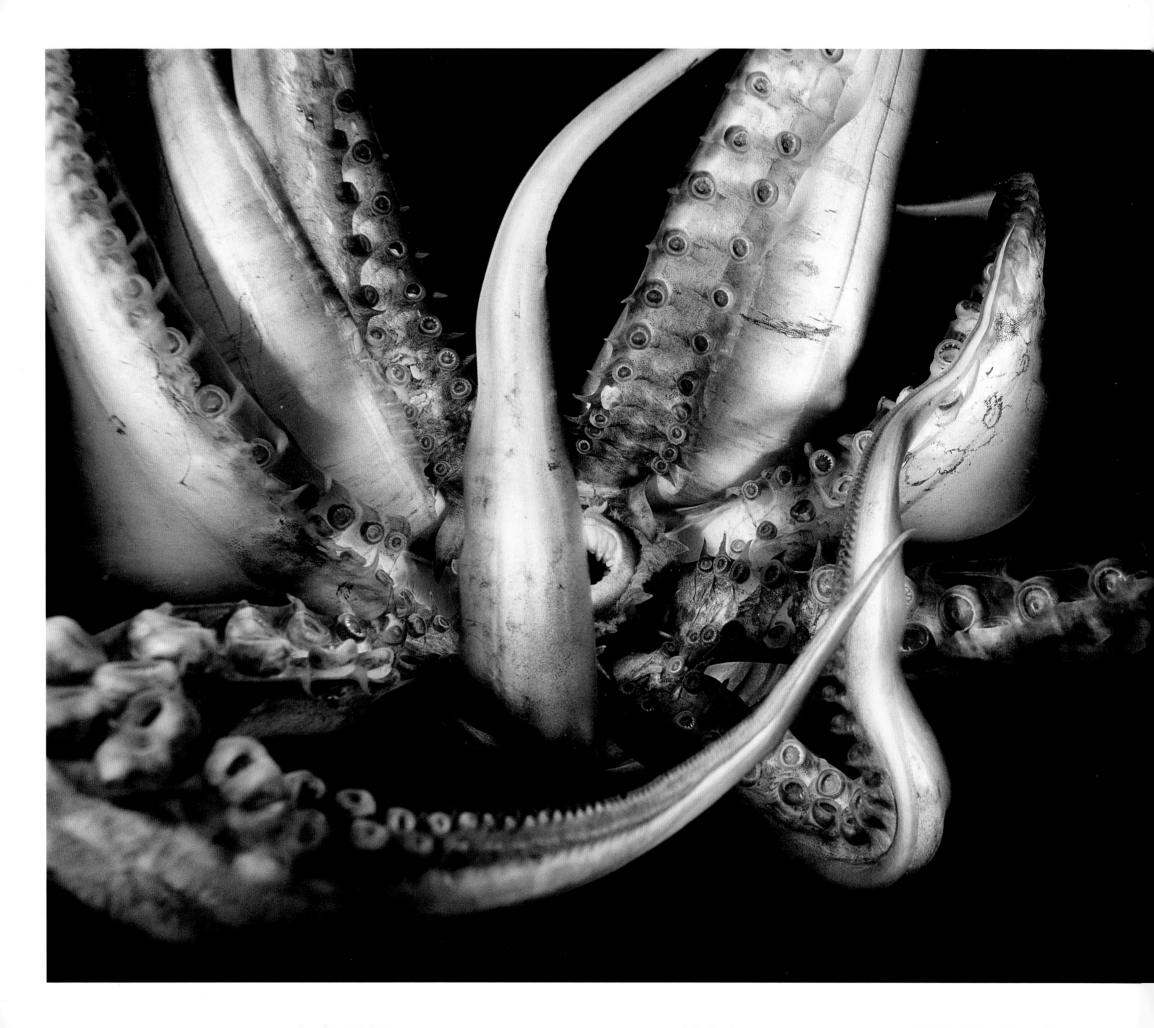

Humboldt squid. Mexico, 2002

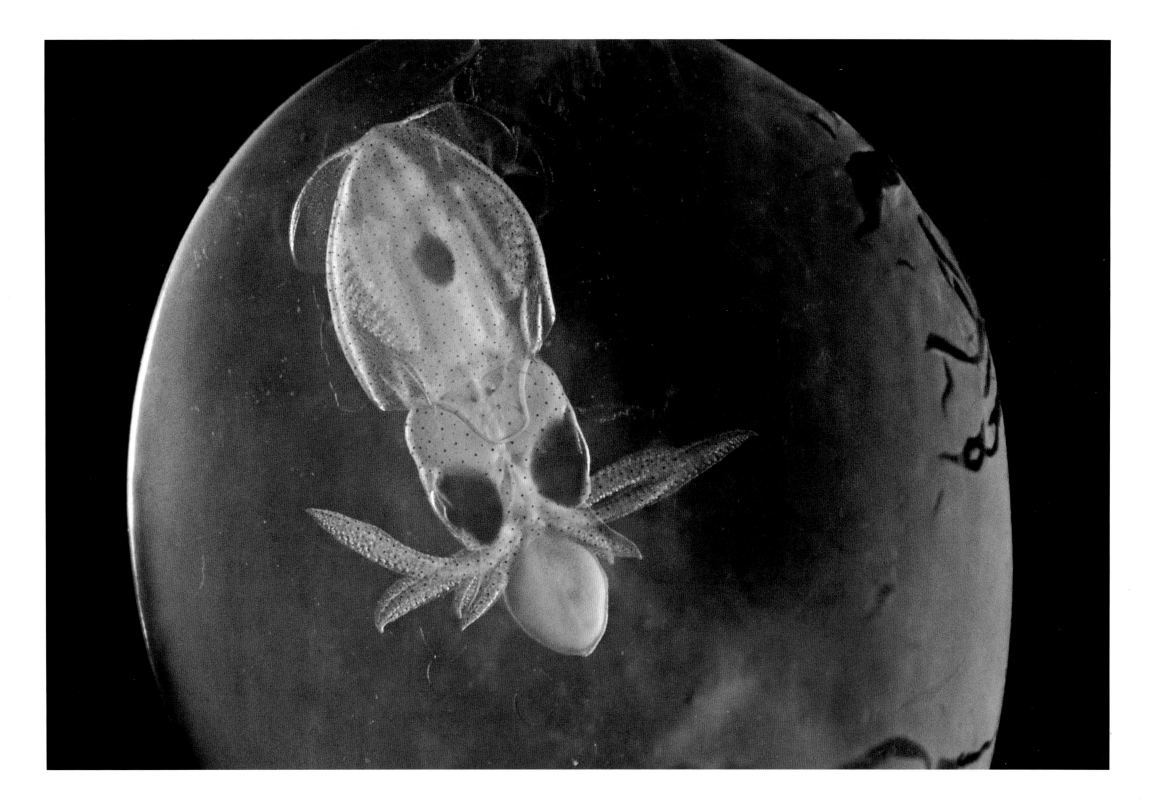

Caribbean reef squid embryo in egg. Venezuela, 2002

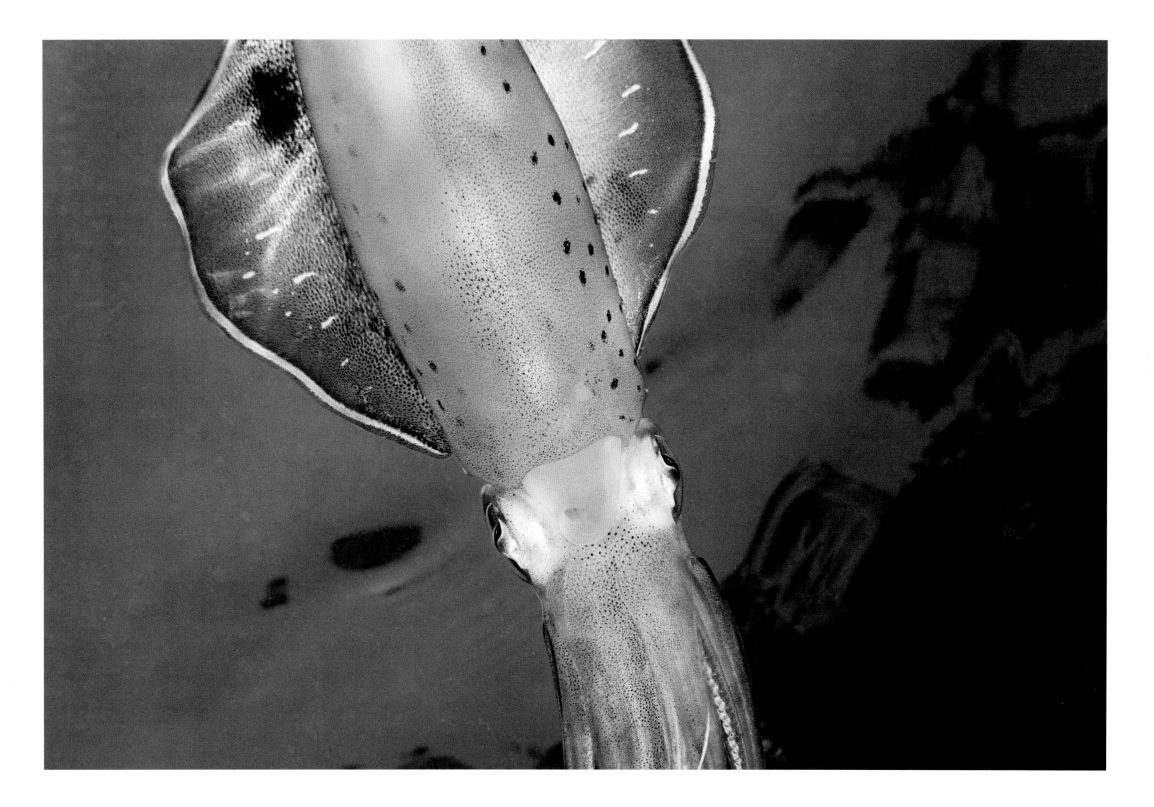

Caribbean reef squid. Venezuela, 2002

Manatees

Free diving with marine mammals in warm water can be a Zen-like experience, especially when the animals allow you into their world. Manatees living in Florida spend much of their time in freshwater rivers and springs during the winter, and with minimal effort they can be seen and experienced underwater. In certain springs the water is crystal clear, and moving through these places is like drifting in air. Known to be the creatures that inspired legends of mermaids, manatees struggle for survival as the result of a gantlet of threats, from watercraft strikes to toxins in the water. The most serious threat, however, is the loss of warm water due to habitat loss.

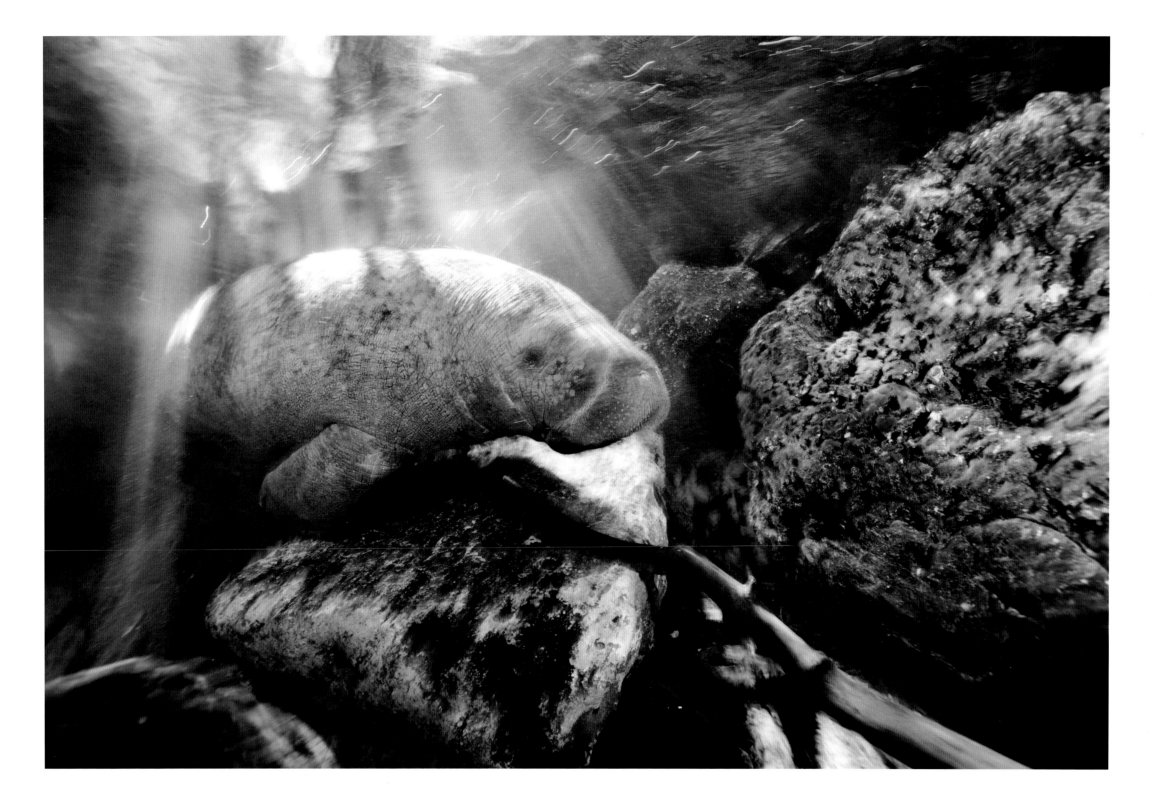

Florida manatee. Florida, 2009

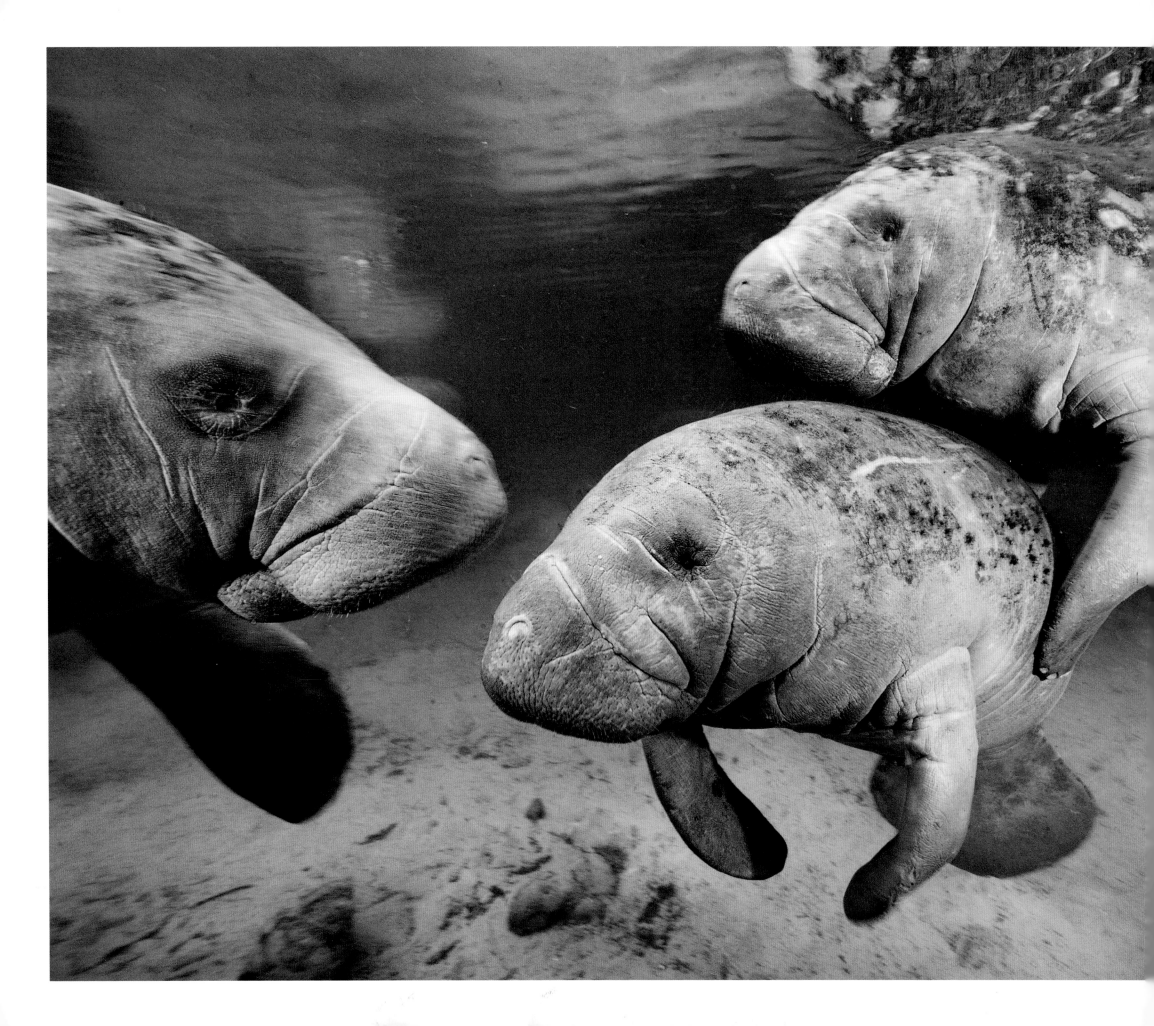

Florida manatees. Florida, 2009

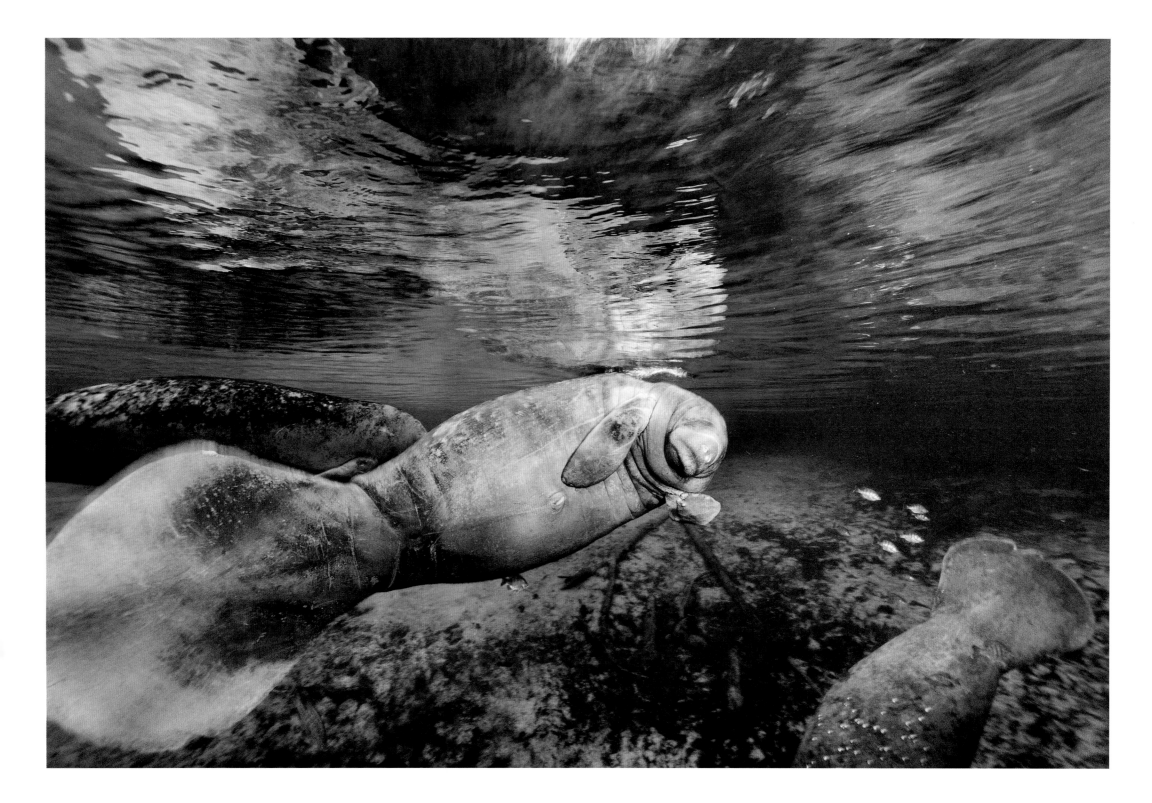

Florida manatee. Florida, 2009

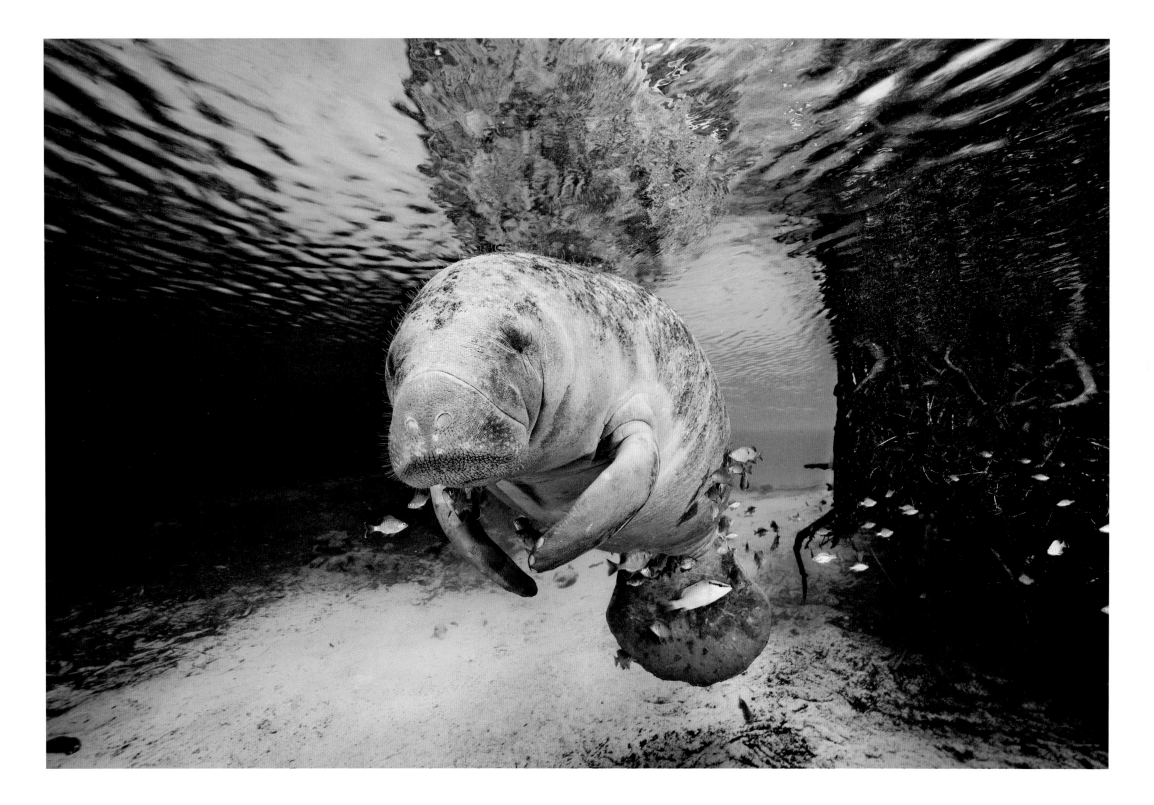

Florida manatee. Florida, 2009

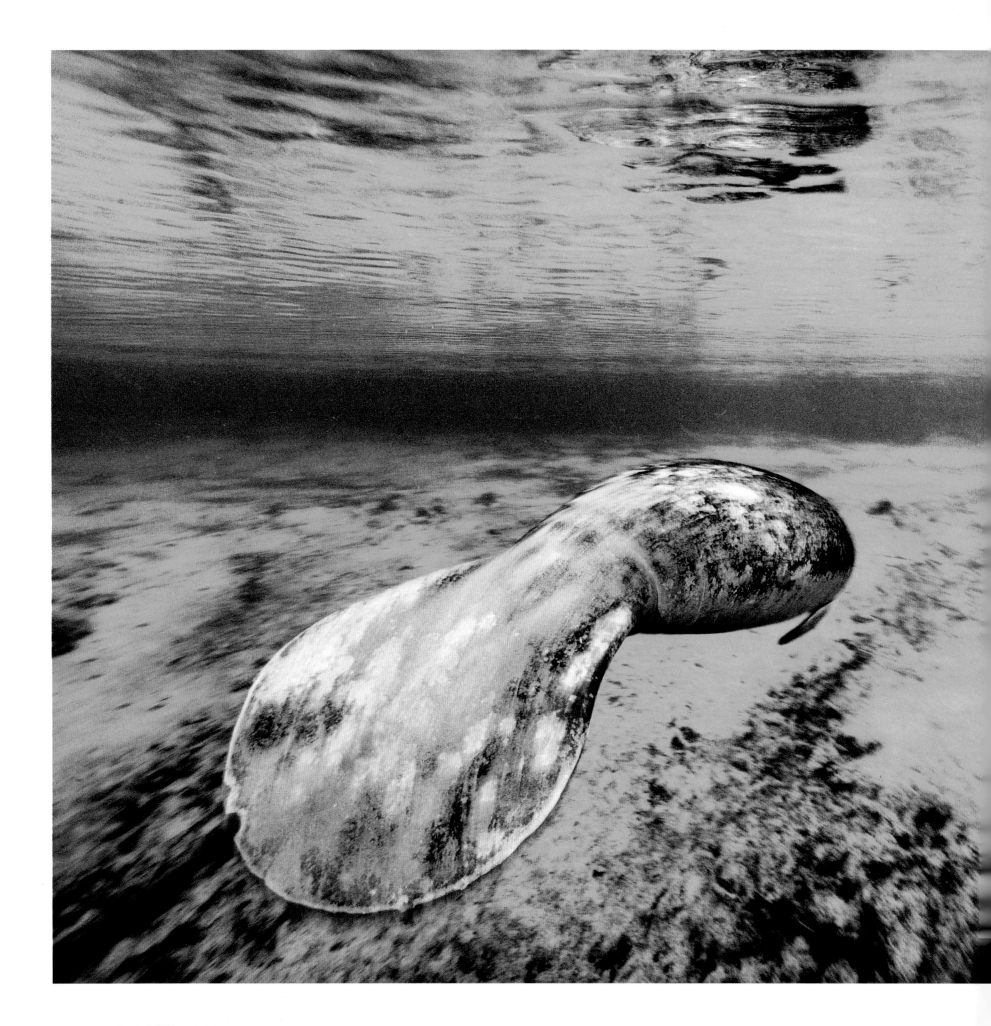

Florida manatees. Florida, 2009

Bahamian Sharks

The Bahamas is a very "sharky" place.
Throughout the more than 700 islands
there are mangrove nurseries, coral reefs,
and deep oceanic trenches, all perfect
habitats for a wide variety of shark spe-
cies. Far from being the solitary, aggressive
monster they have often been portrayed
as, sharks are complex animals, and they
are crucial to the health of the oceans.
With clear, blue water as a backdrop, this
tropical locale is the ideal environment for
an underwater photographer seeking to
capture the special blend of power and
grace that these animals exude.

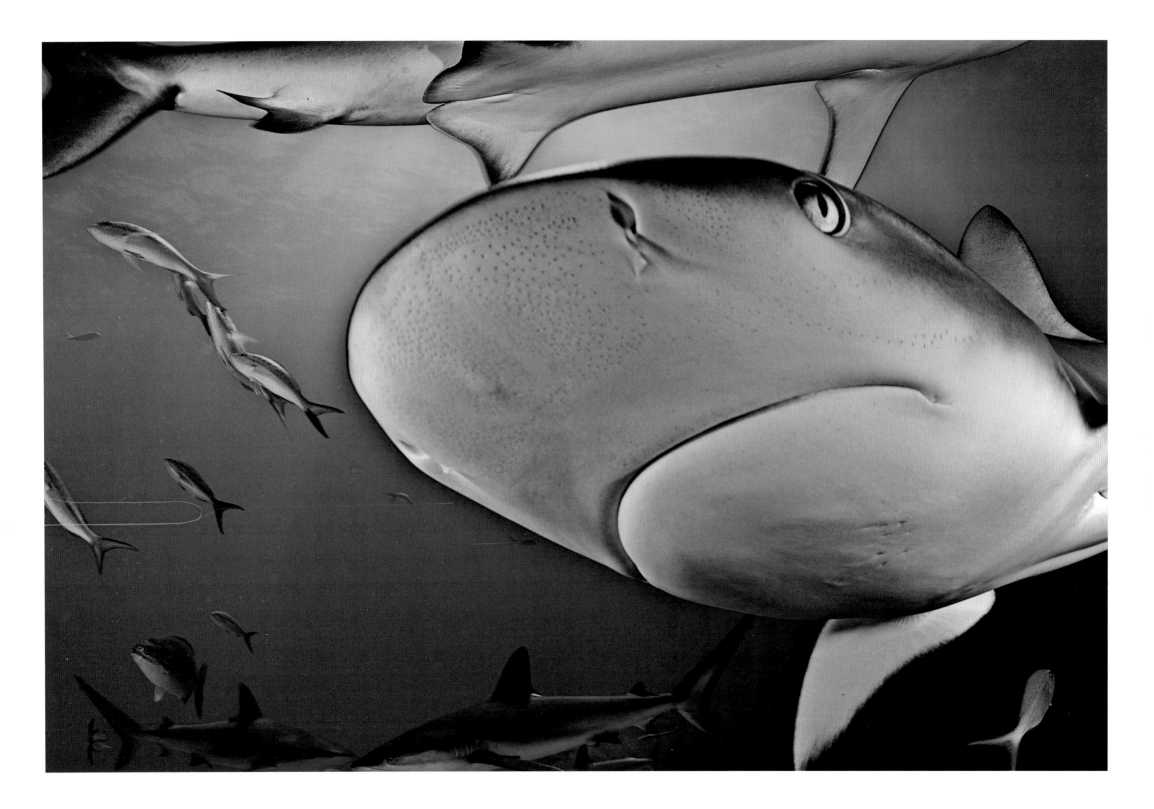

Caribbean reef shark. Bahamas, 2005

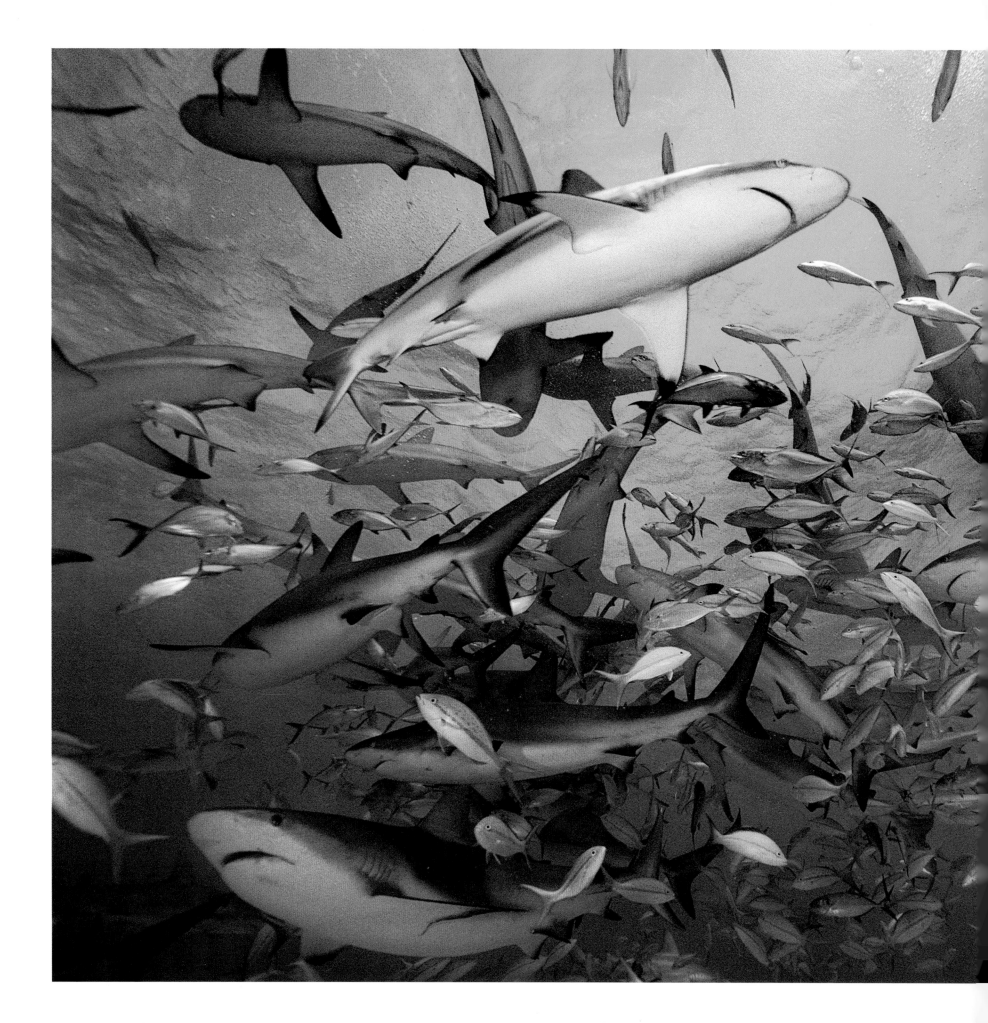

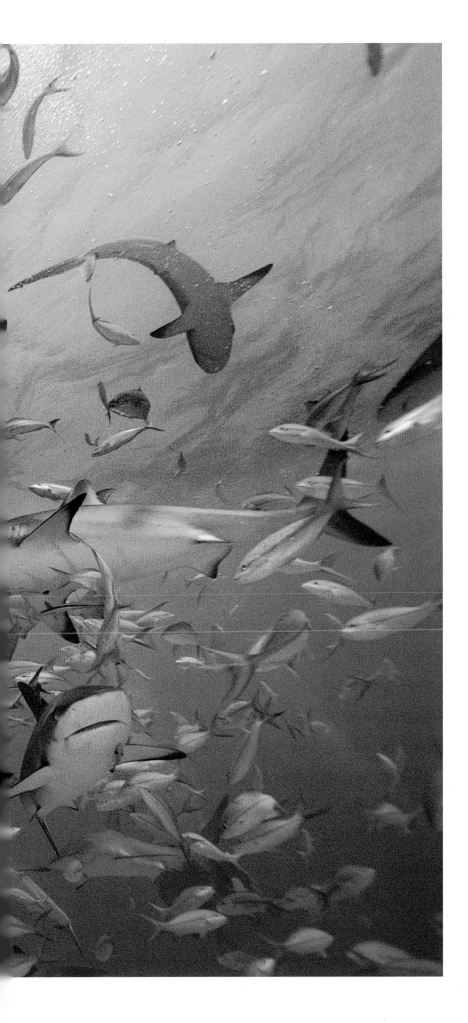

Caribbean reef and blacktip sharks. Bahamas, 2002

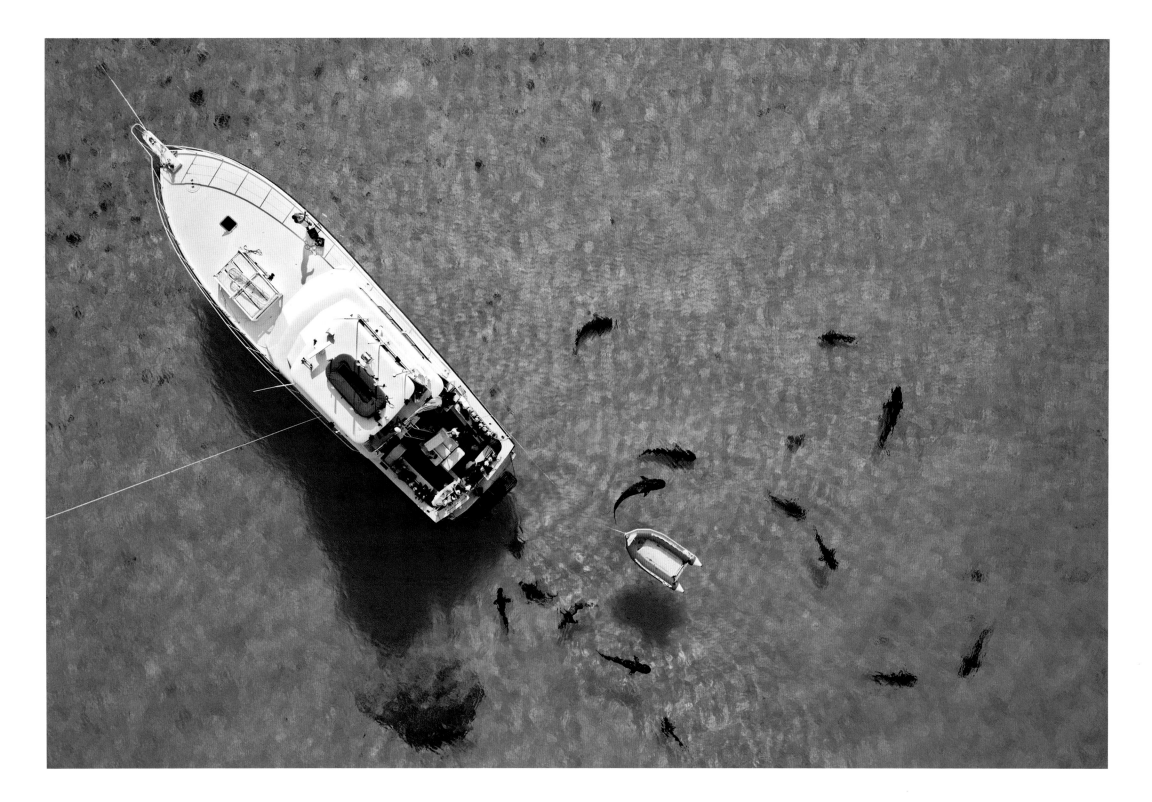

Tiger sharks behind dive boat. Bahamas, 2005

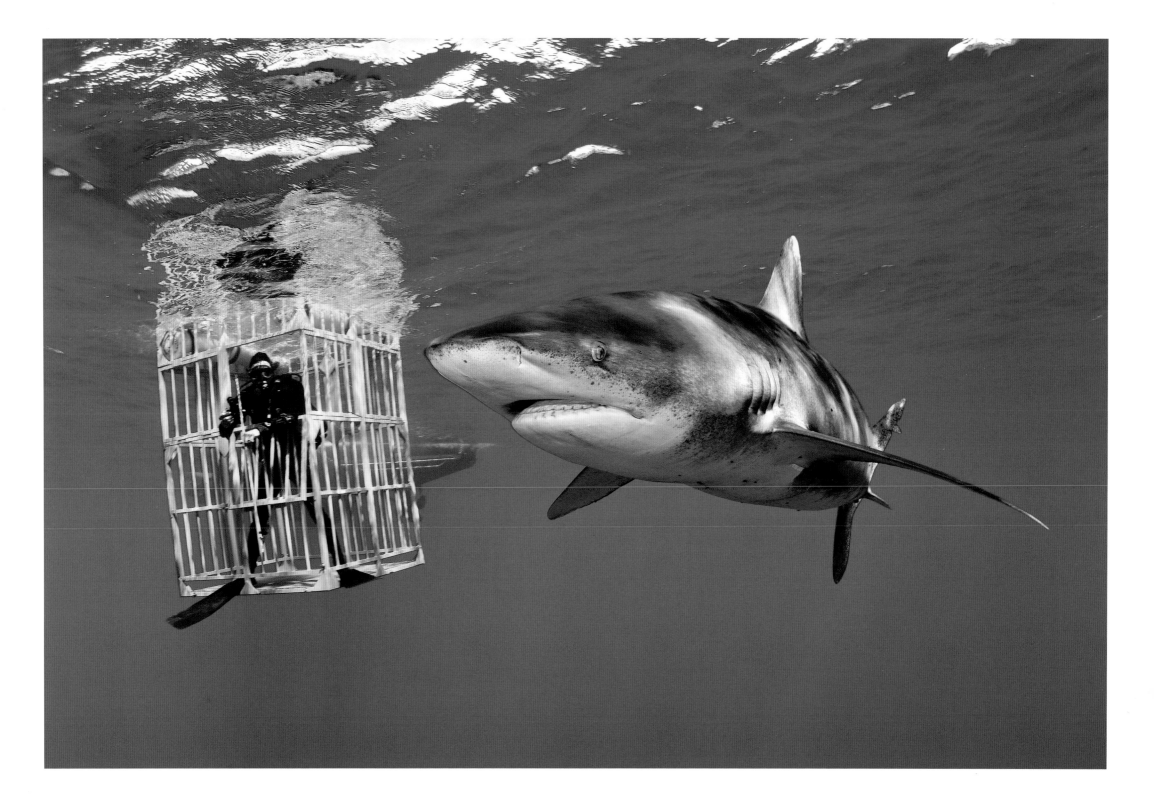

Oceanic whitetip shark. Bahamas, 2005

It's been said that sharks have remained unchanged for hundreds of millions of years because they are perfect and that no further evolutionary change is necessary.

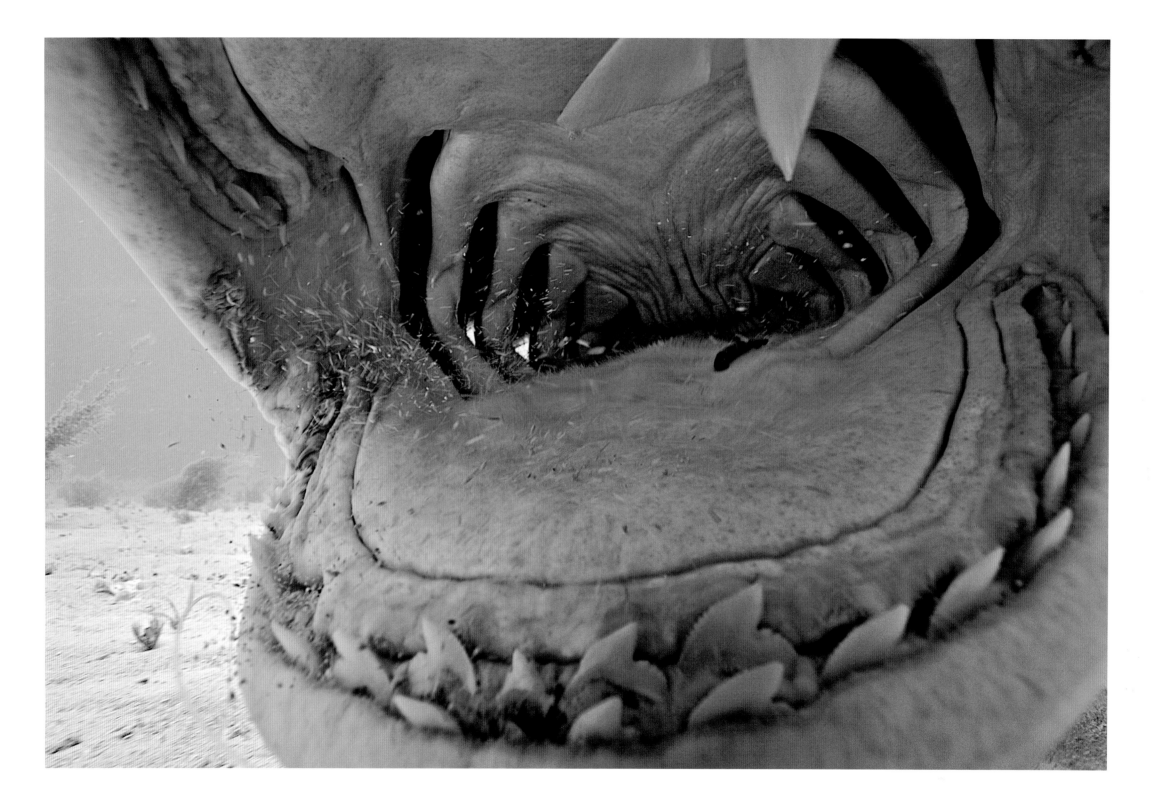

Tiger shark. Bahamas, 2005

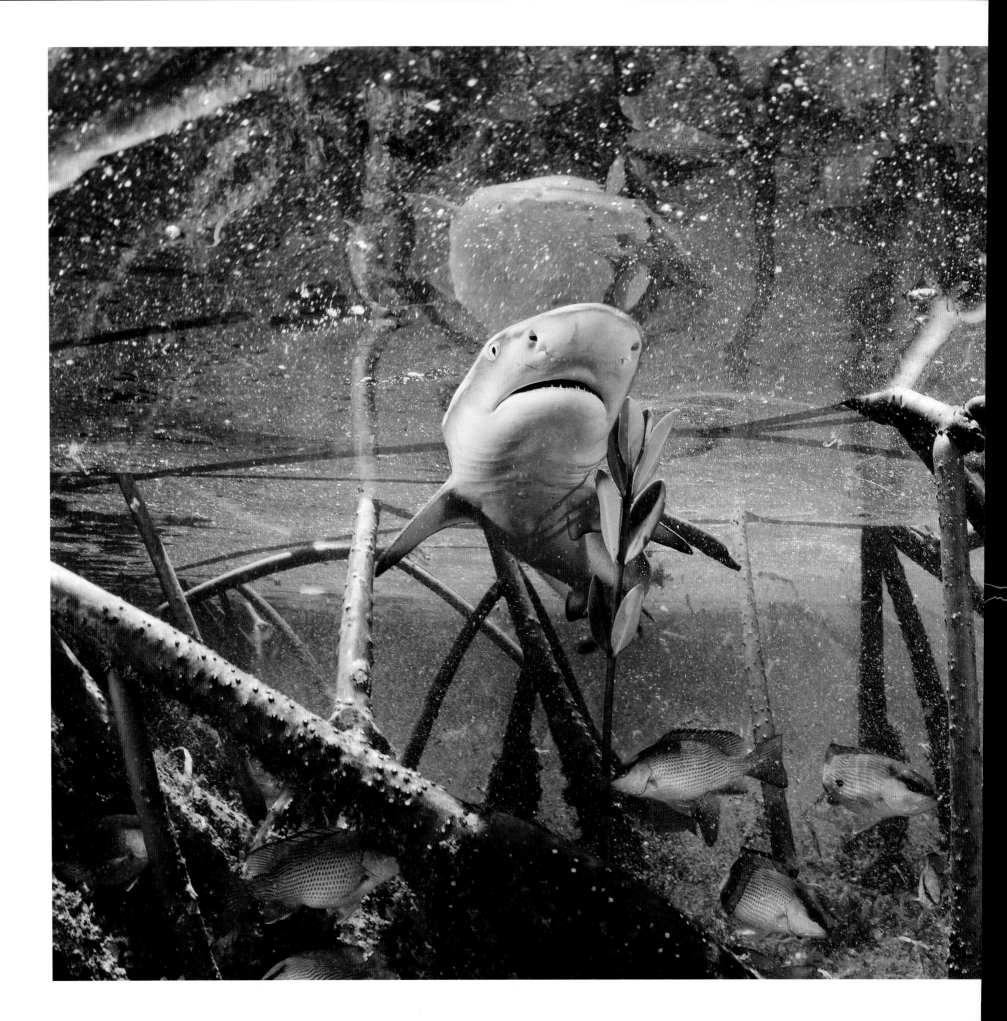

Lemon shark pup in mangrove. Bahamas, 2005

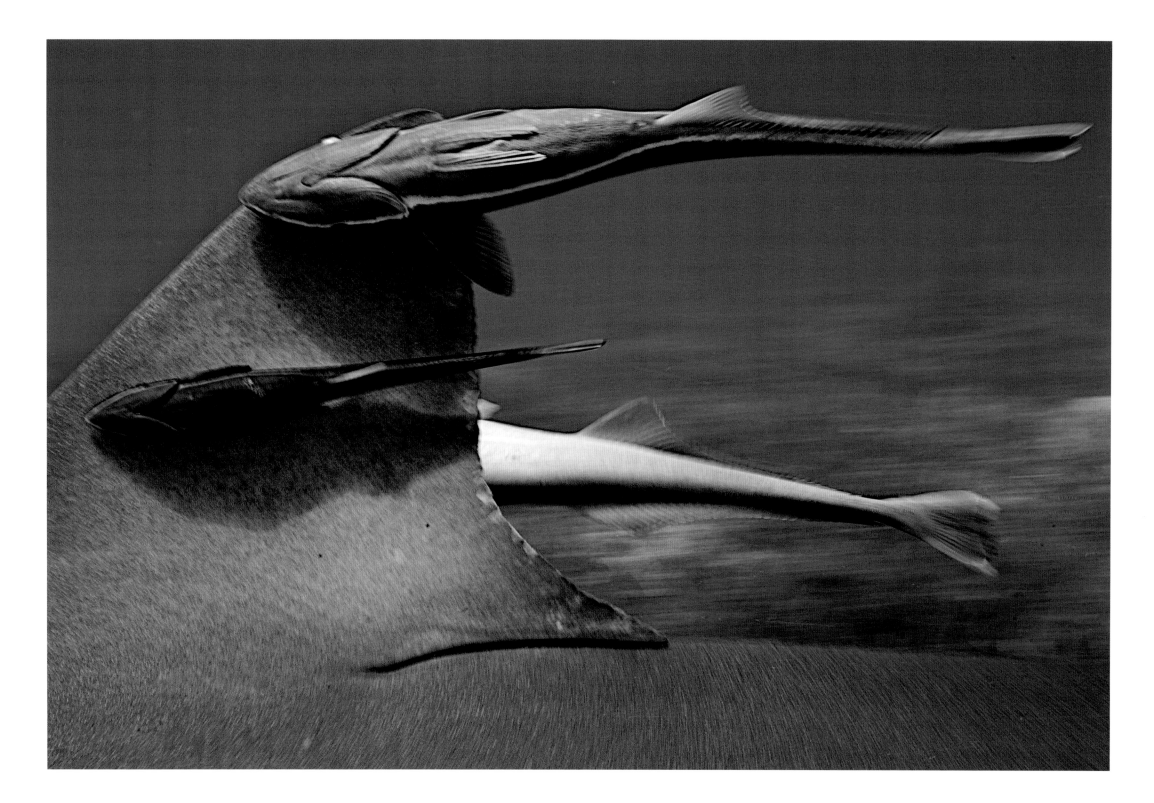

Lemon shark with remoras. Bahamas, 2005

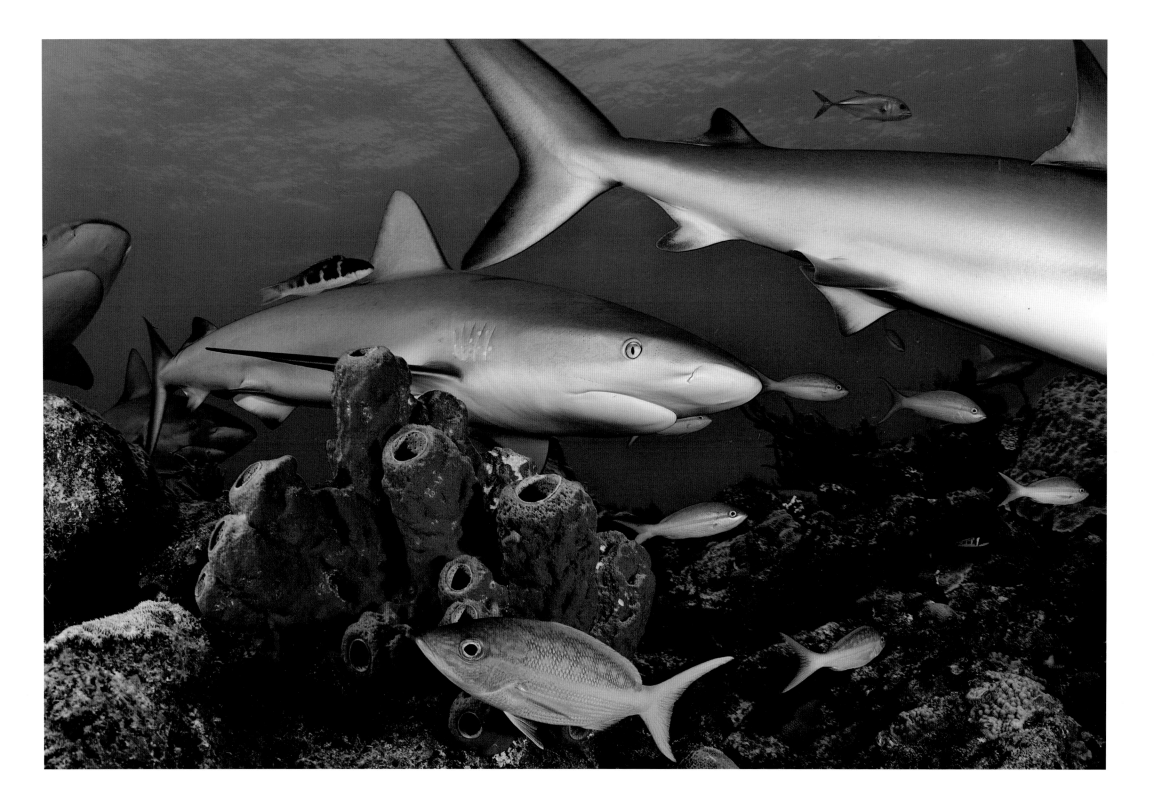

Caribbean reef sharks. Bahamas, 2005

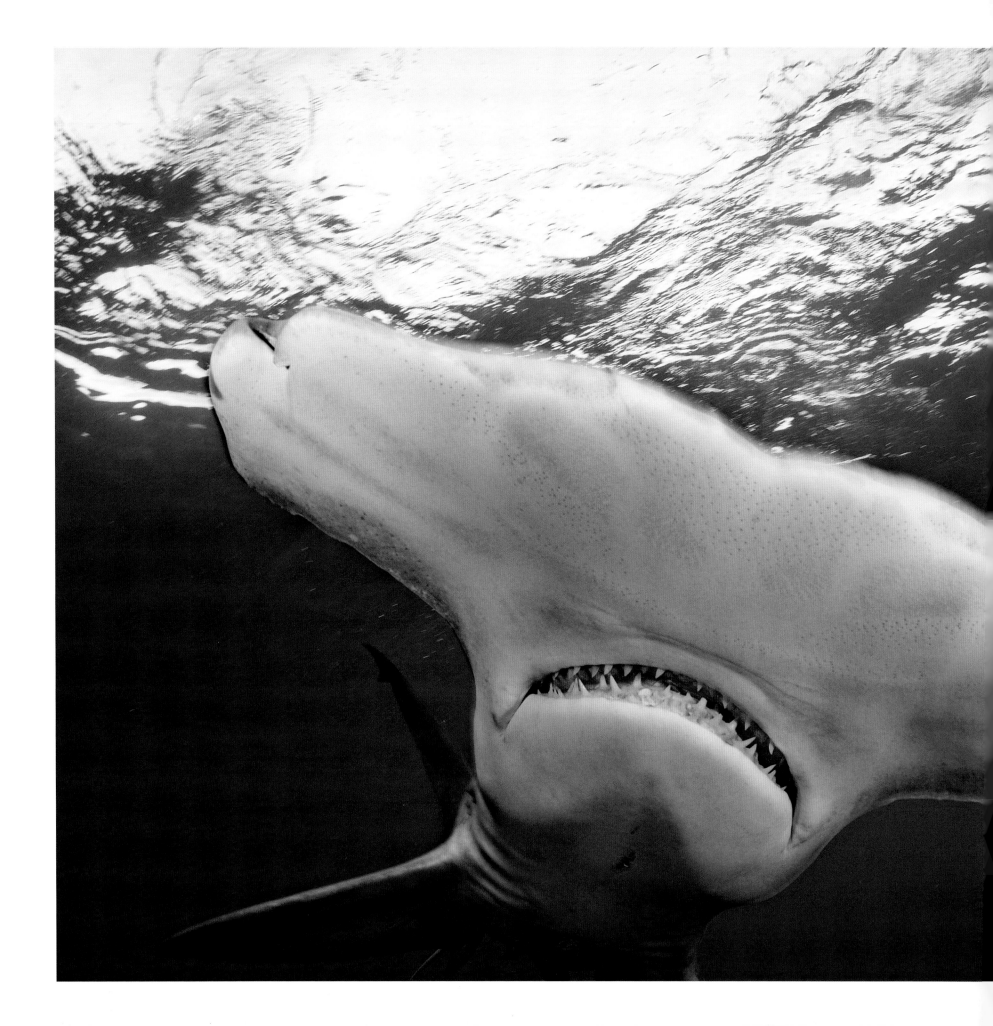

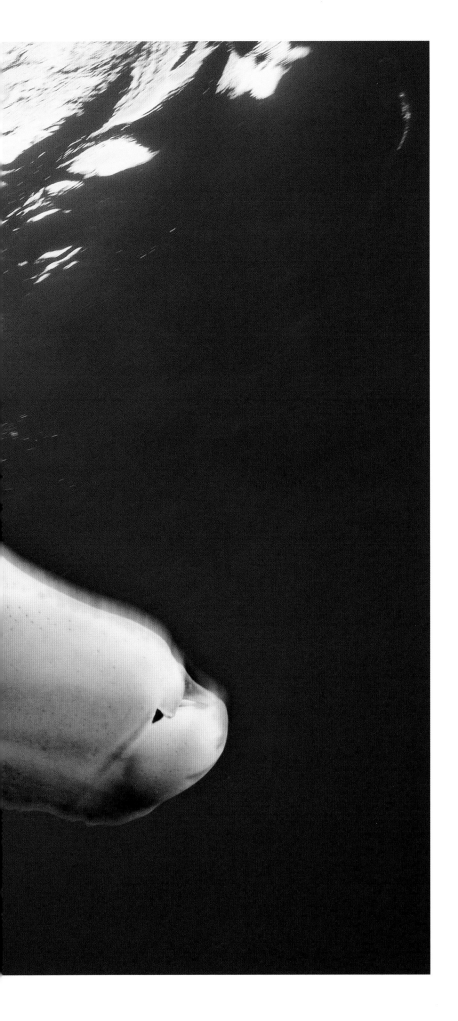

Great hammerhead shark. Bahamas, 2006

Perhaps in time, we will peel back more of the layers of mystery

shrouding sharks and other inhabitants of the oceans,

gaining a larger appreciation and evolving further ourselves.

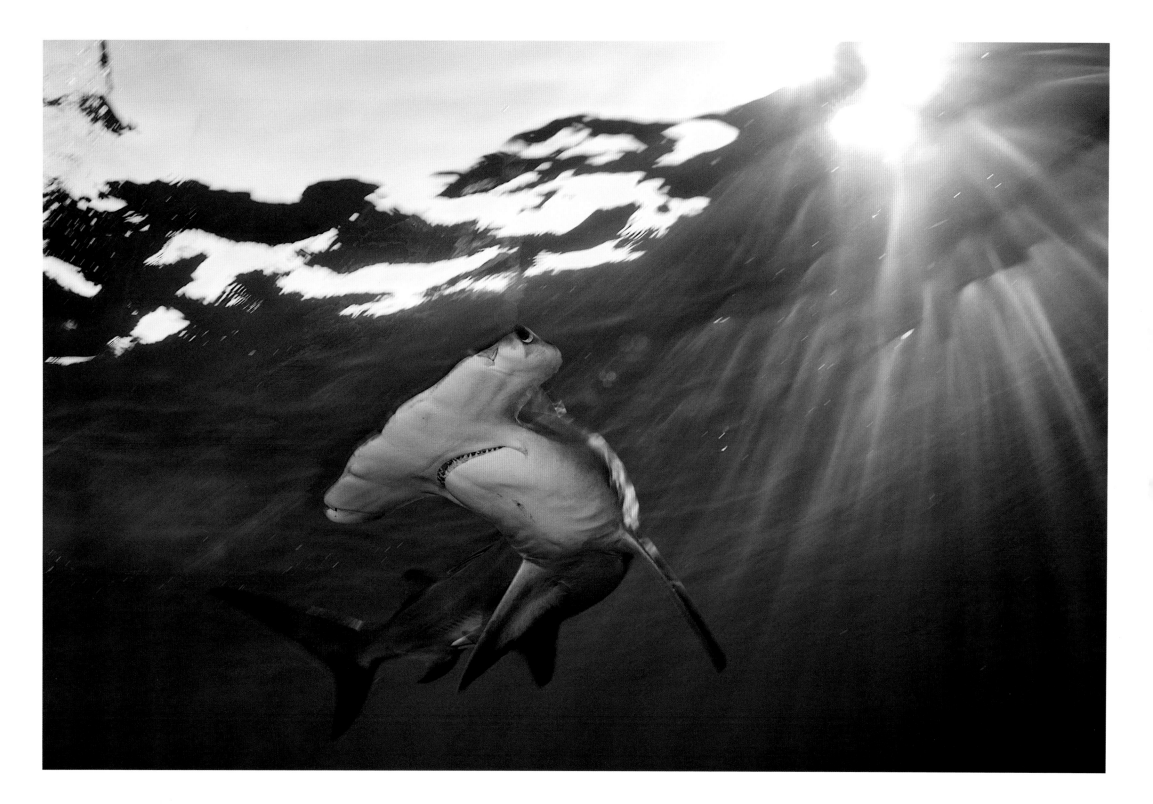

Great hammerhead shark. Bahamas, 2006

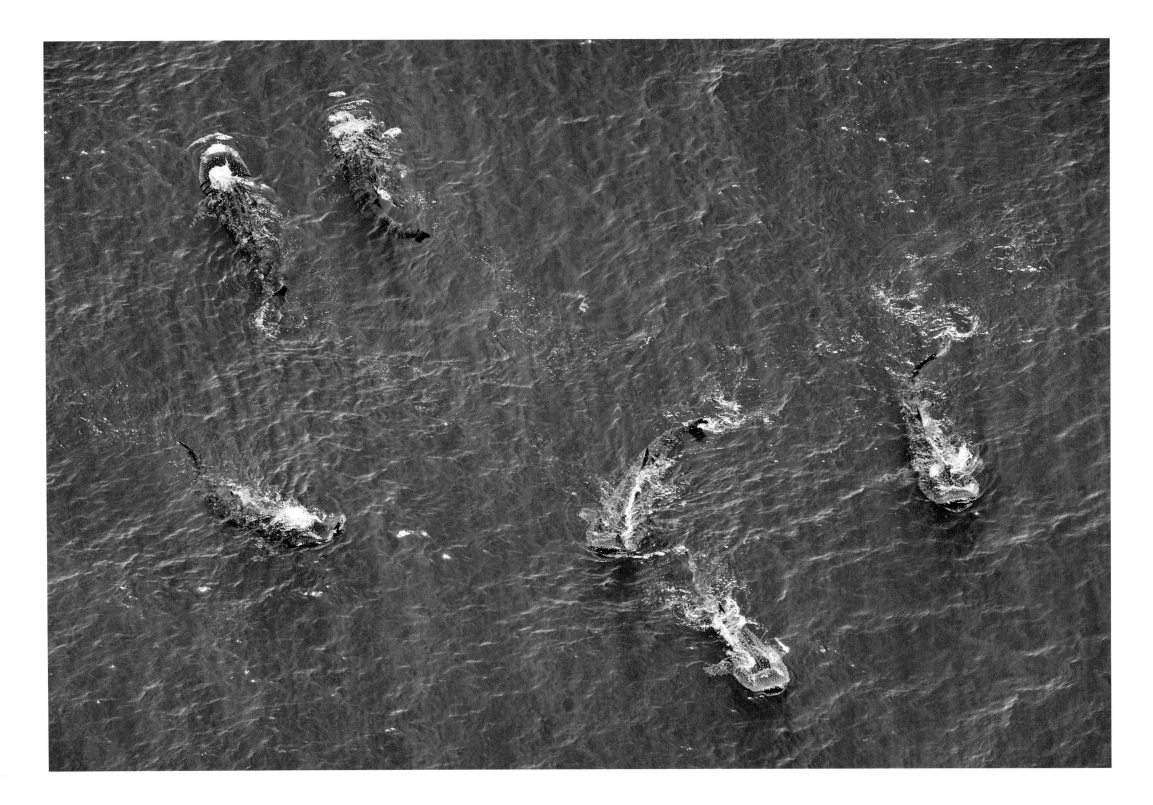

Whale sharks. Mexico, 2009

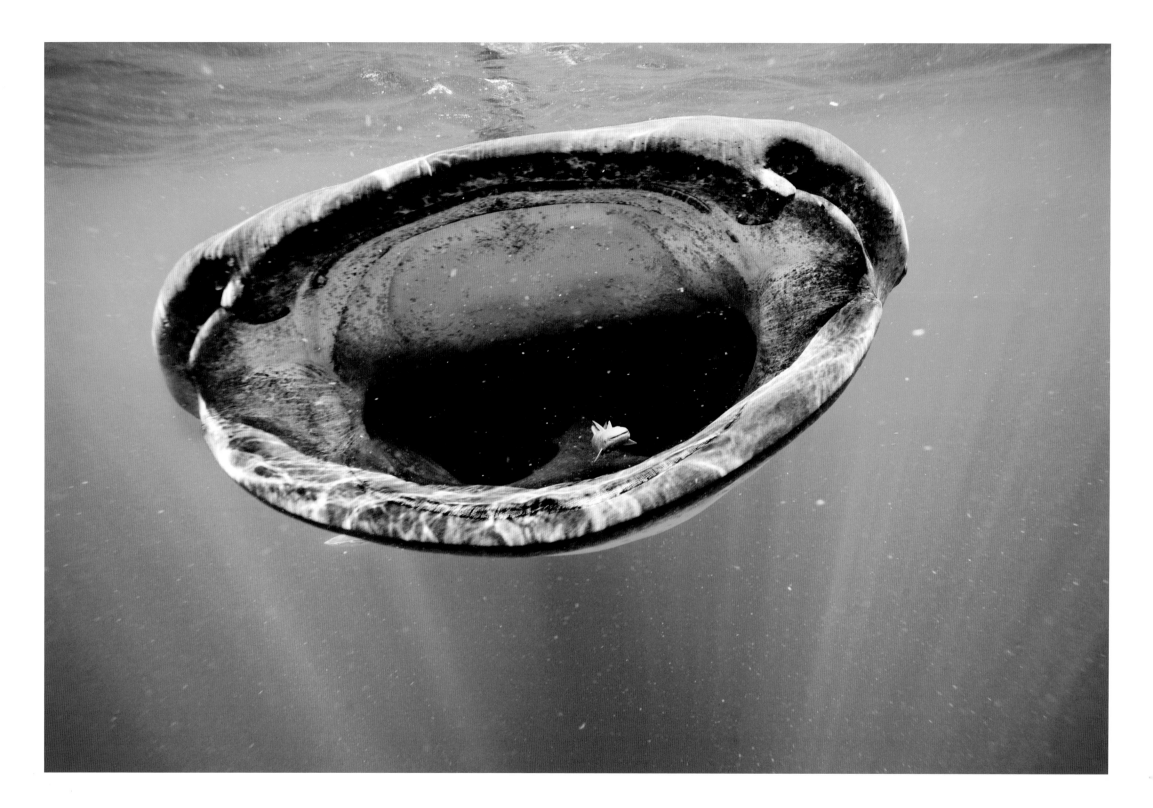

Whale shark. Mexico, 2009

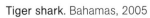

Tiger shark. Bahamas, 2005

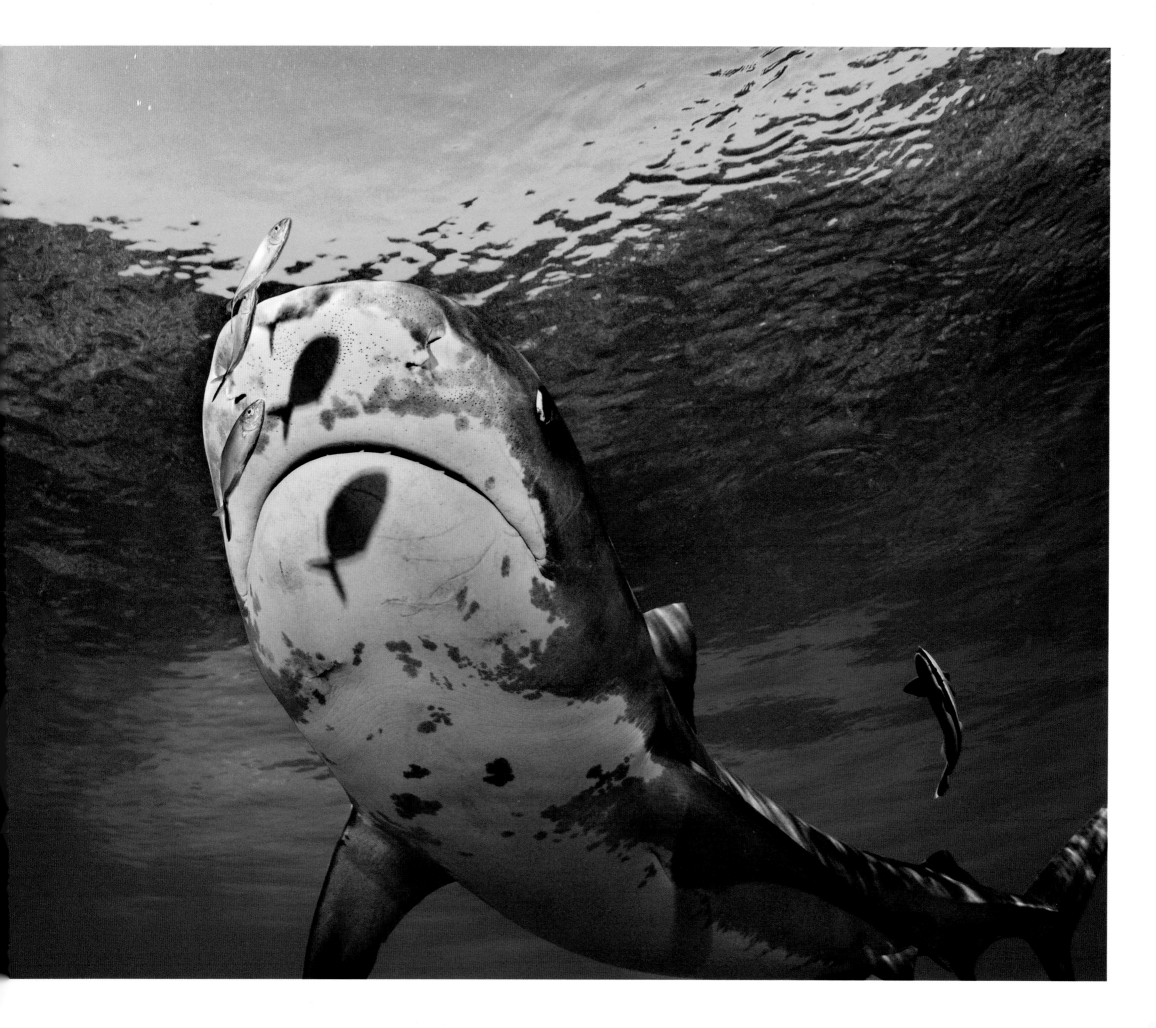

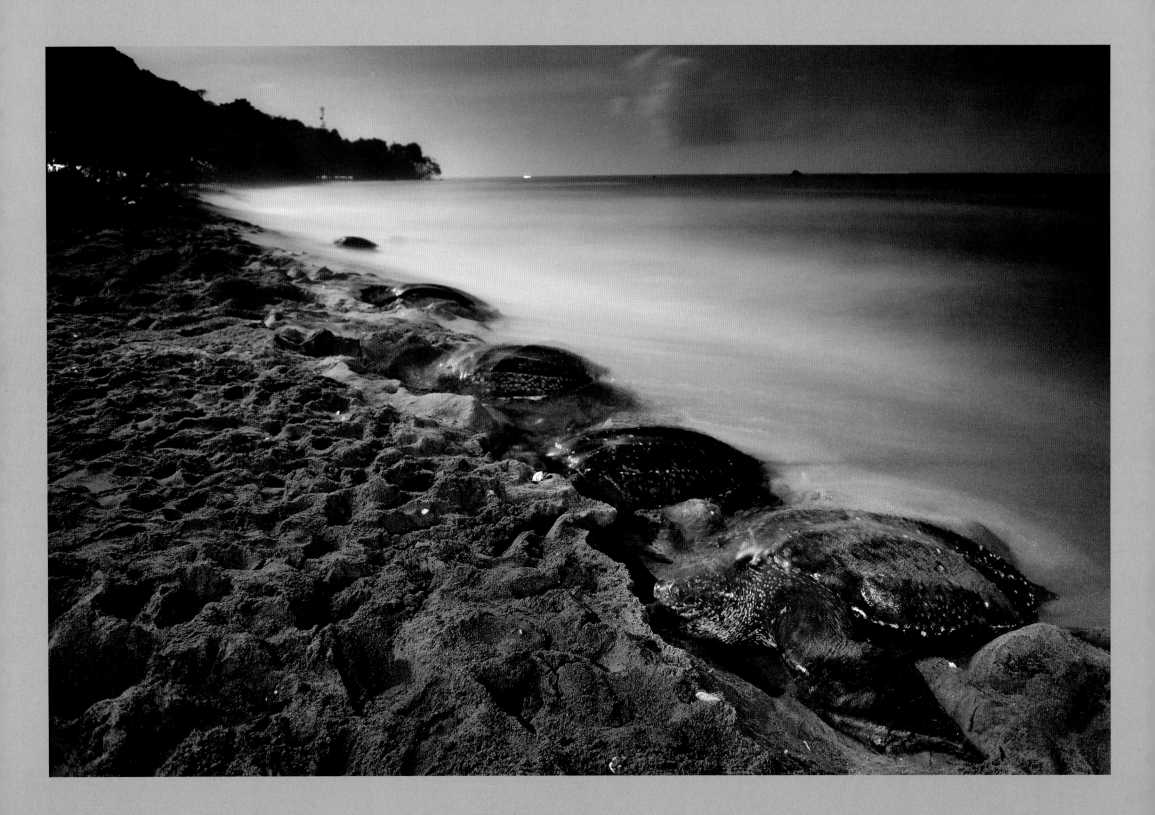

Leatherback turtles. Trinidad, 2007

Leatherback Turtles

Pale rays of moonlight reflected off the palm trees lining the freshwater lagoon behind me as I walked across the sandy beach toward the sea. Except for my assistant, Mauricio, not another soul was in sight, and I imagined I had been transported back through the eons to a prehistoric time. The tropical air was warm and damp, and a light breeze blew steadily from the south. In the faint light I could make out scattered dark shapes that looked like boulders on the beach. But these were not rocks; they were leatherback sea turtles.

I was on Matura Beach on the island of Trinidad off the east coast of South America. This Caribbean island is home to the world's most populous nesting beaches for leatherbacks. Each year in May, female leatherbacks crawl from the sea to nest on or near the beaches where their own lives began many years earlier. It's believed that female leatherbacks reach sexual maturity somewhere between ages 20 and 30, but until that age much of their lives remains a mystery. Trinidad was my first location for a story that I hoped would shed light on these ancient mariners and, in the process, help save them.

Leatherbacks are the oldest, deepest diving, and widest ranging of all sea turtle species. Their lineage dates back more than 100 million years. At one time in their

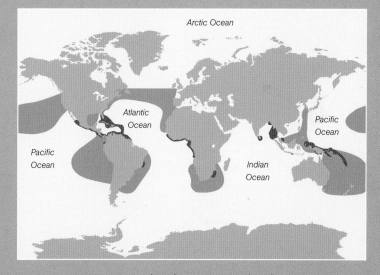

Leatherback turtle nesting (dark) and foraging (light) areas

Leatherback Turtles

history leatherbacks came out of the surf and saw *Tyrannosaurus rex* running past. Today, in some places, they see condominiums. Physiologically, these reptiles are extraordinary. They are capable of diving to depths in excess of 4,000 feet. They never stop swimming in their entire lives— they remain in perpetual motion from the moment they hatch and enter the sea. This nonstop swimming creates internal heat that allows the leatherback to travel into cold waters that would kill other turtle species. Traveling across entire oceans in the course of a year, leatherbacks feed on jellyfish and subsist only on this singular, all-protein diet.

While in Trinidad, I became nocturnal for several weeks, as I photographed on the beaches from about ten o'clock each night until seven o'clock the following morning. To watch these turtles emerge from the nighttime waves, lumber up the beach, and dig their nest is to witness a primal event. The aspect that affected me most was the leatherback's breathing during nesting. Listening to the long, deep, labored breaths was like being in the presence of a dinosaur. It was a sound quite unlike any I have heard before or since and an ingredient that completed the scene.

To photograph nesting leatherbacks, I wanted to try something new. Previous photos of this behavior were typically made at night with a small flash. The flash illuminated the turtle, and perhaps a researcher near the animal, but not much else. I wanted to see more of the habitat, the beach, and the ocean. I also knew from working with leatherback scientists that white light, such as a flash, disturbs turtles and can adversely affect their nesting behavior. I had seen what my colleague Nick Nichols had done recently with digital night photography in the Grand Canyon under moonlight, and I had spoken with him about my interest in using similar techniques with leatherbacks. Armed with his advice, I timed my work in Trinidad to coincide with the moon phase that would provide some natural light.

On the nights when there was a new moon and therefore no moonlight, I switched to infrared photography. Nikon loaned me a camera that they had modified for infrared use. To illuminate the scene, I took to the beach studio lights fitted with infrared filters that cast a red-colored spectrum of light that the turtles could not see. The resulting pictures were rendered black and white, which provided a nice change to the overall coverage I was shooting. Night after night, either under the faint glow of the moon or in total darkness,

Leatherback turtle. Trinidad, 2007

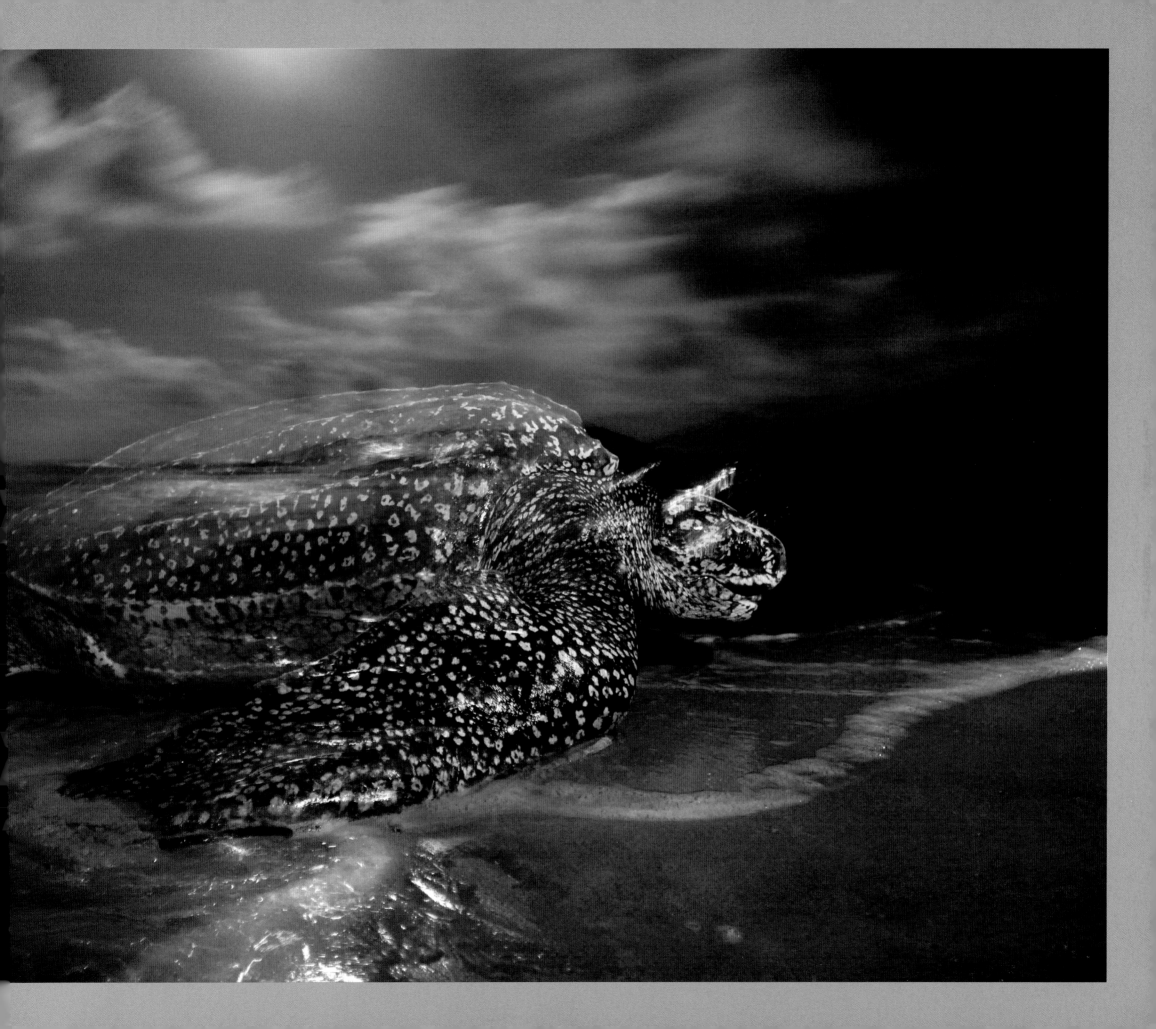

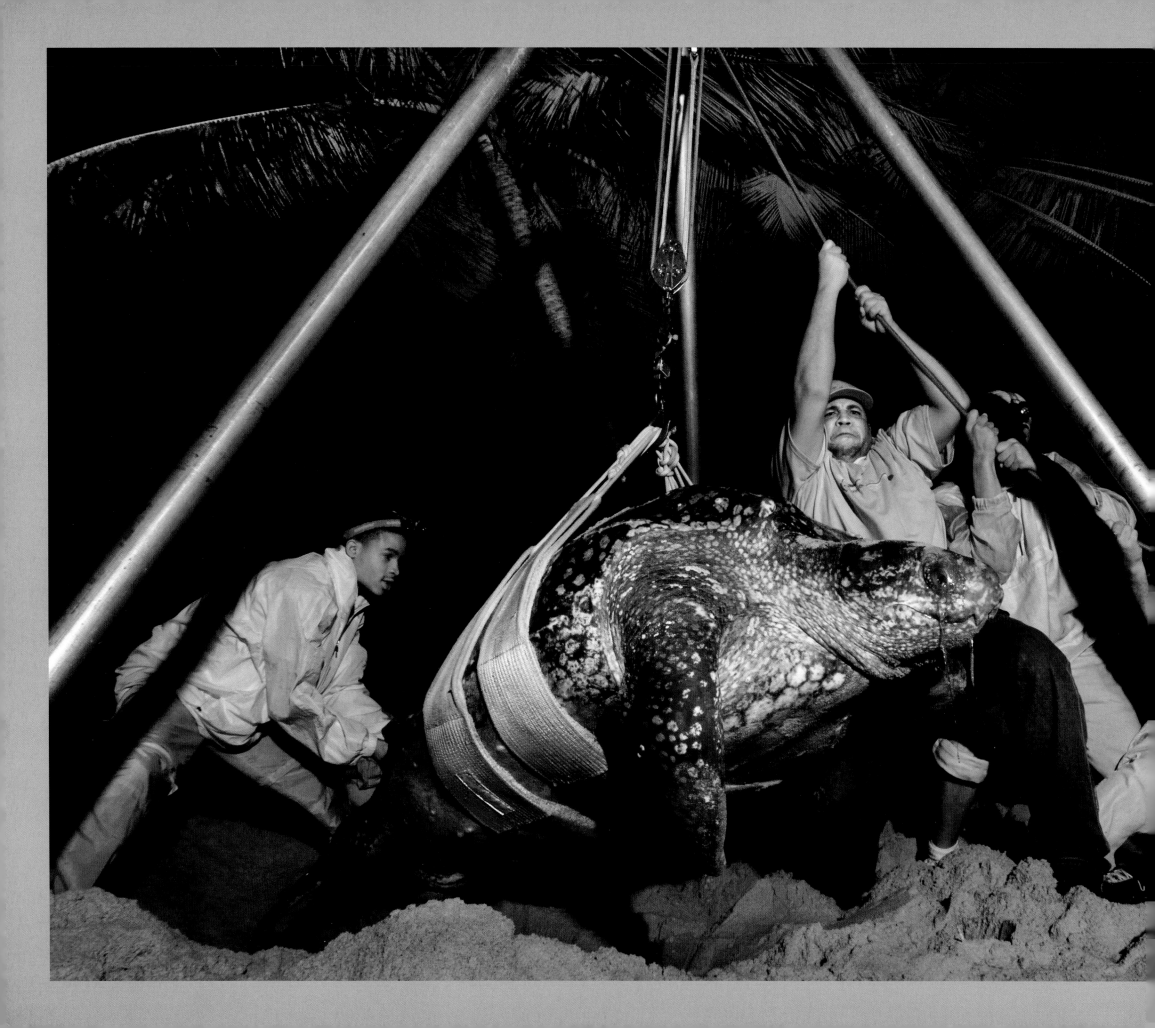

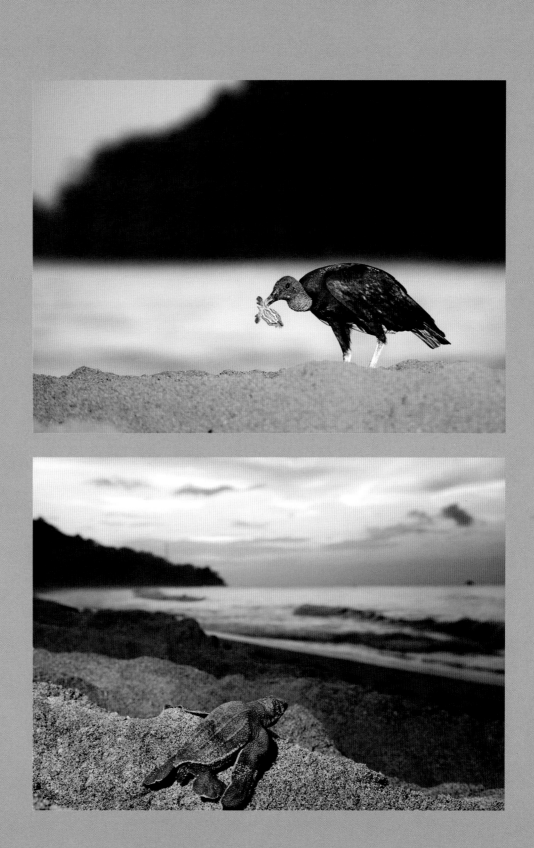

Nature Seekers conservation workers weighing leatherback. Trinidad, 2007 (opposite)

Black vulture predating on leatherback hatchling. Trinidad, 2007 (top)

Leatherback turtle hatchling. Trinidad, 2007

Leatherback Turtles

I worked in the presence of these giant reptiles. It was a solitary endeavor, but one that I loved. The humid, salt air stuck to my skin and equipment, and the sugary sand got into everything. I was not getting much sleep, and I would pick sand out of my hair for weeks after I finished. But the leatherbacks were magnificent and the entire experience extraordinary.

All species of sea turtles are classified as endangered, though some stocks are in worse shape than others. Leatherbacks have survived longer than any other species, yet today they are listed among the most endangered. One of the most serious threats to these animals comes from commercial fishing gear. Leatherbacks frequently become entangled in gill nets or trawls or become hooked on longlines. They are not the intended catch but rather bycatch—animals that become incidental casualties. In Trinidad alone more than 1,000 leatherbacks die each year in gill nets set by people trying to catch fish. To tell a more complete leatherback story, I wanted to focus on these environmental issues. I met with fishermen who offered to let me go out fishing with them at night.

One fisher I worked with was interested in reducing this leatherback mortality. He was consulting with U.S. scientists who were designing new nets they hoped would allow turtles to escape. Chartering my own small boat, I followed the fisherman's boat for several nights. He would set about a mile of gill net that hung down from the surface and let it soak for hours. Then he would begin pulling it in and remove any fish caught in the net. If a leatherback swam into the net and became entangled, the fisherman might not know it until the turtle had drowned. My plan was to patrol the mile of net slowly during the night to see if a turtle might be caught, something that would be easy to determine if I were nearby. The boat I chartered had no running lights—no lights at all—so Mauricio and I set up our dive gear at dusk and laid it all on the deck near my cameras. With only the bottom of my wet suit pulled on, I sat on the bow in the warm night air. As the boat crawled along, I alternately stared at the gill net and at the stars.

A few hours into our third night, we came upon a turtle in the net. As fast as possible, I dressed in my gear and went over the side. I submerged and approached the net and saw the leatherback struggling. Since these creatures never stop swimming, this individual continued to stroke its powerful fore flippers, which further entangled it with each stroke. Its head was completely wrapped, and was unable to break the surface to breathe. I moved in cautiously and began shooting pictures in almost complete darkness. Mauricio approached behind me and switched on a dive light that helped me frame the scene and focus. After a few shots, I handed my housing to Mauricio, pulled out my knife, and began cutting the turtle out of the net. I have witnessed many scenes in nature where I felt compelled to interfere but always resisted if the context was natural. But this was not a natural scene, and I couldn't watch this animal struggle without helping. I also had permission from the fisherman to intervene if the situation warranted. In working to get the turtle loose, I became entangled myself as the current swept the billowing net over me. I cut myself out and then finished with the leatherback, which, once free, simply swam away into the blackness.

Although I now had a picture of a leatherback underwater, and it was indeed an important photo for the story, I wanted a leatherback underwater in the wild. Very few such images exist because we know so little about these animals or where to find them. Unlike other sea turtle species

that can be predictably found in certain places at certain times, leatherbacks remain far more elusive. Places like Trinidad are predictable with regard to nesting turtles, so it would seem to be a good place to photograph them underwater as well. Unfortunately, the visibility underwater is not very good in Trinidad, especially near the beaches, so this would likely prove unproductive.

To find leatherbacks in better conditions underwater, I would move from the Atlantic to the Pacific and eventually settle on a remote location in Indonesia called the Kei Islands. Leatherbacks are listed as critically endangered in the Pacific Ocean, as very few animals remain. To my knowledge, no one had ever tried photographing these animals here before. A leatherback researcher who had visited this place told me that turtles foraged here and that the water looked reasonably clear. It would be a real gamble, but I decided to give it a try.

For three weeks my assistant, Jeff Wildermuth, and I camped out on a beach at the edge of a jungle on a small island where local villagers were known to hunt leatherbacks. No one was hunting while we were there, so I hired local people and their boats to search for turtles each day. We used an Indonesian longboat, about

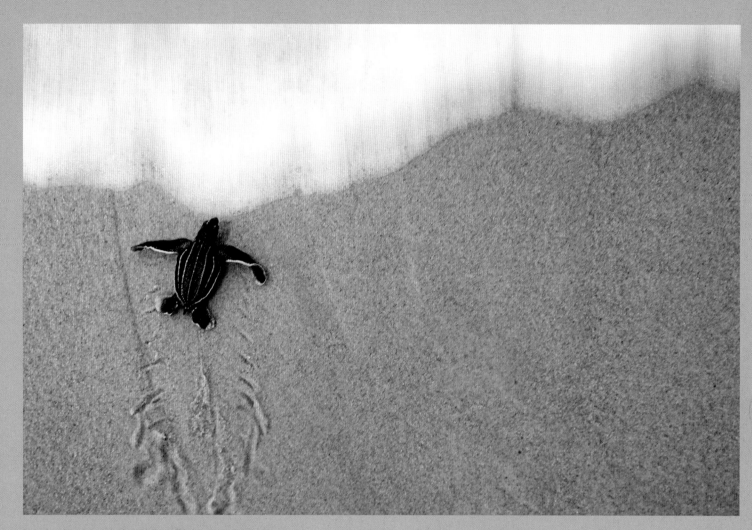

Leatherback turtle hatchling. Trinidad, 2007

Leatherback Turtles

25 feet in length but only about 5 feet wide. The boat was not very stable, yet we sailed it offshore day after day in seas that sometimes built to 10 feet. Working like this was dangerous and not very wise, but it was the only option. And I really wanted to make this picture.

My plan was simple enough, but it would not be easy. We would search for black turtles among the dark, choppy seas, and when we spotted one I would slide into the water and try getting close. Although I took scuba gear with me, I decided to free dive instead, since I would be faster and better able to keep up. We typically spent up to eight hours on the water each day, under scorching sun and tossed around by the waves, just looking intently into the water for our quarry. Food for the day consisted of a jar of peanut butter and bread. In the evenings we dragged our salt-encrusted bodies back to camp, looked for scorpions under our sleeping bags, sealed the mosquito nets, and went to sleep. The morning ritual was a Power Bar and malaria pill for breakfast and then back out to sea.

In three weeks I had four encounters with leatherbacks, but only one yielded great images. The turtle was a female, slightly larger than an old-fashioned bathtub and covered in barnacles. She had come to the surface for a breath and continued to swim slowly with only her head showing from time to time. I quietly slipped into the water and made my way alongside her. I shot a few frames but was not yet in a good position for a perfect picture. When the turtle saw me, she began to dive. She didn't race to get away, but rather made slow and steady strokes with her flippers to dive to about 15 feet, then to cruise along at that depth. She did not appear to be expending any real effort, but I was swimming nearly as hard as I could to keep up. It had taken me days to get to this location and weeks of enduring grueling conditions. Finally, I was underwater with a leatherback in my viewfinder.

She was graceful, regal, and so much better suited to swimming in this oceanic world than to plodding along a beach. Remoras clung to her body, and a school of small fish swam off her nose, while dappled sunlight danced across her back. She was her own living starship, complete with escorts, traveling through this underwater universe on an ancient course that only she knew. With a precious handful of frames exposed, I slowed my kicking, floated to the surface, and watched the turtle fade into the blue. ~

Leatherback turtle. Indonesia, 2007

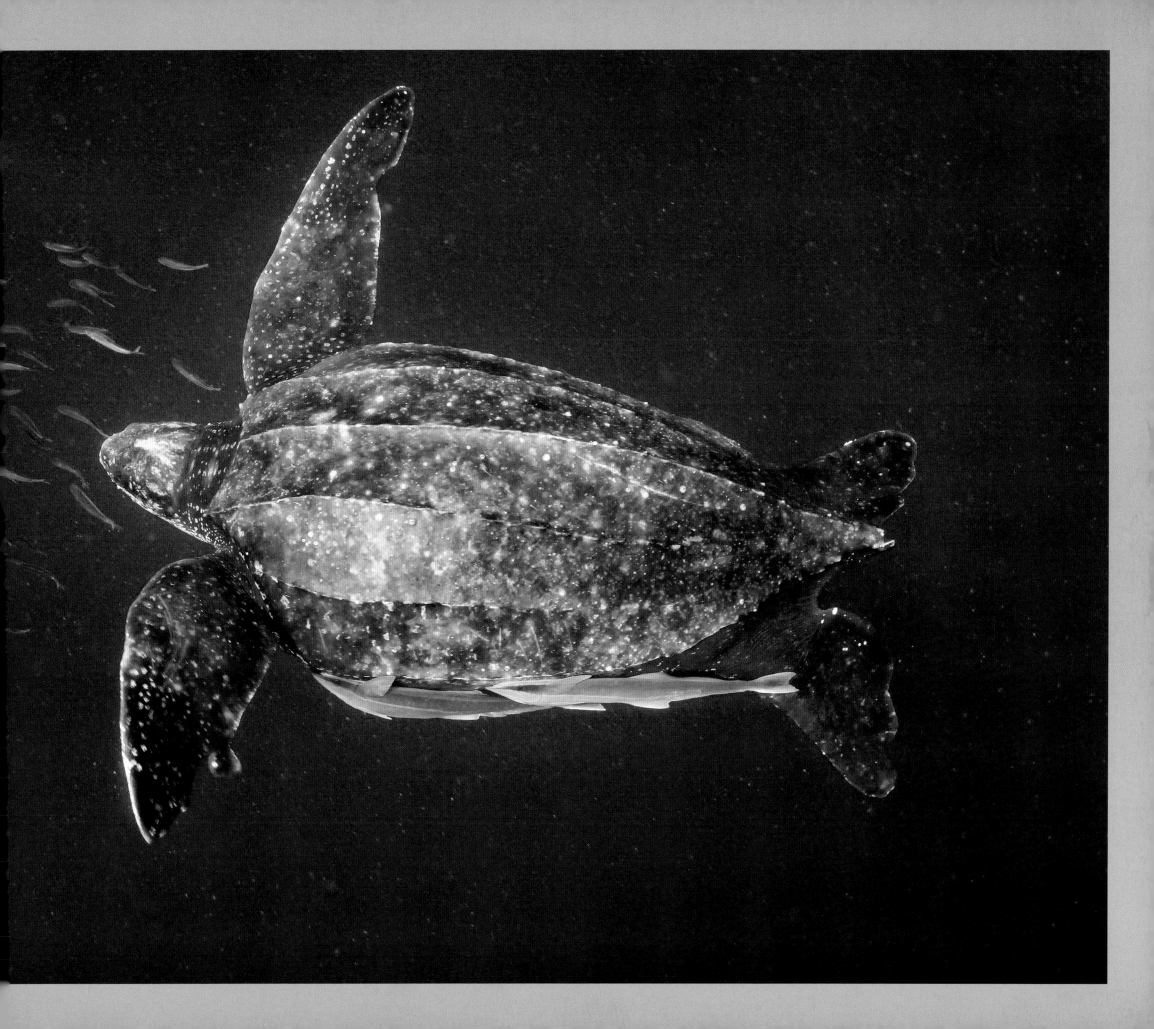

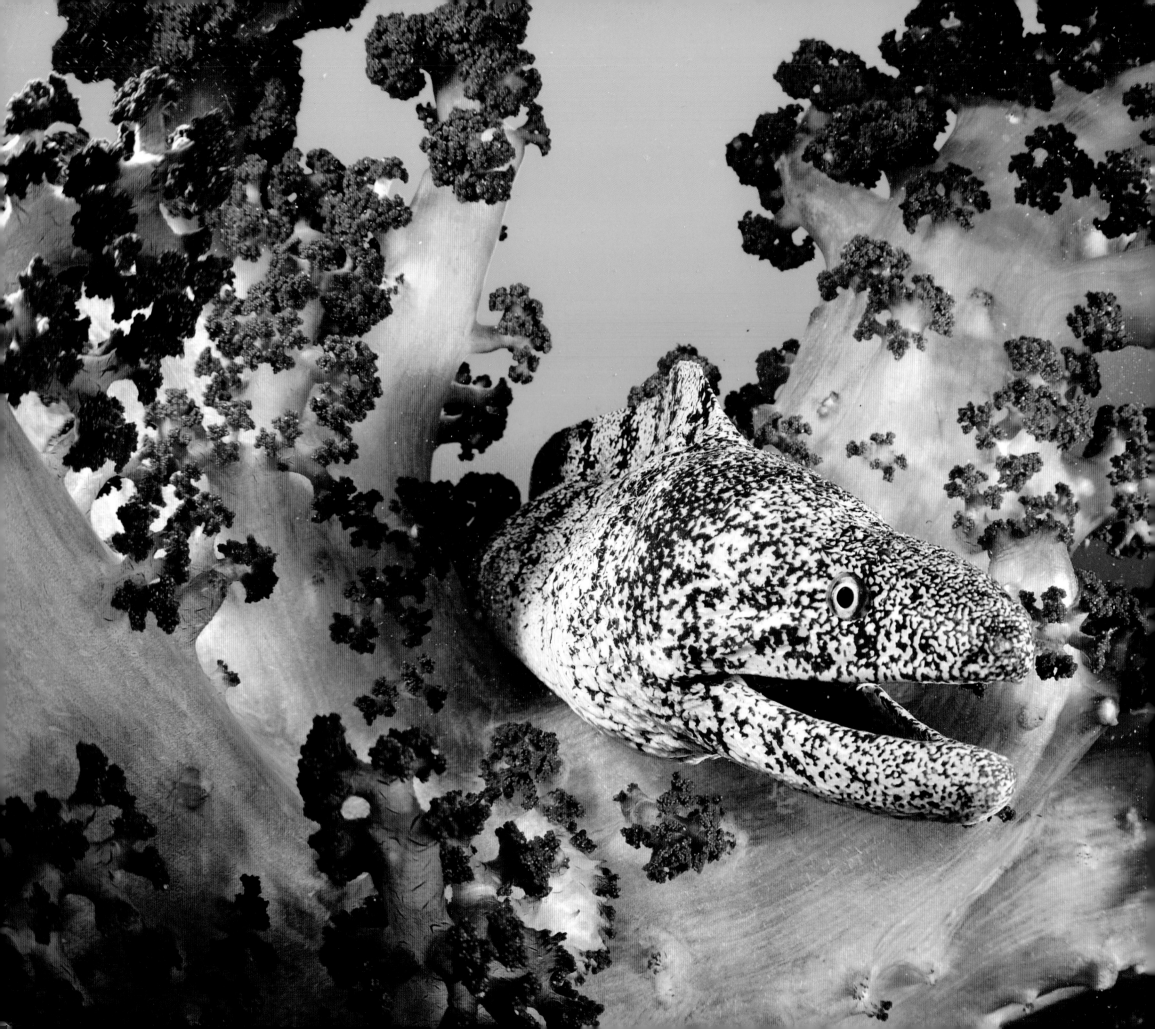

Cool Waters

Moray eel. Japan, 2008

Cool Waters

Perhaps the greatest motivator for my work is connecting with wildlife and interpreting it through photography. After spending a day in the company of animals, there is a sense of peace and calm. That peace is something I believe all humans need. Although I feel this connection with wildlife everywhere—underwater or on land—a big part of what has always lured me to the ocean is its additional sense of mystery and potential for discovery. The sea is adept at disguising what lies beneath her surface, and nowhere is this more evident than in temperate or cool waters.

Here there is a vast contrast between dark, uninviting surface waters and the explosions of life below. I never lose the thrill of drifting down to the bottom in hazy, green water and being blown away at the feast of vibrant colors below. Growing up in New England, I would stare out at the inky sea and wonder what secrets might be found in that submarine world where few dared to venture. Exploring these waters as a diver, I became addicted to the thrill of jumping into cool, dark water and gazing upon a treasure trove of plants and animals as I swam. I also loved the feeling of knowing a secret that no one else knew: underwater, off nearly any beach in New England, is a visual candy store just waiting to be explored. People had lived their entire lives in coastal towns and had looked at the sea every day, but they had no idea of the incredible world that existed a few feet down.

Cool waters are rich with nutrients and teeming with diversity. They are the most productive waters on the planet, with complex webs of life that nourish everything from cod and haddock to great whales and fast-moving, predatory fish such as giant tuna. Photography in cool seas can be tricky, however, because those same nutrient-rich waters that nurture life are also often dark and filled with all kinds of stuff floating in the water column. Lighting is especially challenging, and, if not done properly, the resulting pictures will look as if they were made in a snowstorm.

Despite such photographic challenges, I find myself invigorated in cool water. I always want to stay longer, to endure in hopes of seeing more and making just one more picture. Some of my fondest memories are of warming up beside a fireplace after a day of bone-chilling diving and reflecting on the colors and secret lives of animals hidden beneath the waves.

On a three-day trip to photograph gray seals off Maine, each day I spent five hours underwater allowing the seals to acclimate to me and trying to get just a little bit closer to capture their essence. In the final minutes of the last day, a seal approached me like a family dog inching closer to the couch to be petted. A few feet from me he stopped and allowed his body to float slowly upward into a vertical position. The seal's flippers were perfectly crossed as if he were posing for his picture. I fired a single frame, and then he swam away. One cherished image, my reward for enduring the cold water and patiently waiting for its magic to be revealed.

Certain animals in the sea capture my imagination more than others, and cephalopods, especially squid, are at the top of the list. One of the first large-scale natural history stories that I photographed for *National Geographic* magazine was about these spectacular creatures. Although I traveled to numerous locations for this story, my fieldwork began and ended with fantastic cool-water experiences.

My first stop was Cape Cod, where I searched for the Atlantic long-finned squid. With a 16-foot-long inflatable boat as my platform, I went out every day that the weather allowed, which in the end wasn't often because the wind blew hard and poured down rain for the entire month. In spite of the weather, I found squid and made pictures. As with the seals, each day I spent many hours underwater marveling at these animals and their behaviors and doing everything

possible to produce images that would show a Cape Cod that hadn't been seen before. My dry suit kept me warm for the first few hours, but by the end of each day I was cold. Still, I always had a hard time leaving the water because I loved what I was seeing. Enveloped within massive schools, I recorded frame after frame of what looked like foot-long, alien spacecraft glowing with otherworldly colors and jet-propelled squadrons silhouetted against the green cape waters. It was as if each day I was leaving Earth, traveling to some faraway galaxy, and then returning home for supper.

I trekked around the world for this story—from Mexico's Sea of Cortez to Venezuela—and I ended with an experience that was equally incredible. The California market squid, as they are commonly known, are stunning creatures, as are all cephalopods. But this species demonstrates a particularly visual behavior during mating: the arms of the pale, white male blush red as he embraces the female. During frequent mating events, hundreds of animals hover over translucent beds of egg casings that sway with each surge across the sandy sea floor. I had been trying to photograph this scene for nearly two years, but the squid never had arrived. On a cold, early December evening, however, I received a call from filmmaker Howard Hall, who told me the squid were off the Channel Islands in California. The next morning I hopped on a plane to Santa Barbara.

With only ten days to deliver the goods, my plan was to search for egg beds during the day, then dive at night and attempt to induce the mating behavior with the use of movie lights I had borrowed from Howard. Using diver propulsion vehicles, my assistants, Mark Conlin and Dave Forsythe, covered huge sections of ocean bottom off the islands and finally located a sizable mop of eggs. With a perfect location discovered, all we had to do next was dive at night and see if we could find squid. But there was a problem—squid

fishing boats were working this same location and setting nets right where I wanted to dive each night. It would be far too dangerous to dive while fishing operations were under way. I learned that boats did not fish on Friday and Saturday nights since the markets were closed on the weekend, so these would be our only nights to dive.

I was working nearly around the clock, shooting day and night, and anxious about the small window of opportunity that would close soon. At nine o'clock on Friday night, Dave jumped into the water with the movie lights in hand. Behind him he towed cables that were plugged into the generator on the boat. The plan was for Dave to set the lights and leave them in hopes of attracting squid.

The water was clear, and looking toward the bottom 120 feet below, I could barely make out the dim glow of the lights. About 20 minutes later Dave emerged. The lights were in place, he said, and plenty of squid were already there. I pulled on my dry suit, strapped on a set of double tanks, and went over the side. As I approached the bottom I couldn't believe my eyes—the ocean was alive with squid, swarming and pulsing over the egg bed, mating and laying eggs. I slowly moved into the maelstrom and began making pictures. With only 36 frames on a roll of film, I restrained myself from shooting too quickly and worked the scene carefully. When one camera was spent, I grabbed a second and continued to document the frenzy. Thirty-five minutes into it, I was out of bullets and it was time to come up. The weather was turning, and we had to steam to port, but with two precious rolls of exposed film in my camera bag, the story was finally a wrap.

I have often mused that being a National Geographic magazine photographer is not unlike being a professional athlete, in that you are only as good as your last game—or, in my case, your last story. The magazine expects results, and a photographer cannot have failures and continue to expect assignments. Inevitably things do go wrong,

from luggage not showing up to equipment malfunctioning to people problems. Then, of course, there is Mother Nature, with variables you simply can't control, from bad weather to poor visibility to animals that just don't show up.

Knowing that there are so many things I cannot control, I dedicate most of my time to working on the things I can control. Detailed research is crucial, because I need to know as much as I can about my subjects and locations. I want to know where and when wildlife can be found, whether the water will be clear enough for pictures, and what behaviors I might be able to document. Once I have the assignment, I adopt a mind-set in which failure is not an option. With this in mind, I've learned to become good at research and good at solving problems.

That said, time in the field remains the most valuable element. With time, I can usually overcome challenges and problems that arise. Time also allows me to learn firsthand about the place in which I am working, what happens at different times of day, and how animals behave. But often the best images are made when something unexpected happens. I love the discoveries that come from taking my time in a place and allowing opportunities to present themselves. I can only seize serendipity if I am prepared, however, so while I might be wandering casually through underwater domains, I am always on guard.

Armed with research and as much time as *National Geographic* was persuaded to grant me, I have pursued stories in cool waters worldwide. Some of my favorite places are New Zealand, Ireland, and Japan. New Zealand has created a network of marine protected areas where wildlife has rebounded, thus providing some of my finest photo opportunities. In shadowy Fiordland, where mountains tower over narrow fiords and fresh water flows into the sea, I found myself within darkened waters occupied by gardens of black coral and groves of sea pens. I played peekaboo with days-old fur seal pups in kelp, sparred with octopus, and came eye to eye with seven-gilled sharks.

In the bluer waters of the Poor Knights Islands, where temperate and warmer waters mix, I encountered a completely different but equally enchanting cast of characters. From the depths of underwater canyons I gazed upward at giant yet graceful stingrays patrolling overhead and peered into the microcosm of the tiny blue-eyed triplefin, a fish tinier than a grain of rice that lives among flora and fauna even smaller than itself. These ecosystems were alive from top to bottom, and my senses were on overload.

One afternoon, alone in shallow water, I quietly followed a Sandager's wrasse feeding in a kelp forest. This fish, whose colors reminded me of a face-painted mime, moved gently within the fronds, and for hours I ebbed and flowed in its shadow. Another day, when the sea was rough and the sky was filled with dark clouds, I lay at the mouth of an underwater cavern surrounded by schools of blue maomao. This is a place, old-time divers explained, where wildlife is more abundant today than in the 1960s, thanks to protection. Able to think of no other place in the world that could make such a claim, I wanted to make a picture of this abundance. I wanted the picture to be of a primal ocean, the way the sea here looked hundreds of years ago. Spying a red pigfish frequently darting through the school, I adjusted my camera's settings in hopes of creating a dreamlike image. As the school swirled around me, I experimented with the movement and mixing light, and I released the shutter at those fleeting moments when gesture and grace blended together.

The craggy coast of Ireland provided a bewitching view of cool water during my many weeks of diving there. Delicate, purple-hued jellyfish drifted through sunlit, aqua shallows as I dove past them to a benthic universe sparkling with color below. I remember watching a painted top shell that looked to be made of porcelain as it steadily

crawled through a field of magenta-colored jeweled anemones, each one reminding me of a crown fit for a king. Lobsters here, nearly identical to those of my native New England, were colored blue instead of red, and starfish feasted on birds' eggs that fell from cliff-side nests above.

Night dives off the Aran Islands were unreal. From an old stone pier I would enter the water. I'd exit sometime three hours later and walk back to my bed-and-breakfast with a pocketful of exposed film rolls depicting myriad exotic creatures. Kneeling on the seafloor at midnight, I once watched a pair of little bobtail squid, known locally as sepiola, mating several feet off the bottom. Their multicolored bodies glowed like M&M-size Fabergé eggs, and I wondered if they even noticed me—a dry-suit-clad, camera-wielding Peeping Tom invading their privacy in this remote corner of a cool-water sea.

Japan's Suruga Bay is a deep and narrow body of water that plunges more than 8,000 feet. Washed by cool-water, nutrient-rich currents, the bay teems with diverse habitats and astonishing life forms. Diving here was like swimming through the pages of a storybook, as each day brought vastly different experiences. On one dive I would be deep within a forest of vibrant pink soft coral, where delicate schools of fish morphed into silver clouds above and yellow moray eels slithered below. A day later I would find myself swimming 130 feet beneath the waves through an eerie garden of whip coral, where fish hid in shadows and polyp-studded strands of coral fed in the dimly lit green water. With Mount Fuji looming in the distance, I waded in from rocky beaches or somersaulted off the sides of boats and glided over volcanic sands, each dive bringing something new and fantastic.

Perhaps here more than anywhere else, I was struck by the fact that two vastly different worlds can coexist. On the shore of Osezaki one morning, outfitted in all my dive gear, I carefully walked into the sea, camera housing in my hands. Around me I watched dozens of people walking by, talking, laughing, eating, and going about their daily routines. I saw cars and trucks driving by on roads, jets in the sky, and boats on the water. Kneeling in shallow water, I pulled on my fins, and then I put my face in the water and looked around. Schools of little fish scattered as I swam past them, on my way into deeper water. I propelled myself over the flat bottom and eventually came to a declining bank that descended into the haze. The little fish I saw upon entering the water gave way to a wonderland of creatures, and I felt like Alice having entered the looking glass. Eels peered out from a rusty old sewing machine someone had thrown into the sea, and stargazers looked skyward, their menacing grins seemingly etched in the mud. An exotic lionfish, with flashes of neon blue on its pectoral fins, hunted over the bottom, and I lingered to watch a lizardfish eating another fish it had recently caught and to make a few frames before moving on. In the distance I spied what looked like a miniature tornado swirling over the dark sands. Closing the distance between us, the cloud revealed itself to be a school of juvenile stinging catfish, their yellow and black striped bodies wriggling as a unified mass as their barbs probed the bottom in search of food.

As the banking leveled off at a depth of about 100 feet, I saw a soda can, its shiny exterior encrusted with marine growth. From inside the can I saw a flash of color and moved in for a better view. In a prone position, I crawled to within a few feet of the can. Materializing from the darkness inside, a tiny yellow goby stared at me with green eyes from his pop-top window. I inched closer and watched the fish disappear and then reappear not unlike the Cheshire Cat. Thinking I might hear the goby speak at any moment, I focused my lens on the fairy tale scene. With my air supply running low, and satisfied that I had the picture, I steadily ascended. ∼

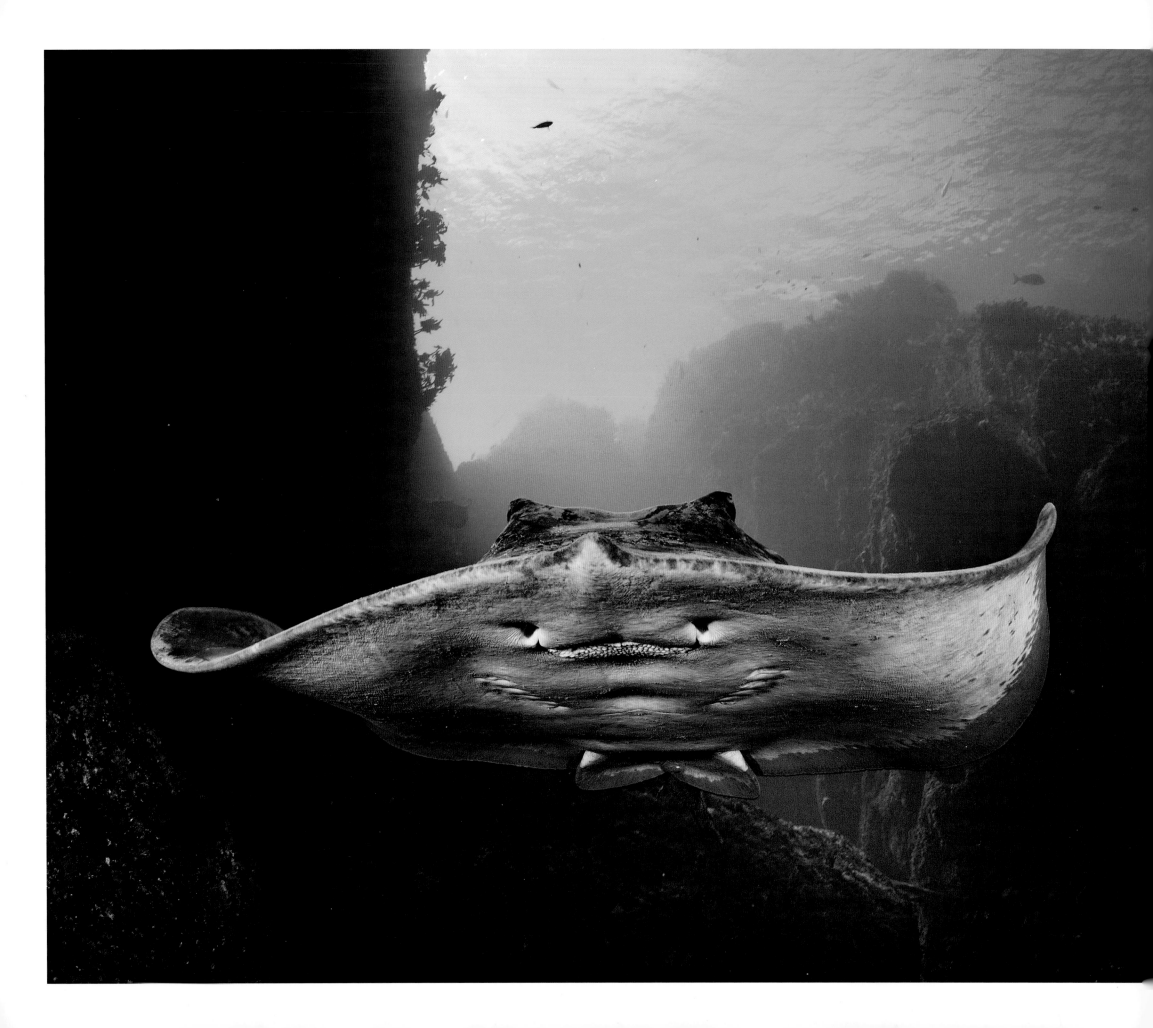

New Zealand Marine Reserves

The resilience of the oceans is evident within the many marine reserves throughout New Zealand. In places like the Poor Knights Islands, Fiordland, and Goat Island, no-take protection has resulted in a rebounding of marine life, creating a new baseline for healthy marine ecosystems. Some of these places were protected because they were extraordinary; others became extraordinary thanks to protection. Diving in these waters, surrounded by schools of fish and seeing animals everywhere, people become aware of the restorative powers of conservation. This is how the ocean looked a hundred years ago, perhaps.

Short-tailed stingray. New Zealand, 2006

In shadowy Fiordland, where mountains tower over narrow fiords and fresh water flows into the sea, I found myself within darkened waters occupied by gardens of black coral and groves of sea pens.

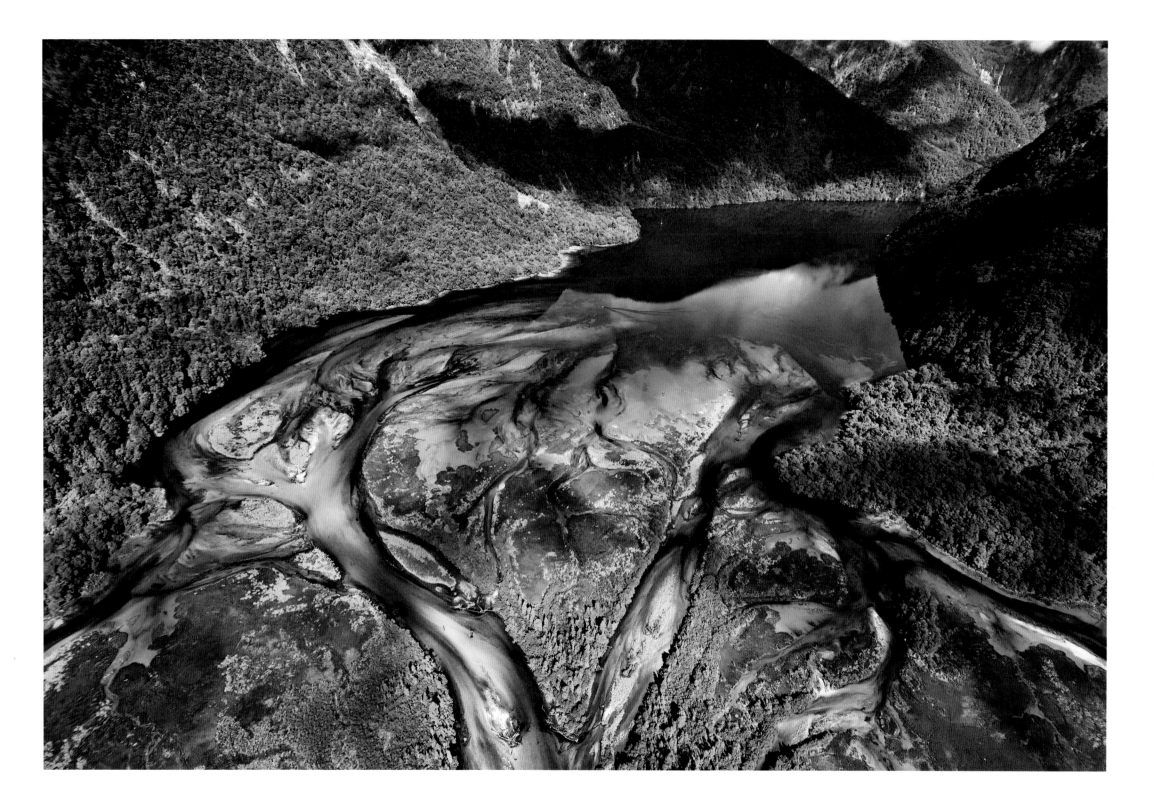

Camelot River. New Zealand, 2006

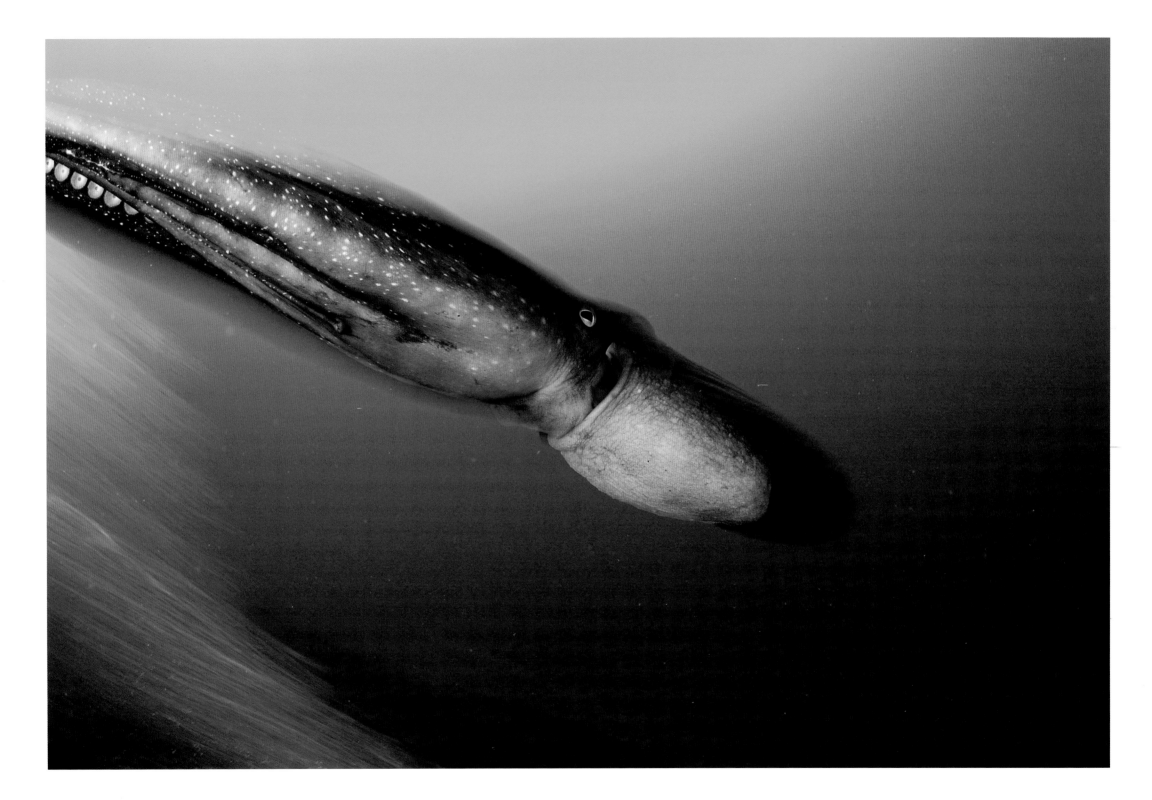

Octopus. New Zealand, 2006

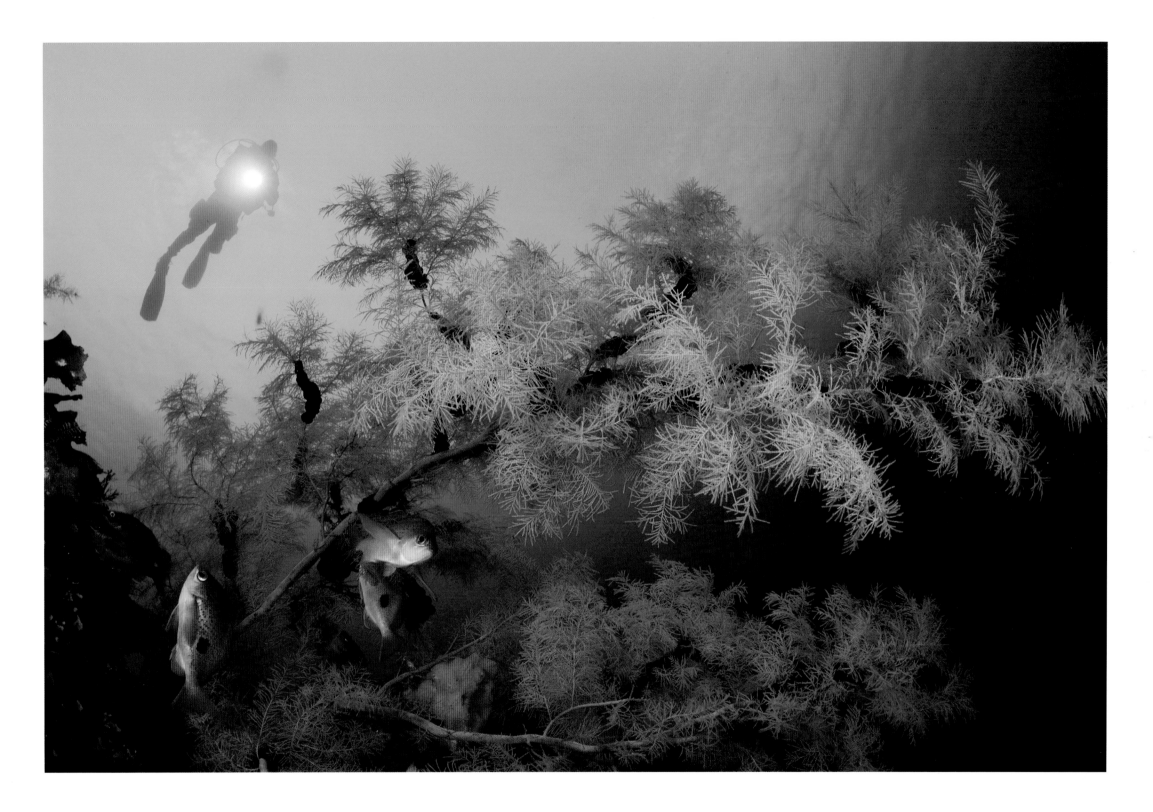

Black coral. New Zealand, 2006

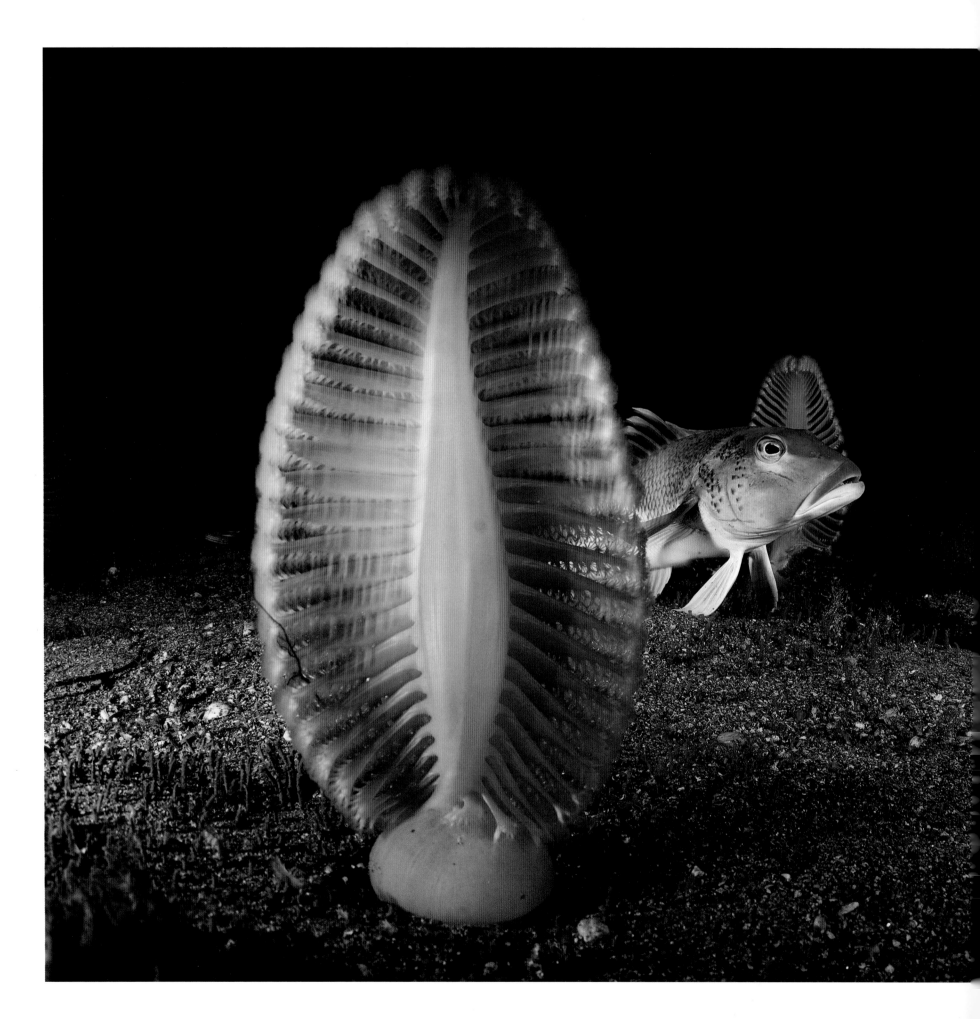

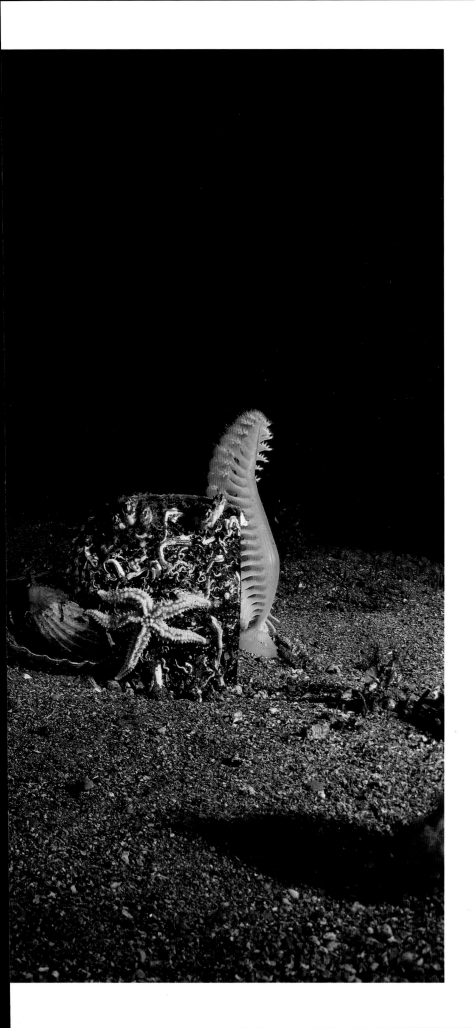

Sea pens. New Zealand, 2006

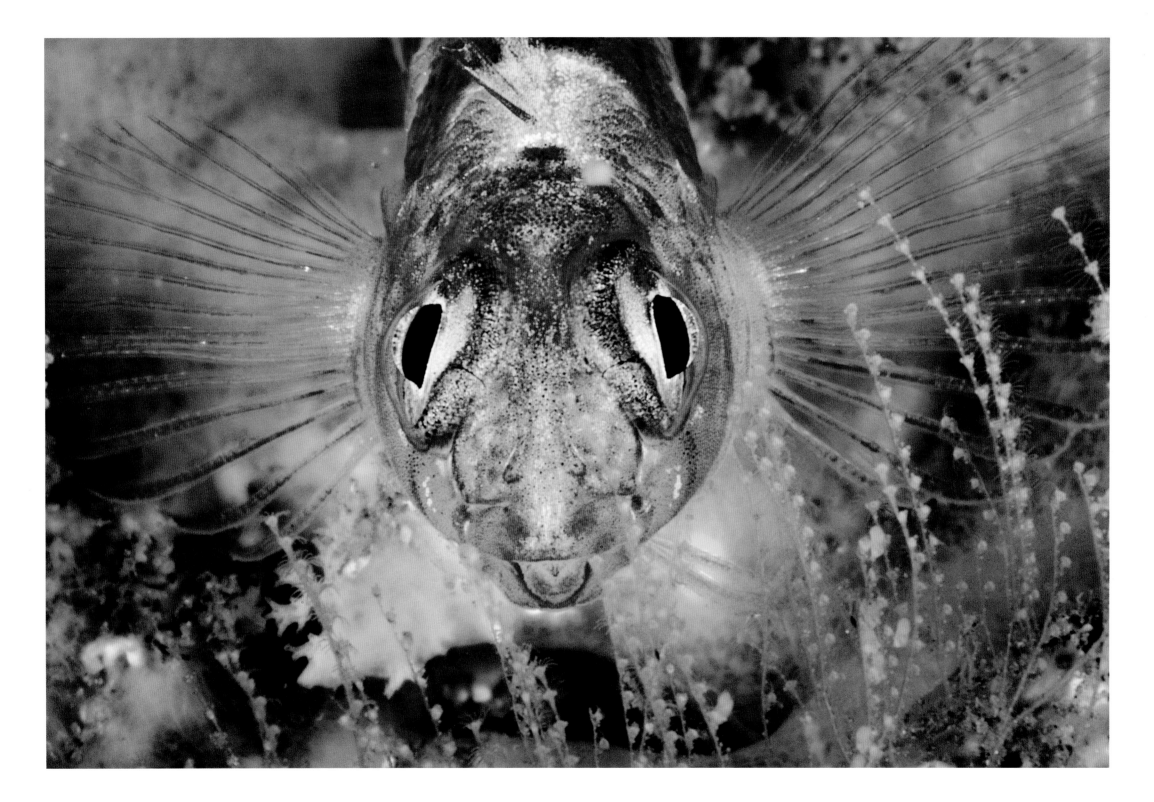

Blue-eyed triplefin. New Zealand, 2006

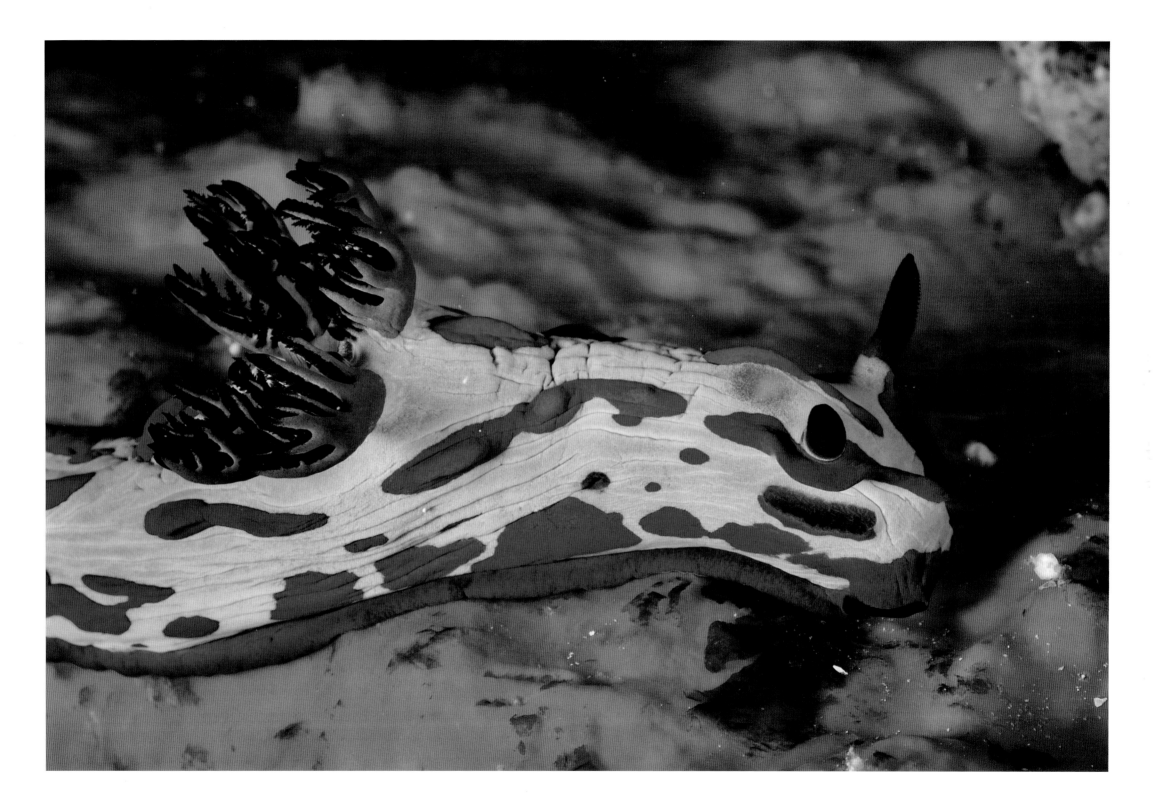

Nudibranch. New Zealand, 2006

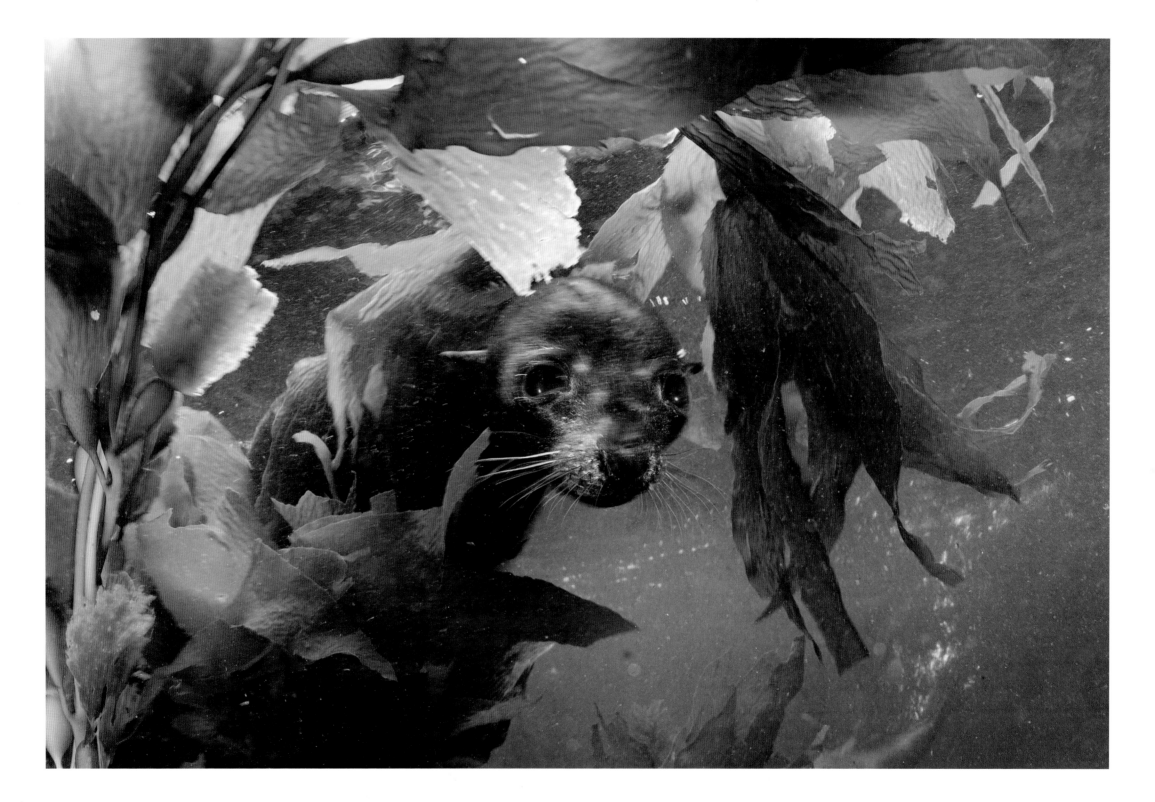

New Zealand fur seal pup. New Zealand, 2006

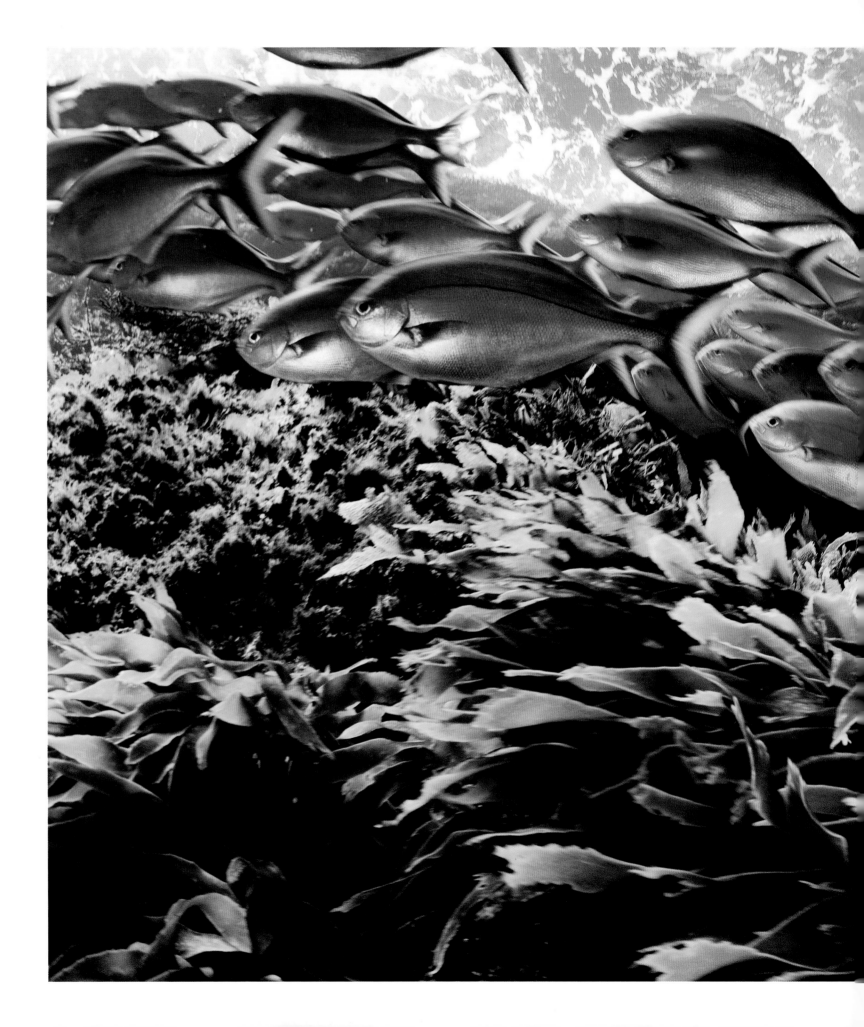

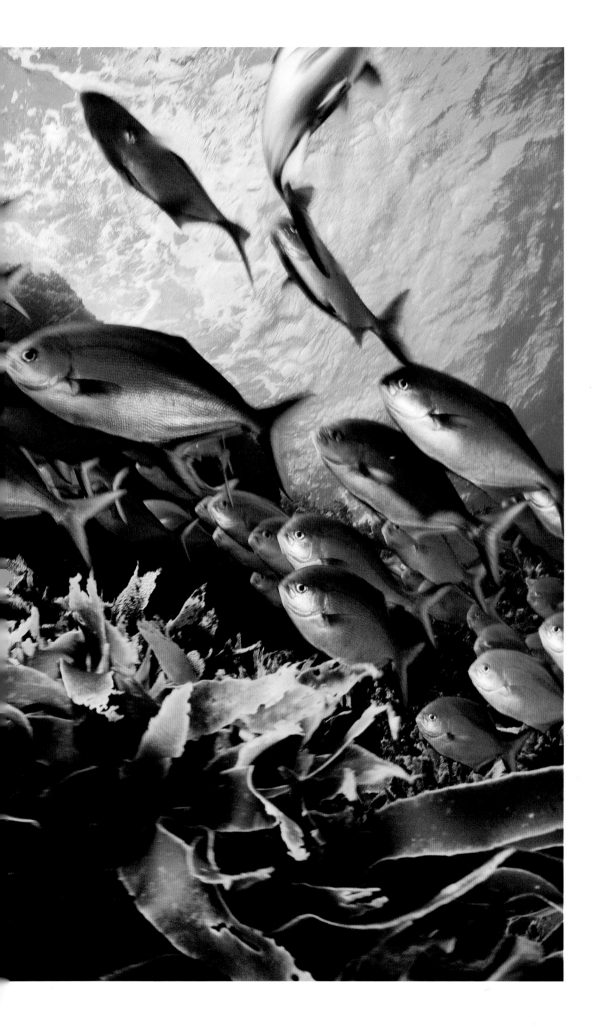

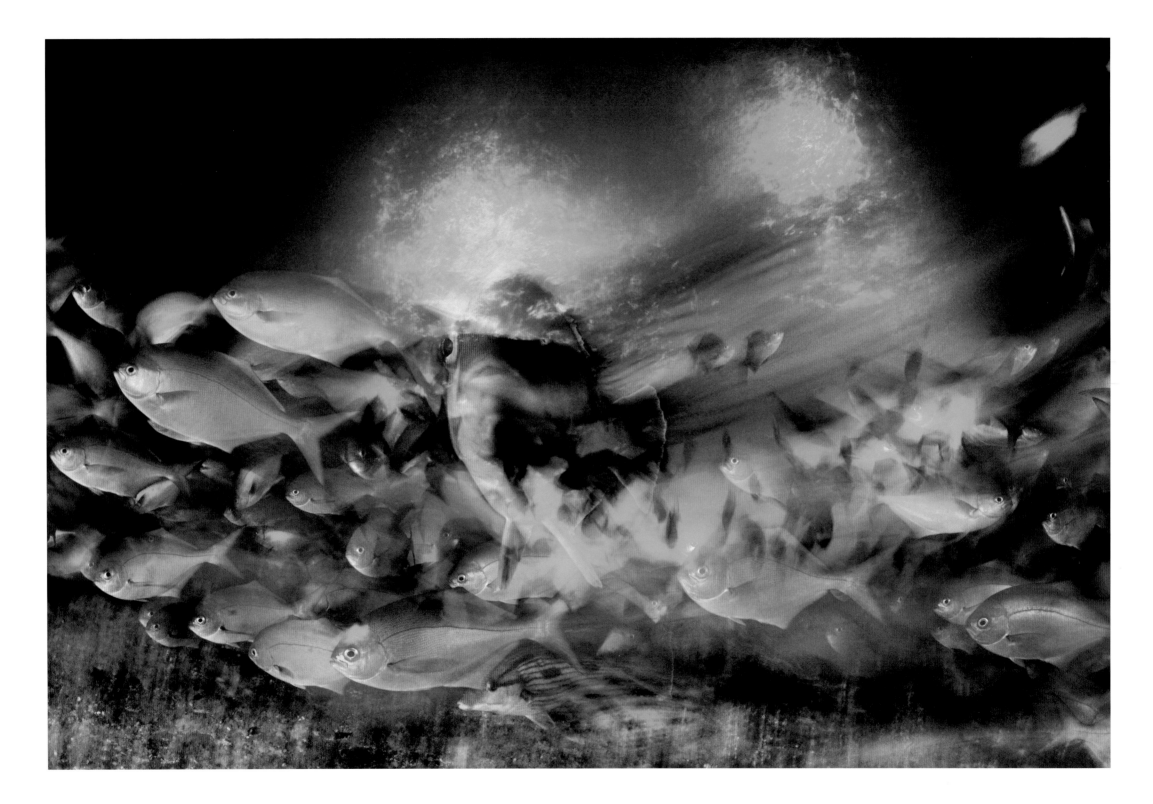

Red pigfish and blue maomao. New Zealand, 2006

Sandager's wrasse. New Zealand, 2006

I have photographed marine protected areas around the world that are alive and vibrant and speak volumes about the value of conservation. New Zealand's abundant no-take zones showed me the sea's restorative powers and how well she heals with care.

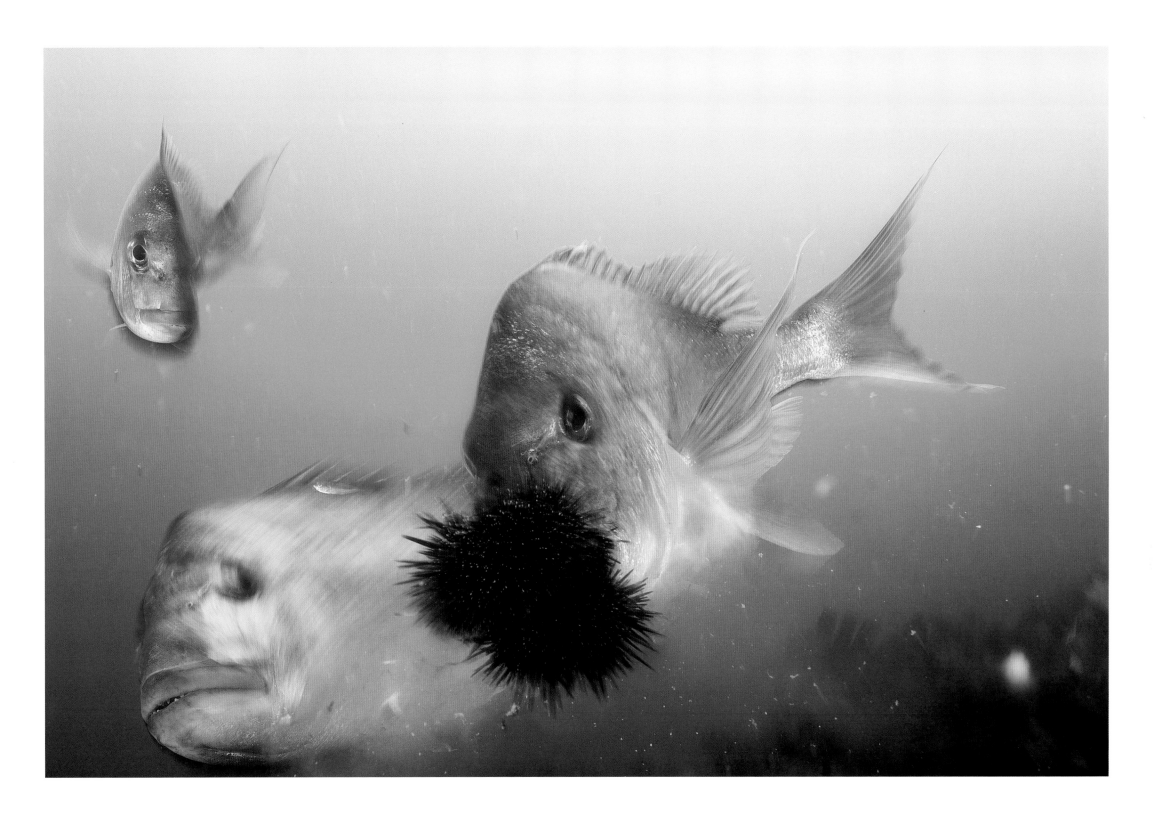

New Zealand snapper predating on sea urchins. New Zealand, 2006

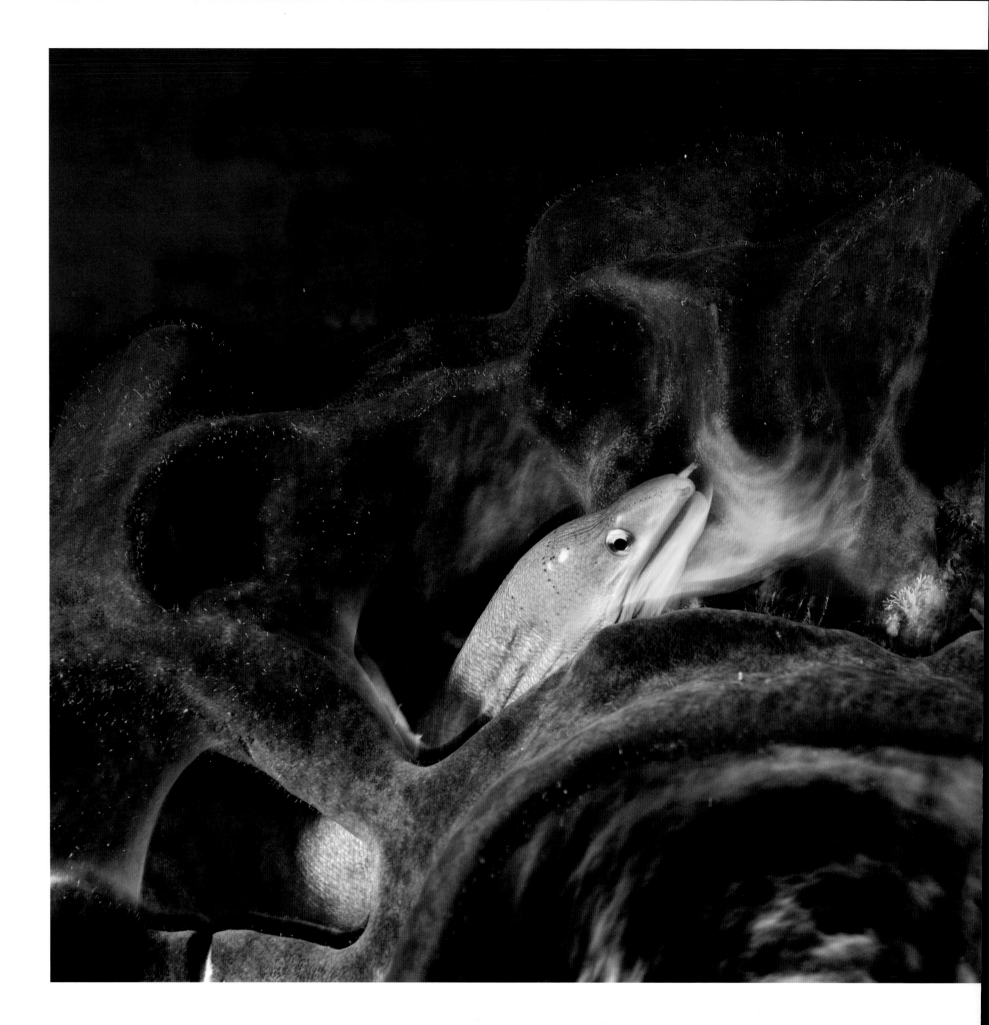

Moray eel. New Zealand, 2006

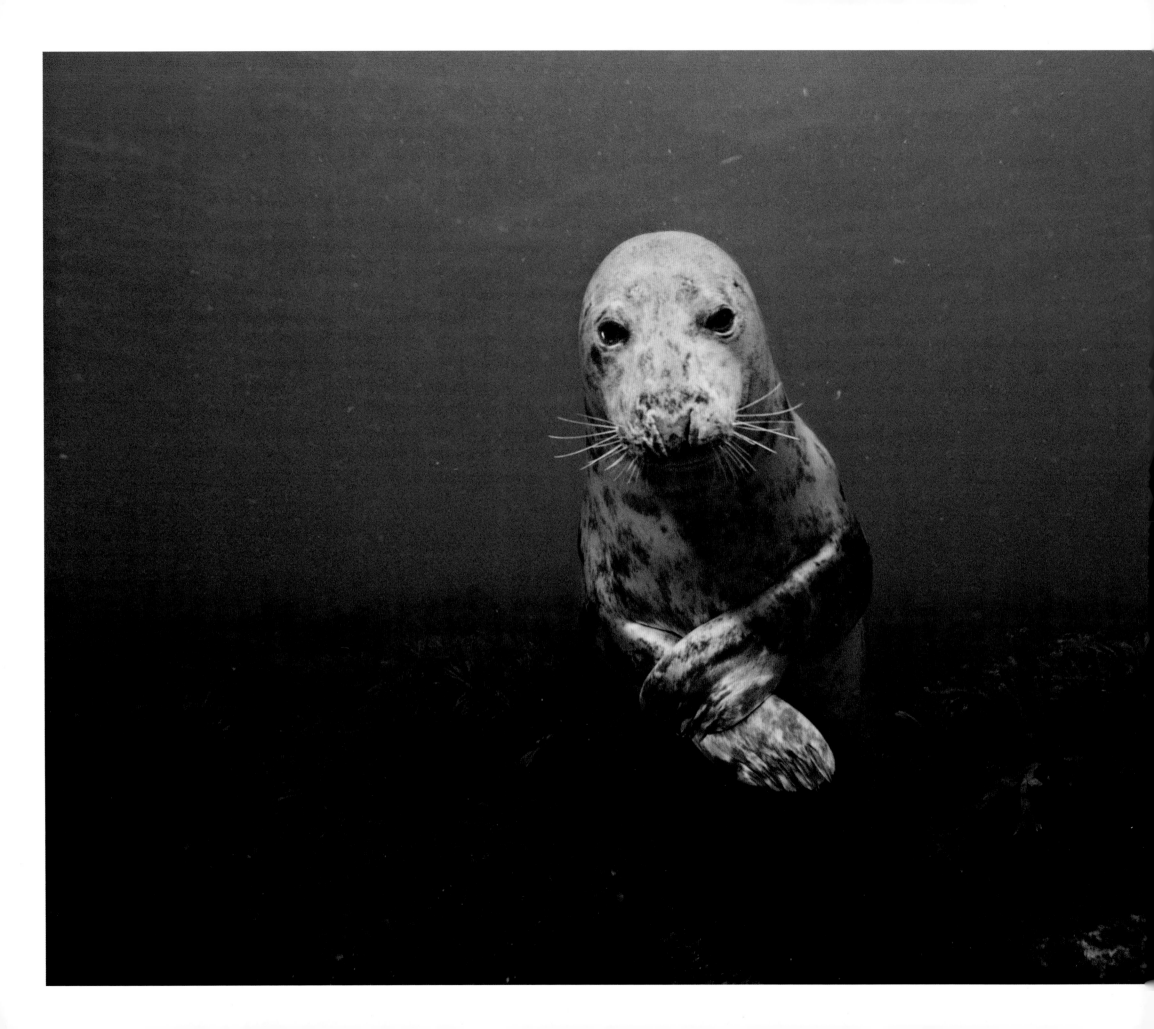

Gulf of Maine

Temperate waters can be deceptive, for beneath the dark surface lies a treasure trove of colorful marine life. New England waters have been plied for centuries by mariners with little notion of what lies below. For divers these secrets are revealed on each foray into the deep. Within the Gulf of Maine exists a complex web of life, with plankton at one end of the spectrum and great whales at the other, and a multitude of species in between. For those with patience, the sea shares its secrets, a reward for persistence and endurance.

Gray seal. Maine, 1995

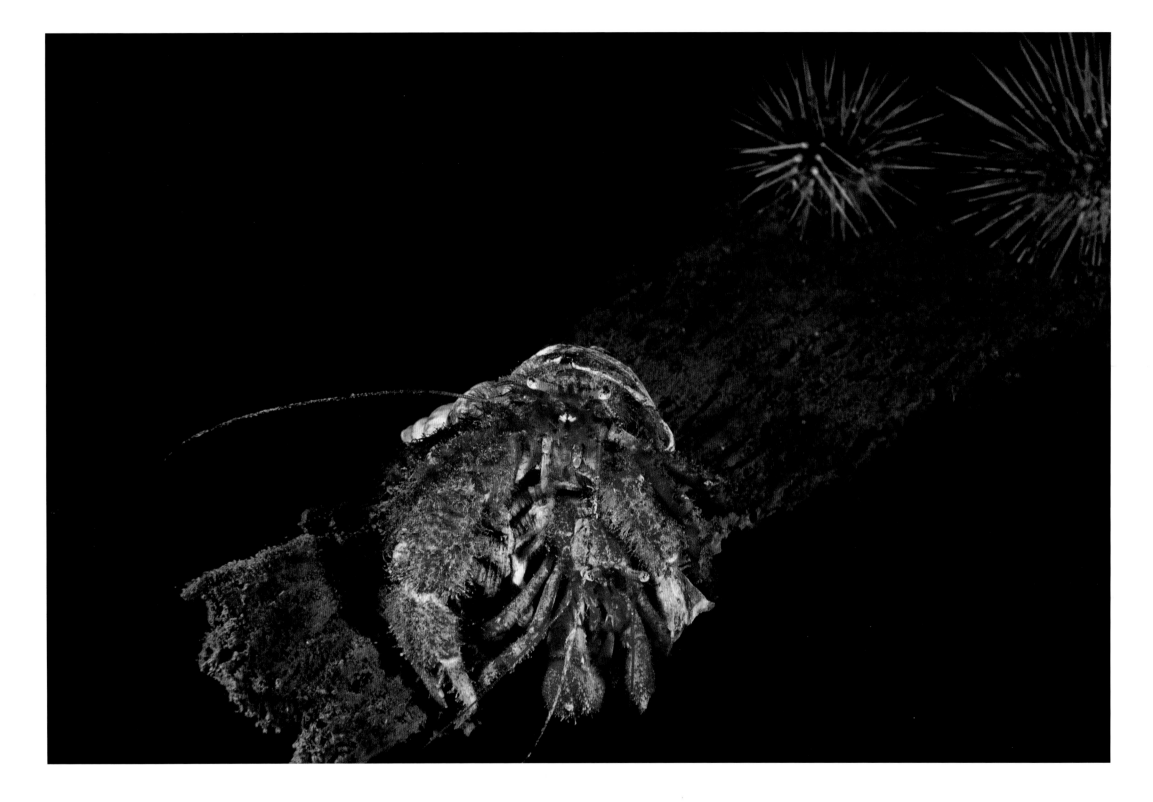

Hermit crabs. Maine, 1993

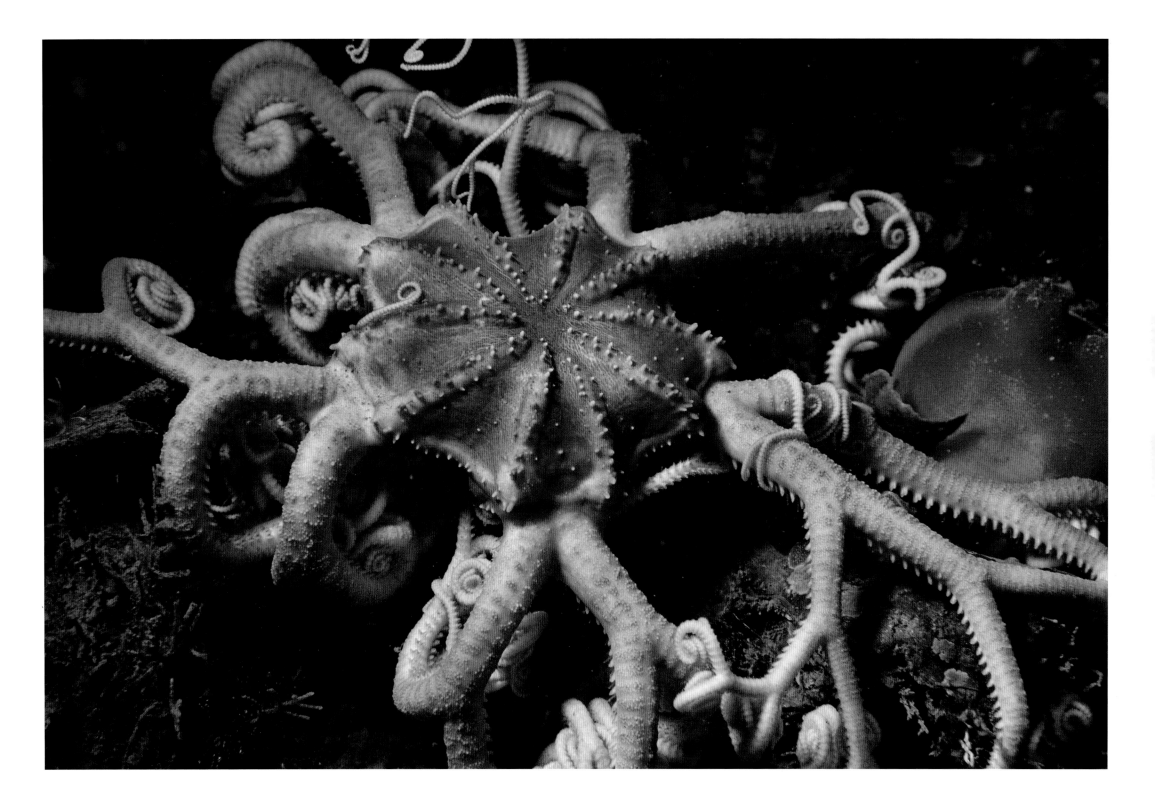

Basket star. Maine, 1992

Beneath the Emerald Isle

A different view of Ireland can be found
within its coastal seas. Living below rocky
cliffs and beaches, a myriad of exotic
creatures call these cool waters home.
It has been said that 40 shades of green
can be found in the fields and hills of
Ireland. Underwater, beneath a gentle
Atlantic swell, explode colors of every hue
found in the rainbow. Entire dives can be
spent exploring small patches of ocean
floor, where jeweled anemones carpet
the bottom, crabs and lobster peer out
from crevices, and curious fish cruise by.
A single stone pier in Ireland can offer
years of discovery, every nook and cranny
occupied with life.

Scorpion spider crab. Ireland, 2003

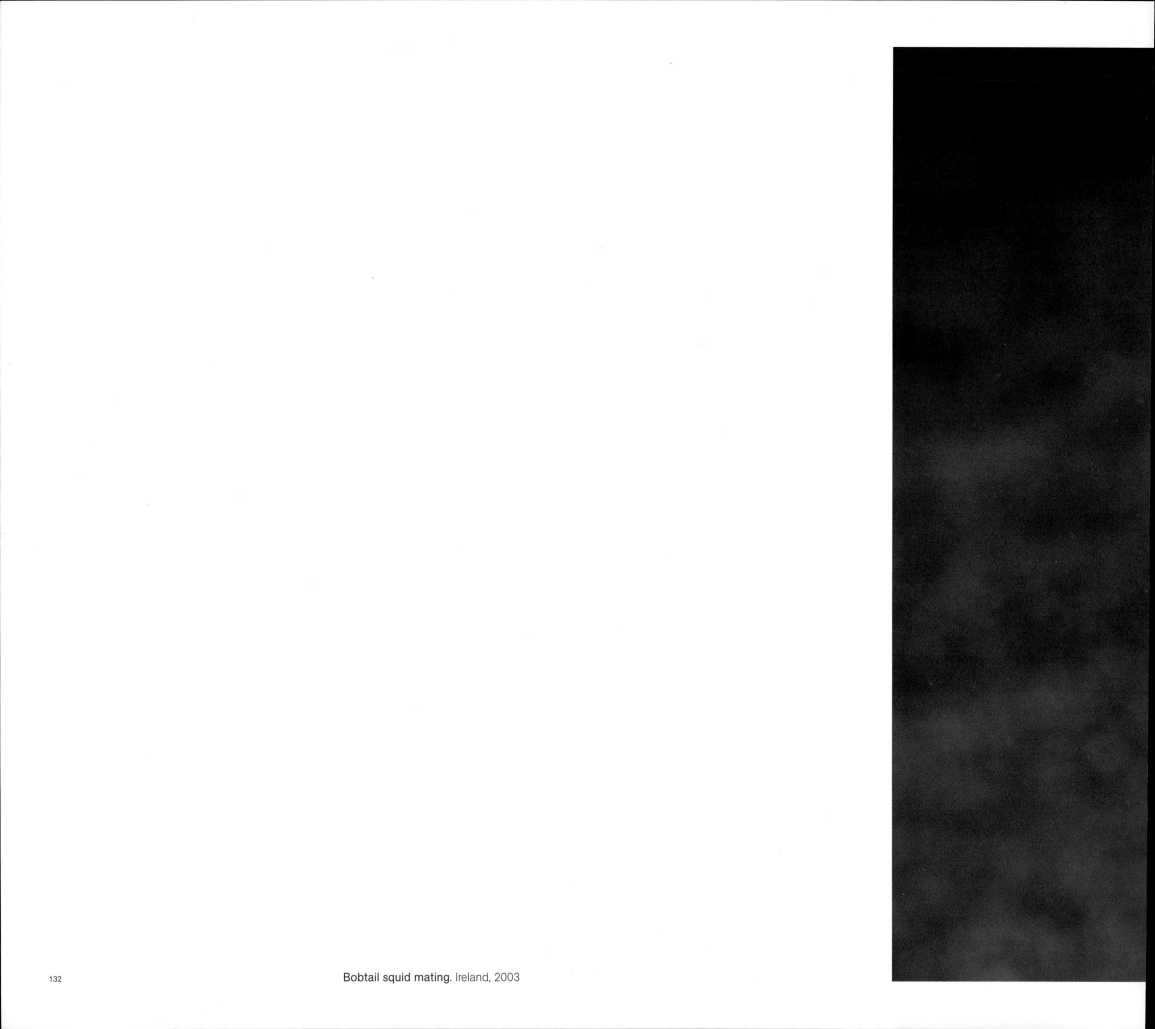

Bobtail squid mating. Ireland, 2003

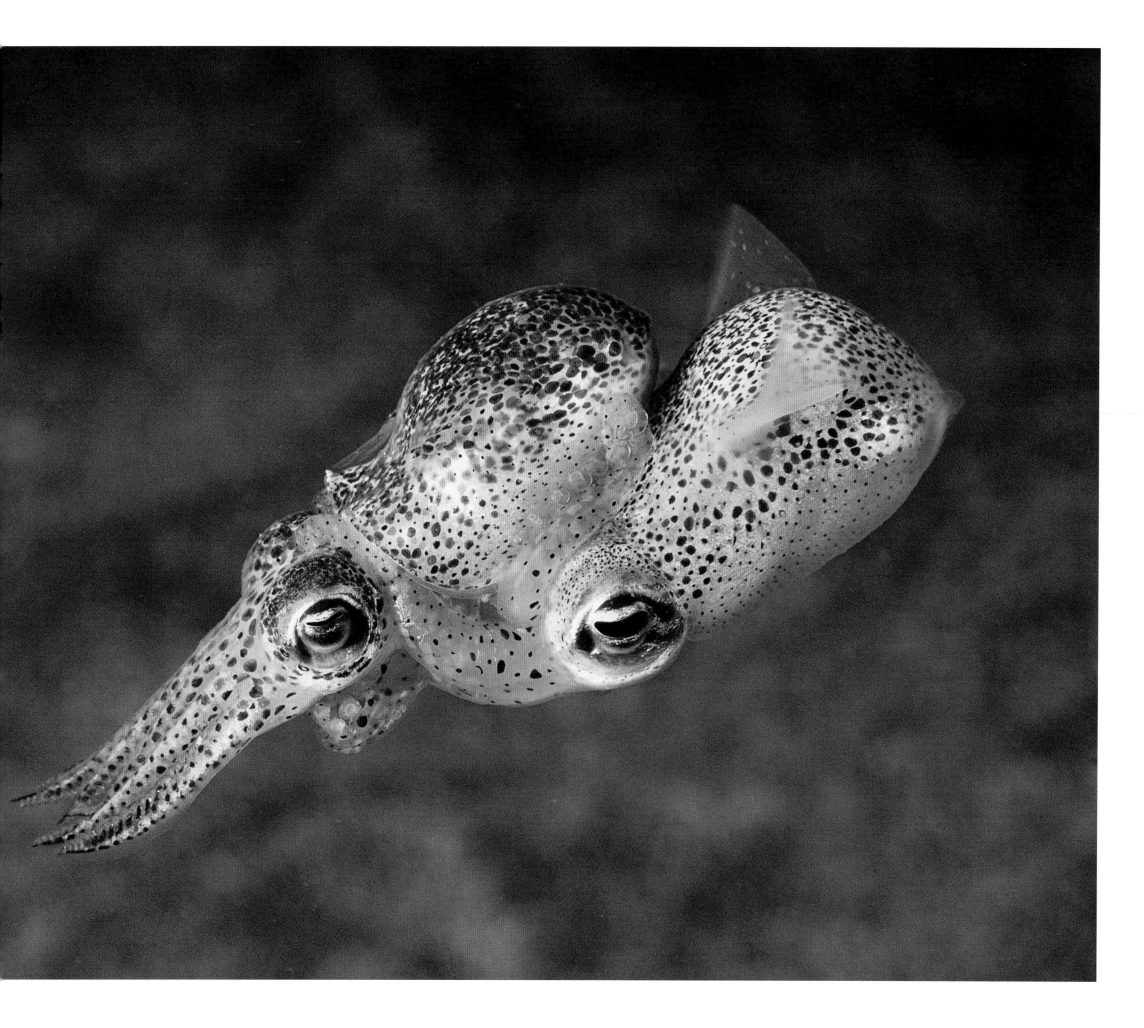

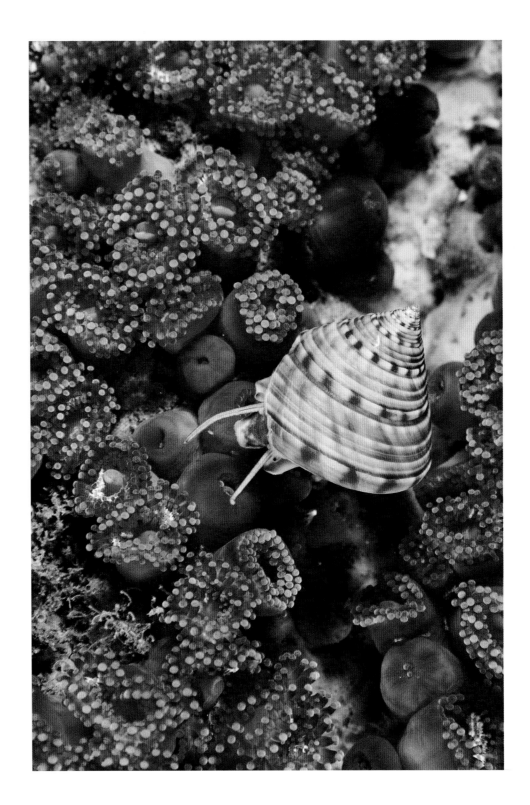

Painted top shell. Ireland, 2003 ~ **Mauve stinger.** Ireland, 2003 (opposite)

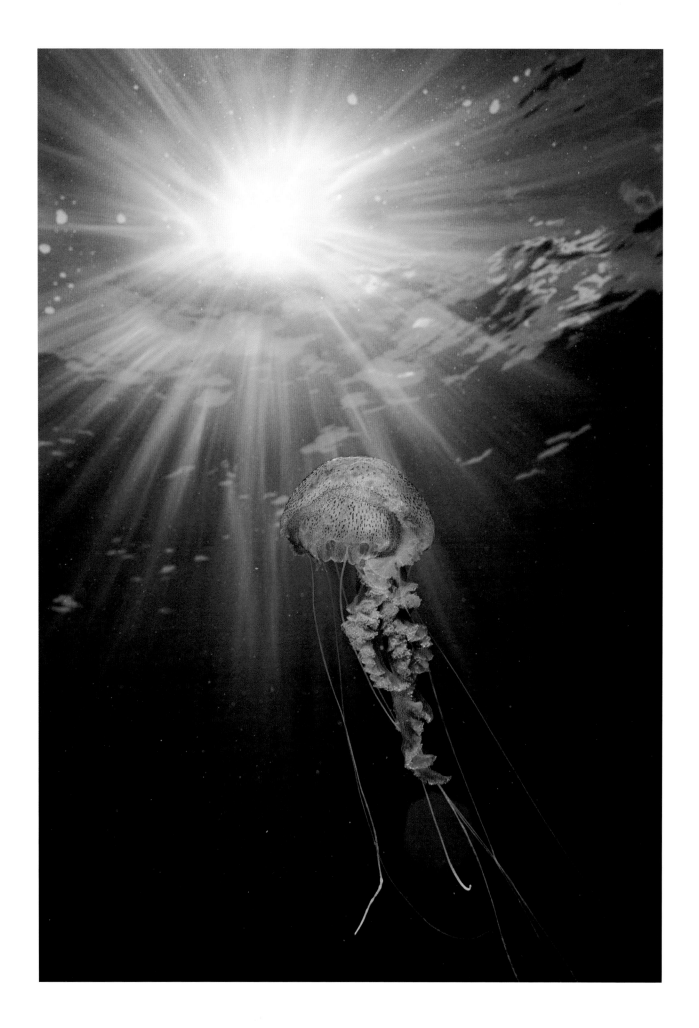

Storybook Seas

Washed by a mix of nutrient-rich currents, the temperate waters of central Japan hold a stunning array of wildlife. Swimming over the volcanic sands of Suruga Bay is like entering a fairy tale, with characters to be found around every turn and each dive like another chapter. In spooky forests of whip coral, a pair of shrimp, male and female, are found living on a single strand, while nearby a goby mimics the brilliant orange of soft coral as a defense against predators. Other cool-water sites offer more fablelike scenes. For a few nights each year in spring, firefly squid spawn in the deep waters off Toyama Bay. On moonless nights they rise to the surface, and dying females get swept by currents to nearby beaches, glowing an eerie blue as they wash ashore.

Yellow goby. Japan, 2008

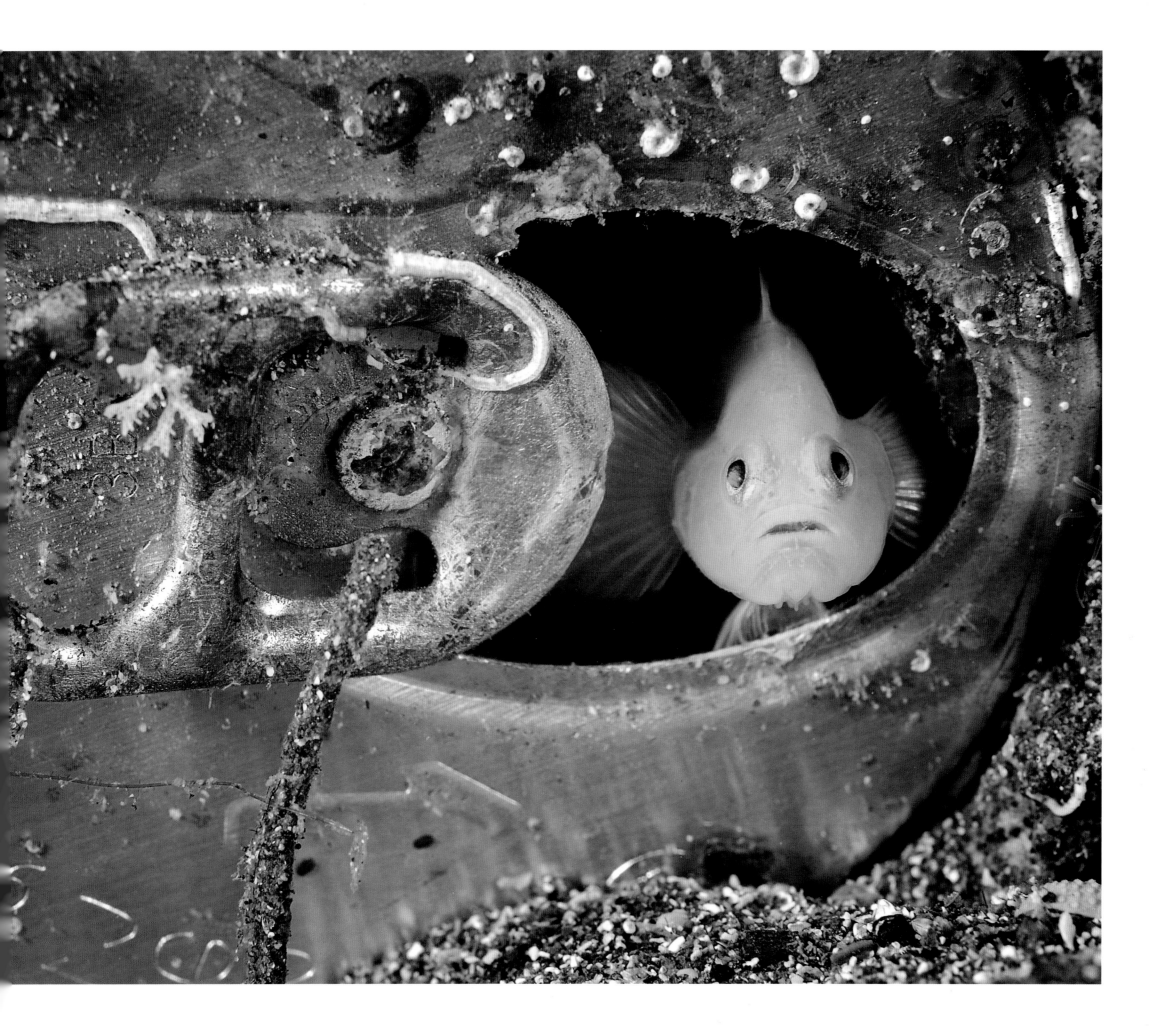

With Mount Fuji ever present in the distance, I waded in from rocky beaches or somersaulted off the sides of boats, gliding over volcanic sands, each dive bringing something new, something fantastic.

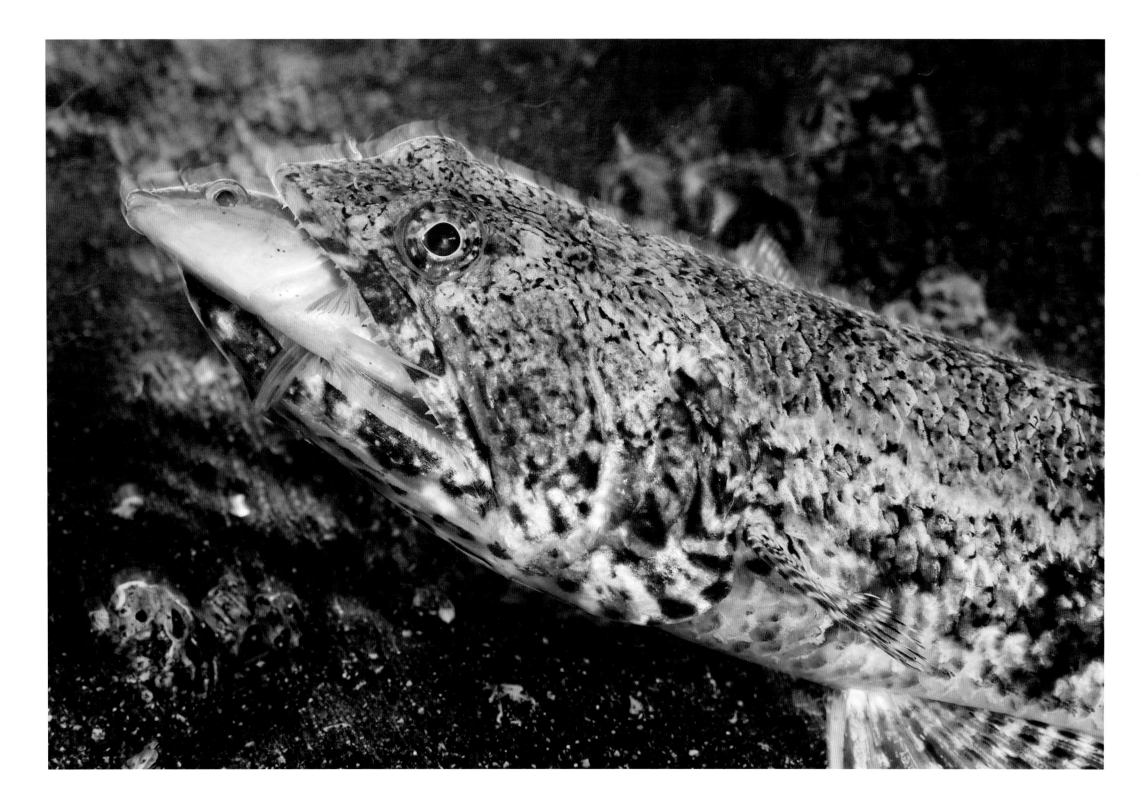

Lizard fish predating on wrasse. Japan, 2008

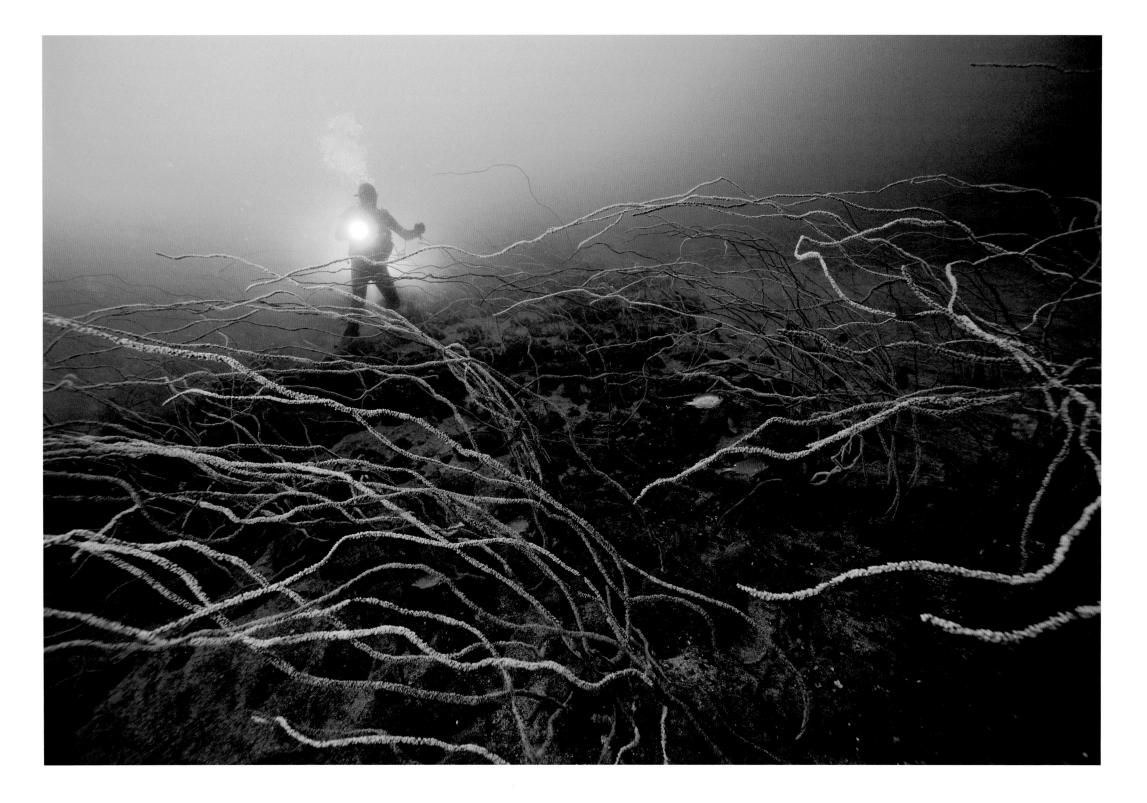

Whip coral forest. Japan, 2008

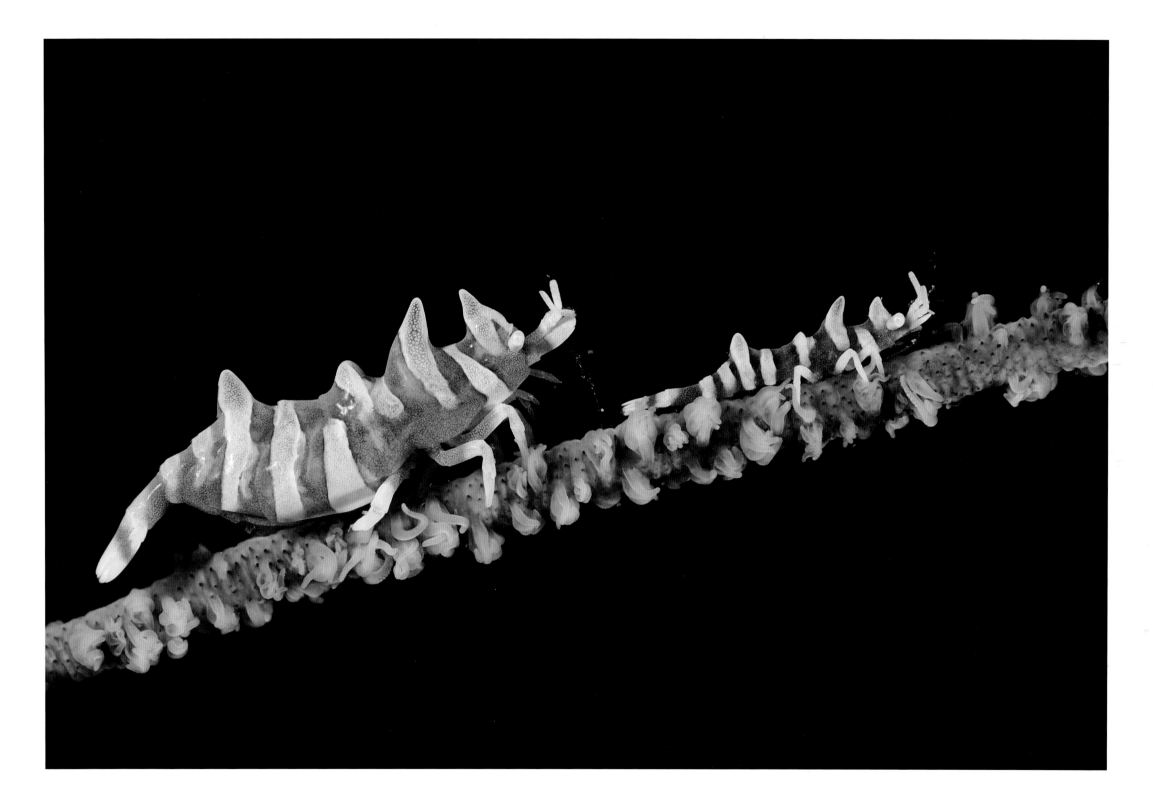

Whip coral shrimp. Japan, 2008

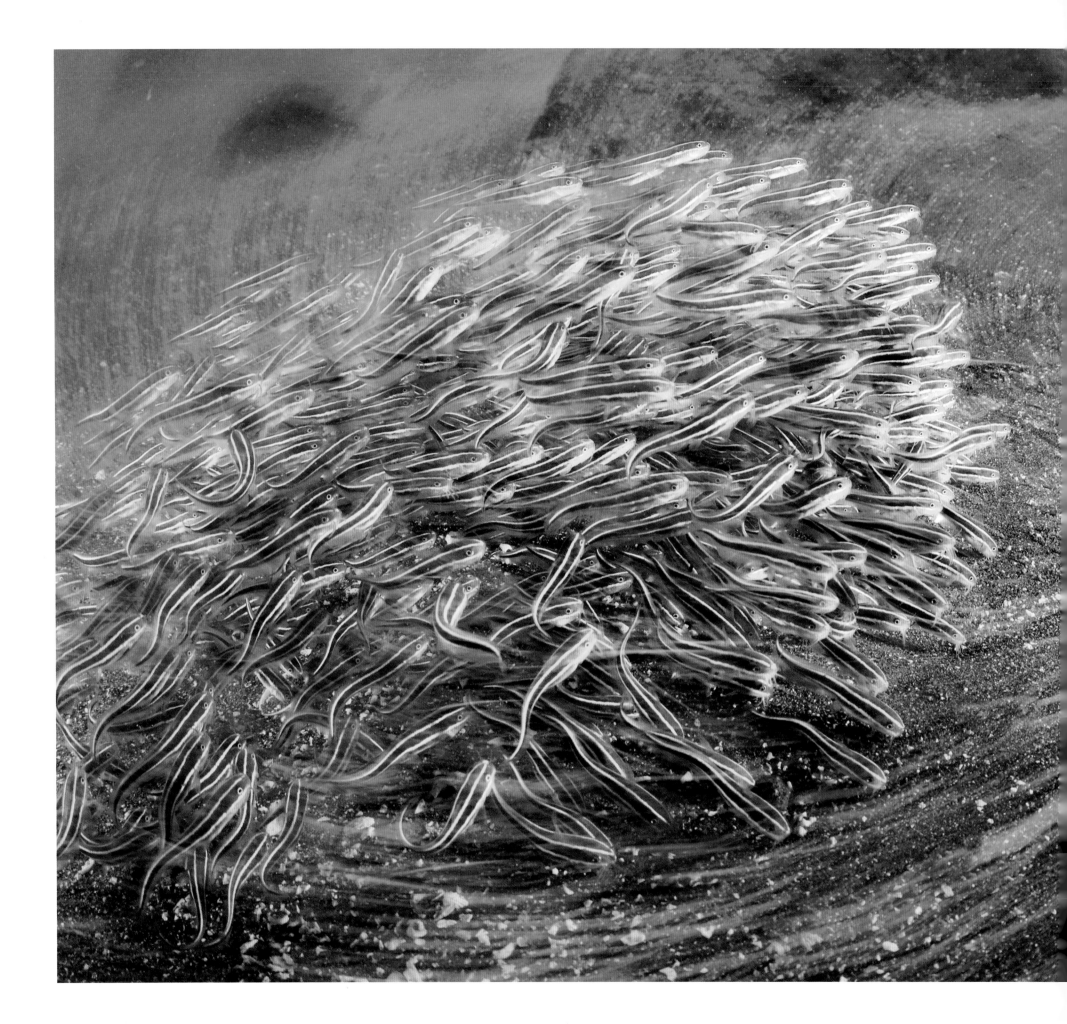

Marine catfish. Japan, 2008

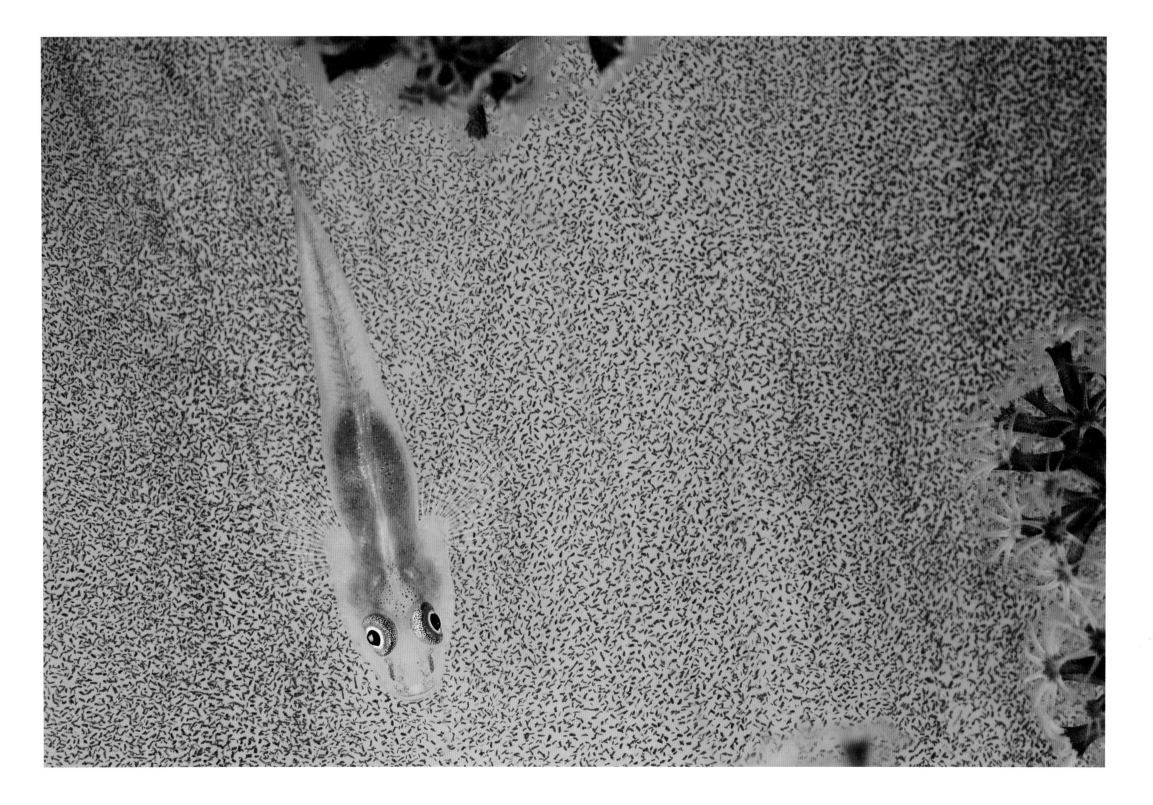

Coral goby on soft coral. Japan, 2008

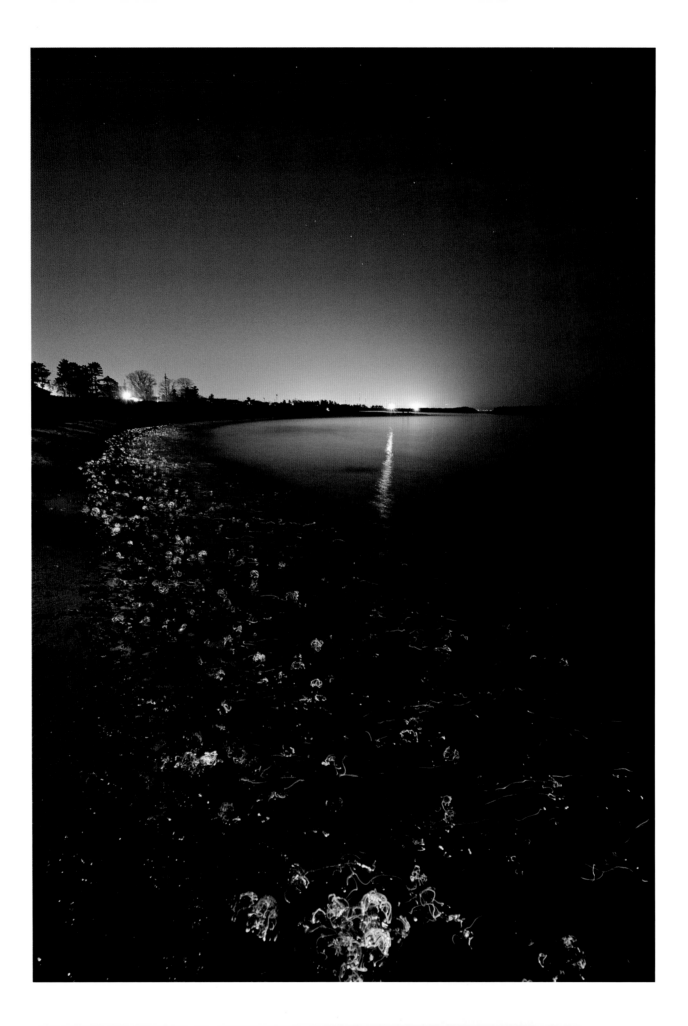

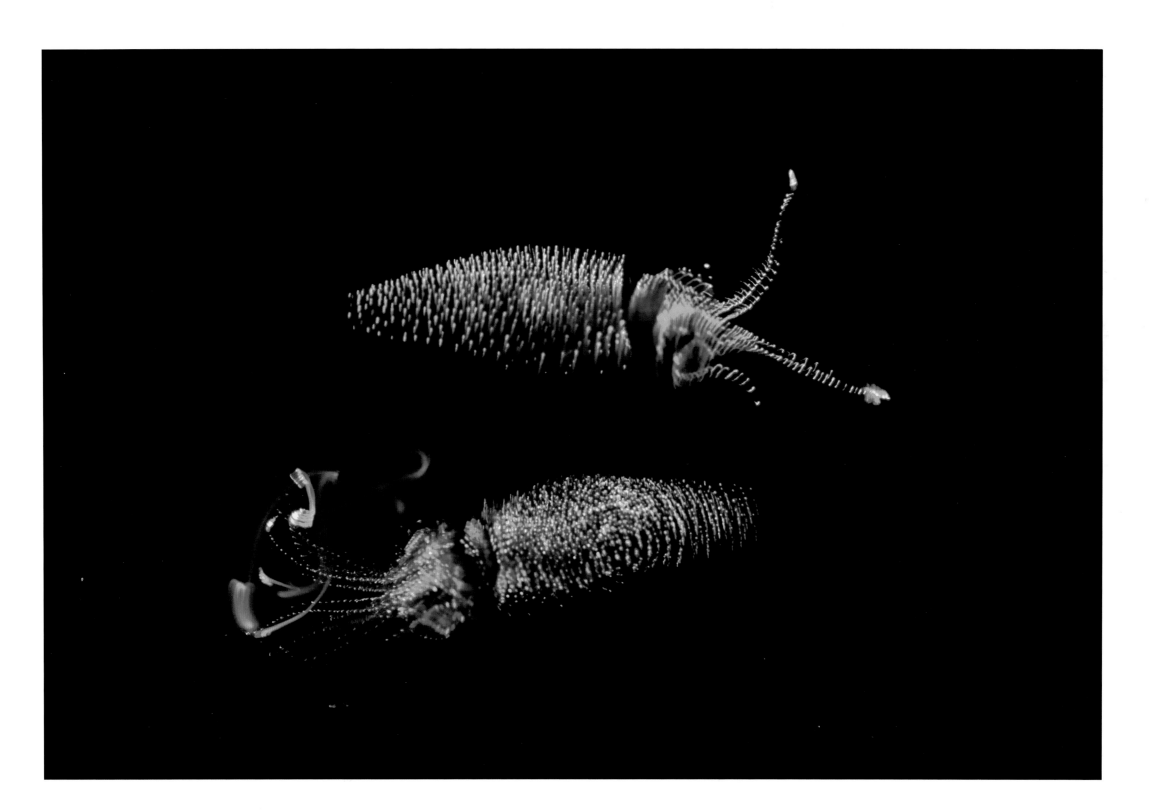

Dying firefly squid. Japan, 2008 (opposite) ~ **Firefly squid (captive)**. Japan, 2008

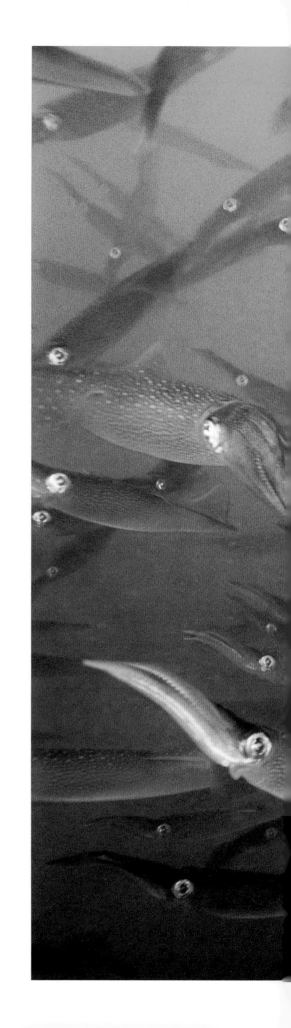

Cool-Water Aliens

Driven by the urge to spawn, massive
schools of squid gather in the waters
off the east and west coasts of North
America. In Cape Cod, springtime brings
Atlantic long-finned squid into shallow
green waters, glowing and pulsating like
miniature alien spacecraft. After mating,
females deposit egg casings on the sea-
floor in large clusters. In winter, opalescent
squid, also known as California market
squid, aggregate off the Channel Islands in
similar behaviors. Thousand of squid hover
over the egg beds, seeking partners some-
times for hours. During mating, the arms
on the male of this species blush red as a
warning to other males to keep away.

Atlantic long-finned squid. Cape Cod, 2002

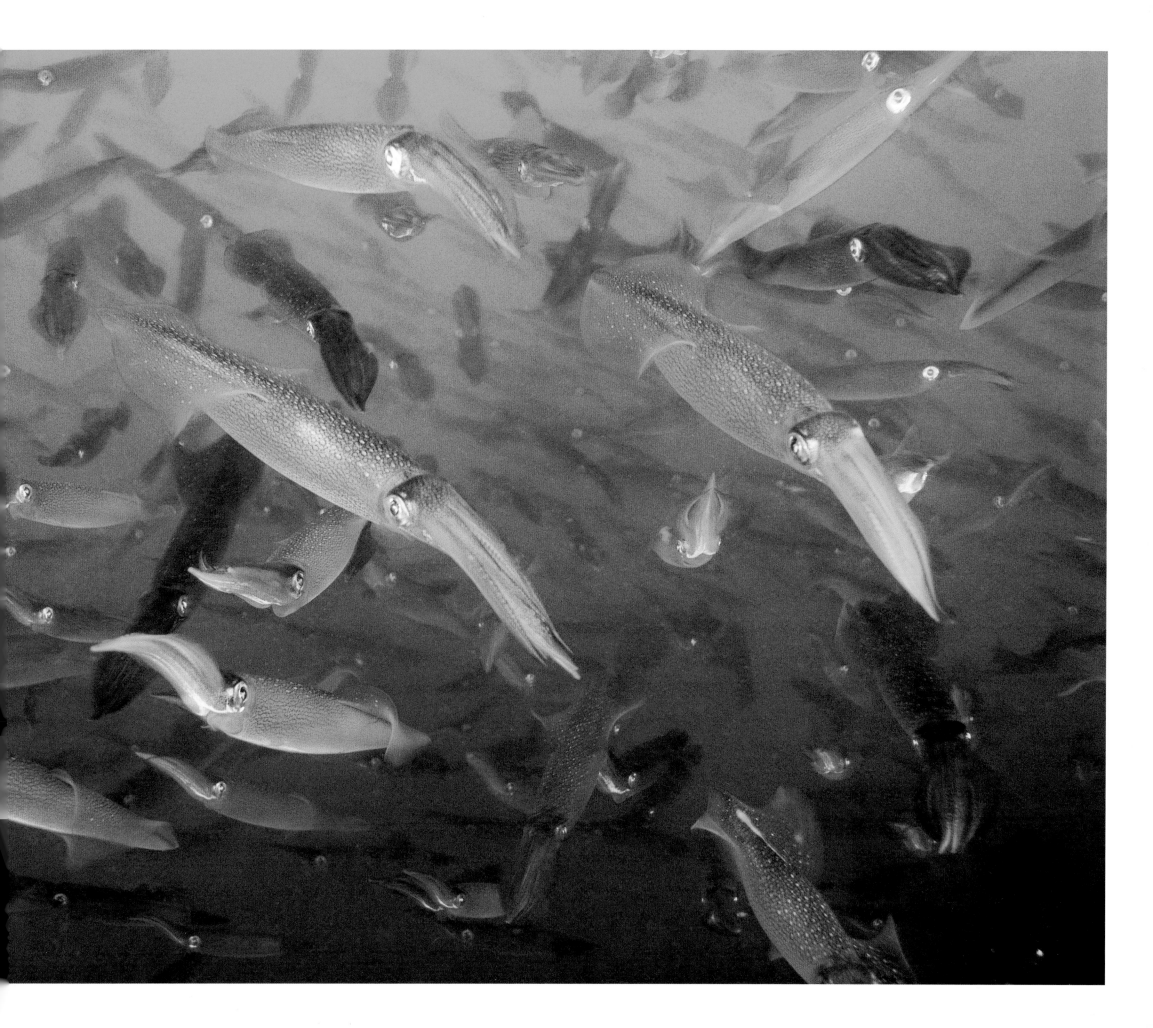

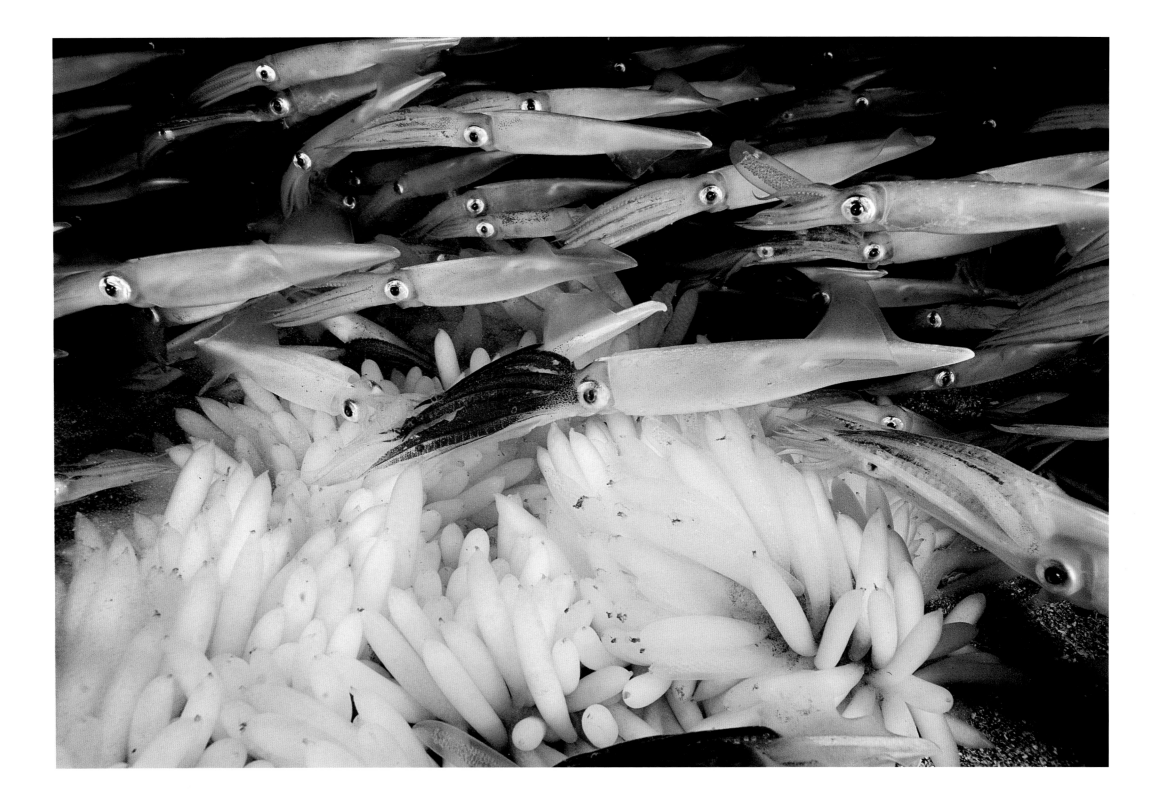

California market squid. California, 2002

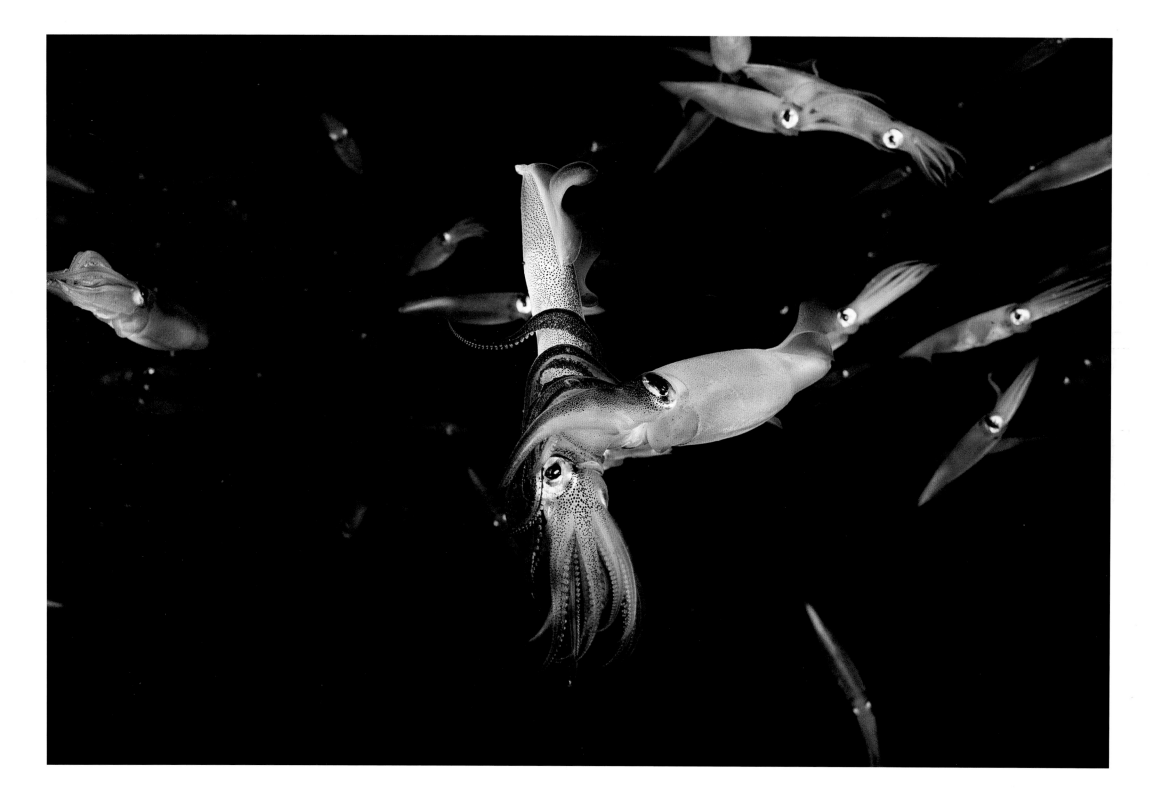

California market squid. California, 2002

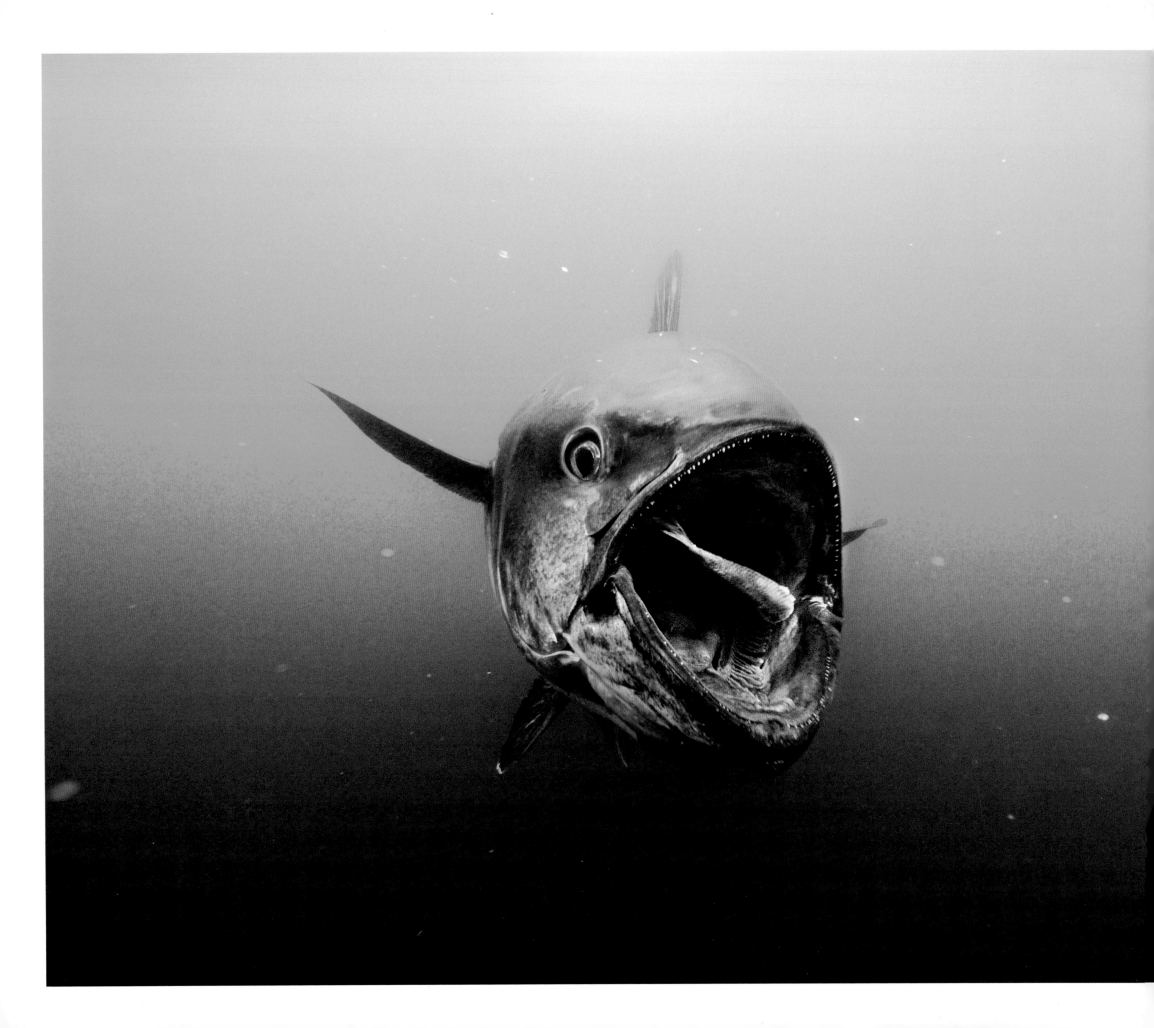

Oceanic Perfection

Migrating to the North Atlantic waters off Nova Scotia, Canada, during autumn, giant bluefin tuna come here to feed on oily fish, such as herring and mackerel. Many of these animals weigh in excess of 1,000 pounds and travel thousands of miles each year. Bluefin actually continue to grow their entire lives, and they have the ability to produce heat, allowing them to swim into chilly waters to find prey. Sculpted by eons of evolution, bluefin have a perfect hydrodynamic body that has been studied for torpedo design, although the tuna swim faster than torpedoes. They have been called underwater Porsches, almost as big and nearly as fast and valuable. Although they were once abundant throughout the Atlantic, their stocks have plummeted in recent decades.

Bluefin tuna. Canada, 2010

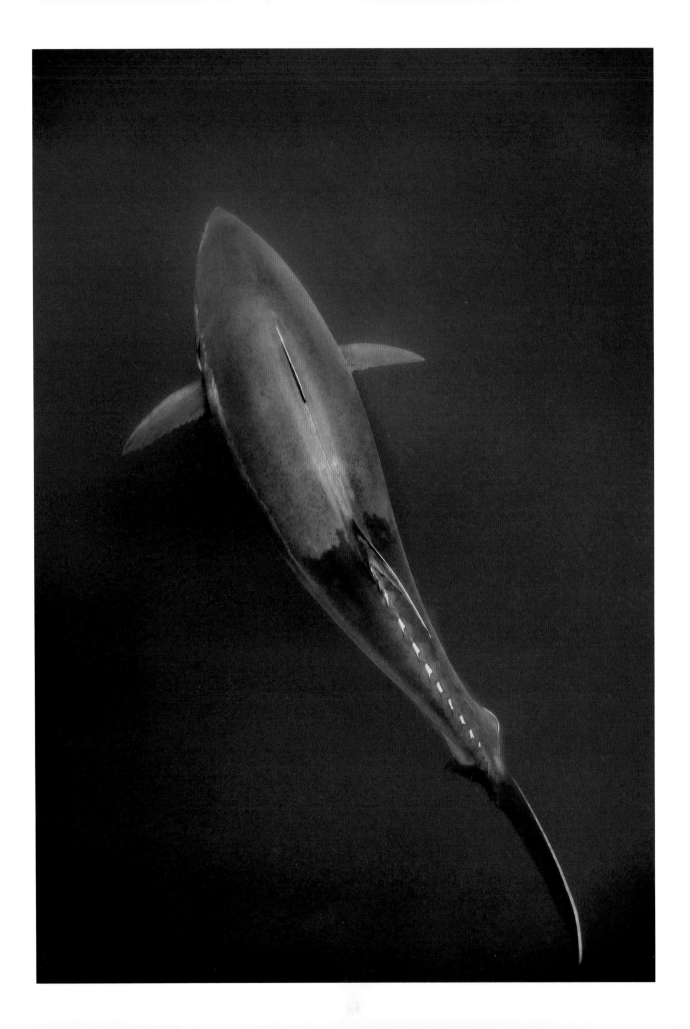

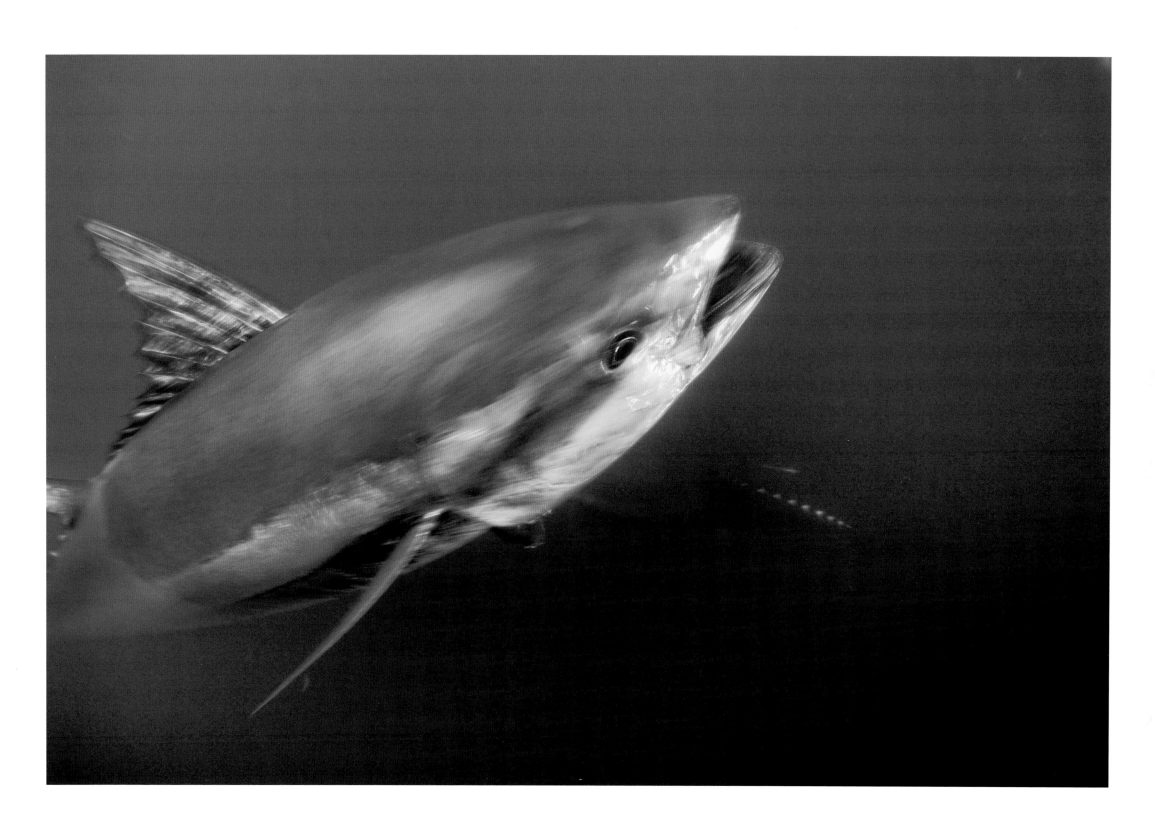

Bluefin tuna. Canada, 2010 (both)

To be underwater with these magnificent animals is to witness the divine sense of nature. They are true thoroughbreds of the sea, with few equals, if any.

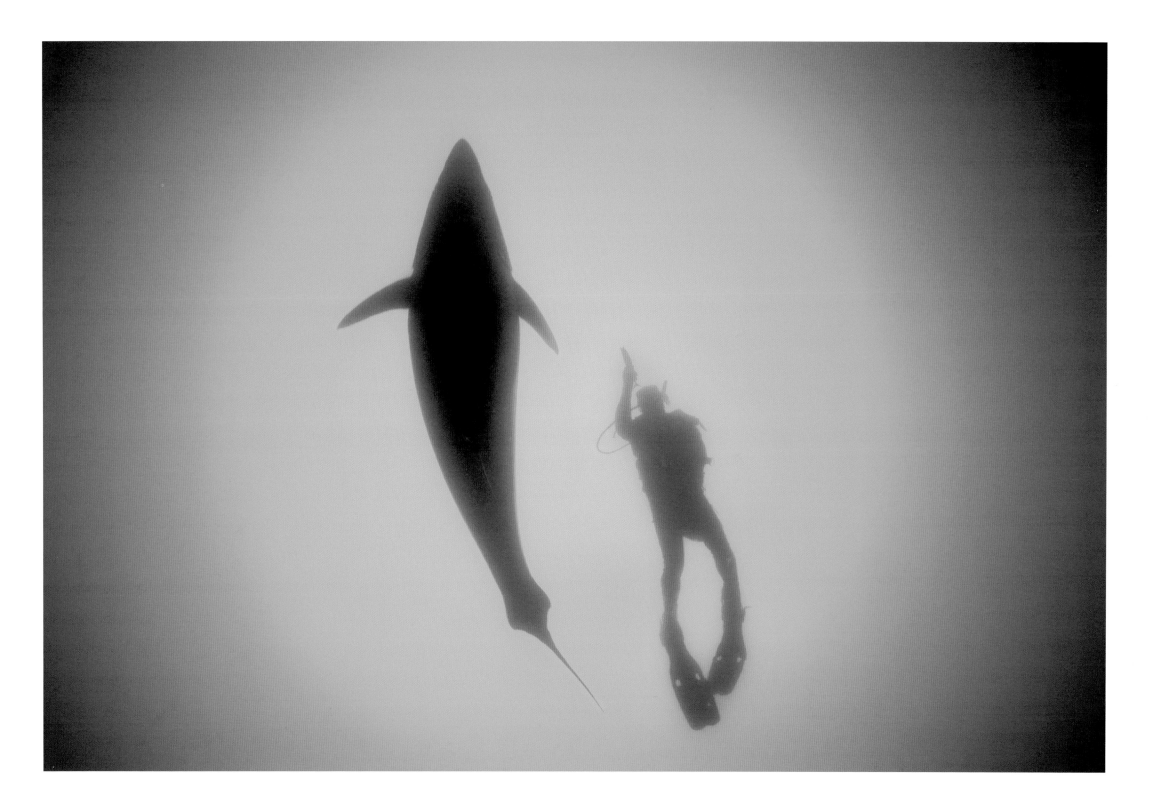

Bluefin tuna. Canada, 2010

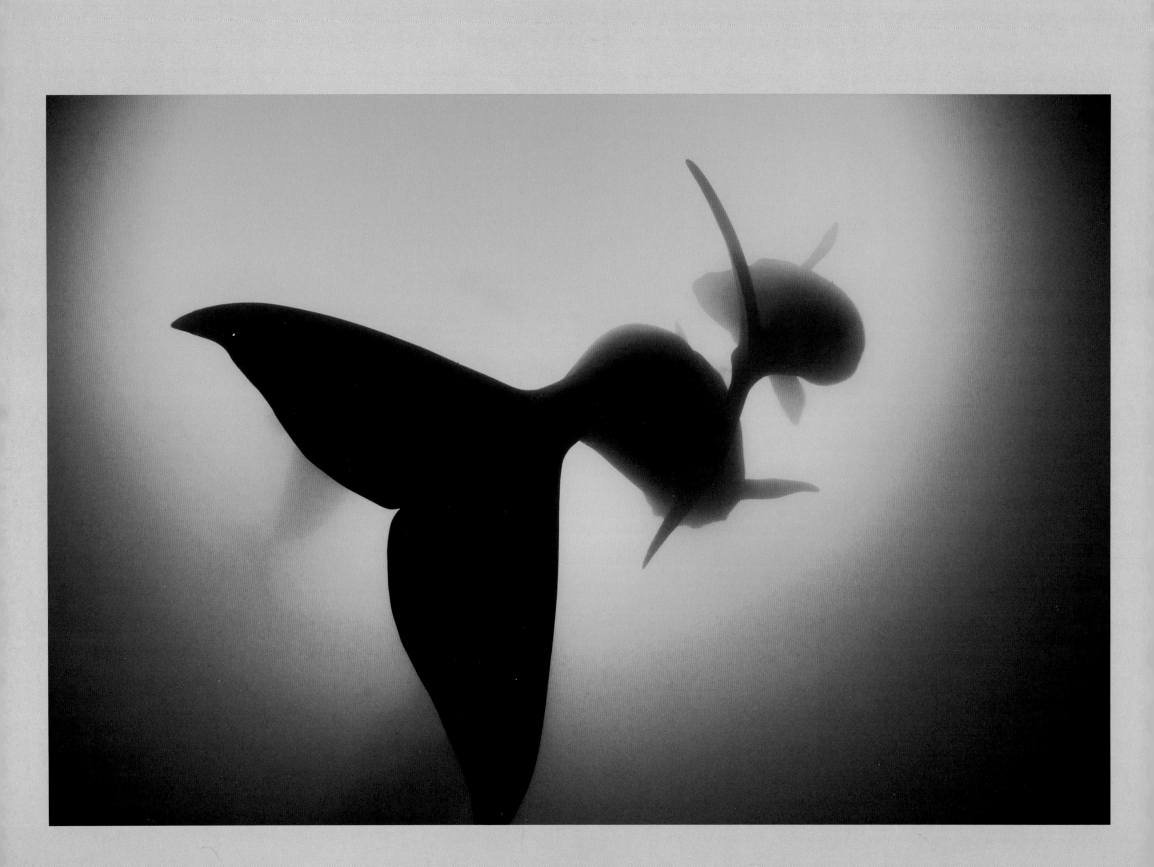

Southern right whales. New Zealand, 2007

Right Whales

As my eyes scanned the calm green sea for whales, a nagging thought kept creeping into my mind. I was 26 miles offshore, a long way to be out over water in a single-engine Cessna. I had been in Florida for nearly a month to work on a story about right whales, and this was one of the very few days when the weather was calm enough to shoot aerial pictures of the whales. So, while there were risks, I was confident in the aircraft and the pilot, and I prayed that today I would make a great picture of a mother and calf on the surface.

Named the right whale by early whalers because they were slow moving, easy to approach, and given to float when dead, this creature was considered the right whale to hunt. My story idea was to compare and contrast two populations of these animals—the North Atlantic right whales and the southern Atlantic rights. Both species were hunted to the brink of extinction, but the southern rights rebounded much more readily than the northern whales, largely because they live in places that are farther from human industrialization. The Atlantic rights are "urban whales" that live close to the coastline of North America and, as such, must live with substantial pollution—both from toxins that are flushed into the sea, which may affect their reproduction, and from sound pollution from

Habitats of North Atlantic, North Pacific, and southern right whale

Right Whales

ship traffic, which has adversely affected their communication. They also fall victim to ship strikes and become entangled in fishing gear, such as crab pots and lobster traps, which dot the seaboard like a minefield. This gauntlet of threats results in whale deaths every year and has kept their stocks from recovering from centuries of whaling.

My coverage in the Atlantic would center on Canada's Bay of Fundy, the eastern coast of Florida, and Cape Cod Bay. There would be no diving in any of these places, though. My photography would illustrate surface behavior and the environmental threats facing this species. After months of fieldwork, I had great images and a solid grasp on the coverage I had outlined. But the story would be incomplete without pictures of whales underwater—that's what I needed to bring it all together. Nearly all the photographs I had seen of right whales underwater were those made of southern rights in Patagonia, where water clarity was variable. Then I learned about a place in New Zealand called the Auckland Islands, where right whales swam in clear water. This existing population of whales was discovered in 1998, and because it was so remote, few people had traveled there and almost no

one had dived with them. The trip would be highly speculative, but I had a feeling this was the place I needed to be. I put together an itinerary, which included securing 12 permits from the New Zealand government. The whales would only be there in the austral winter, so on a sunny day in July I left home for the cold and stormy sub-Antarctic.

I chartered an 82-foot sailboat called *Evohe* for this voyage, and along with five of the world's leading whale scientists, I began the voyage. The trip would take two days, and sailing the Southern Ocean in winter meant contending with rough seas. But two days of hell would be a small price to pay if we found the whales and conditions were good.

We arrived at Enderby Island on a clear, sunny day, and *Evohe* slowly cruised into a place called Sandy Bay. From the forward deck I studied the island's landscape, which was stark, hilly, and green. I looked over the gunwale as we maneuvered into shallower water to drop anchor and was thrilled with the clarity of the water. I could see the bright, sandy bottom at least 30 feet below. Walking aft to the stern, my heart began to race, for approaching rapidly from underneath were whales! I counted at least five animals coming toward *Evohe*

Southern right whale and diver. New Zealand, 2007

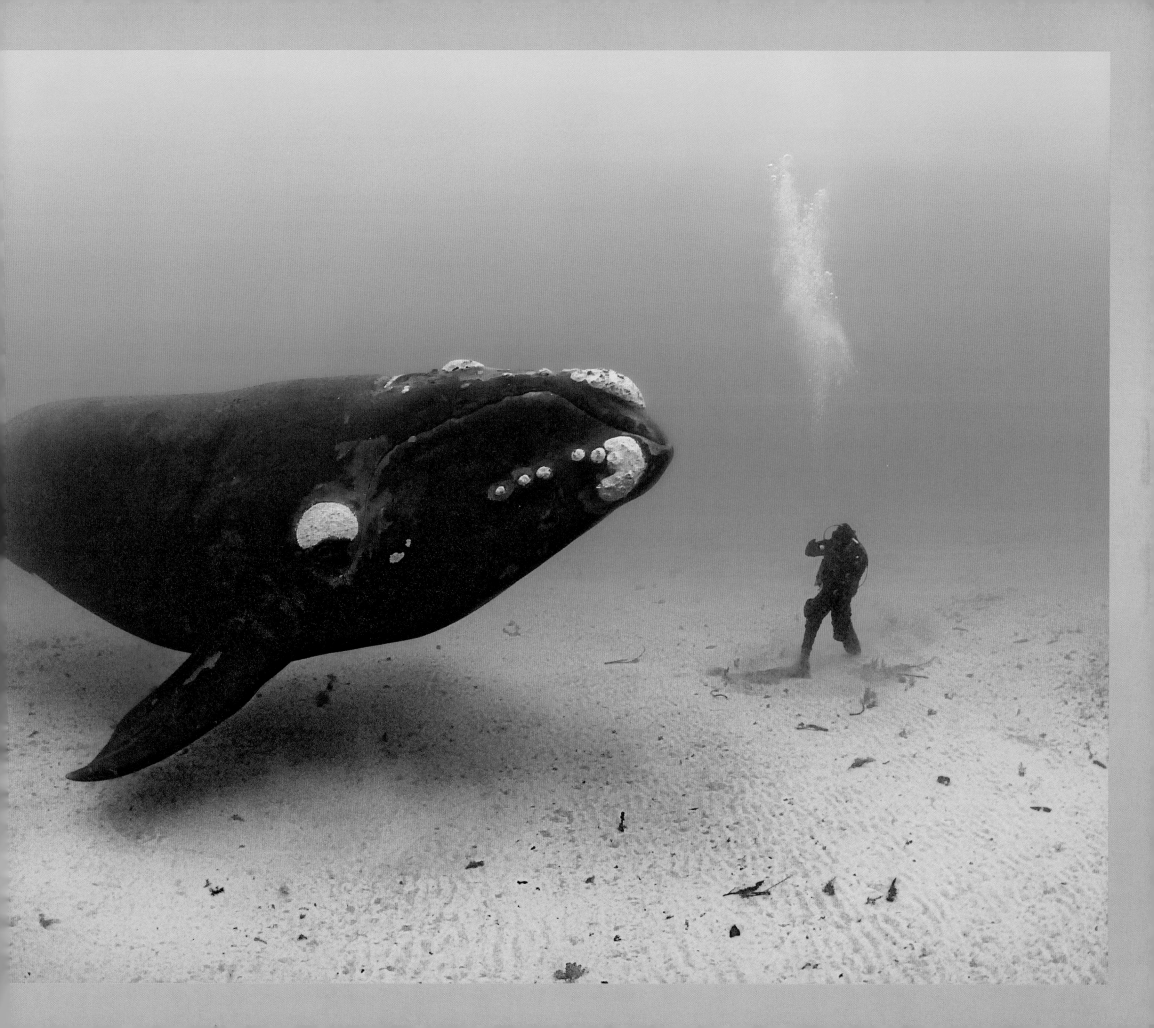

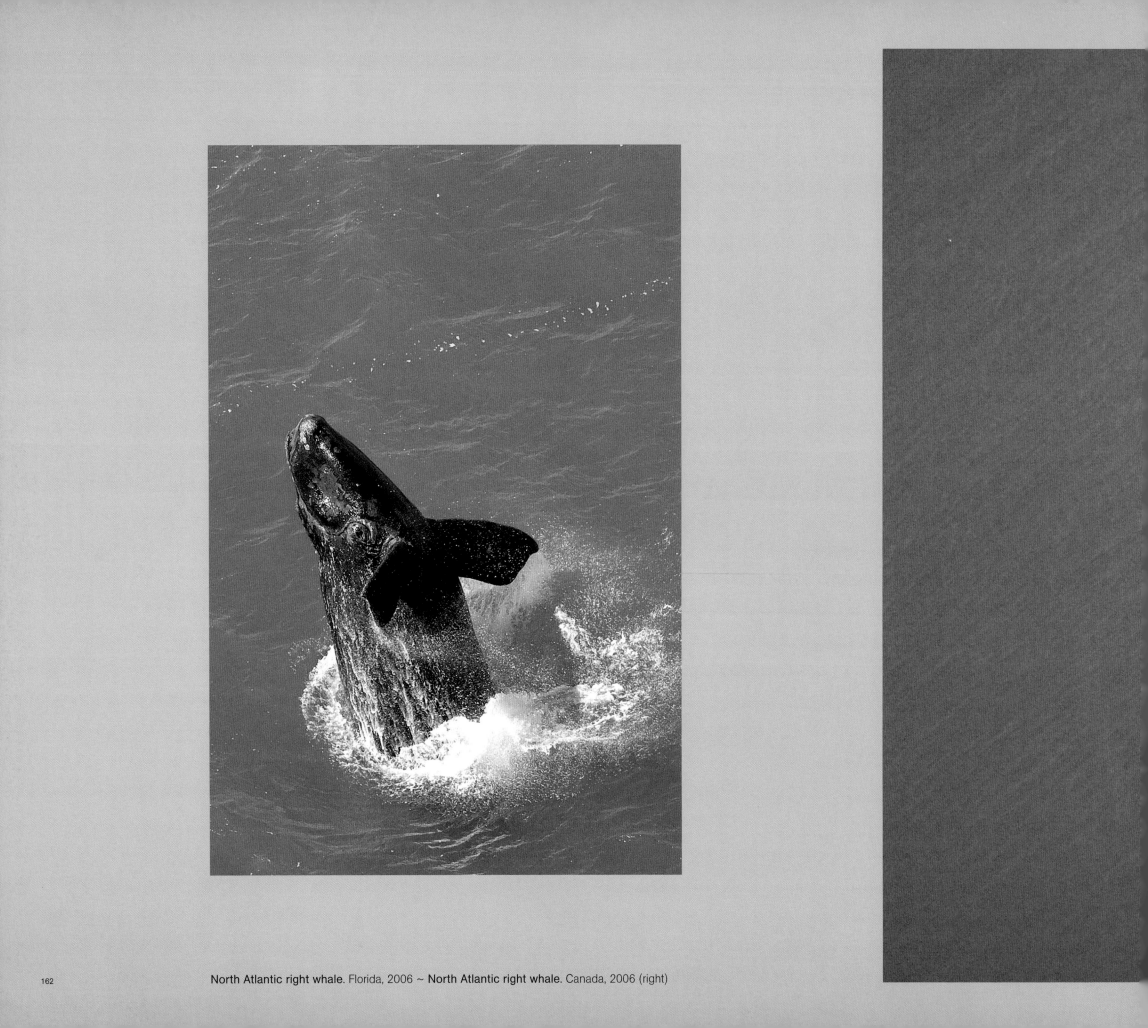

North Atlantic right whale. Florida, 2006 ~ North Atlantic right whale. Canada, 2006 (right)

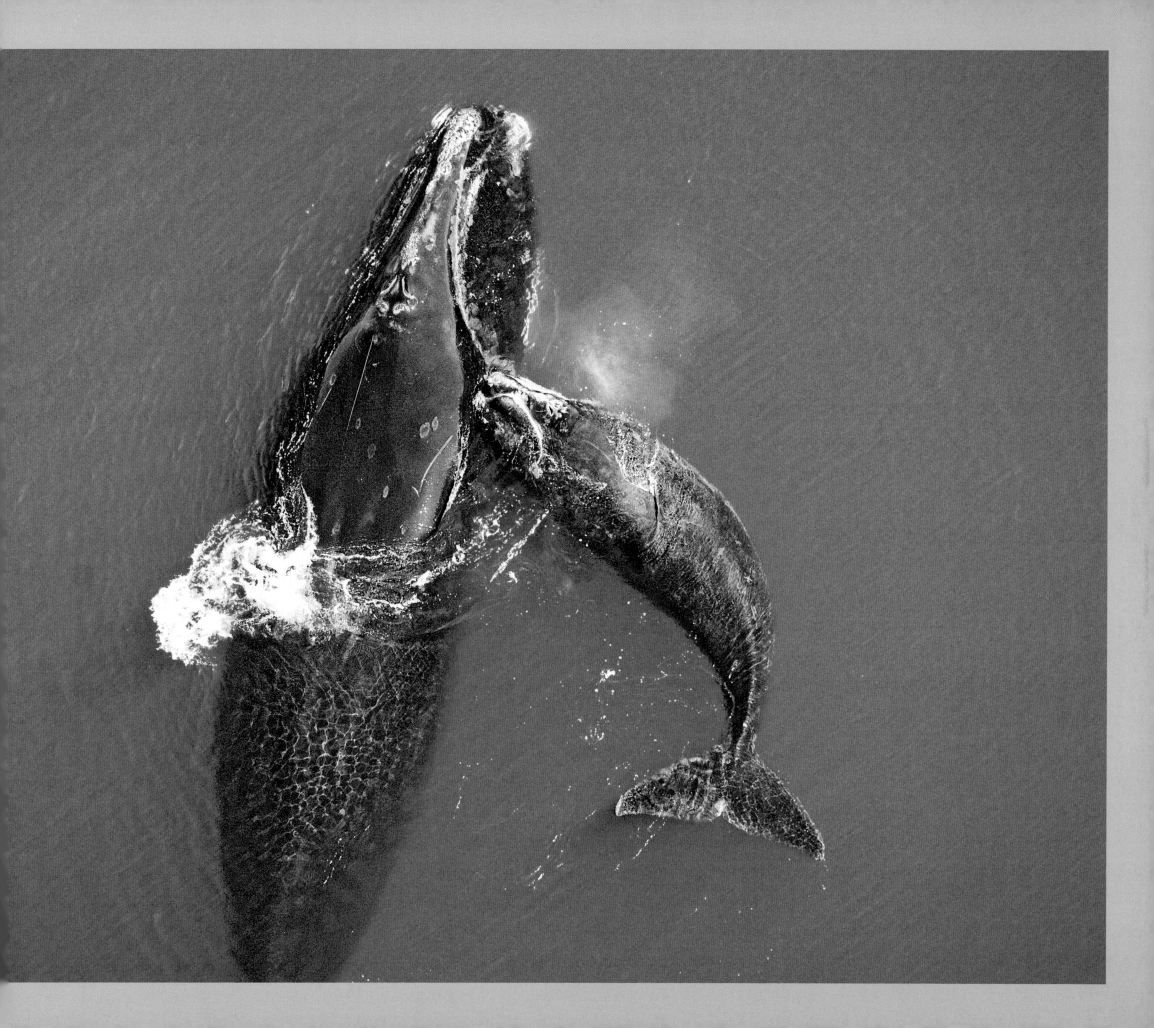

like submarines. Once they reached the boat, they moved slowly, swam around and under the boat, and actually seemed curious about us. Their mottled dark and light bodies were a striking contrast to the clear water, and as I watched in awe I could not imagine a more exciting greeting.

This stunning scene was hypnotic, and I wanted to just keep staring, but I knew I needed to get in the water. As quickly as possible I dressed in thermal undergarments and pulled on my dry suit as my assistant, Mauricio Handler, loaded tanks and cameras into the inflatable boat we would use for diving. We pushed off from *Evohe* but stayed close since the whales were right there. With the rest of my gear on, I slipped into the water and submerged. Not wanting to scare the whales, and thinking that they might come close with only one person in the water, I decided to dive alone. Seconds after I settled down on the sea floor, I looked up to see a whale swimming 20 feet above me.

Being underwater with an animal as large as a right whale is both awe-inspiring and unnerving. I watched as the whale moved closer to me. It was clearly curious and wanted to inspect me further. The left side of my brain was telling me to check aperture and shutter speed, to make sure

the exposure was perfect and the focus was sharp, while my right brain was blown away by the graceful movements of this creature the size of a city bus swimming toward me. Its bulk was enormous, yet it moved gently, and I studied its eyes, which were without question studying me. The whale swam just a few feet over my head, its perfectly sculpted flukes trailing carefully behind its stout body.

Other whales moved in to join the first, and I ascended into the water column to meet them. I was pirouetting around continually and looking in every direction so as not to miss a second of this incredible action. For me, looking through the viewfinder of a camera is often like watching a movie. I become enveloped in "the zone" and am so intensely focused on making pictures that I rarely enjoy the magnificent scene playing out before my eyes. While this was certainly the case on this dive, I still vividly recall the sensation of dancing underwater with these whales. They were fatter and far more robust than their northern cousins and had no scars from battles with fishing gear. They were, I imagined, how the whales back home once looked, before human activity altered their realm.

During the three weeks I spent in the Auckland Islands, I shared experiences I

could never have imagined. My shipmates and I were in one of the most remote corners of the planet, alone with albatross, fur seals, yellow-eyed penguins, and whales. I dived as often as I could, though the pleasant weather that initially greeted us upon our arrival turned cold, windy, gray, and snowy for most of our time there. For days on end we were cabin bound, forced by weather to stay below decks on board *Evohe*, where we huddled next to the kerosene stove, sipped tea, and mused about whales. Whenever the weather showed even a hint of relenting, we were off in small boats in search of whales.

On the days when the underwater visibility was poor, I dived beneath the whales and photographed their silhouettes against the bright, aqua-green water above. I remember one day when I spent more than five hours standing on a muddy sea floor and watching male and female whales engaged in courtship. Another day I had a curious whale following me like a puppy near the surface. I have always been reluctant to touch an animal underwater— particularly a whale—since I never can tell how they might react. If they do not like it, they might react violently. On the other hand, if they do like being touched, that might prove equally dangerous. On this

dive I had a whale inches away from me, clearly trying to make contact. I was back-pedaling, desperately avoiding the massive head covered in razor-sharp barnacles. But what was most amazing was the eye that just kept looking at me with a gaze that seemed primordial and wise.

One morning, while I was kneeling on the sandy bottom, a whale swam straight down on top of me and stopped inches from my head. I was bent over backward, my scuba tank digging into the sand, and I stared up at this "submarine" in front of me. There was no way to make a picture because the whale was blocking all the light, and with a single flick of its tail it easily could have crushed me like a bug. Instead, the whale turned to its side so that its softball-size eye was less than a foot away from my face mask and just looked at me. How I wished at that moment that I could communicate, that I could say something profound to this animal, but all I could do was gaze back and tell myself this was not a dream.

Despite the absence of discernable language, I was certain that some level of communication was occurring whenever I was in the company of these whales. I have always found marine mammals to be especially aware of humans underwater

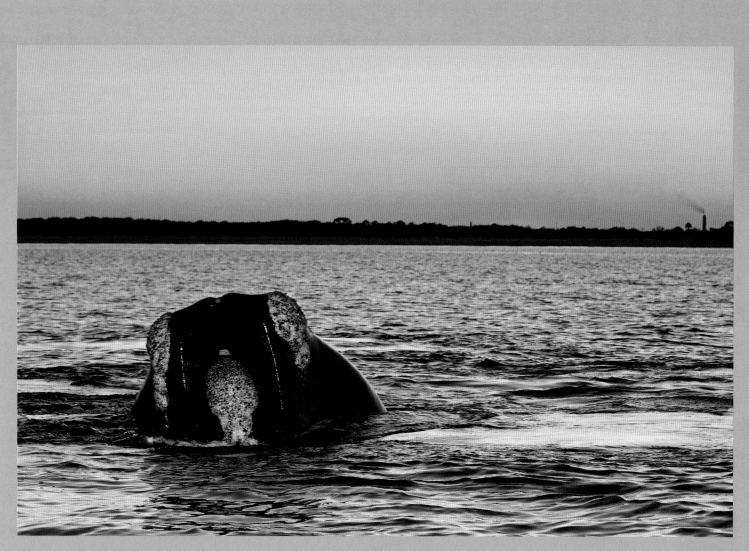

North Atlantic right whale. Florida, 2007

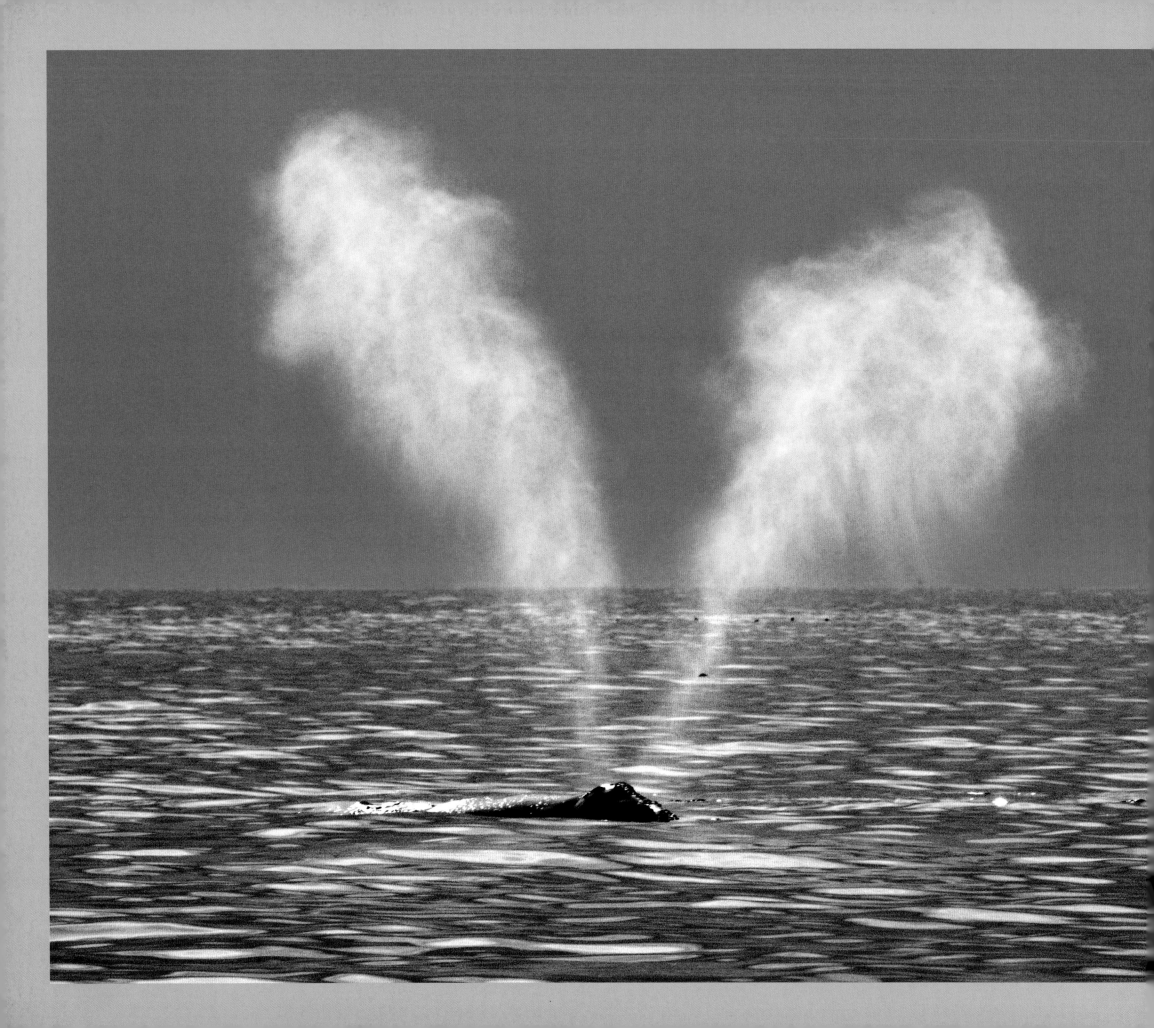

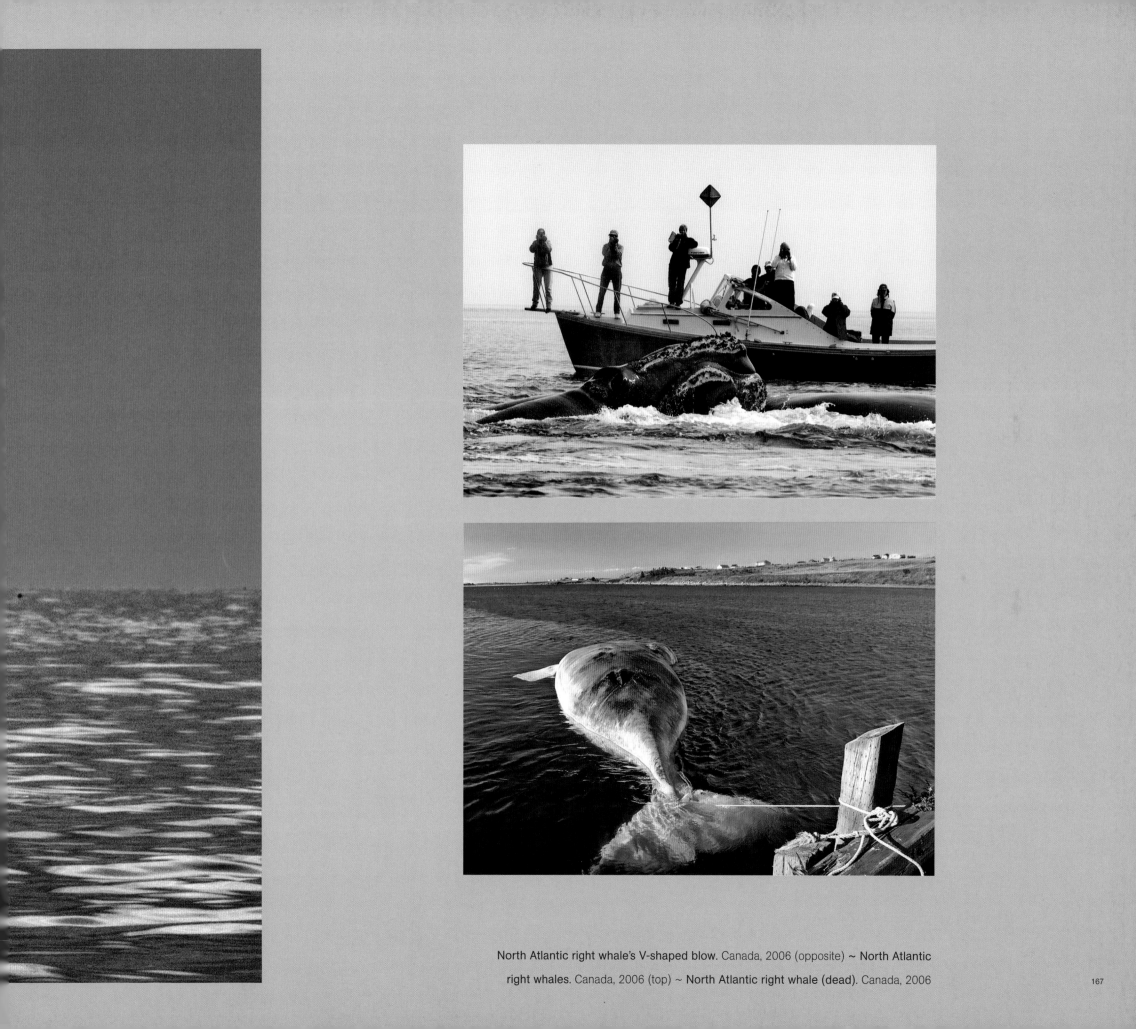

North Atlantic right whale's V-shaped blow. Canada, 2006 (opposite) ~ North Atlantic right whales. Canada, 2006 (top) ~ North Atlantic right whale (dead). Canada, 2006

Right Whales

and able to read us in ways that we cannot yet fully understand. These whales easily could have stayed away or left me rolling in their wakes, but instead they chose to interact. They did this repeatedly—not only for a few moments, but sometimes for hours. On one of our last days in the Auckland Islands, I asked Mauricio to dive with me. I wanted to make a photograph showing a whale with a human near the ocean bottom. From *Evohe*'s forward deck that morning I scanned the surrounding waters for whales but couldn't see any. The sun was shining, clouds were building, and the wind was freshening, and I worried that conditions would deteriorate to the point where we would have to scrap the day. Bundled up in layers of warm clothing, I continued to pace the decks in search of a spout or a fluke, but all was quiet.

Early that afternoon, we finally spotted whales on the horizon. They were a good distance off but still within range, and I wanted to give it a try, so we loaded the inflatable and headed out. When we reached the whales, we suited up and slid into the water. We touched down at a depth of 70 feet, but the sea looked empty. Gazing upward, I spied a single whale slowly moving on the surface.

Hoping to catch the whale's attention, I ascended slowly, venting air from my dry suit and working not to rise too quickly. I broke the surface about 12 yards away, swam for a few seconds, then submerged and slowly drifted downward again. My plan worked. The whale also dipped below the waves and followed me toward the bottom. I landed fairly close to Mauricio, but the whale swam off to the edge of our visibility. We watched the massive, silhouetted form as it moved in the distance, just a few feet over the sandy bottom, then changed course and headed straight for us.

It swam in ever so slowly, coming first to me and then to Mauricio. I moved into position to compose the frame and began shooting. It was a stunning scene—a 45-foot-long, 70-ton right whale hovering over the bottom just a few feet away from a diver standing on the bottom. The three of us then began swimming in unison across the seafloor as I directed Mauricio into the optimum position for photographs and the whale simply cruised slowly. I was shooting rapid fire and swimming hard, with at least 80 pounds of equipment on my body and a bulky dry suit. At some point I stopped and kneeled on the sand to catch my breath, and I was certain the whale

would just keep swimming. Instead, the whale also stopped, turned, and hovered over me as it stared with that soulful eye. A few seconds later, I resumed swimming alongside the whale, making pictures, and savoring every second.

After more than two hours, the whale found another whale, and together they swam toward the surface in what appeared to be an act of courtship. With the clouds now very thick in the sky and the wind blowing harder, Mauricio and I pulled ourselves onto our little boat. We were cold and tired and at a loss for words. Later that night, next to the flickering flame of the stove in *Evohe*'s salon, we sipped a glass of scotch and reflected on the experience we had shared. The researchers with us speculated that these whales had never seen a human being before, certainly not underwater. And so, I thought to myself, this is how whales behave with humans when they've had no bad experiences. This is how it was meant to be. ~

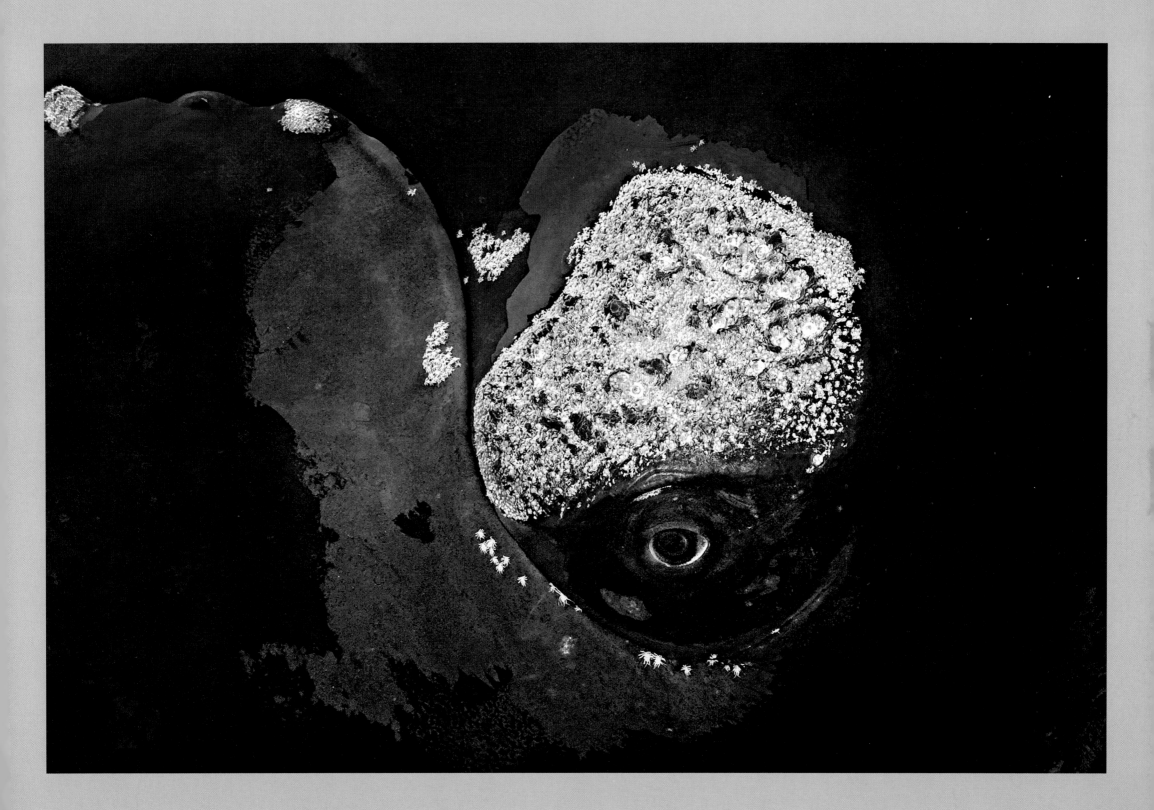

Southern right whale eye. New Zealand, 2007

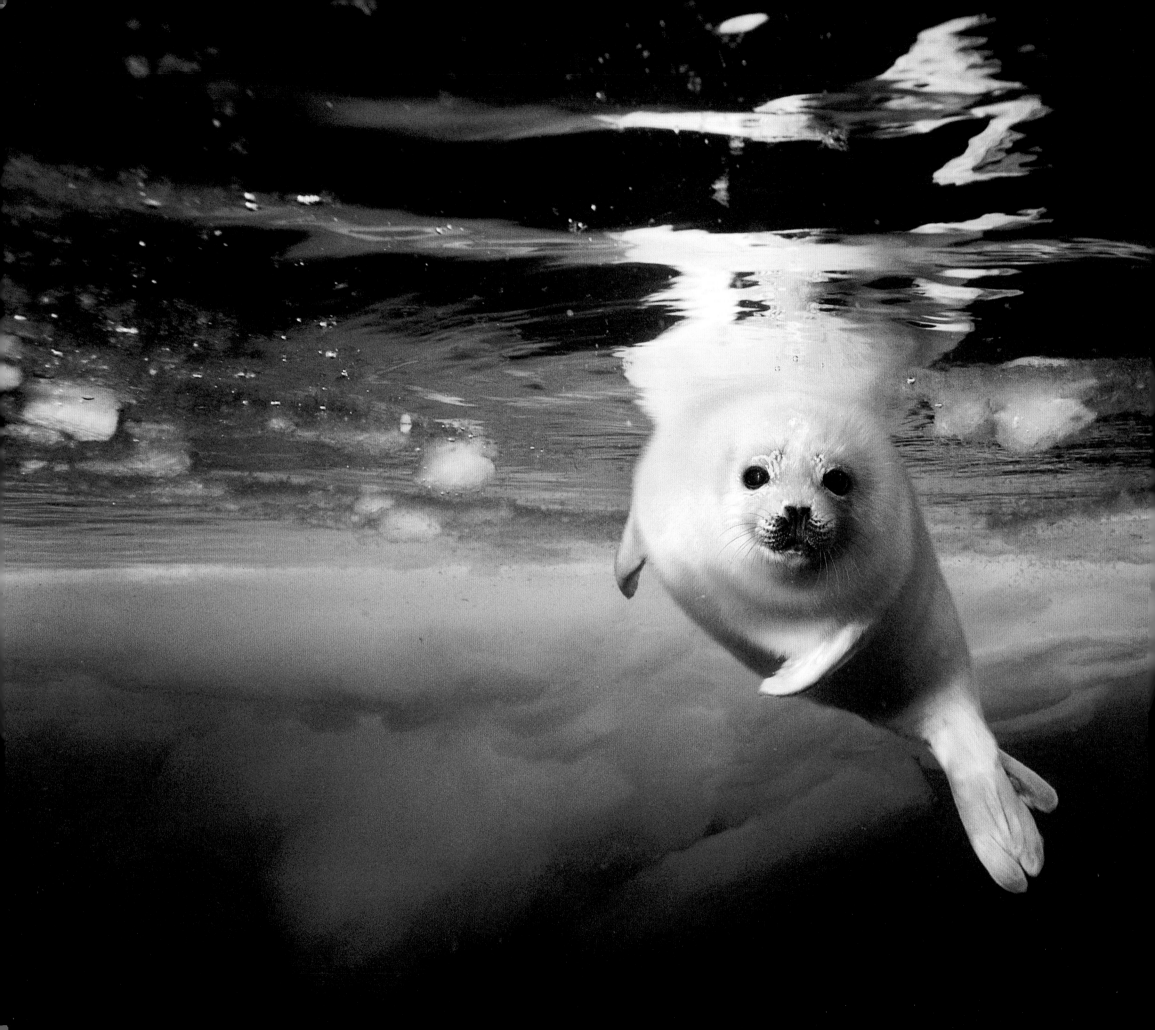

Cold Waters

Harp seal pup. Canada, 2002

Cold Waters

Human beings have a special bond with water. Even before our birth, we live immersed in water for nine months. This innate connection to water remains an integral part of many of our lives. Though warm waters may soothe and comfort us throughout our lives, we do not generally hold cold water in the same regard. As outside temperatures fall below our body temperatures, the normal reaction is to begin putting on layers and to bundle up, not to jump in the water. Cold waters are hostile and unforgiving places for humans. They can be painful, and even deadly, if we do not prepare for them properly. Yet despite being inhospitable, cold waters hold some of the greatest wonders on the planet. They are galaxies of strange seascapes and wonderful creatures, and they are far less traveled than waters of warmer climes.

I can't really explain why, but I have always been attracted to cold water. Perhaps it is the perception that cold, frozen places are pristine, or maybe it's the sense of discovery that I feel knowing that few divers ever explore such places. Or I suppose it might be a touch of Viking blood that mixed with my Irish ancestors long ago. Whatever the reason, I find myself drawn toward icy waters. More than a decade after becoming a diver, when I finally had enough money to travel for photography, my first wildlife trips were to places like the Norwegian Arctic and Canada, and I dived in these cold netherworlds in search of animals that stirred my imagination.

My first experience with truly cold water happened when I was about 18 years old and began ice diving near my home in Massachusetts. I would drive to local lakes, shovel off the snow, and use a chain saw to cut through ice that was often more than three feet thick. Once I removed the triangular ice block, I would sit on the edge with my feet in the water, adjust my gear, and slide into the hole. In those days I wore a wet suit and would often spend more than an hour under the ice. Holding on to a thick line that was clipped to my torso, I would venture off toward the bottom in search of signs of life in these winter waters. But it was the ice that interested me most, and I spent most of my dives sliding along its smooth undersurface.

During my college years I often dived beneath the ice to find cars that had been dumped into quarries. Some were stolen cars; others were vehicles dumped for the insurance money. I worked with police departments by getting the VIN numbers on windshields so the cars could be traced. Sometimes I also removed parts, such as tires and wheels, and sold them—a rather unique way of helping pay for my college tuition. Diving under ice with a wet suit was cold, but when you are 18 or 20 years old, you tolerate it better. Getting out was the coldest. Stripping out of my wet suit while standing in the snow and dressing in warm clothes was something I learned to do in seconds. It was all great training for what was yet to come.

My work as an underwater photojournalist is driven by story ideas. Almost every story I have photographed for *National Geographic* magazine originated as an idea about a place or species of animal that I wanted to photograph or about an issue I believed needed to be covered. Then I'd figure out how I could tell the story. Telling stories about cold-water places and creatures has always had tremendous allure for me, since cold-water regions, with the exception of the deep ocean, are the least explored and, as such, offer immense potential for images that have never been seen before. Polar and subpolar regions remain some of the last true frontiers in diving. Since few divers venture to such places, very little infrastructure exists, so you often have to bring everything with you, including air compressors and tanks. Just getting to remote, cold-water regions is a logistical

challenge, and if something goes wrong, you are pretty much on your own.

The first location in my story "Three Degrees of Japan's Seas" was Hokkaido in northern Japan. I was based in a small fishing village on the Shiretoko Peninsula during February and March, when ice covered the Sea of Okhotsk. My very first dive was from a snow-covered beach. I waded into the water, pushed aside thick chunks of ice, and submerged. I had decided to use a new regulator on this dive, although testing new equipment on a dive like this is something I rarely do since I'd rather use gear I know will work. But this regulator was specifically designed for use under the ice, so I gave it a try.

I swam along the gravel bottom, followed its contours deeper, then ascended off the bottom toward the ice pack overhead. Shafts of sunlight stabbed the water through cracks in the ice, and I began making photographs of the icy formations. I was perhaps eight minutes into the dive when my regulator began to free-flow. The cold water had frozen some mechanism inside the regulator, and air was escaping uncontrolled. It was not a "full on" free flow that would have emptied my tank in a couple of minutes, but it was serious enough. I was about 400 yards offshore and had to get back as soon as possible. If I lingered or if the free flow worsened, I would be stuck beneath the ice with no air. Staying close to the surface, I navigated through the ice to shallow water, found some loose ice near shore, pushed the ice aside, and made my exit onto the beach. I replaced the new regulator with my old standby and dived for the next three weeks without incident.

Diving in cold water is harder than diving under any other conditions. It's harder on equipment, and it's harder on your body. I have long since passed my college days. These days, when diving in cold water, I wear a dry suit with attached boots and gloves and a neck seal that keeps water out. Underneath my dry suit I wear different layers of thermal garments depending on water temperature. My scuba tank pumps air inside the suit, which adds an additional layer of insulation. On long or especially cold or deep dives I sometimes use a separate suit inflation bottle filled with the inert gas argon, which prevents warmth inside the suit from dissipating as quickly as it does with air. When diving beneath ice I typically wear two separate hoods. The first one, called an ice hood, covers my head and face and has openings for only my eyes and mouth. The second hood leaves a portion of my face exposed but protects my entire head and neck. On my hands, beneath the dry suit's rubber gloves, I wear heavy mountain-climbing glove liners.

All of this equipment is bulky and cumbersome. I have to add substantially more weight than when I dive with a wet suit—sometimes more than 40 pounds. Add in a scuba tank and all the other equipment, and I am carrying more than 100 pounds on my body. In Japan, I did much of my diving from a protected little beach in the town of Rausu. My guide was a local dive shop owner named Seki-san, who knew these waters well and was also an expert ice explorer. On the beach he built a small wooden hut with a wood-burning stove in the center and a diving locker on the side. Each morning I would dress in my gear in the dive locker and make sure every piece was fitted properly. Then, looking like some strange combination of the Michelin Man and Godzilla, I'd walk toward the water's edge, pick up my camera housing and fins, and wade into the water. Between dives I would thaw out next to the fire, sip a cup of tea, and eat lunch.

Most dives in cold water follow a similar pattern. I usually start out feeling warm, and then I get a bit of a chill several minutes into the dive. The chill wears off as I move around but eventually returns. And when it returns, it is an adversary I battle

until the dive is over. One thing I have noticed over the years, however, is that to some degree, cold is as much mental as it is physical. When I am underwater and completely engrossed in photographing an interesting subject, I rarely feel the cold. When the subject is no longer there, my mind returns to the cold, and it's hard to shake off. In the waters off Rausu, there was plenty to occupy my mind.

My dives off the beach focused primarily on benthic creatures—animals that live on the ocean bottom. Many of these animals were similar to those I had seen elsewhere, yet they were oddly different. On the sandy sea floor near a thicket of kelp, I spied a fish called a barbed poacher, which reminded me of a sea raven or gurnard but had a bizarre, swordlike feature for a nose. A baby king crab looked much like other crabs I had photographed, but this one had spikes lining its bright orange body, so that it reminded me of a rubber stress-relief toy. Crawling over an equally spiky black-and-white sea star, this crab, about the size of a nickel, would grow to become the size of a truck tire in the coming years. A few feet away from the crab lay a brilliantly colored sculpin. Trying not to disturb this resting fish, I inched my way toward it over a period of perhaps 15 minutes. I purged air from my dry suit so that I would not float and crawled slowly across the bottom while my body ached with cold. I was intrigued by the sculpin's color pattern—a mosaic of reds, yellows, and browns—and framed an image of its eyes that stared upward at me, no doubt trying to make sense of this ungainly, bubble-blowing beast that had come in for a look.

When not diving off the beach, I dove farther offshore from a boat. Out here Steller's sea eagles hunted for herring among the ice packs and seals drifting on floes. The ice canopy was thicker in these offshore waters, and I was fascinated with the shapes and colors that formed overhead. I swam with Seki-san and Mauricio far into the ice and then dropped down deeper to compose images of my companions aloft. The scene through my viewfinder was a sky filled with frozen clouds. Algae living in these frigid waters gave color to the ice that morphed from green to blue to yellow. Shadows and light were ever changing, and the divers looked as if they were floating and falling from this frosty heaven above.

The water offshore was deep, at least several hundred yards, and safety was always on my mind. Should one of my gloves pull off from my dry suit, water would pour in and fill the suit in seconds. Although I was wearing a buoyancy compensator that was capable of providing enough lift to offset a flooded dry suit, it would be close. The notion of exiting the ice and swimming back to the boat while fighting to stay afloat was unnerving to say the least. Add in the fact that the water was 29°F, and a flooded suit became deadly. Note to self: Don't loose a glove.

As with the benthic region, the water column and zone just beneath the ice was alive with animals that had evolved to thrive in this freezing corner of the ocean world. The creature I most wanted to photograph was a species of pteropod known locally as a clione or sea angel. This tiny winged sea snail can sometimes be seen flying beneath the ice. About the size of a Tic Tac, it moves through these icy waters and feeds on its relative, another species of pteropod known locally as the my-my. Adjusting my buoyancy to float a few feet beneath the ice, I swam along until I sighted a clione. Its tiny body was translucent with shades of blue, red, and yellow glowing from within. Keeping the flying sea angel in my viewfinder was a challenge as I added and purged air and kicked gently to compose the perfect frame. As I followed it for more than an hour, I watched it sometimes diving deeper and sometimes disappearing behind chunks of ice. Focusing was tricky given the

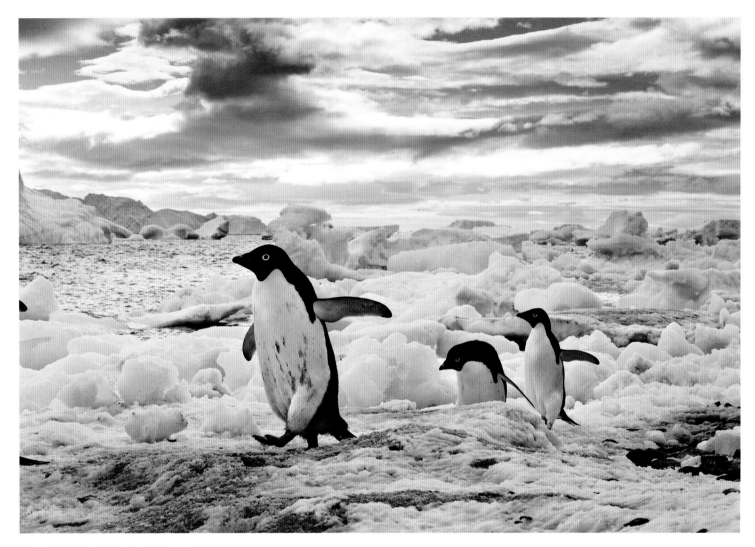

Adélie penguins. Antarctica, 2010

My senses were on overload . . . as I photographed whales, seals, and penguins. Mountains and wind-sculpted ice provided the backdrop, with enchanting light always flattering this dynamic landscape.

Cold Waters

loss of dexterity from my thick gloves. With my fingers numb and my hands in pain, I gave up the pursuit, turned around, and kicked back to the boat.

Following a tiny animal for more than an hour in 29-degree water requires determination or, perhaps more aptly, stubbornness. But wildlife photography is all about being patient—to find my subjects, to wait for good visibility, and to achieve the perfect light. So many times over the years it would have been easier to quit, to just say, "I've had enough," but patience and a refusal to give up are what make the difference between failure and success. Perfection is rarely achieved without many attempts.

Patience and perfection come with a cost, however. Traveling for eight or nine months out of the year takes its toll, and loneliness is a familiar companion on almost every trip. To some, my work might seem like one long, endless vacation in which I travel to exotic locales and live out romantic adventures. The reality is far less romantic, of course, and on those days when nothing is going right and I am in some faraway place, my mind starts to wander. While I have been lucky to be accompanied by great assistants who were also wonderful friends, I think about all that I have missed at home with my family and wonder how my life would be had I pursued a more conventional course.

I sometimes think that an ideal solution would be to have my family join me on assignments, but I realize this alternative is impractical and would, in most situations, detract from my work. Living on boats or in desolate locations and working 18-hour days does not make for fun family vacations. And I have also learned that having fewer people around is generally best for my work. The photographic results that are produced from months in the field each year happen because of the intense focus of a small team—essentially just my assistant and me.

Still, the burden of success rests with the photographer alone. Overcoming problems and frustrating conditions simply goes with the territory. My feelings of isolation usually fade quickly enough, particularly with the inspiration I find in my surroundings and with the knowledge that beautiful, important, and even world-changing pictures can be made as long as I persevere. I spend many months making pictures in the field each year, because that's what it takes.

Few places on Earth are as inspirational as Antarctica. There is grandeur to this continent on a scale that is unrivaled, and to journey here is to behold sights that words can barely describe and photographs only begin to reveal. I yearned to go there for decades, even before I held my first camera. With a three-week expedition to the Antarctic Peninsula in 2010 I finally arrived, yet all that I saw and experienced only whetted my appetite for more. My senses were on overload from morning until night as I photographed whales, seals, and penguins. Mountains and wind-sculpted ice provided the backdrop, while enchanting light always flattered this dynamic landscape.

Exploring underwater in Antarctica, as in all truly cold-water realms, requires careful preparation. I always donned my thermal undergarments and dry suit on board the expedition vessel and carefully adjusted my gloves, boots, and double hoods so that I wouldn't encounter any problems underwater. We would then load tanks and cameras into the Zodiac and motor off to the dive sites. Most days it was overcast, and as we traveled along waves splashed over the bow and the water froze wherever it landed. My face was the only part of my body that was exposed to the air, and it quickly grew numb in the cold wind and spray.

My first dive was at the site of an abandoned whaling station. Floating in the water next to the small boat, I grabbed my camera,

pressed the exhalation valve on my suit, and submerged. Visibility was poor, no more than ten feet, and my eyes strained to see something, anything, as I descended through the dimly lit void. I settled down at a depth of about 25 feet on a bottom that was strewn with small rocks and kelp. My dive partner, Lisa Trotter, who had dived here in the past, said we'd find a gently sloping bank that we should follow to reach a depth of about 40 feet, where we might find old whalebones. As I cruised downward, I pumped a little air into my suit to compensate for the compression of depth and to keep from touching the bottom, which had changed to mud. I didn't want to create billowing clouds of silt that would completely obscure our surroundings.

As the topography leveled off, I moved slowly as I searched for photo subjects and kept an eye on Lisa's dive light in the darkness, just at the edge of my visibility. Within just a few minutes, a whalebone came into view. Lying partially buried in the mud, it appeared to be the rib bone of a large baleen whale. I purged a little air from my suit to gain a lower angle for a photo. On another dive at Deception Island, a dormant volcanic caldera that also once served as a whaling station, I found and photographed even more such bones. Large vertebrae, ribs, and other assorted skeletal remains were a somber reminder of what had happened here many years earlier.

Other dives in Antarctica were focused on living creatures. Despite the cumbersome, bulky equipment that made gearing up on the Zodiac more of an effort than usual, I had to smile as I watched Adélie and gentoo penguins swim in the wake of the boat, their tiny bodies acting like a needle that was sewing together sea and air. On one dive in the Ross Sea at a place called Devil's Island, where the visibility was more than 40 feet, I swam alongside a massive chunk of ice that had grounded itself in the shallows. The bottom here was a field of small rocks, and scanning in all directions, I could see no life. I swam over the bottom at a depth of about 20 feet for a few hundred yards and came to a sharp drop-off. Angling downward, I descended headfirst in the hope of seeing marine life, but even at 40 feet, all I could see was bare rock face. I was still in the "scour zone"—depths that get scoured by icebergs on the move. At a depth of about 60 feet, however, the wall came alive—the deeper I descended, the more I became mesmerized by invertebrates that exploded with color. There were sea stars and tunicates, sponges and hydroids. This vertical, lush garden of life was growing in a place that was hidden from most people's view.

Three weeks might sound like a long time, but in this business it is equivalent to a brief visit, especially in a place like Antarctica. I know that I could spend an entire lifetime there and still see only a fraction of what exists. On this frozen continent everything is connected to the sea. Harsh and inhospitable, it is also a galaxy teeming with life and harboring limitless photographic possibilities.

Exploring all cold waters requires effort and presents challenges magnitudes greater than in other oceanic realms. But then taking the road less traveled, as Robert Frost famously observed, makes all the difference. ~

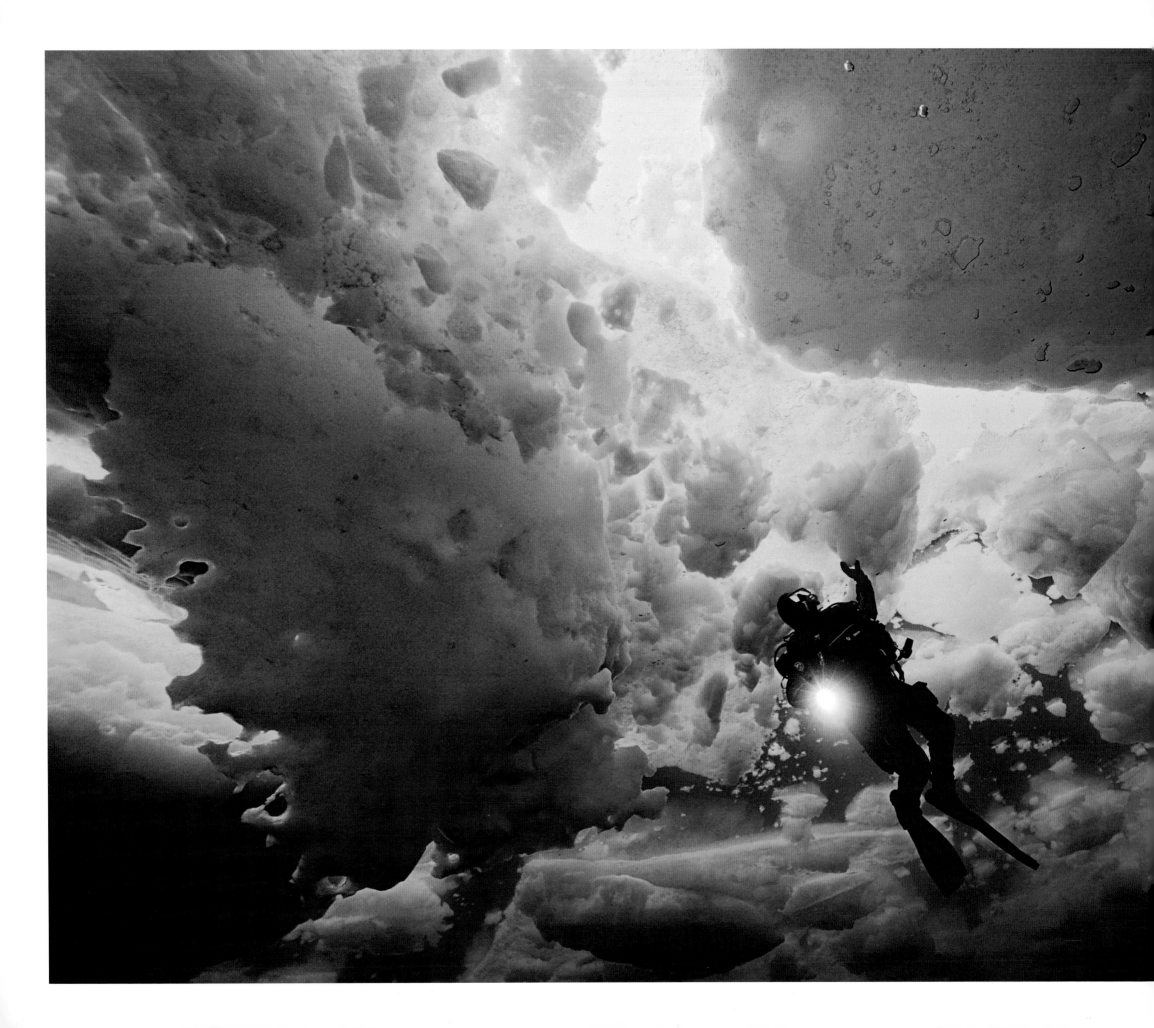

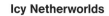

Icy Netherworlds

The frozen seas off Hokkaido, Japan, are a harsh realm to explore, but these frozen seas are anything but bleak. Algae infused within the ice canopy create shades of blue and green. Above the ice pack, sea eagles hunt for prey in water between the cracks. Beneath the ice, which can be as thick as 25 feet, a cold-water universe of life thrives. In the water column, tiny pteropods and gelatinous creatures drift with the tide, while the benthic region stirs with bizarre and colorful fish below. Diving in conditions where water temperatures hold steady at 29°F can be brutal and hard on equipment and people. Venturing into unexplored frontiers is not without risk, yet it is hard to resist the attraction of cold, pristine waters in which wonders bristle on every dive.

Diver exploring ice canopy. Japan, 2008

One thing I have noticed over the years is that, to some degree, cold is as much mental as it is physical. When I am underwater and completely engrossed in photographing an interesting subject I rarely feel the cold.

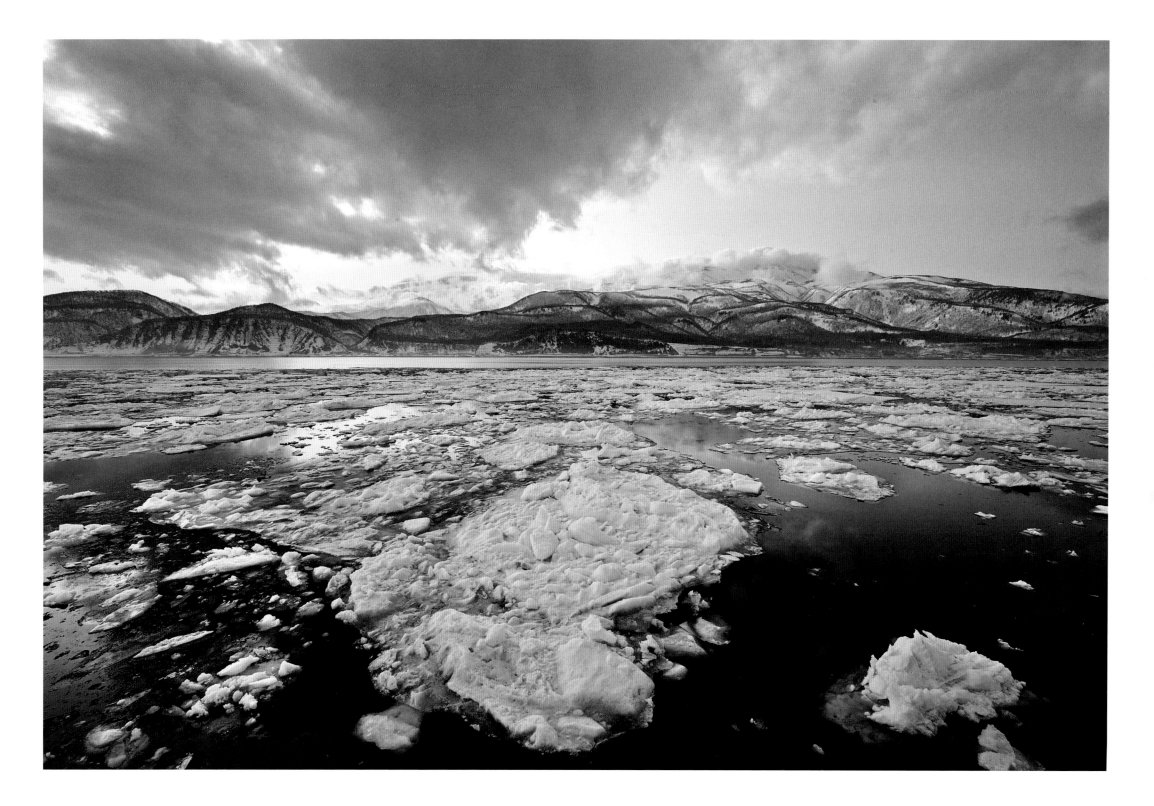

Sea of Okhotsk. Japan, 2008

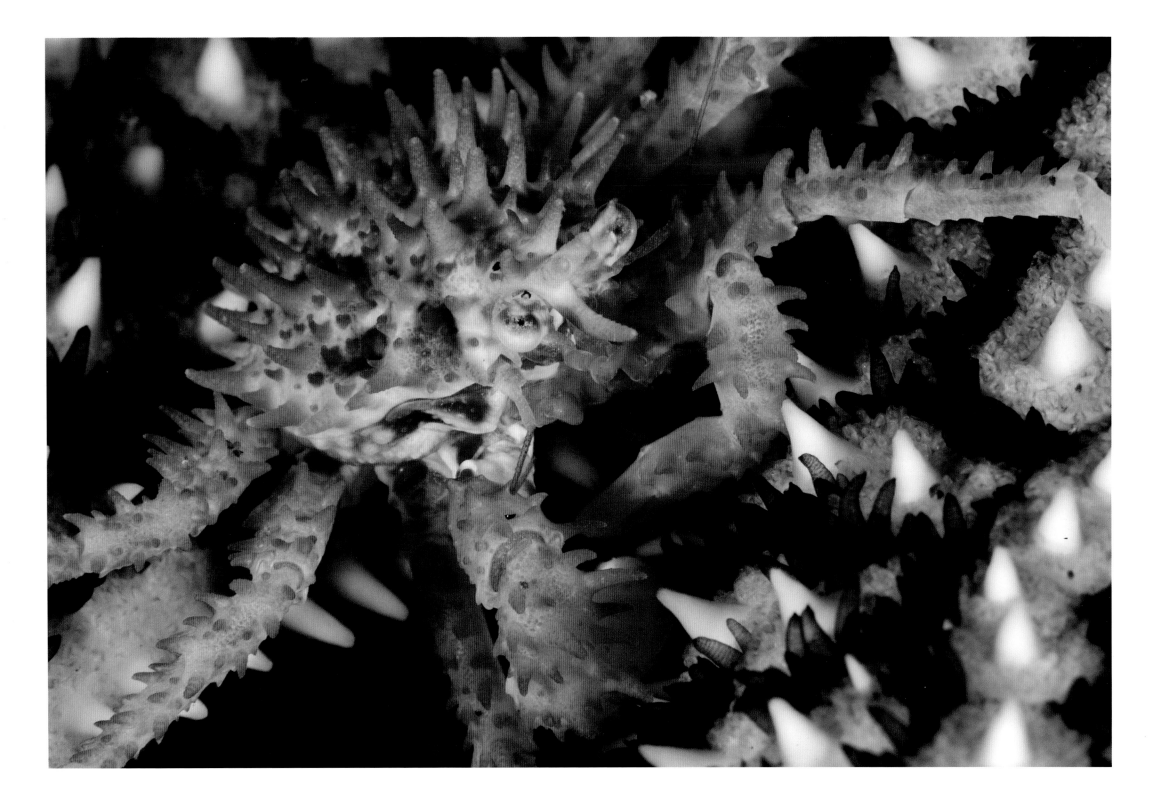

Juvenile king crab. Japan, 2008

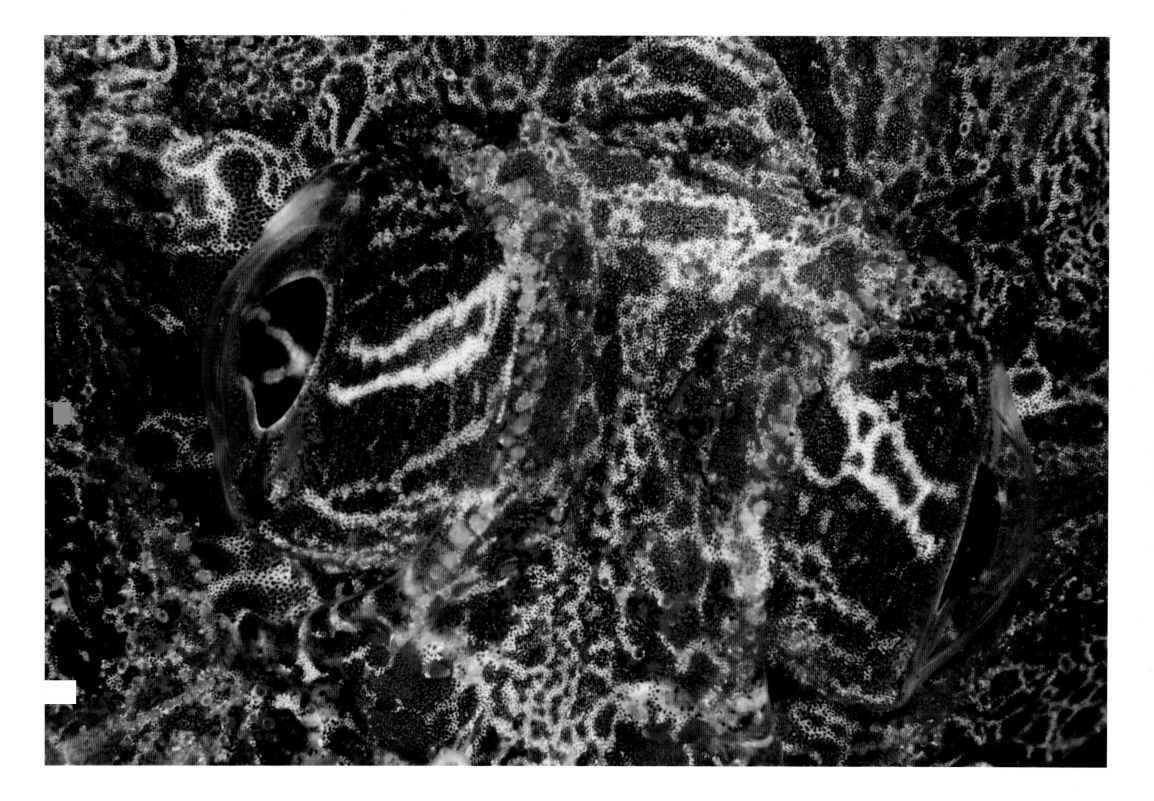

Sculpin eyes. Japan, 2008

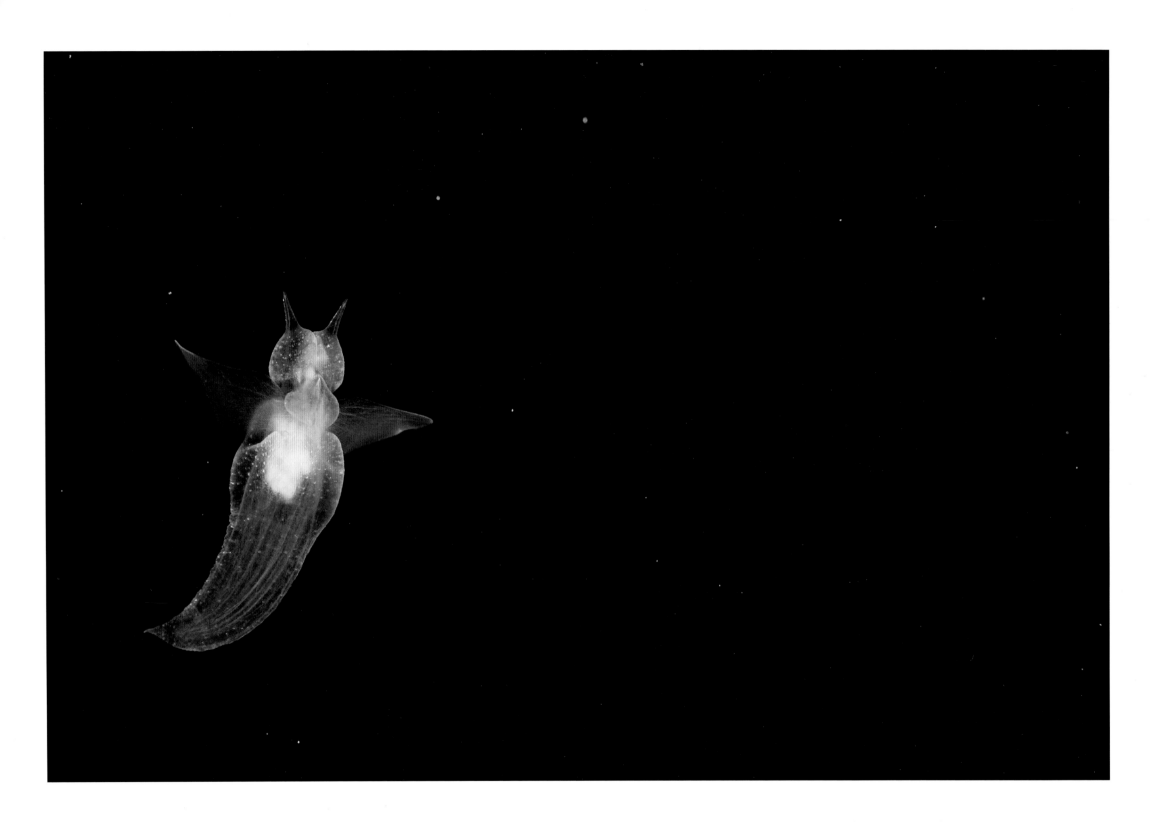

Clione pteropod, sea angel. Japan, 2008

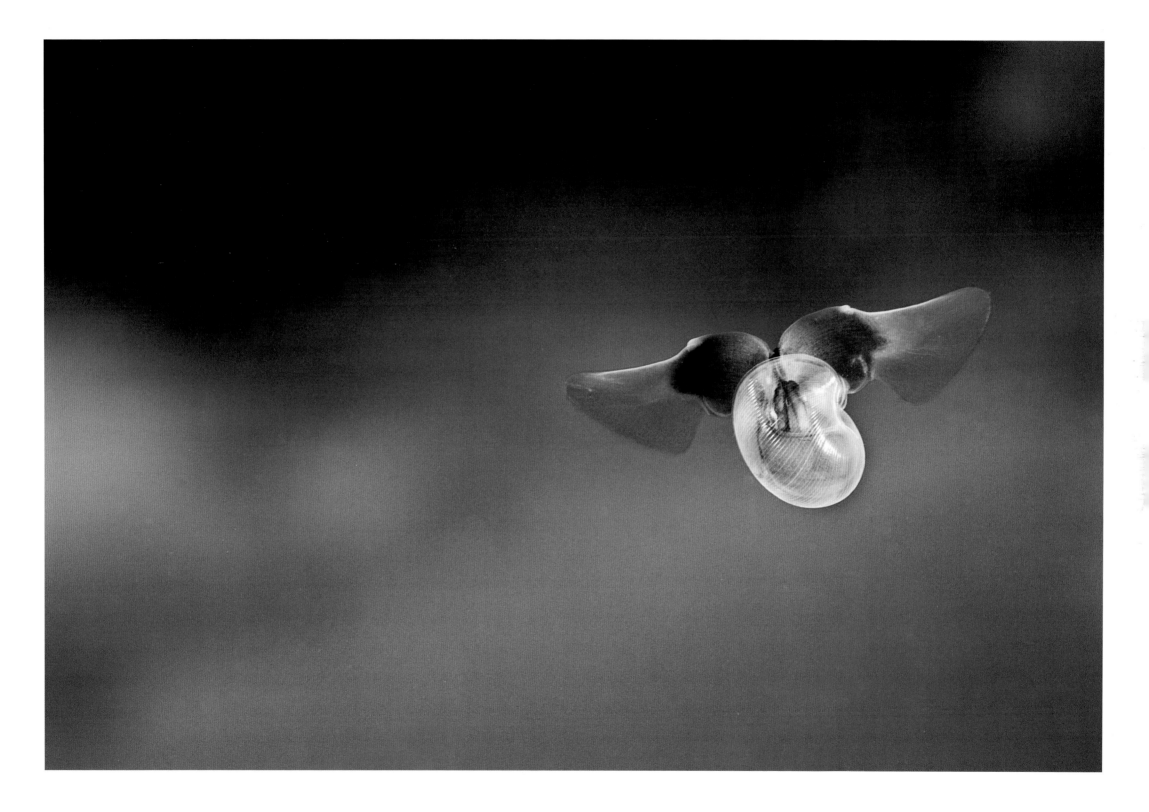

Limacina pteropod, my-my. Japan, 2008

Many of these animals were similar to those I have seen elsewhere yet were oddly different. I spied a fish called a barbed poacher, which reminded me of a sea raven or gurnard, but this animal had a bizarre, swordlike feature for a nose.

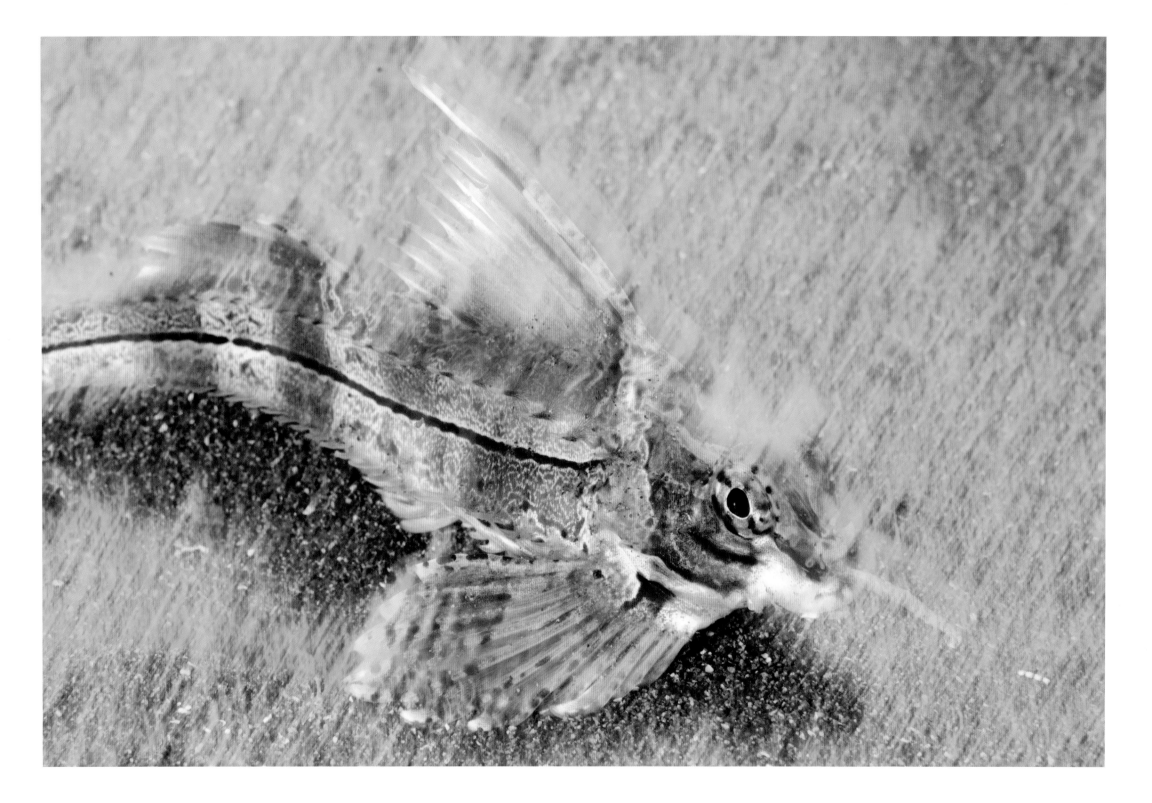

Barbed poacher. Japan, 2008

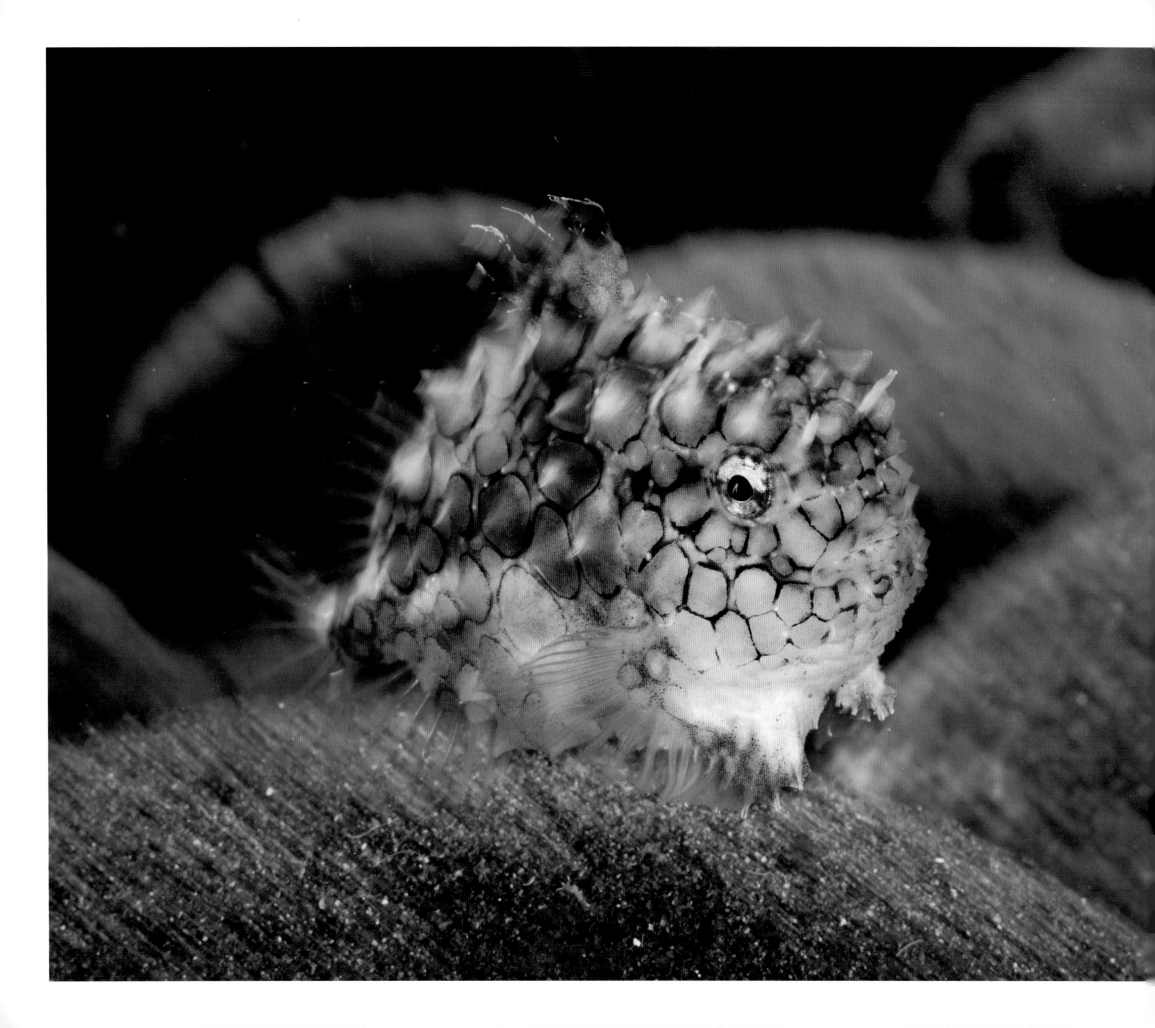

Lumpsucker. Japan, 2008

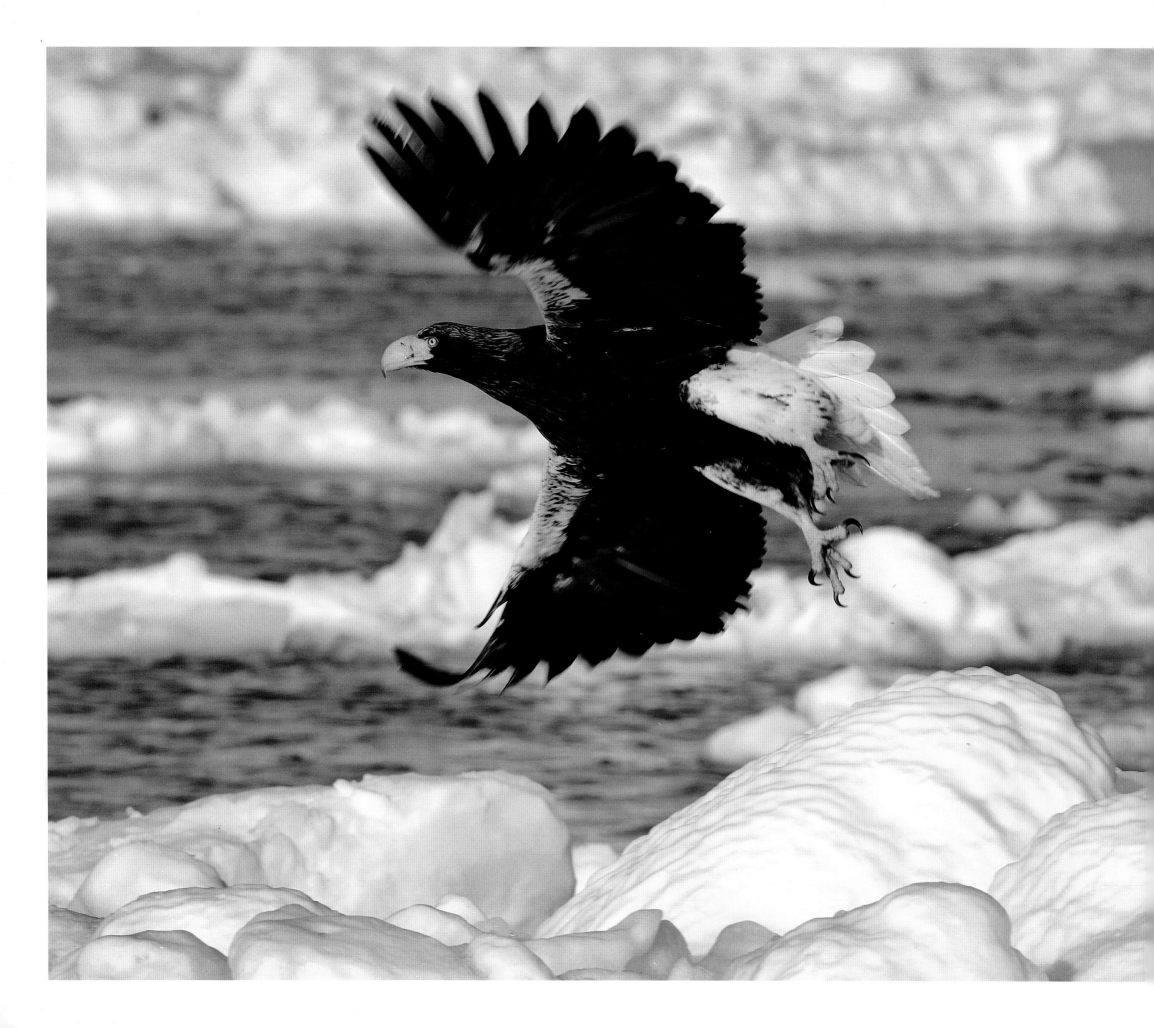

Steller's sea eagle. Japan, 2008

Ocean of Ice

The sense of wilderness in Antarctica is unique, as is the feeling of being in a very remote and special place. Grandeur exists in this dynamic landscape, too, with towering mountains, tabular icebergs, and open spaces that dwarf everything else. Opportunities abound for photographing wildlife around this icy continent, with its abundant animals and long days marked by dramatic light. Polar realms can be hostile and unforgiving environments for people, however. Exploring such places requires effort and presents challenges magnitudes greater than those in other oceanic realms. Yet the potential for discovery is great, and taking the road less traveled often yields invaluable rewards.

Gentoo penguins. Antarctica, 2010

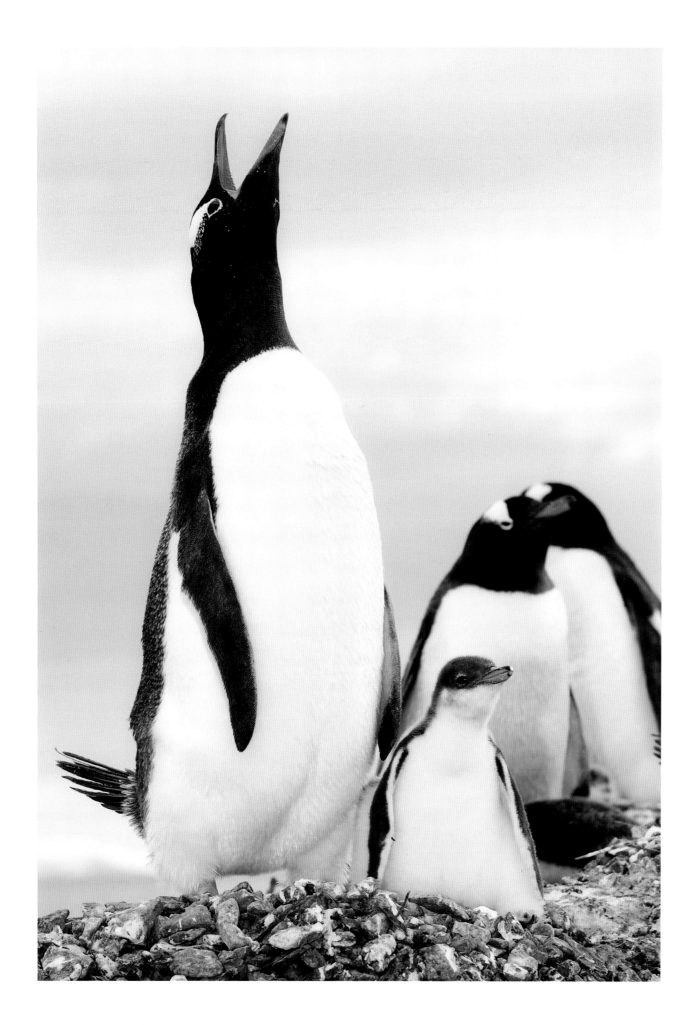

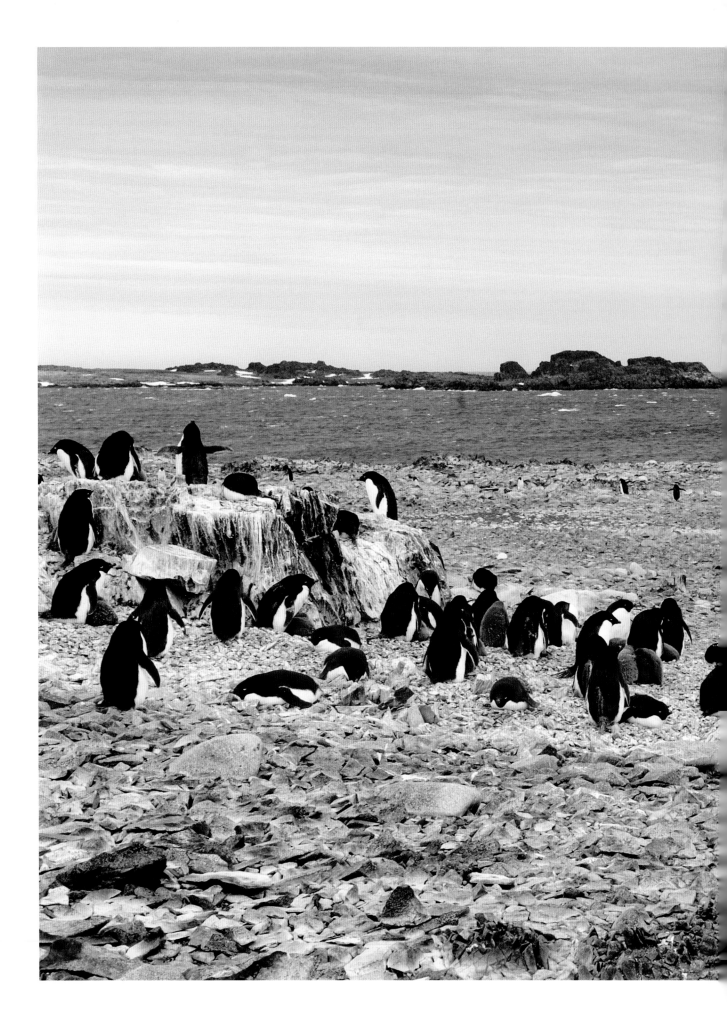

Adélie penguin colony. Antarctica, 2010

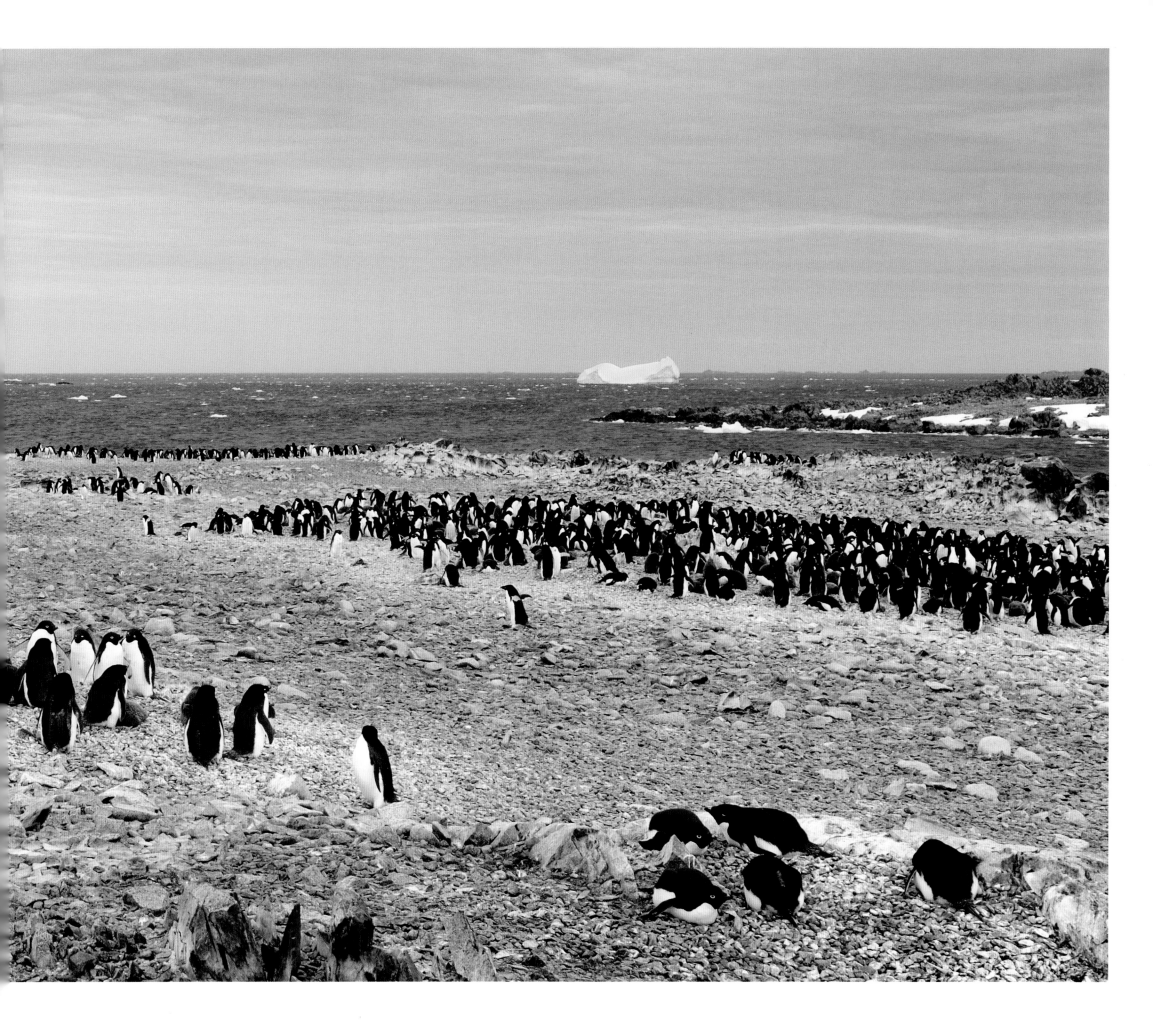

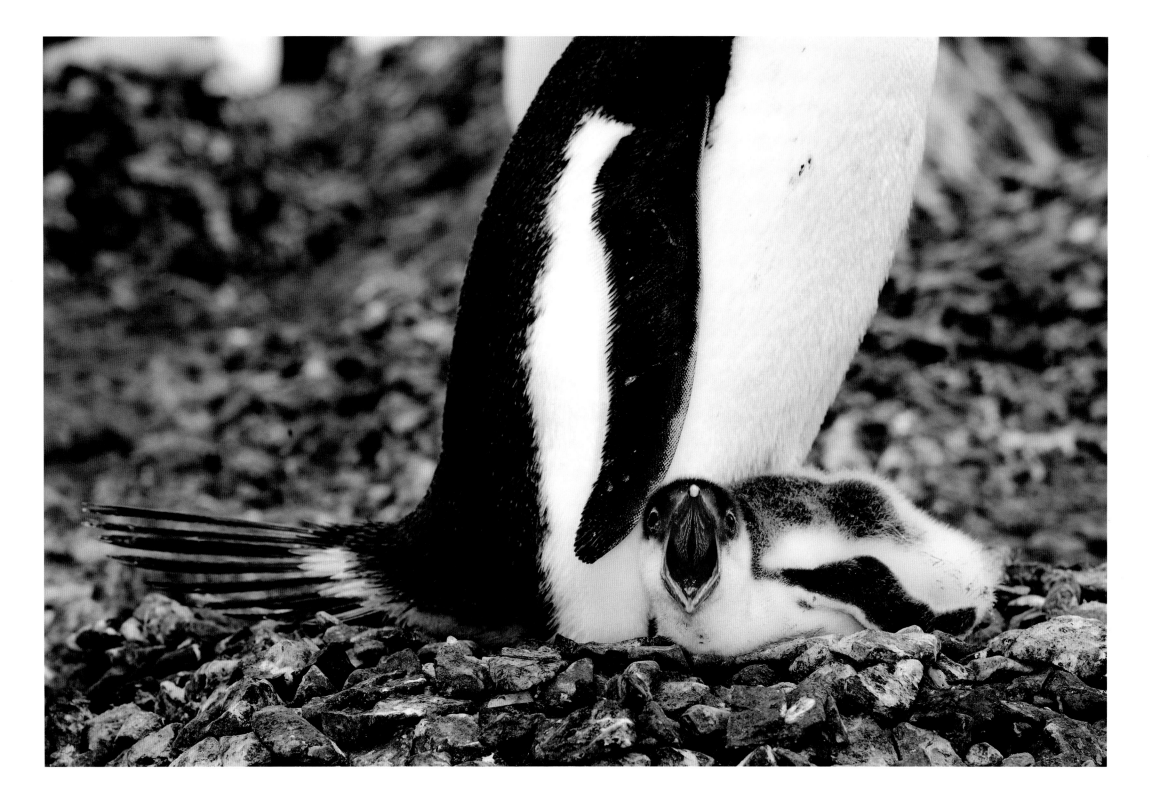

Gentoo penguin chick. Antarctica, 2010

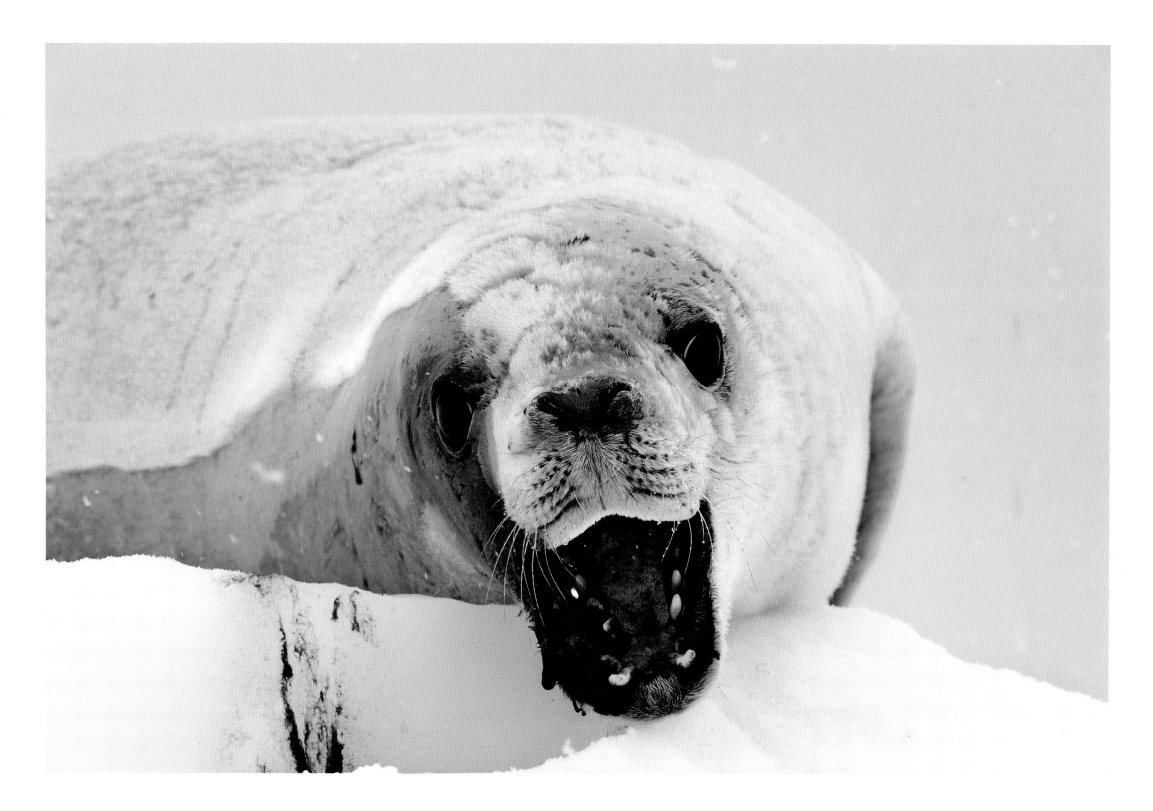

Crabeater seal. Antarctica, 2010

Wildlife photography is all about being patient—having patience to find my subjects, to wait for good visibility, and to achieve the perfect light.

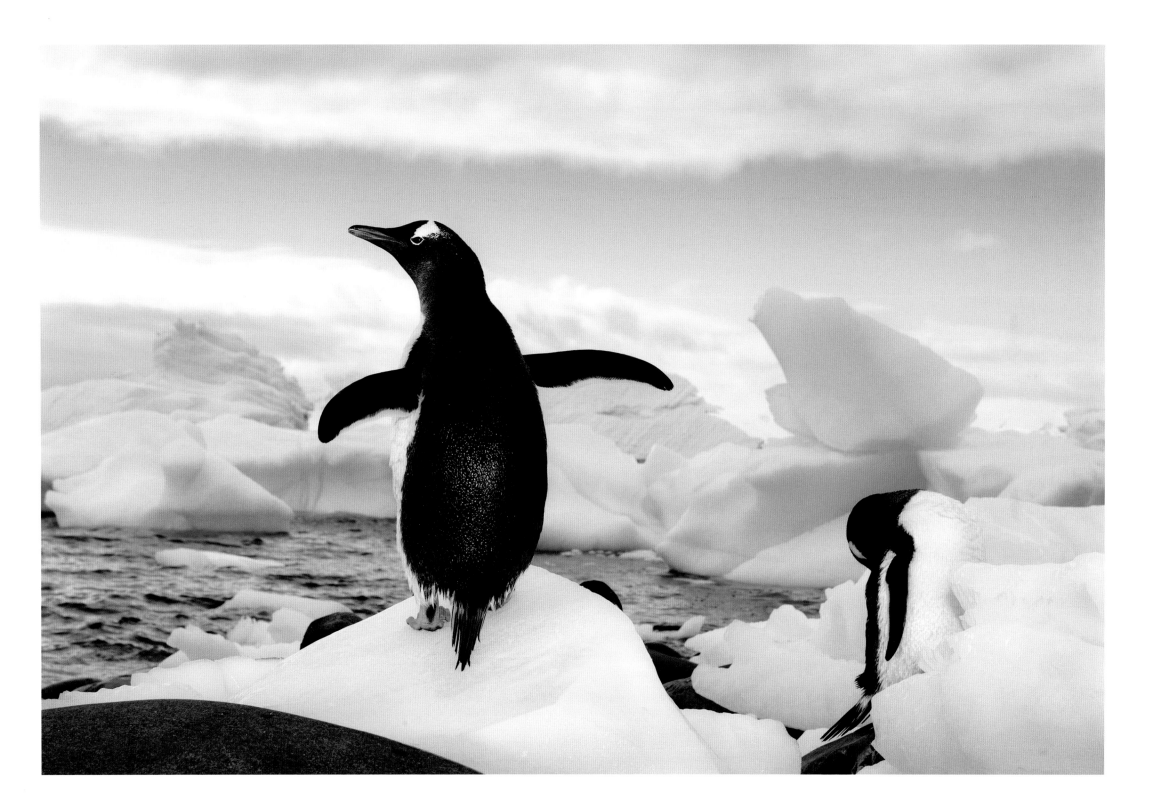

Gentoo penguins. Antarctica, 2010

Crabeater seal. Antarctica, 2010

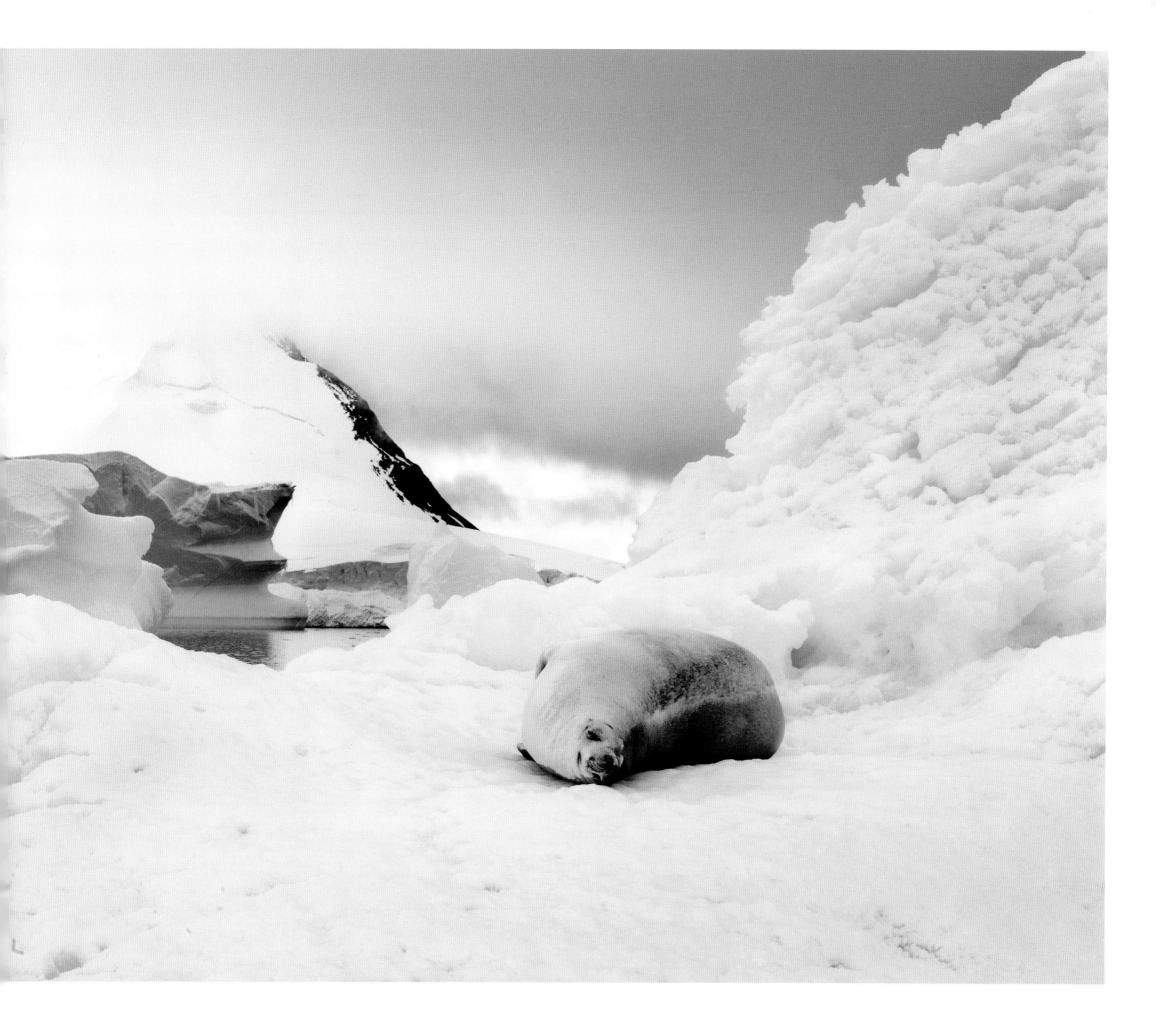

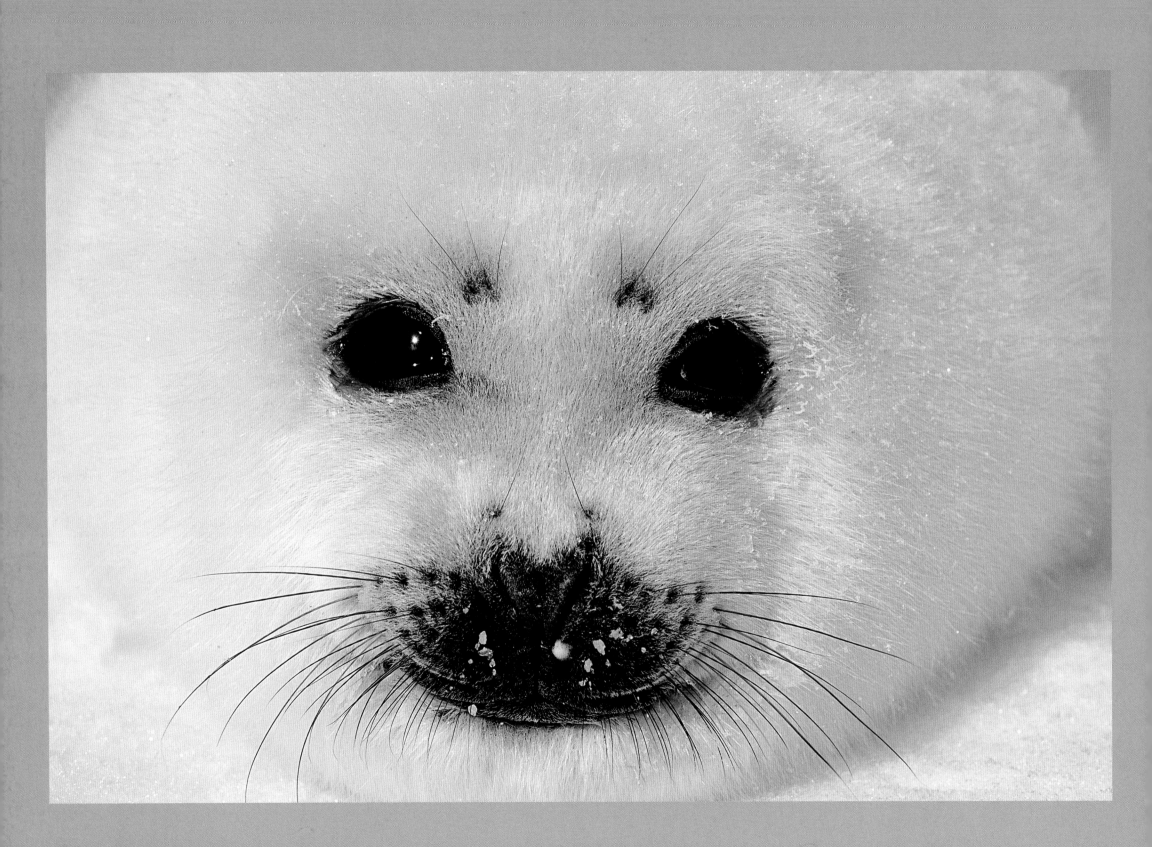

Harp seal pup. Canada, 2002

Harp Seals

It was two o'clock in the morning, and I was sound asleep in my bunk aboard a 65-foot, steel-hulled fishing boat in the middle of Canada's Gulf of Saint Lawrence, when the first mate awakened me. "The captain wants to see you on the bridge," he said. I pulled on my boots and climbed the ladders up to the bridge, where the captain was sitting at the helm and staring outside at a blizzard raging down through the spotlight. Without ever looking away from the snow, the captain said, "The ice is against the hull now, and the pressure will keep building. We'll be crushed sometime soon and will sink, so get into your survival suit and have the satellite phone in your hand when we jump onto the ice."

I ran out to the little wooden shack that we had built on the back deck and surveyed all the photo equipment I had stored inside for my work with harp seals. There were cameras and housings and dozens of strobes. There were tripods, dome ports, and lenses ranging from super wide angle to very long telephoto. Collectively there was more than $100,000 worth of gear in here and no way to save it if the boat went down. I opened a couple of my housings, pulled out the camera bodies, and stuffed them into a bag along with a few key lenses. Back inside the ship, I placed the

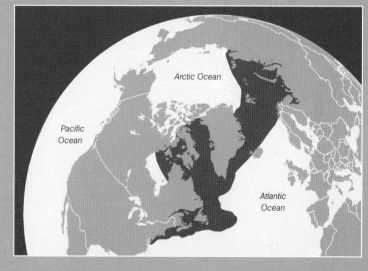
Habitat of the harp seal

camera bag along with satellite phone next to the gallery doorway. This would be our exit when it was time to go.

In the glow of the ship's spotlight I could see only ice all around and heavy snow coming down. Several feet in front of our bow, a massive ice block at least 25 feet square had thrust up through the pack ice like a frozen version of plate tectonics. I felt like I was in the middle of Superman's Fortress of Solitude, but it was more like a castle of tension and fear. The thought of jumping onto shifting pack ice in the middle of the ocean, amid a blizzard at night, was scary as hell. For the next two hours, we sat in our Mustang suits, listened to the wind howl, and waited for the sound of buckling steel.

Although the ice completely surrounded the boat and touched the hull on all sides, the pressure didn't build and the hull never buckled. Sometime after four o'clock, a 300-foot Canadian Coast Guard icebreaker came into view and proceeded to cut a path that we followed for nine hours until we arrived safely back at the dock at Grand Entrée in the Magdalen Islands.

My adventures with harp seals had begun the previous year, when I first arrived in the Magdalen Islands. I was photographing a story, which would look at a brief but important period in the annual life cycle of these animals. Living most of their lives in the Arctic, harp seals migrate to the Gulf of Saint Lawrence for a few weeks each year to engage in courtship and mating. Females, pregnant from the previous year, also come to this place to give birth to their pups. All of this drama is played out against a backdrop of transient pack ice that blankets the gulf and moves continuously with the wind and tide. The story I wanted to produce would offer a rare look into the world of these elusive and endearing animals and the struggles they must overcome from the moment they are born on the ice.

While researching this subject, I learned that previous photographers of harp seals had used helicopters to fly out to the pack ice, to spend a few hours each day shooting, and then to fly back to land. I wanted more opportunities with the seals, though, and I wanted to shoot in better light, so I decided to charter a boat, which would allow me to work from early morning until sunset. Not just any boat would work, however. It had to be a steel-hulled ship, able to navigate through ice, with a captain and crew experienced in these tricky waters. I completed my team with my assistant, Sean Whelan, and also hired expert ice diver and cameraman Mario Cyr, who lived

Harp seal pup. Canada, 2002

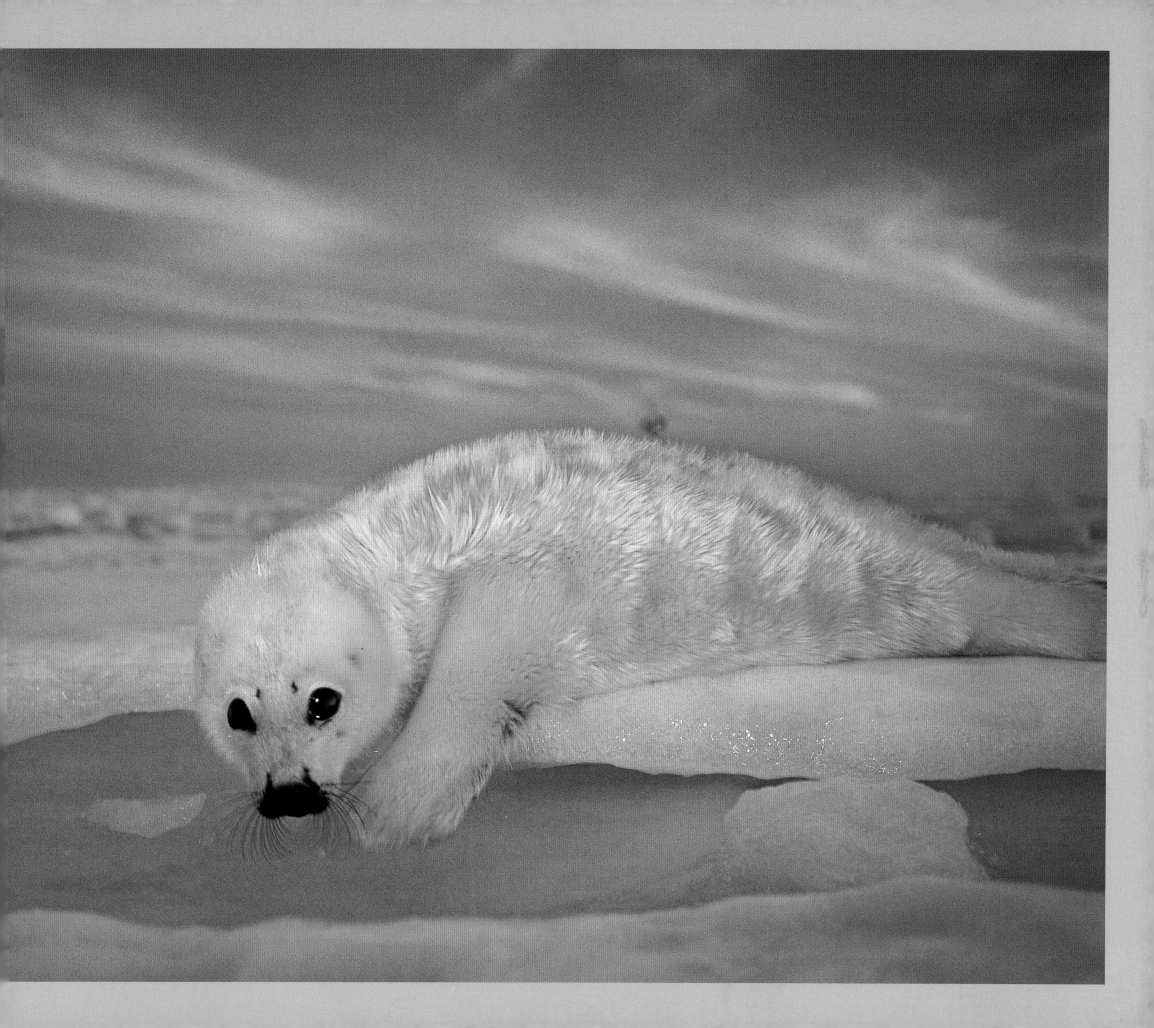

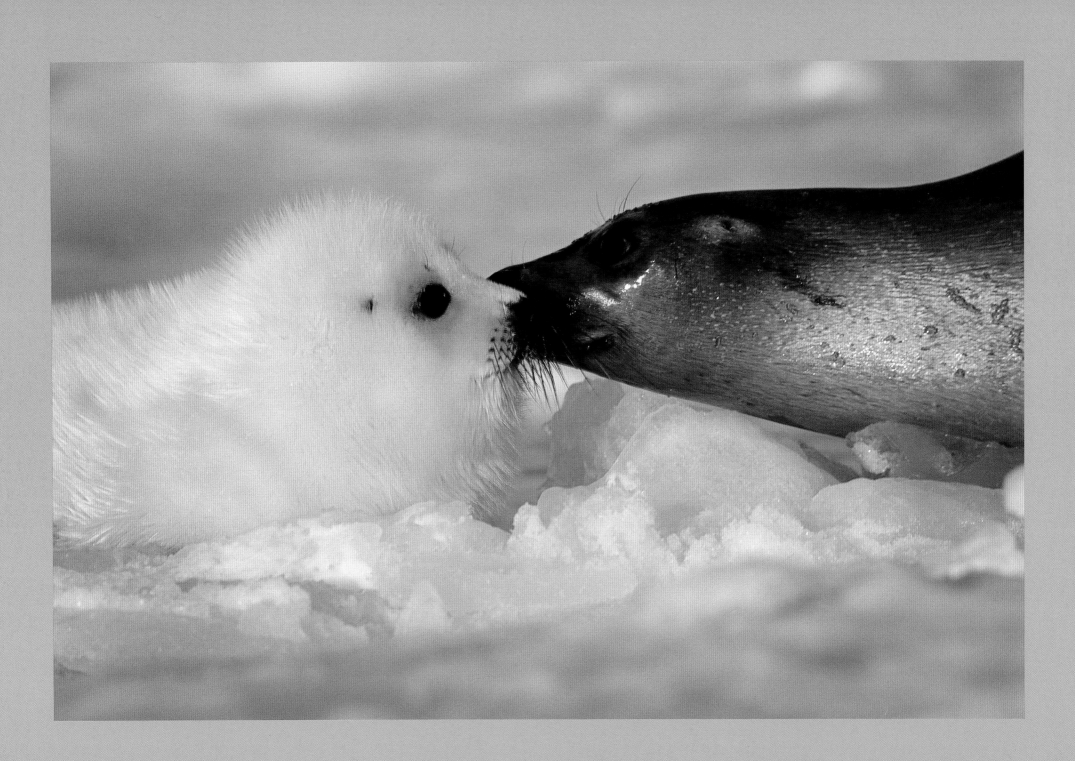

Harp seal mother and pup. Canada, 2002 ~ Newborn harp seal pup and mother. Canada, 2002 (opposite)

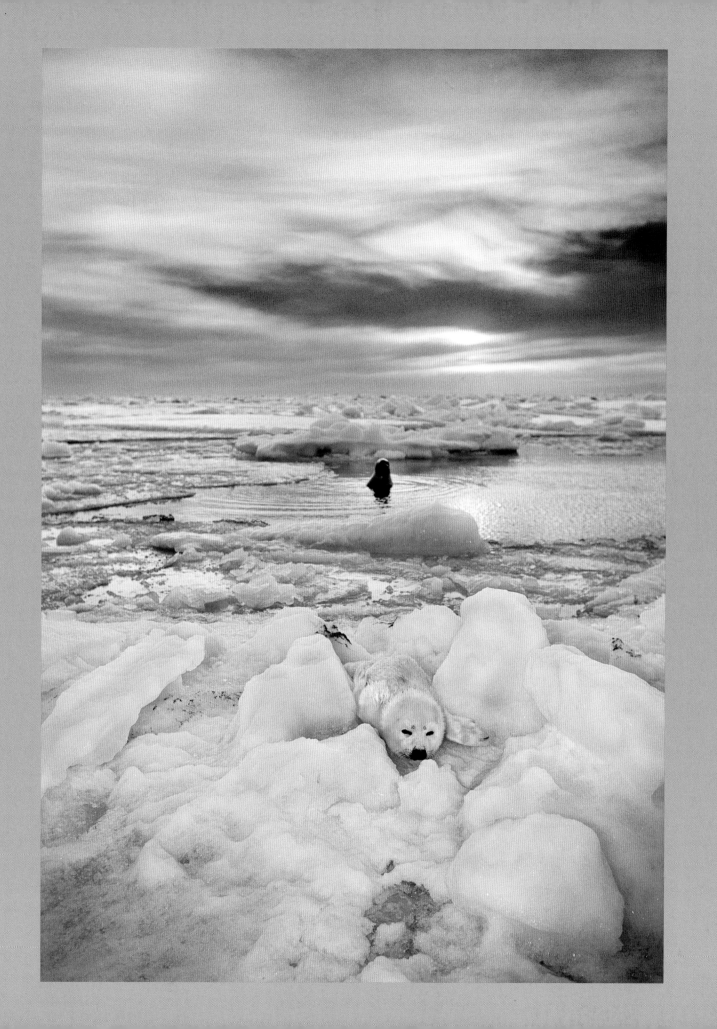

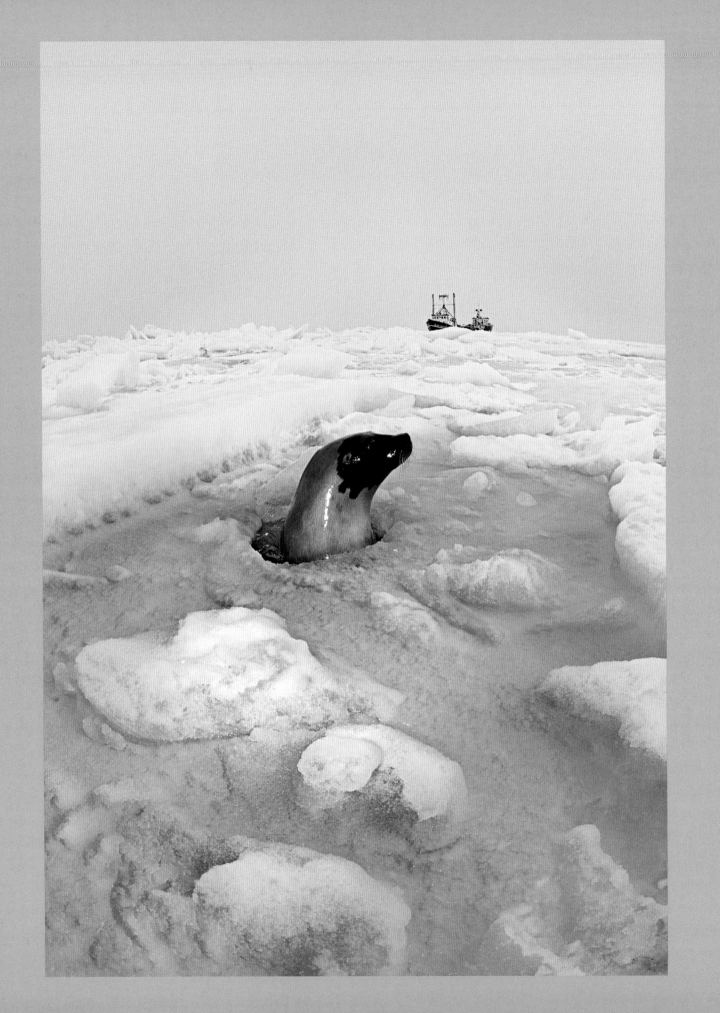

in the Magdalen Islands and knew this territory well. I would stagger my coverage over two seasons in hopes of observing different behaviors.

For 17 days the first season, six of us lived on board the fishing boat and stayed with the seal herd around the clock. Oftentimes we used the boat as a miniature icebreaker, riding up on the thick ice and breaking it, making slow but steady progress as we followed the seals' movements. It was the perfect platform from which to work, and after a few days at sea I settled into a productive rhythm. I would rise at six o'clock in the morning, dress into many layers, and walk onto the ice. Carrying a couple of cameras and tripods, I would photograph the seals for a few hours in the soft, morning light. Then it was back to the ship for breakfast, which usually consisted of eggs, at least four different types of meat, and plenty of hot coffee. Around 10:30 it was time for my first dive, so off with the surface layers and on with the dry-suit undergarments. After the dive, I would either make a second dive right away or shoot on the surface for a while and then dive again. By late afternoon, I was always back on the ice to photograph the seals until sunset. As twilight settled in around us, soaked

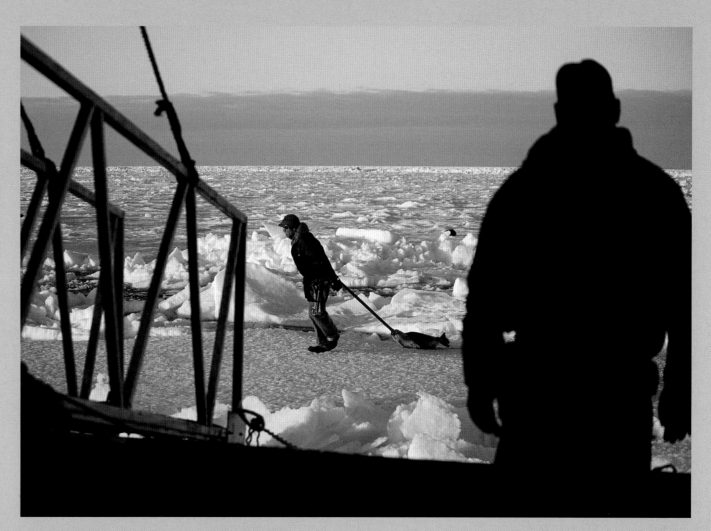

Harp seal hunters. Canada, 2003 ~ **Harp seal.** Canada, 2002 (opposite)

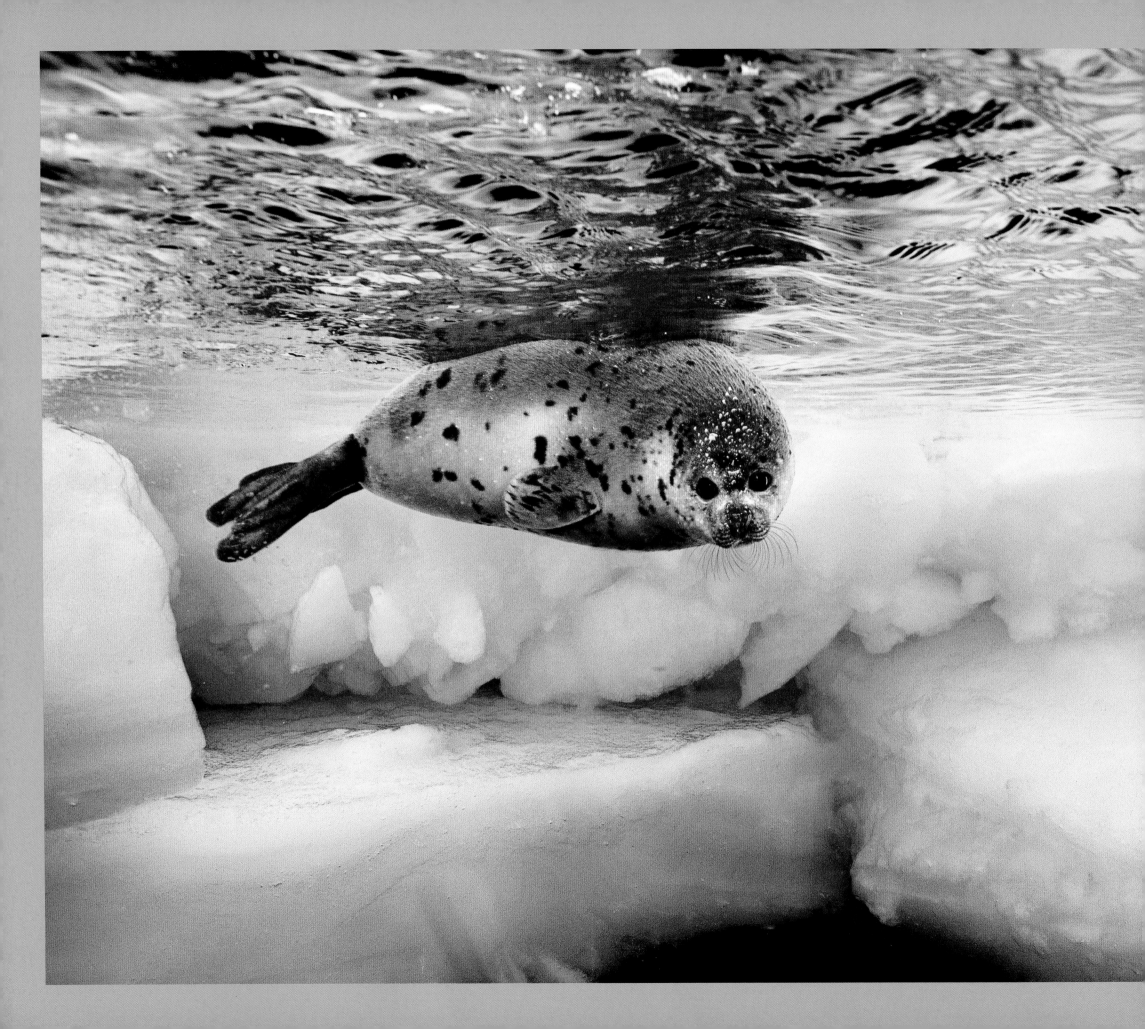

and frozen to the bone, I climbed back on board the boat, pulled off my boots, and listened to the deafening roar of the portable air compressor while Sean refilled our tanks. Lying in my bunk each night, I fell asleep to the cries of pups calling for their mothers in the darkness.

Called harp seals because of the lyre-shaped pattern on the backs of adults, these pinnipeds are true polar animals. Their scientific name, *Pagophilus groenlandicus,* means "ice lover from Greenland," and their behavior on the ice illustrates how they got their name. I found that living with them around the clock in full harp seal immersion was inspiring and addictive in a way that few wildlife experiences have been. The more I saw, the more I wanted to see, and as each roll of film was wound up, I wanted to shoot another. I also loved being far away from everything else. We had a radio on the boat and a satellite phone that I used occasionally, but for the most part it was just the ice, the seals, and me.

Each day I would lie on the ice for hours in temperatures that sometimes dipped to 20 below zero, in winds that reached speeds of 70 miles per hour. My hands would ache and go numb from the cold while holding the camera's cable release,

as I waited for the precise moment when a mother popped up in a breathing hole to check on her pup. I wore ski goggles to shield my eyes from wind and snow, and despite great boots, I didn't feel my toes on most days. The physical pain paled in comparison to the spectacular scenery around me, however. I was on a frozen planet of white and blue ice occupied by striking seals and their fluffy white pups. I had arrived early during the first season in hopes of seeing newborn pups. On one of my very first days I spied such a scene—a golden-white pup only hours old, lying on the ice and stained with afterbirth, while its mother watched vigilantly from a pool of open water behind.

Underwater the scene was vastly different but equally stunning. The ice over my head had a mountainous terrain where peaks and valleys rolled on as far as I could see and massive chunks of ice froze together in a confusing and convoluted seascape. It was a glazed, crystal realm of emerald green that glowed from above, where harp seals flew like angels, gracefully navigating places that divers fear to tread. The adult harp seals were wary of us, however, and rarely came close. To photograph them I hid among the ice below a breathing hole and waited

Harp seal beater pup. Canada, 2003

Harp Seals

for those fleeting seconds when one would dive through the ice. On some dives I spent more than three hours making a few frames but mostly waiting in the 29-degree water.

Photographing the pups underwater was slightly better, because they didn't yet know how to swim. Harp seal pups begin testing the waters when they are about 12 days old, and they often slide in the icy sea for only a few minutes before crawling back to the ice. When they are a few days older, they begin swimming deeper, along the ice shelf and beneath the canopy. Upon first entering the water, they are buoyant, with their fat white coats holding air. This stage was my best chance to make pictures, as the young seal tried to figure out its world and acclimate to the ocean that would become its home.

During my second season, I switched to using helicopters to reach the seals after our boat became locked in the ice. My focus on this trip was to photograph pups at a slightly older age. At about 14 days old, the pups begin shedding their white coats and replacing them with lovely mottled gray coats. The pups are called beaters at this stage because they beat the water with their flippers as they try to learn how to swim. This is also the time when the pups become the targets of seal hunters. Hundreds of thousands of pups, barely more than two weeks old, are clubbed and killed for their coats, which are used to make hats, mittens, and jackets. While working on this assignment, I became the first journalist in more than 15 years to be allowed to make pictures on board a seal-hunting boat.

As disturbing as that experience was, I believe the larger threat looming for these animals is from climate change caused by global warming. During my time in the gulf I saw pups dying because they fell into the icy sea before they were ready. They only need 14 days to be fully weaned and on their own, but pups only a few days old were falling through thin ice and not making it back. In recent years, thick and stable ice has been almost nonexistent, and pup mortality rates have increased precipitously.

I hope to return to the Gulf of Saint Lawrence someday, since my time with the seals there remains one of my most cherished experiences. My hope is that, with increased awareness, the situation there will improve and I will be able to swim once again with these seals in their crystal kingdom beneath the sea. ~

Harp seal. Canada, 2002

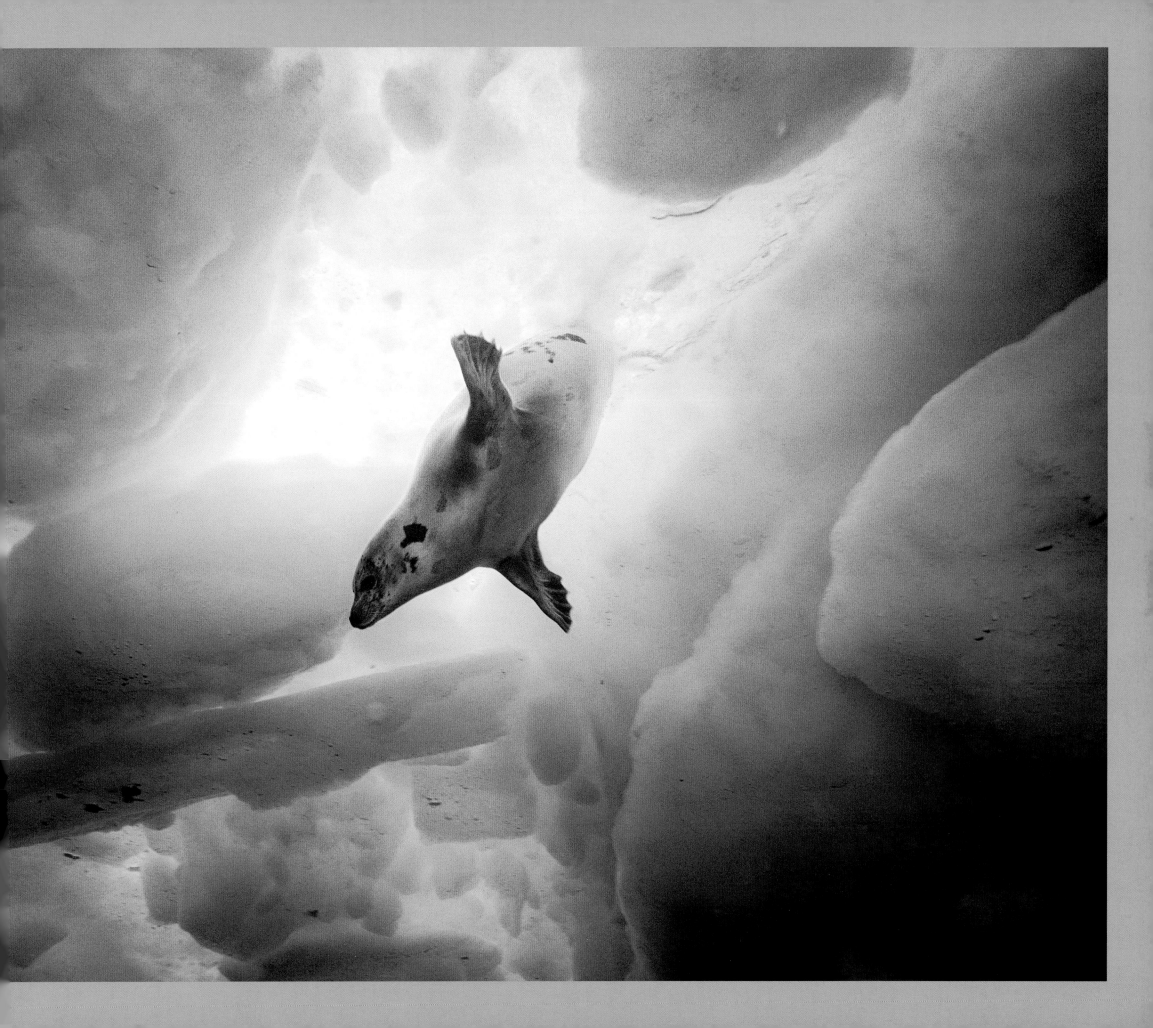

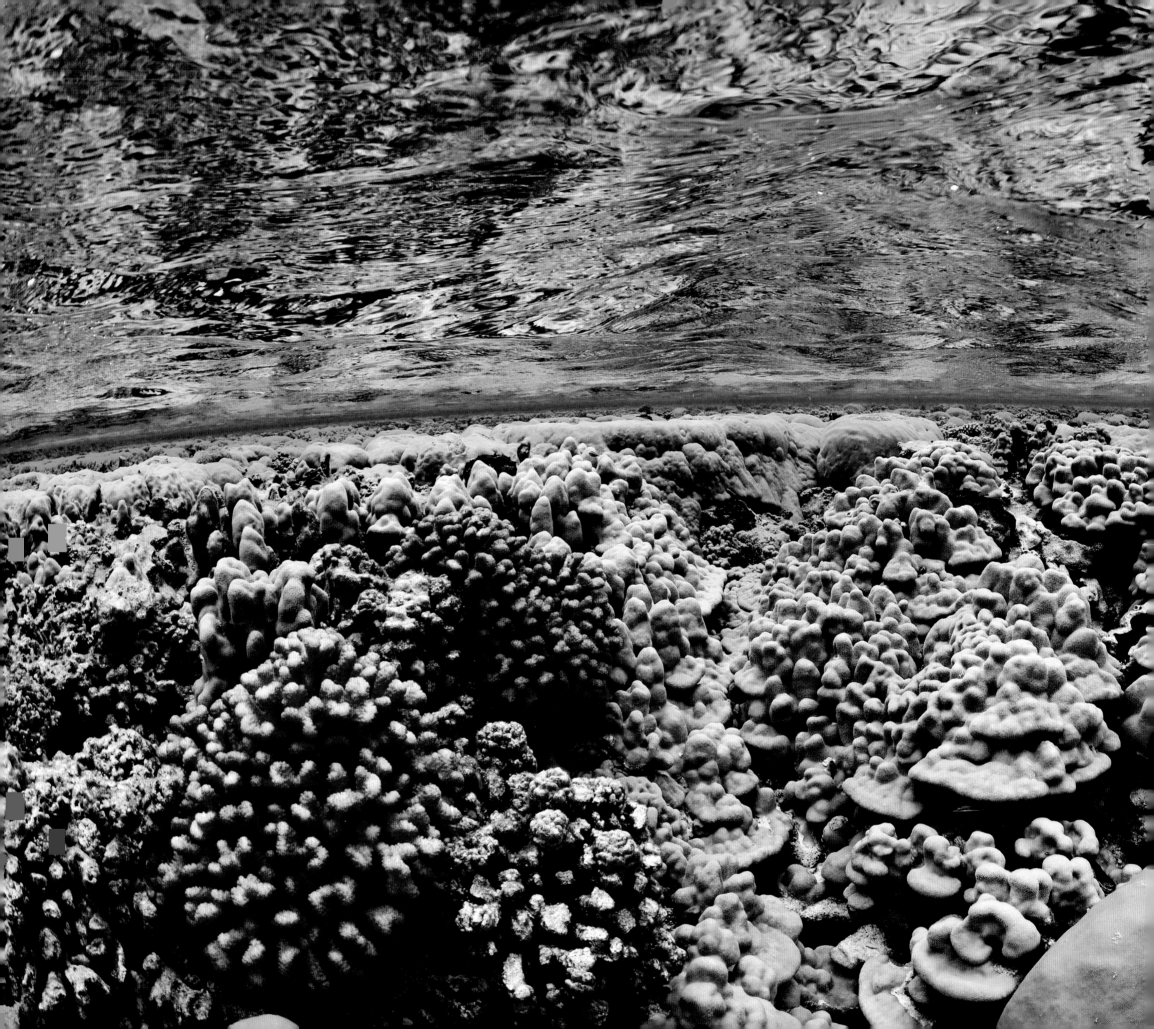

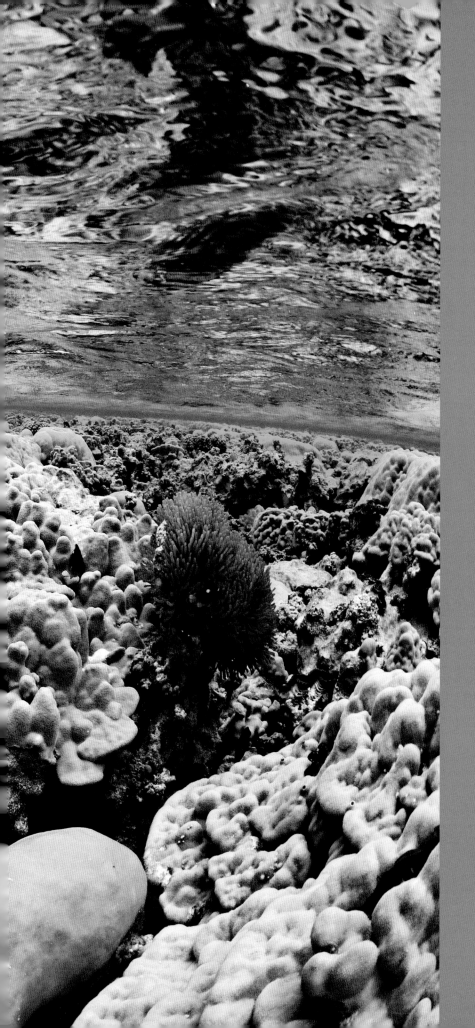

Pristine Waters

Shallow-water corals. Kingman Reef, 2007

Pristine Waters

Over the past 30 years, while I have been privileged to see many wonders, I've also witnessed changes in the ocean that have left me troubled. I see fewer fish in places where I once saw massive shoals. I see fewer animals of nearly every species. I have seen coral reefs that were once teeming with life but are now overrun by algae and devoid of the algae-loving fish necessary to keep things in check. I have revisited once-rich kelp beds and gardens of temperate benthic life that are now barren desert seafloors. Just in my lifetime, I have seen signs of decline at locations around the globe. Before more is lost, we must take measures to protect ocean wildlife and its environments. Some measures will be easier to enact than others. But, as with any multistep program for recovery, the first step is to admit there is a problem.

That simple admission, though, requires that we accurately grasp just how much we have lost. A diver today swims in a kelp forest, sees a few fish, and thinks, "Wow, this is beautiful." That diver has no idea that another diver swimming in this very same place a decade ago would have seen so much more. Yet, without this first-hand knowledge from a time gone by, we establish our ideas about the health of a natural ecosystem based only on what we see right now. For the diver in that kelp forest today, a few fish and some kelp appear to be a healthy kelp forest. In reality, it is a skeleton of what it once was. This frequent redefining of natural environments is what marine scientists refer to as shifting baselines. Since we have no true benchmark, the baseline for what we *think* a healthy ecosystem should be is reset by each succeeding generation, based on its current observations.

To see a clearer picture of what the ocean looked like before the damaging effects of industrialization, we must travel to the most remote places on Earth. The daunting reality is that we can find human presence everywhere on our planet. Our proverbial footprints have trampled all corners of Earth and pretty much every place in between. Still, some places exist off the beaten path—places that are difficult or costly to reach and, by virtue of their remoteness, largely untouched. Among the most remote locales on Earth is a region in the central Pacific Ocean where islands and atolls dot the sea like jewels tossed upon a blanket of blue velvet. These undersea ecosystems are some of the least spoiled and healthiest marine habitats discovered to date. By visiting pristine waters like these, we take a journey back in time to experience what was once common everywhere. This journey to the past also becomes a vision of what can be realized in the future, provided that we take action.

Currently about half of all coral reefs have been lost or severely degraded due to overfishing, bleaching, runoff, and a host of other assailants. It is, therefore, nearly impossible to see a truly intact coral reef system anywhere except in these far-flung locations. My colleague Enric Sala, who studies coral reef systems, makes the analogy that trying to learn about coral reefs by looking at degraded sites is like an alien trying to learn about automobiles by visiting a junkyard. In years past, scientists studied only reefs that had been overfished, so the ecosystems' true workings could not be understood, because key pieces were missing. By studying pristine reefs—systems that remain healthy and intact—we can establish a whole new baseline. Armed with this clearer understanding of how the ecosystem is supposed to look and work, we can better conserve damaged coral reefs worldwide.

For a diver and underwater photographer, there is no thrill quite like exploring a place where few other divers have been. If even the most frequented dive sites can deliver amazing experiences, then diving in remote places is especially appealing for its potential to see truly extraordinary things. On three separate expeditions—to

Kingman Reef, the Southern Line Islands, and the Phoenix Islands— I had grasped the diver's holy grail. These locations are about as remote as possible, and divers rarely visit them. Some of the islands and sites had never been dived before. We were the very first.

The pristine waters I explored on these expeditions were like undersea Gardens of Eden, each with its own unique characteristics and feel. While these three expeditions took me to the same general part of the world, and the ecosystems are all coral reefs consisting primarily of hard corals, they are unlike other reefs I have seen anywhere in the world. From shallow to deep, they explode with life and swirl with color and vibrancy. The coral cover was determined to be more than 85 percent in most locations, and in some places it was 100 percent. This is unheard of elsewhere in the world, and it made each dive like a foray into an enchanted forest.

At Kingman Reef we discovered a new species of coral—a massive, saucer-shaped colony believed to be more than 500 years old. Even though the other corals we saw might have been identified previously, their density and vibrancy were unique. We called one site the Clam Gardens because the bottom was thick with giant clams. I spent hours in these shallows, where I was mesmerized by the electric colors of the clam mantels and the dizzying patterns extending as far as the eye could see. In other places mushroom corals littered the seafloor. They ranged from silver dollar to dinner plate size and were vibrantly colored in hot pinks, yellows, and greens. Yet another site we called the Shire, after J. R. R. Tolkien's Lord of the Rings, because coral grew in high mounds like charming knolls in a storybook countryside.

Despite their remoteness, these waters are not immune to threats. In the Phoenix Islands, working alongside visionary marine scientist Greg Stone, I saw coral bleaching magnitudes worse than anything I had seen on other reefs. The scientists studying this region determined that it had suffered the worst thermal heating on record in the ocean. Historically, it has been identified as the source for El Niño's warm waters—the site where these periodic warming events begin and then spread out across the Pacific Ocean. But this time was different: Instead of moving, the water remained localized around these islands for years and caused severe damage to the corals. Even still, because this region had been conserved as a marine protected area and was otherwise unharmed, the corals were starting to grow again. The phoenix was rising from the ashes and showing us the resiliency of the reef and the value of keeping ecosystems like it healthy and intact.

The difference that was most evident to me in all three of these places was the abundance of fish life, particularly the predators. Until very recently, scientists believed that the biomass of a healthy coral reef consisted of mostly reef fish, with very few predators. We saw the exact opposite in these pristine reef ecosystems, whose biomass consisted of mostly predators. In fact, the science team calculated that 85 percent of the animal life on these reefs is made up of large predatory fish, such as sharks, snapper, and grouper. Every dive I made confirmed these numbers. Everywhere I looked I saw such animals. In other parts of the world on most reefs where I have dived, seeing a shark is quite rare these days. By contrast, in perhaps 150 dives in the Phoenix Islands, I saw sharks on almost every one. This is the natural balance—the way nature designed these habitats to function—yet in most places worldwide this balance has been altered. A faraway location is all that has spared pristine reefs from similar fates.

Unlike the majority of my assignments, during which I primarily work alone, on these three expeditions I was part of a larger team. An expedition leader selected a group of scientists to gather data and to study these ecosystems at all levels, from microbes to apex

predators. My assignment was to photograph each expedition for *National Geographic* magazine and to bring readers a personal view of places never before photographed. The dynamic of being on a ship for many weeks with a dozen or more team members is quite different from working alone. A predetermined scientific objective dictated both the dive sites and the length of time we stayed in each place, so I had to adjust my style of working with the knowledge that I would rarely be able to reshoot any subject. For me these dives were like walks in the forest with my camera, but walks during which I couldn't stop for very long and had to keep photographing what I saw without the chance to return. Consulting with researchers on a daily basis, however, was valuable and often helped me to photograph scenes with greater complexity and to make images that contain important journalistic elements. Still, I believe my most important role remains as a storyteller and an artistic interpreter of all that I see. I want to understand the science, but I also want to capture the poetry.

The logistics of getting to such remote sites is considerable. To reach the Phoenix Islands from Fiji by boat required a journey of more than five days. Kingman Reef and the Southern Line Islands were equally isolated and necessitated expeditions in which we had to bring literally tons of gear aboard well-equipped research vessels. While such trips are exciting, they also make me think a lot about risk and just how narrow the margin of error can be when working in the ocean in distant locales.

Dealing with risk has always been part of my life. From the time I was a teenager taking my scuba certification class and learning about air embolisms and decompression sickness, I knew that the path I had chosen was riskier than most. As I have traveled that path, I've certainly had my share of misadventures. Diving shipwrecks, especially those in deep water, is perhaps the most dangerous thing

I've ever done. Dives in the North Atlantic to 320 feet on mixed gas had very tight margins of error. There were times when I lost my way inside wrecks like the *Andrea Doria* for just a few seconds, although it seemed like hours. Watching my exit hole close in the pack ice above me as the ice shifted during harp seal dives was equally unnerving. I have been chased by a sperm whale in the Azores and stalked by a saltwater crocodile in Mexico. Sharks bit through my strobe cords in the Caribbean. In Canada, I once surfaced from a dive in a blizzard to watch my boat sink and its captain leap off the gunwale into the water in a survival suit. In Ireland, my assistant, Sean, and I drifted for two and a half hours in a strong current when the dive boat crew missed us on the surface after our dive. A fishing boat that happened to be passing by saw us drifting and eventually picked us up. So I have become accustomed to a certain degree of risk and learned how to plan for it in the best ways possible.

In remote places like the Southern Line Islands, you are completely on your own. There are virtually no boats around for thousands of miles and no help if you have a problem. When diving in these uninhabited regions, I double up on safety gear and carry a variety of signaling devices, including strobes, safety sausages, mirrors, whistles, Dive Alerts, and even a VHS radio or EPIRB (a type of emergency radio beacon) in a watertight canister. We carry tourniquets underwater in the event of a shark bite. Redundancy is built into everything. But even with detailed planning, things can go wrong.

I had been diving off Starbuck Island in the Southern Line Island chain for a couple of days, but I wanted to go ashore to photograph life on land. Although I spend the majority of my time shooting underwater, it is important to photograph on the surface, too. Images above water provide a sense of place to a story and help orient readers to the locations of these remote reefs. The islands

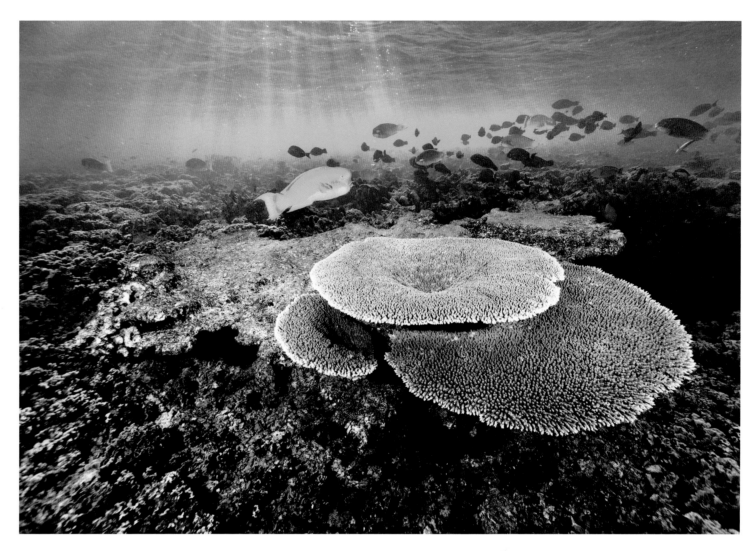

Table coral regrowth. Phoenix Islands, 2009

The phoenix was rising from the ashes and showing us the resiliency of the reef and the value of keeping ecosystems like it healthy and intact.

are connected to the reefs, and what happens topside can greatly affect habitats underwater. On these islands, however, there are no docks or piers, and rarely is there an easy place to land a small boat. The shoreline is clustered with coral that can rip boats apart. To get ashore, we would most often swim. This meant wearing a wet suit, mask, snorkel, and fins and towing a Pelican case of surface photo equipment. On the morning I swam to Starbuck, the surf was heavy, but my assistant and I were able to swim through it; find a narrow, natural channel in the coral; and make it to the sandy beach. Once on land, we stripped off our wet suits, prepped the camera gear, and headed off to explore. Also on the island this morning were five other members of our expedition. Our plan was to rendezvous at an extraction point back on the beach at two o'clock in the afternoon, swim out to the waiting dinghies, and head back to the ship.

By the time we returned to the beach, the waves had increased substantially. Very large waves were smashing the surf zone in sets of eight or nine, and there was no way we could safely swim against them. By radio we talked to our colleagues on a dinghy, and they confirmed from their vantage point that it would be foolish to attempt extraction. We were stranded and would have to spend the night on the island and see what conditions looked like the following morning. The captain and crew of our ship, the *Hanse Explorer,* used a rocket gun to shoot us a line attached to a case containing some water and a plastic tarp. With wood found on the beach and the tarp we built a lean-to, which would serve as our shelter for the night. I had gotten badly sunburned while hiking the island earlier, as I had worn only a bathing suit and a T-shirt, and as night fell I was shivering with chills. Exhausted and hungry, I settled in next to my shipmates under the lean-to and wondered what the morning would bring. Rain poured down that night, and I managed maybe an hour of sleep. Mostly I just lay there, a million

miles from home, and thought about my swim through the surf to get back to the ship.

We were up at six o'clock the next morning, and though the waves had not subsided, we decided to try for it anyway. We would go in three teams. Two would go first, then another two, then the last three. I was in the last team. We talked about how best to do this and potential pitfalls, such as getting battered by a wave and smashing your head on coral underwater. The key was timing the sets of waves and going when the window of calm appeared. We watched the first swimmers get battered a bit and thrown by the unexpected force of the water. My team waited for that brief lull and then swam as fast as possible to get out beyond the surf zone.

At one point I looked back to see the person behind me having problems, so I turned and swam back toward her. She shouted, "Should we go back?" to which I replied loudly, "No, put your head down and swim hard!" I turned and began swimming myself. Peering above the waterline, I saw a huge wave coming toward me, took a deep breath, and dived slightly as it passed overhead. A couple more of those, and I was through the danger zone. Exhausted and slightly winded, we all clambered back aboard the *Hanse Explorer.* We were lucky—things could have turned out very differently.

Despite my handful of dicey moments over the years, the opportunity to explore and photograph unique locations and to share these images with the world has been the stuff of dreams. On the Southern Line Islands expedition I made some 70 dives and produced photographs of incredible scenes that I hope will help save these priceless places. Being able to make a difference in this way will have a far more lasting effect than one bad night stranded on that desolate island.

My favorite time to dive and make pictures in this environment is at dusk, when light levels are low and I can capture movement

and color with my camera. This is also the time when I love to watch animal behaviors. Parrotfish stream over the reef single file as they head for a safe place to rest for the night, and evening creatures emerge from their daytime hiding places. Sharks quicken their pace and hunt in the shadows as the last rays of light sweep across the corals in a time I view as my own kind of witching hour. You can almost feel their energy vibrating through the water.

Dusk is also a time for spawning, when many species of fish gather at specific spots along the reef and engage in a fluid ballet of procreation. One evening, while diving off Millennium Atoll in the Southern Line Islands, I followed a pair of purple goatfish preparing to spawn. Like a voyeur I watched as they swam together through vibrant, green-colored coral in a delicate and gentle dance before ascending upward into the dark water and out of my view. Another sunset had me stalking a stunning pair of unicorn fish that were patrolling the edge of the reef near the drop-off into deep water. Not wanting to disturb them yet needing to be just a bit closer for a great picture, I followed them for what seemed like ages. The moment presented itself as the pair came together for an instant, their horns almost crossing as I released the shutter.

At the end of each day of diving in distant and pristine waters, I reflect on my remarkable experiences. As a boy swimming in my parents' pool more than three decades ago I had very big dreams, but even in my wildest dreams I could not have imagined all that I have seen and photographed. I have certainly come a long way from the first time I sat in the shallow end in that pool and breathed underwater. My lifelong voyage has taken me through many waters, and I have seen amazing things. Yet I know that all I have seen is only a small fraction of what remains to be discovered. The dream remains vivid, my ocean soul renews with each dive, and the voyage continues. ~

Phoenix Islands

A lethal spike in seawater temperature produced by El Niño, which stalled over the reefs of the Phoenix Islands, killed much of the lush and abundant coral that had previously been here. Thanks to its protection as a massive marine reserve, all other components of the ecosystem were intact and helped in the recovery of the reefs, including large schools of herbivore fish that control algae growth. With conservation and the resilience of the sea, the Phoenix Islands literally rose from the ashes of a catastrophic warming event. Healthy seas are vital not only to marine animals but also to bird species, which depend on nearby sources of fish for food. As the influence of human activity continues to affect the world's oceans, the greatest defense against destruction is the creation of more protected areas.

Green turtle over dead corals. Phoenix Islands, 2009

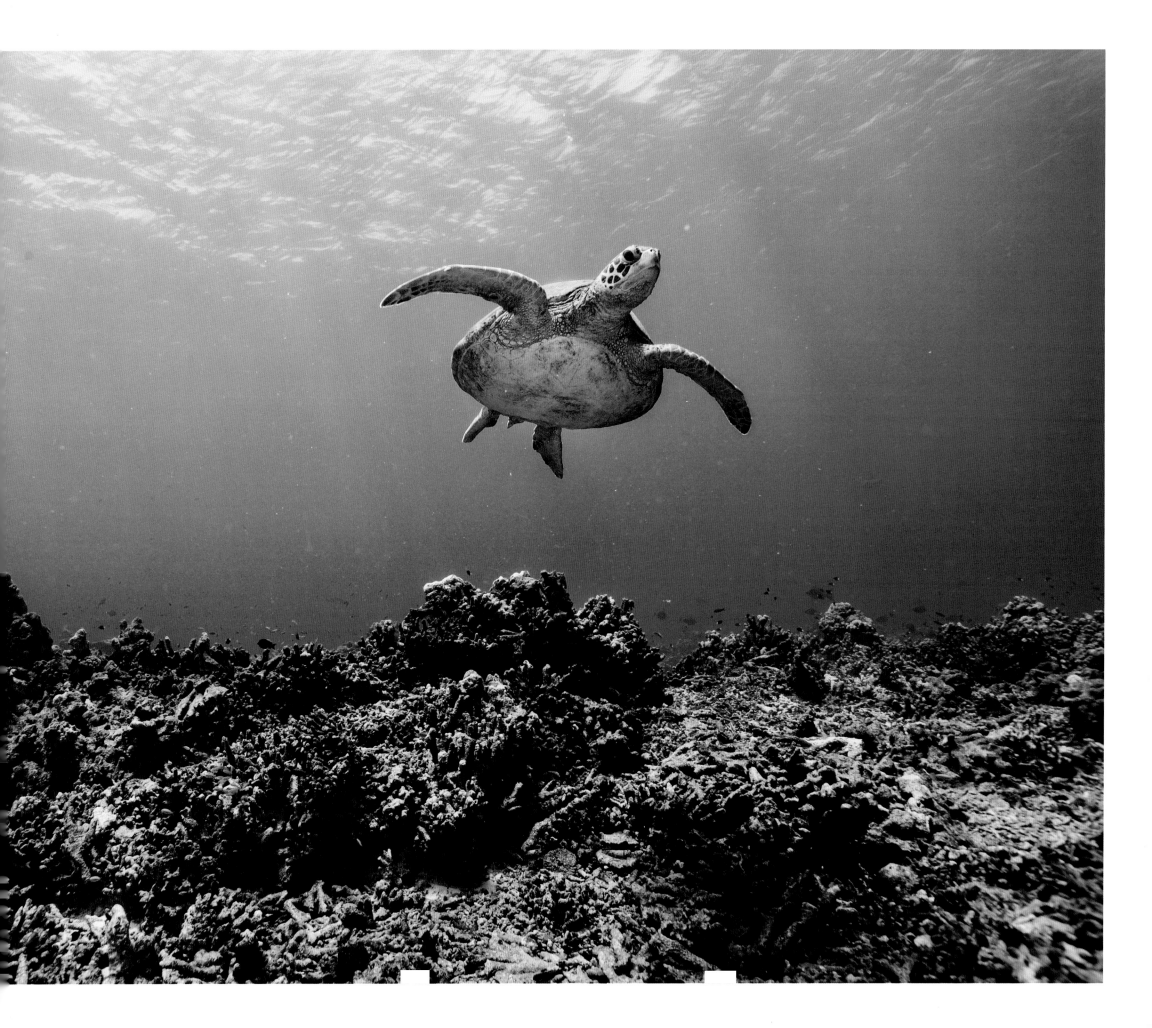

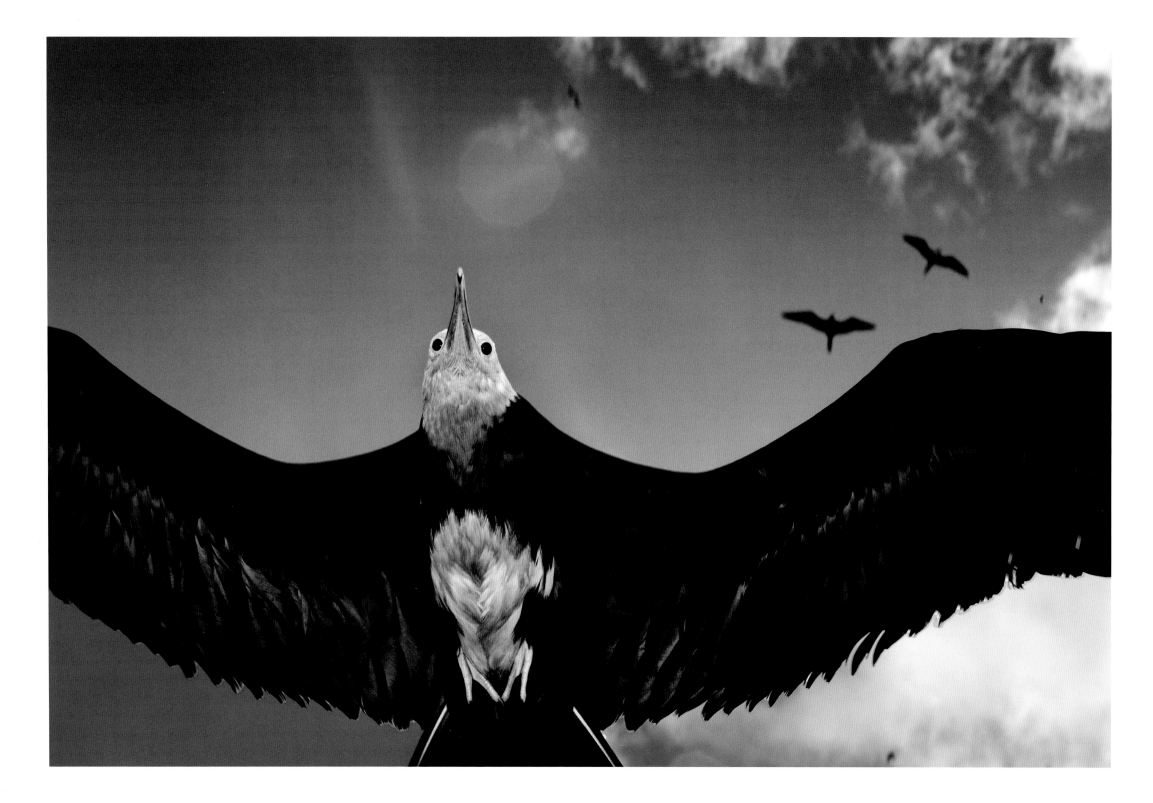

Frigatebirds. Phoenix Islands, 2009

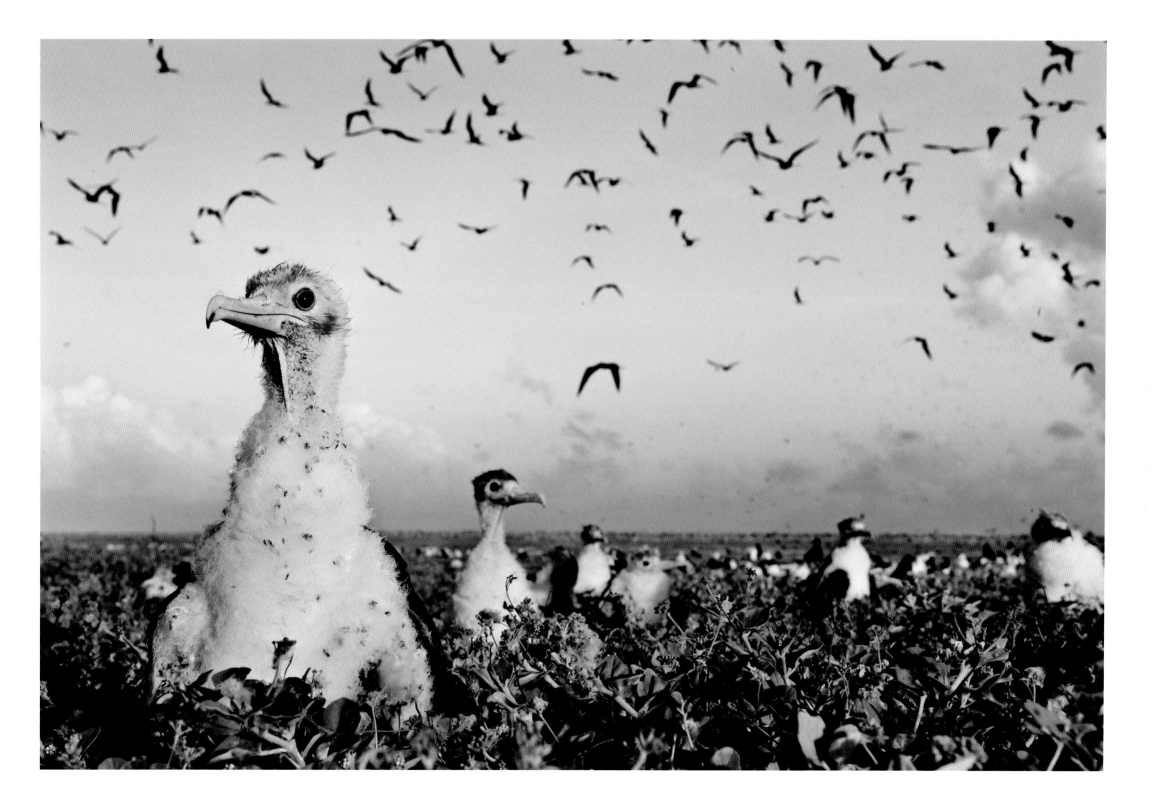

Frigatebird chicks. Phoenix Islands, 2009

My favorite time to dive and make pictures in this environment

is at dusk, when light levels are low and I can capture movement

and color with my camera.

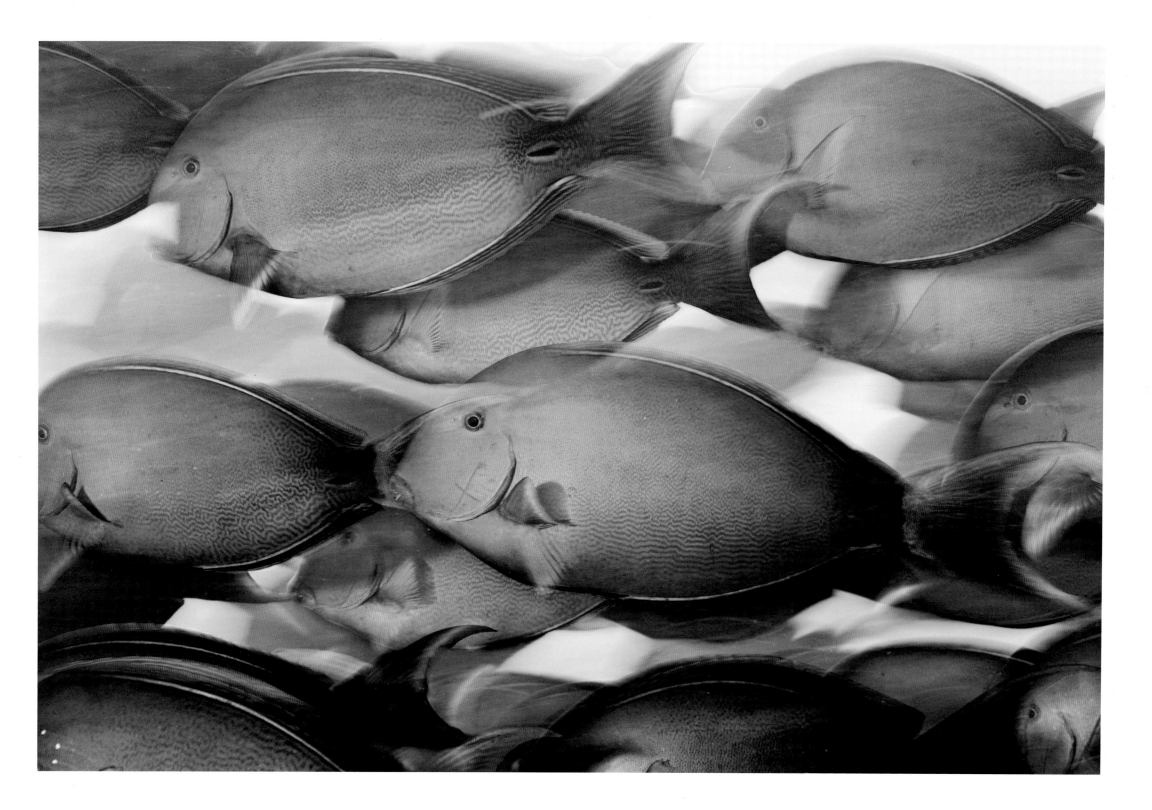

Yellow surgeonfish. Phoenix Islands, 2009

Giant trevally. Phoenix Islands, 2009

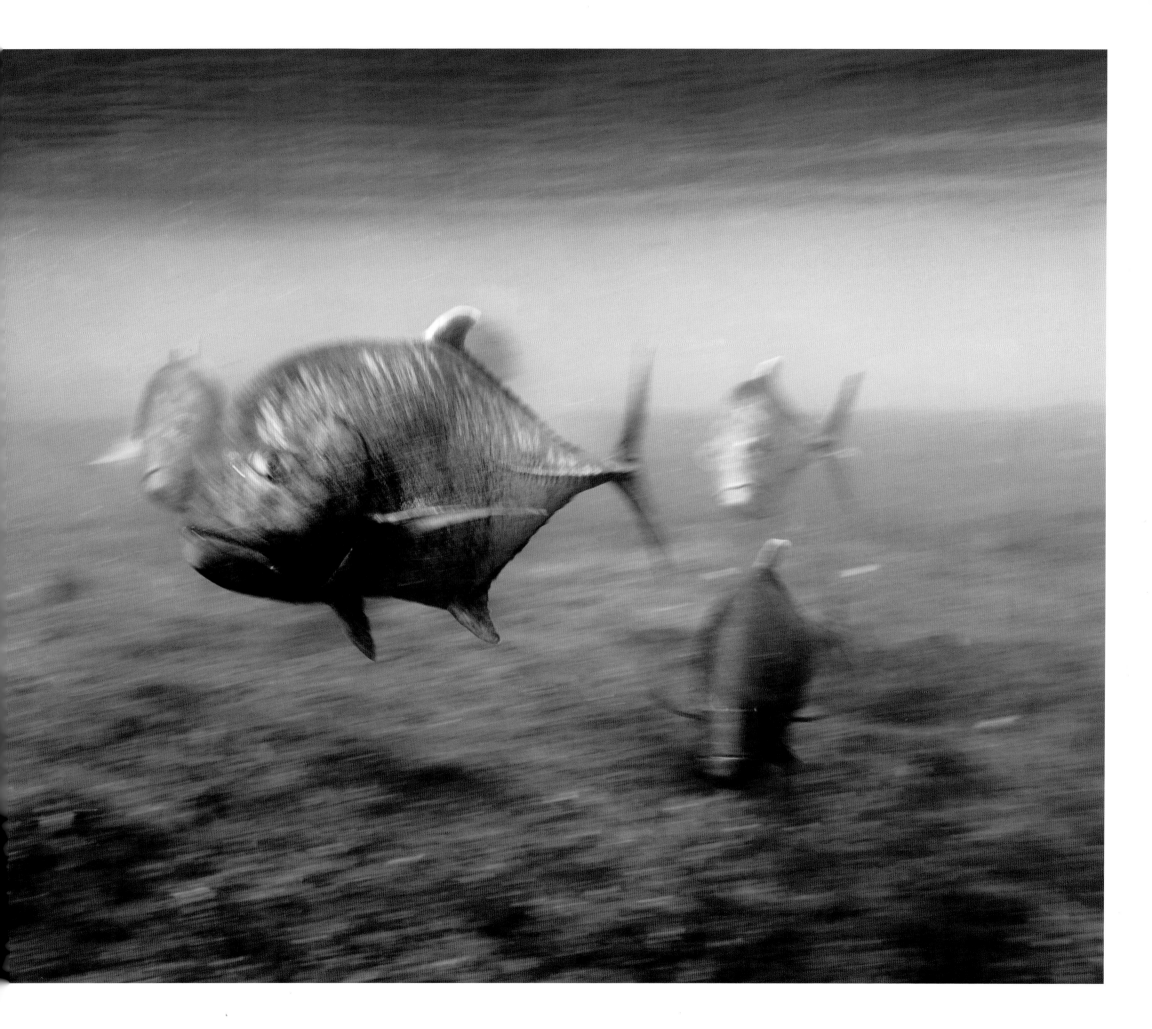

Kingman Reef

The remoteness of Kingman Reef, which barely breaks the ocean's surface, has kept it relatively unspoiled and removed from the overfishing and pollution affecting more easily reached locales. Swimming through these waters is a feast for the eyes: Gardens of giant clams clutter the bottom, their neon-colored mantles glowing vibrantly, and are juxtaposed with brightly hued mushroom corals ranging in size from silver dollar to dinner plate. Within Kingman's massive lagoon, water quality is exceptional, allowing reef systems to thrive, and in every corner, wildlife teems. In the handful of places like this that remain, we can learn how coral reefs were meant to function, and create models for conservation elsewhere.

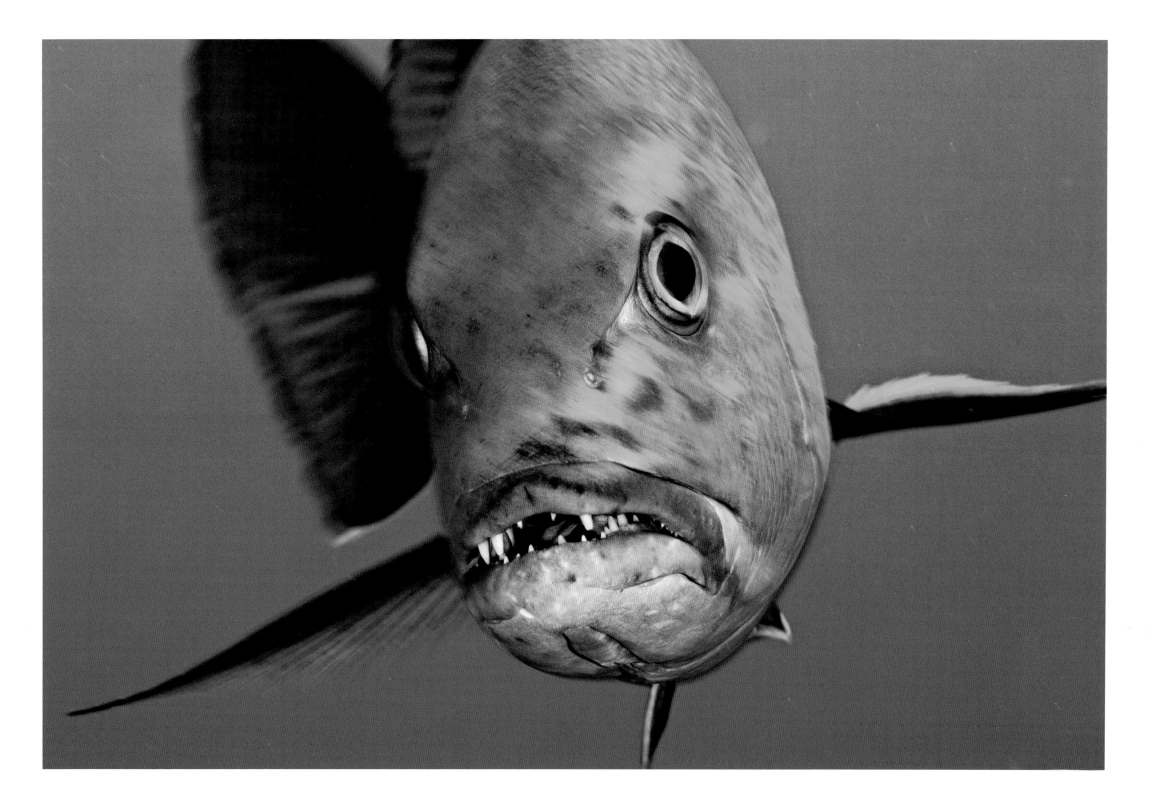

Bohar snapper. Kingman Reef, 2007

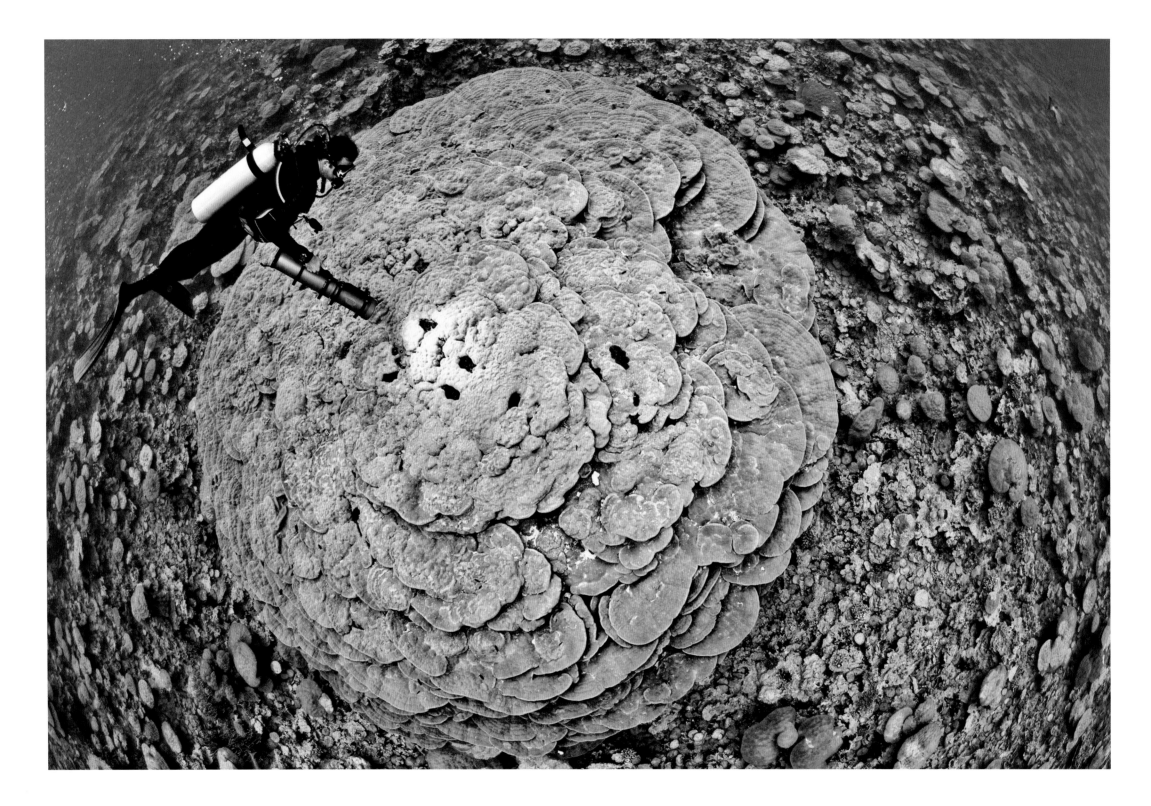

Undescribed coral species. Kingman Reef, 2007

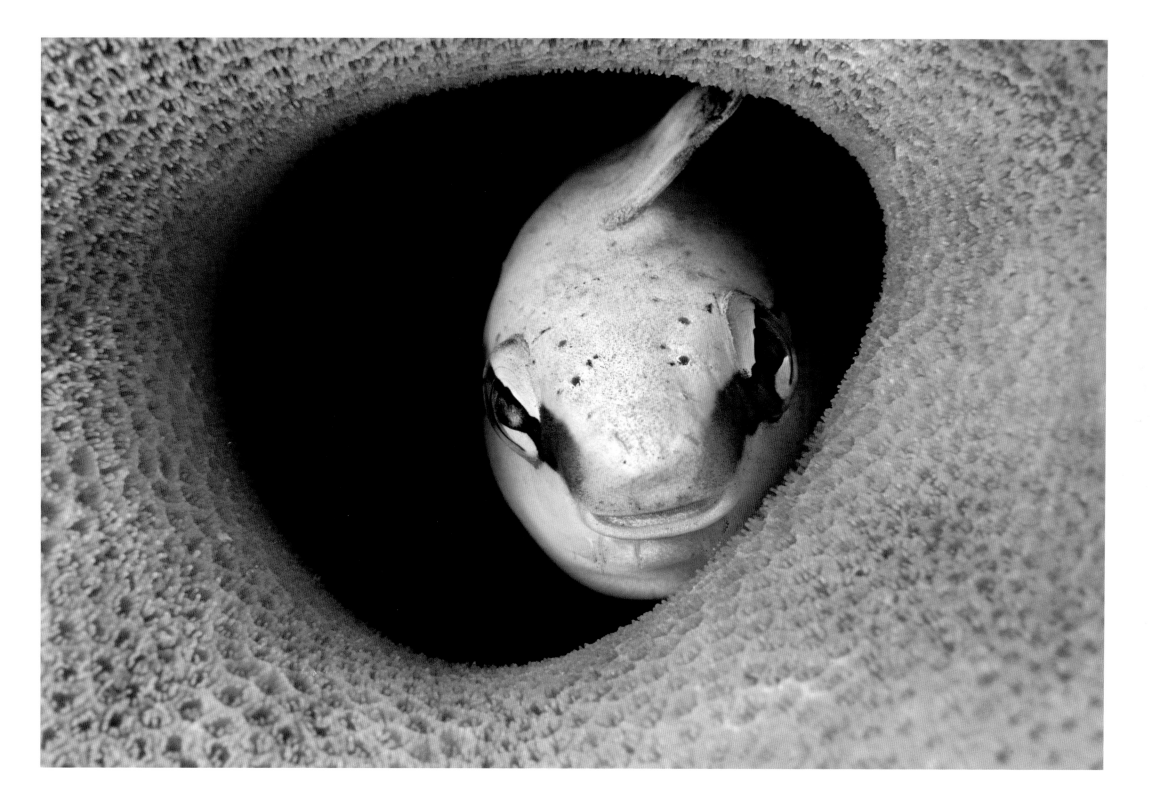

Fang blenny. Kingman Reef, 2007

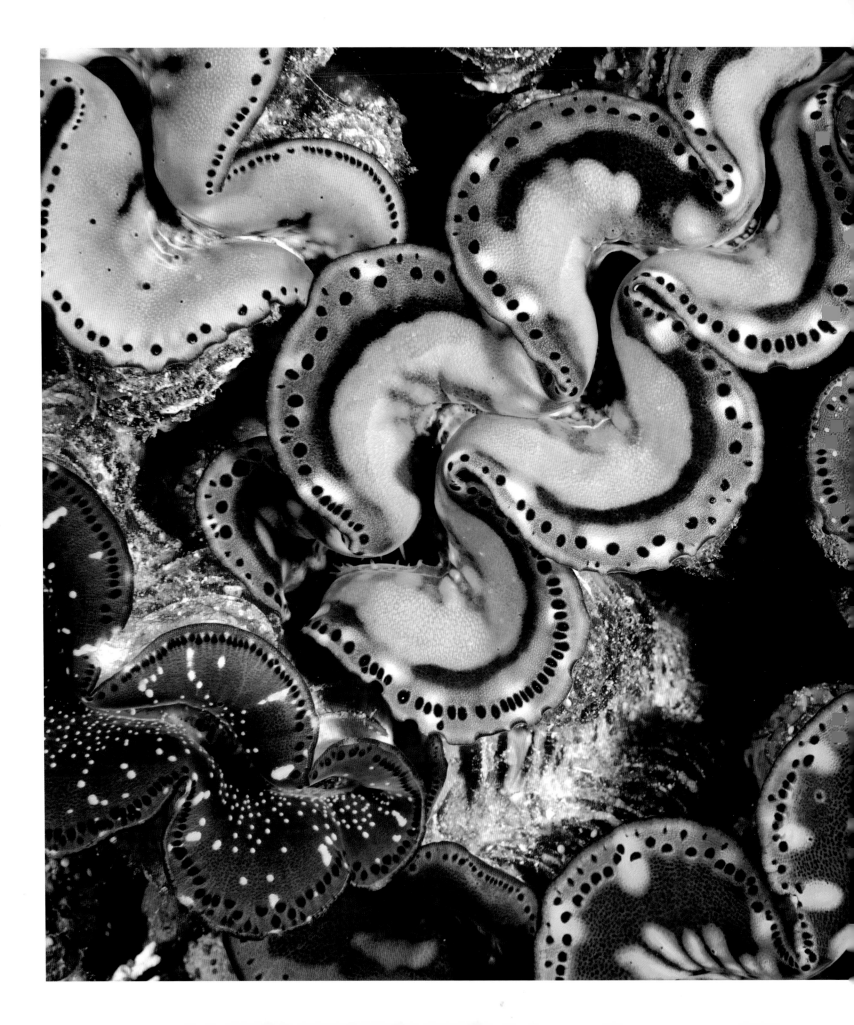

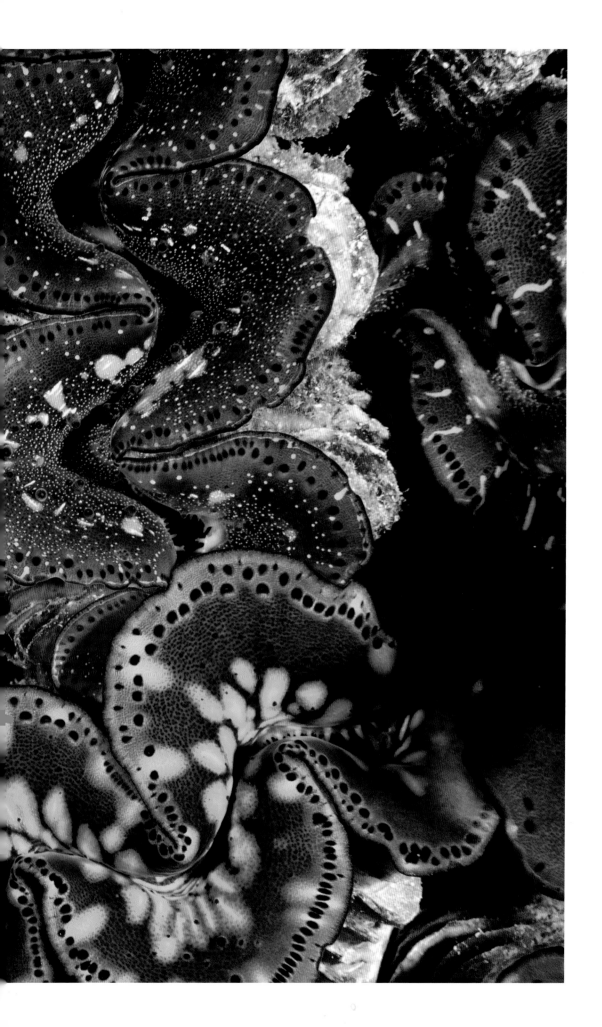

Giant clams. Kingman Reef, 2007

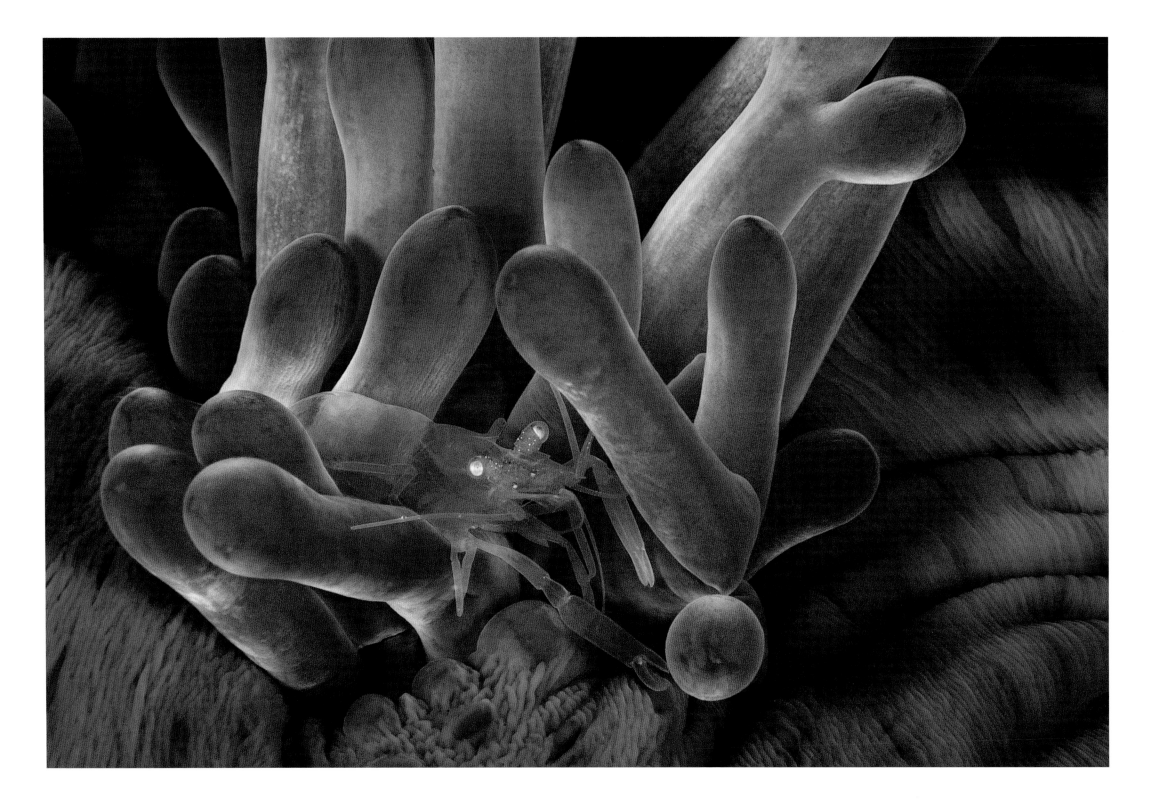

Translucent shrimp on anemones. Kingman Reef, 2007

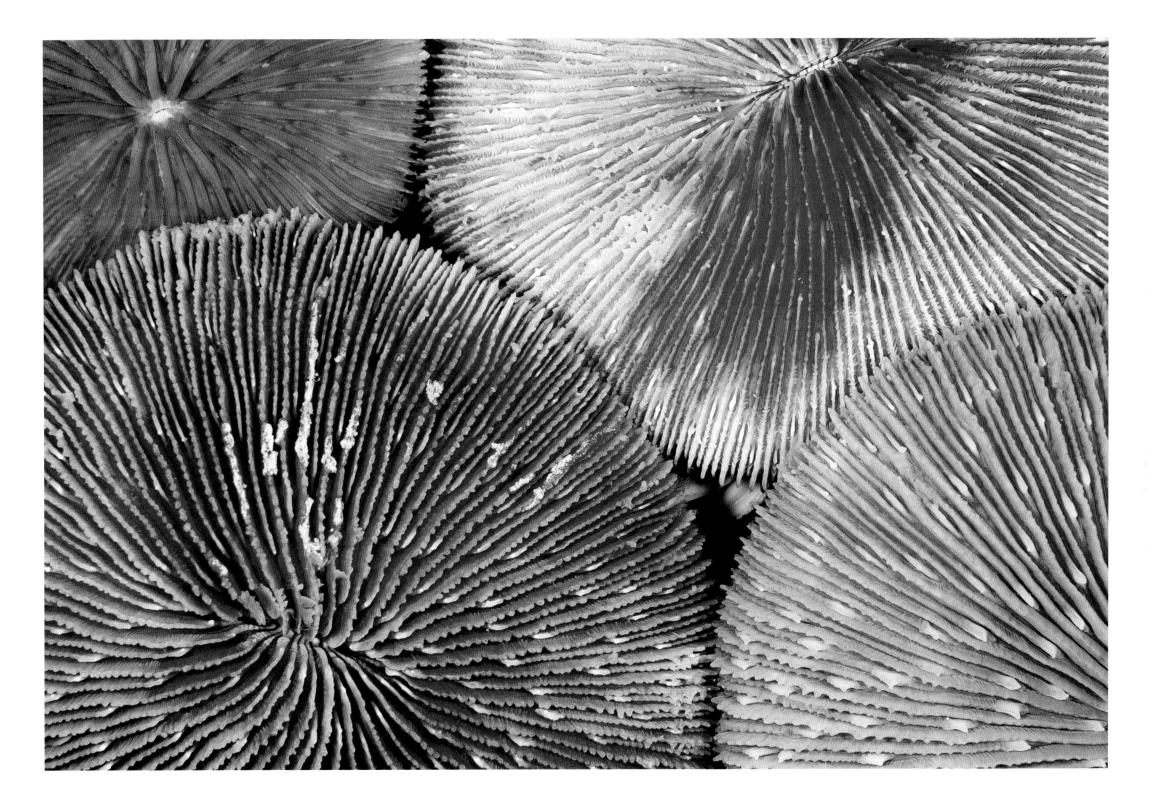

Mushroom corals. Kingman Reef, 2007

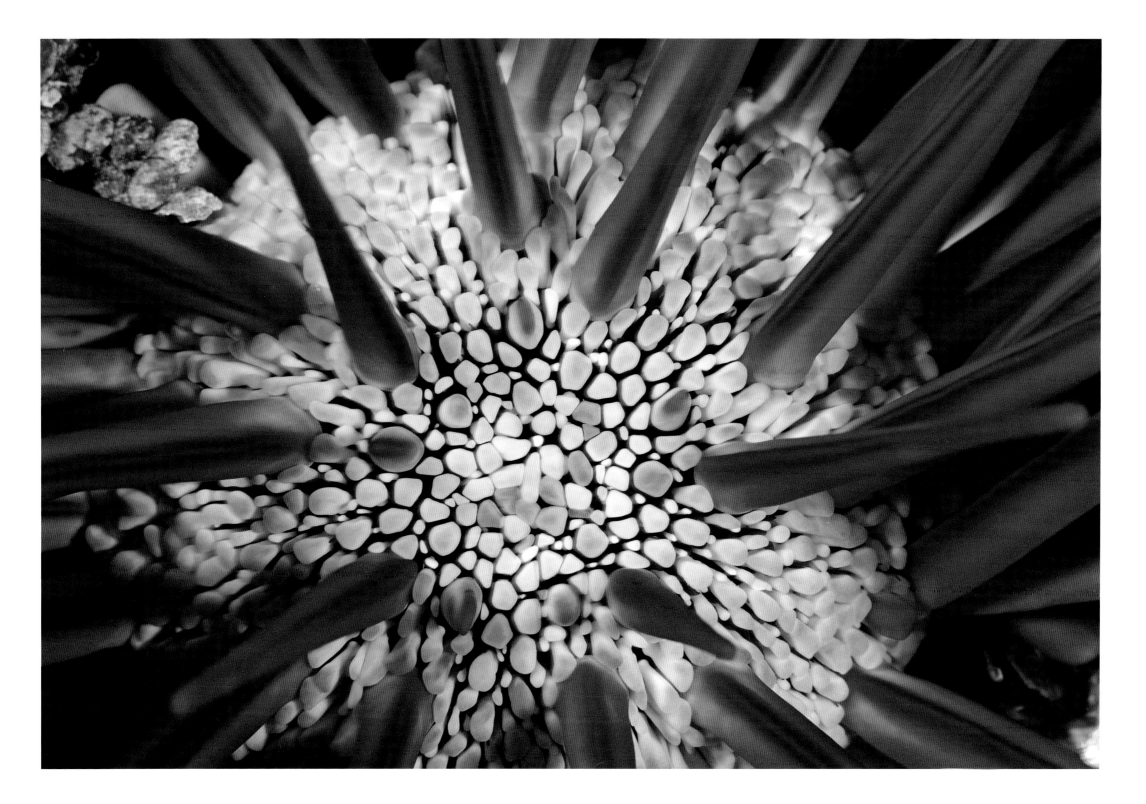

Pencil-spined urchin. Kingman Reef, 2007

Southern Line Islands

Composing up to 85 percent of the fish biomass, predators rule on healthy coral reefs. Species such as shark, grouper, and snapper patrol the seascapes, always hunting, always hungry. To function perfectly, ecosystems need all parts—on reefs this means not only predators but also herbivores and planktivores; every species must play a role. In the Southern Line Islands, the result of such a healthy "machine" is extraordinary coral cover, nearly 100 percent in places. Exploring underwater here is like traveling back in time, watching animal behaviors and interactions that are rare elsewhere in the world because of degradation. Journeys to remote underwater habitats should not be viewed only in terms of what once was everywhere, but rather what can be again with conservation.

Gray reef shark. Southern Line Islands, 2009

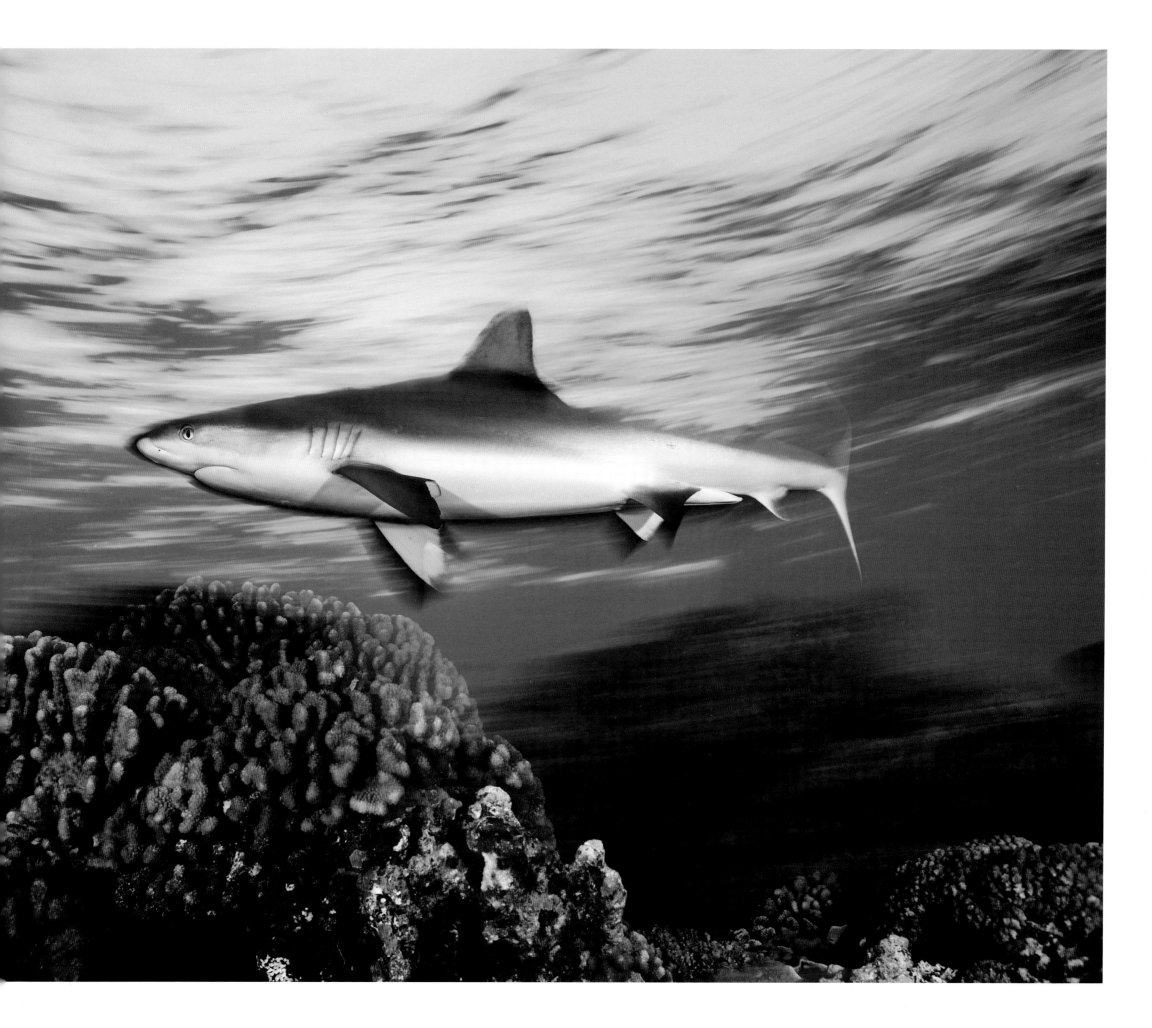

I believe my most important role remains as an artistic interpreter of all that I see and as a storyteller. I want to understand the science, but want to see and capture the poetry.

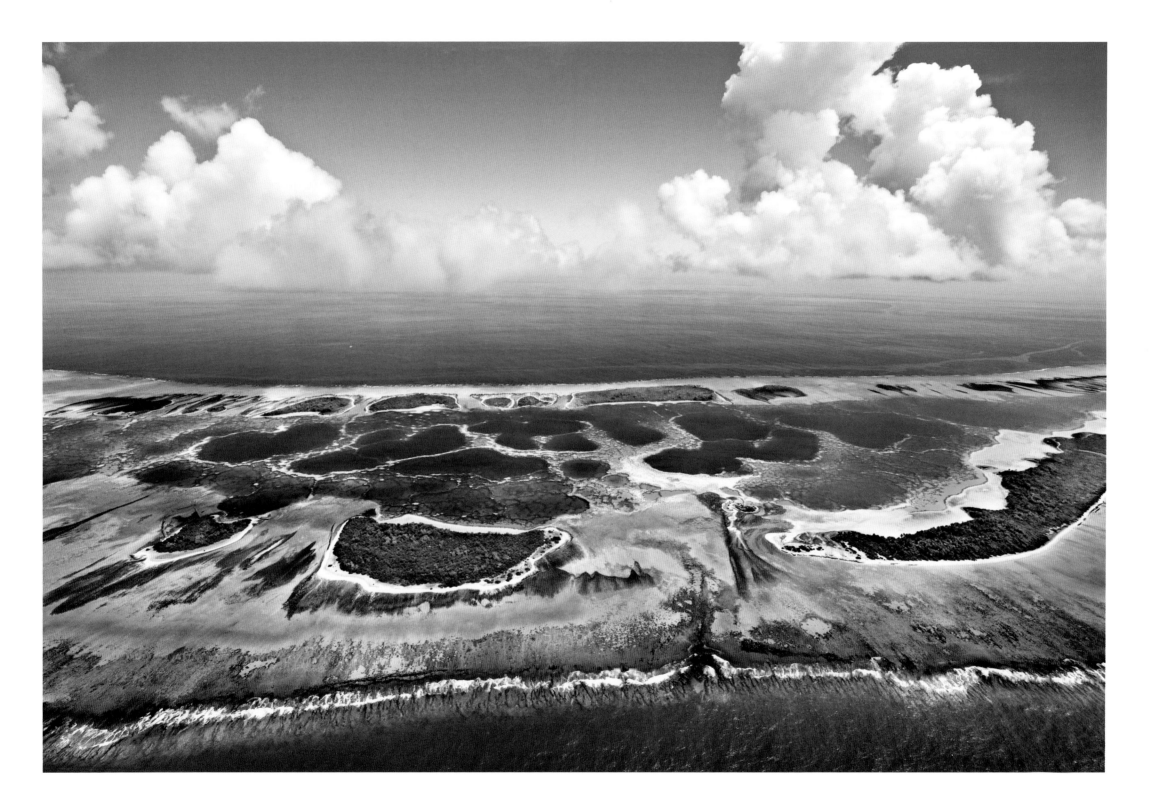

Millennium Atoll. Southern Line Islands, 2009

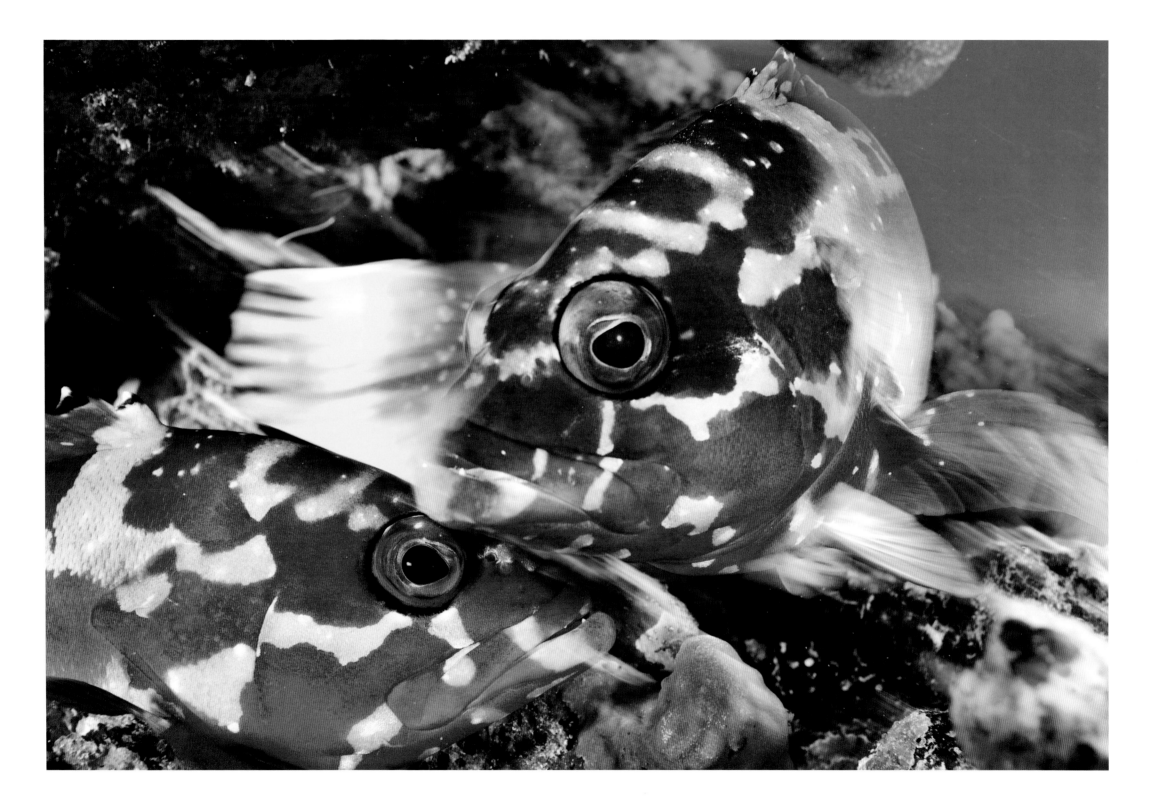

Reef groupers. Southern Line Islands, 2009

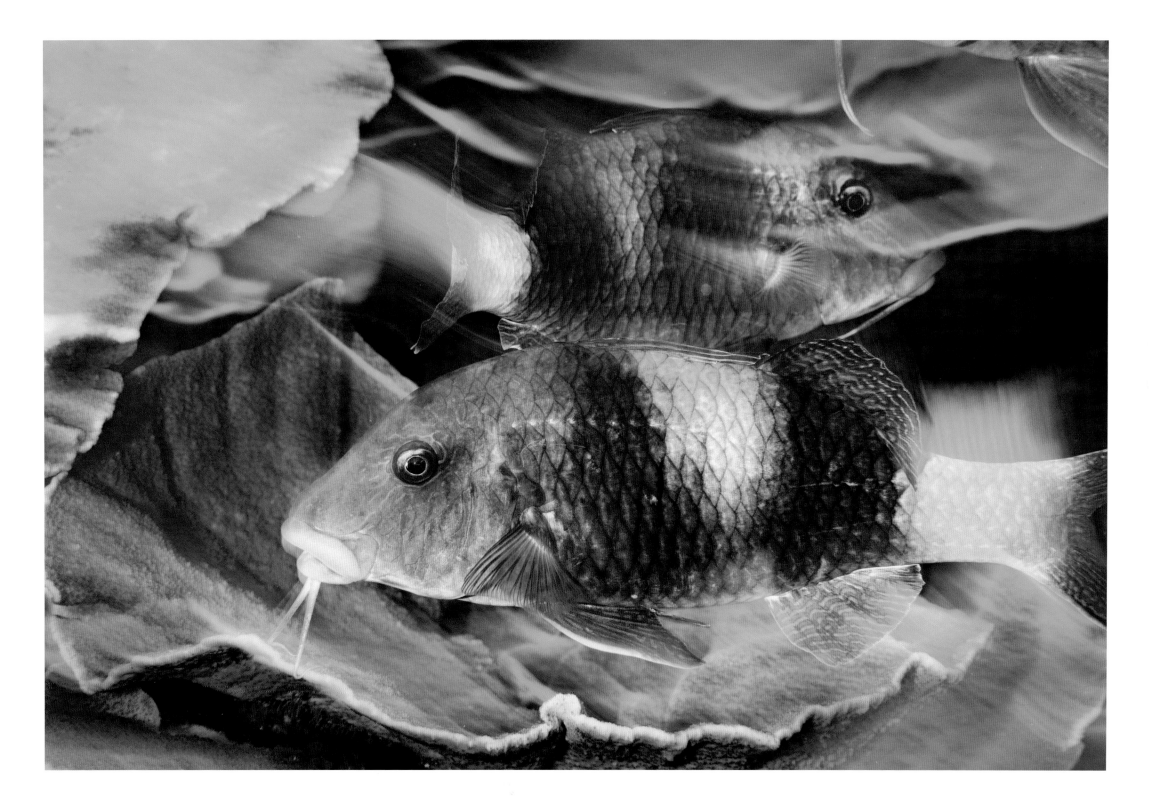

Double-bar goatfish. Southern Line Islands, 2009

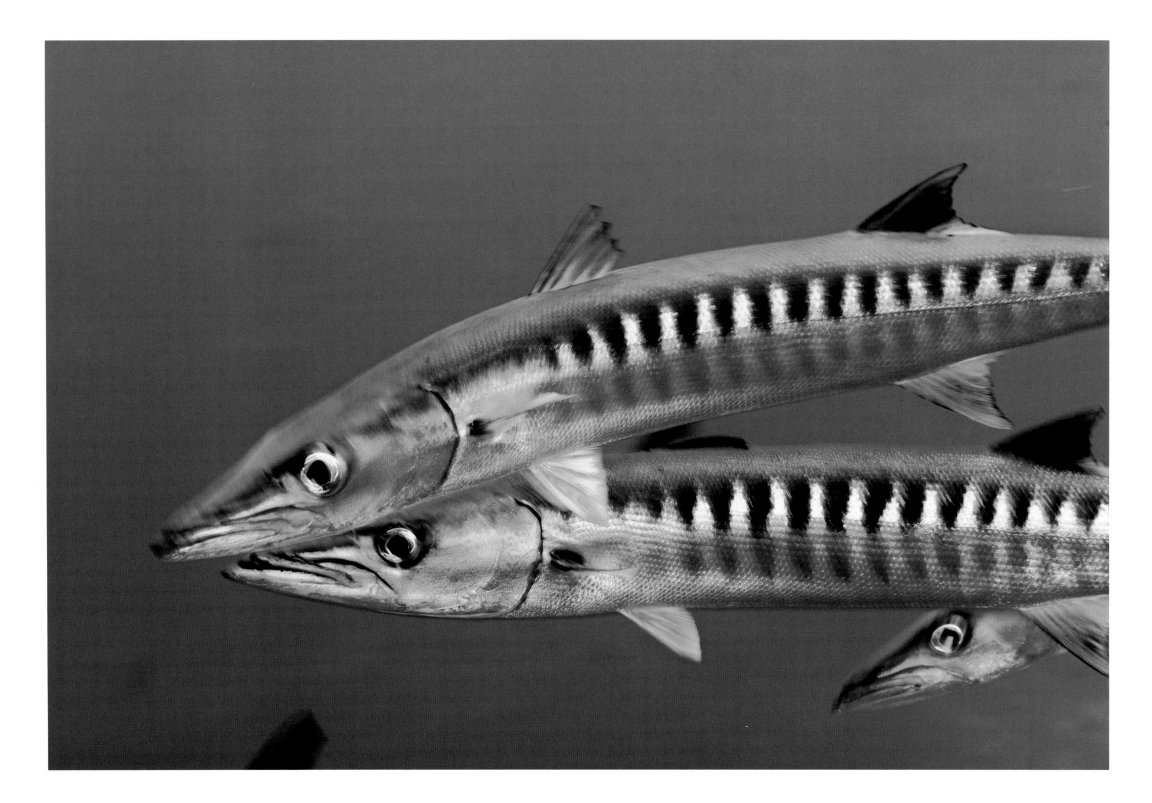

Chevron barracuda. Southern Line Islands, 2009

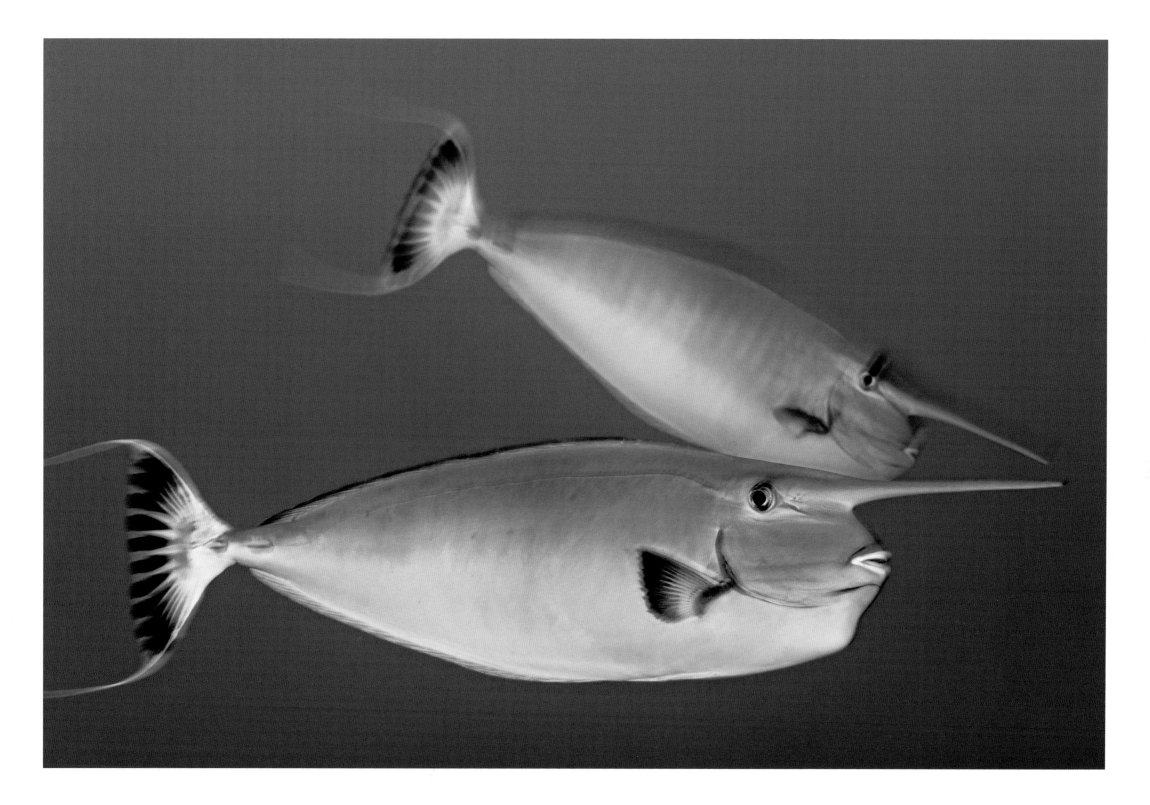

Unicorn fish. Southern Line Islands, 2009

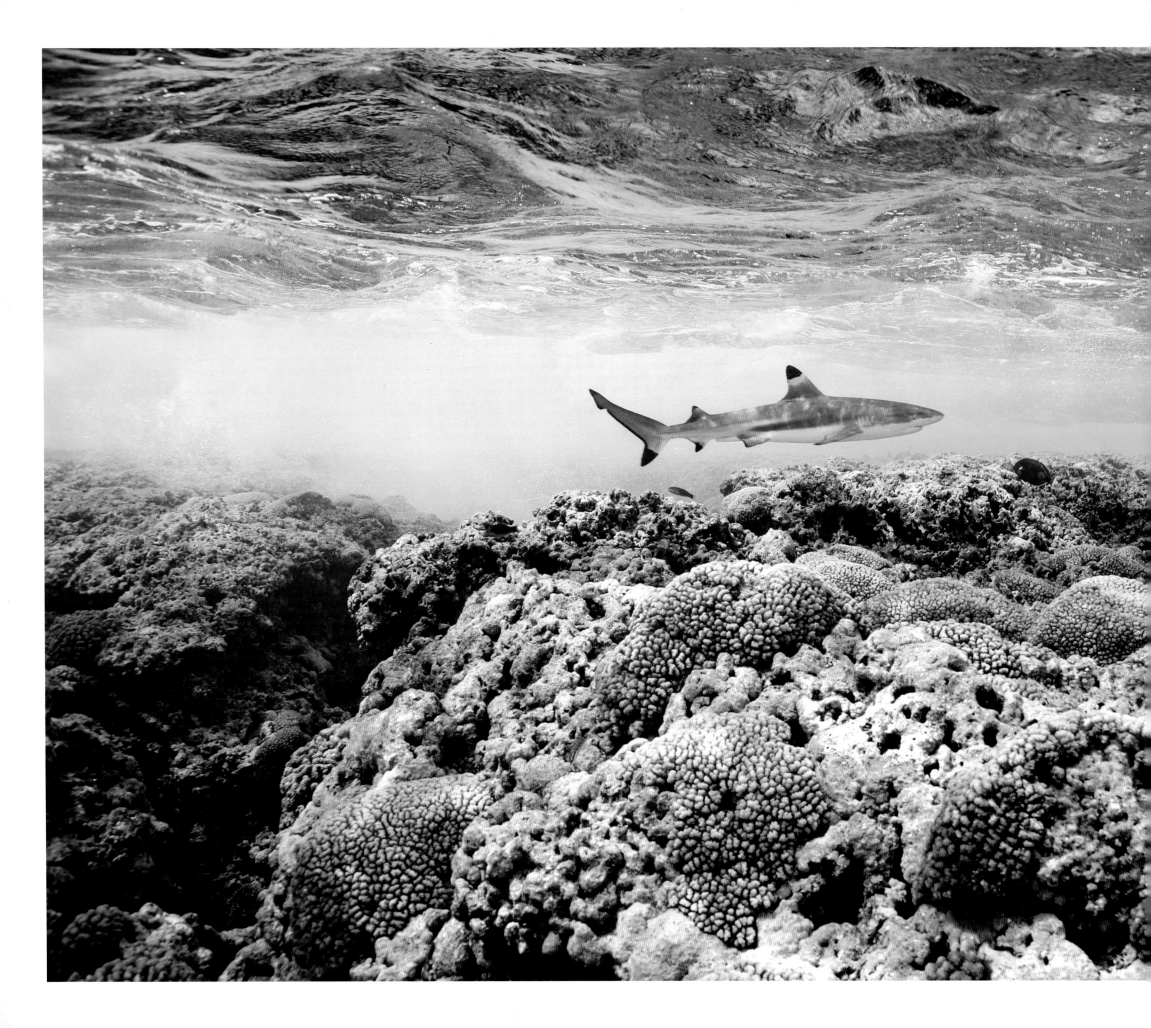

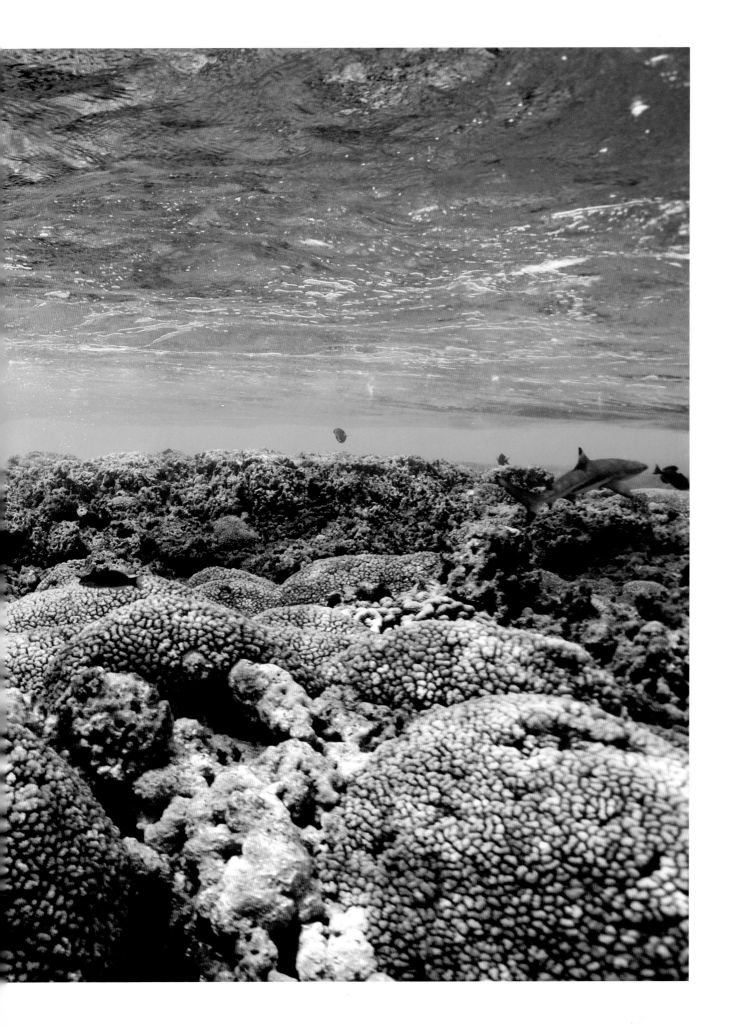

Blacktip reef shark. Southern Line Islands, 2009

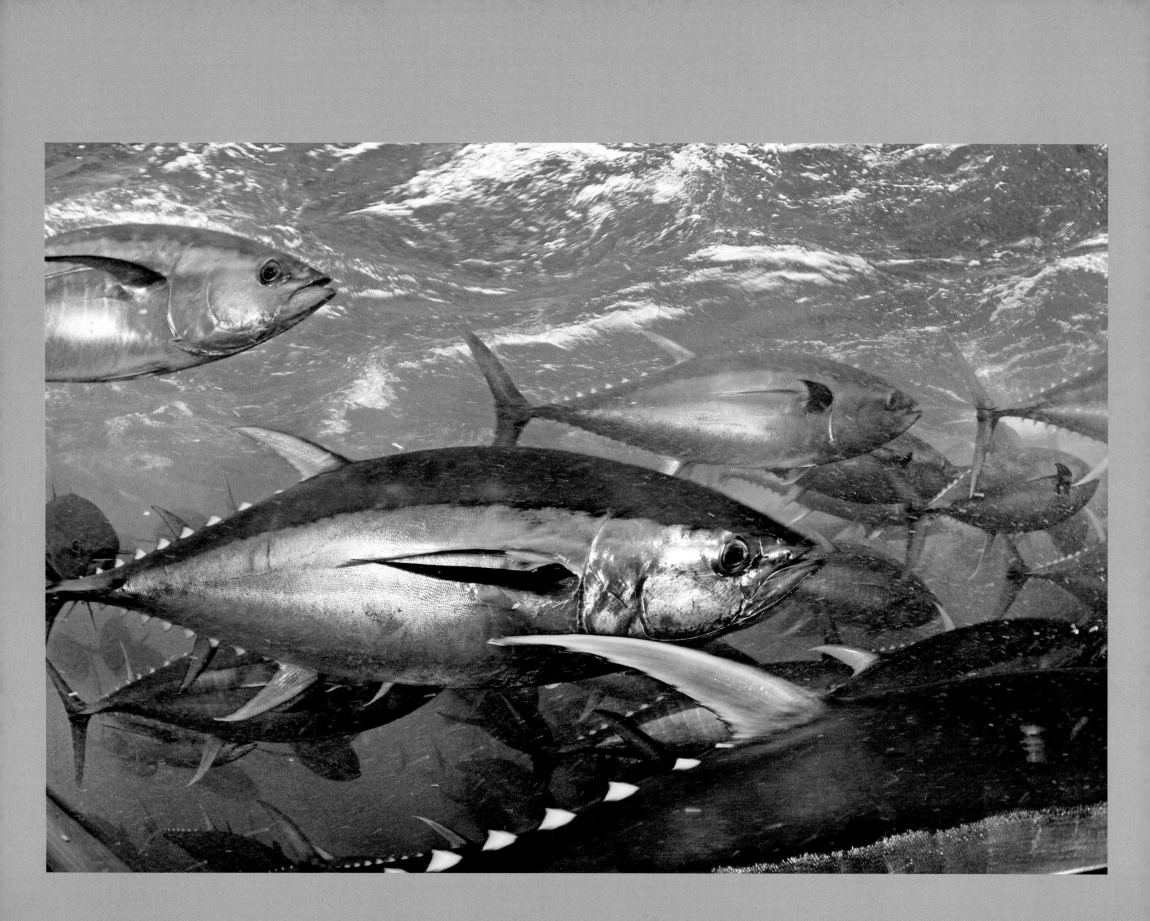

Yellowfin tuna (captive). Mexico, 2005

Ocean Wild

I'll never forget the first time I saw a blue-fin tuna in the wild. I knew instantly that I was seeing a supreme ocean creature. I had heard reports that bluefin were feeding about 25 miles off the Outer Banks of North Carolina, and so I made three separate trips to Cape Hatteras, with only the last producing any results. On that final trip, in winter 1995, I got into the water alone and found myself among dozens of fish, all weighing 500 to 700 pounds. I watched these majestic fish rocket past me, with contrails of bubbles escaping from their gills. I suppose I should have been afraid of being hit by something so large and powerful, but rather than fear I was struck

with awe instead. Sun glinted off their reflective torsos, and the small, yellow fins near the sickle-shaped tail glowed in the blue water as the fish fed near the surface. This singular experience fueled my passion for these elusive fish, and ever since I've learned all that I can about them.

Fifteen years later, I was off the coast of Nova Scotia working on a story about bluefin for *National Geographic* magazine. It was there that I could find the last of the giants—bluefin weighing as much as 1,200 pounds. They migrated there in the fall, I had learned, to feed on fatty fish such as mackerel and herring. I hoped that, in the last few days before the opening of the

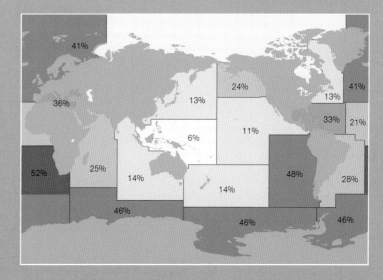

Percentage of stocks overfished, by region, based on UN assessments

commercial fishing season, I would get another chance to swim alongside these ultimate beings.

In the dark, green, chilly waters they materialized: massive beings with large eyes that I knew were watching my every move long before I saw them. These fish were nearly ten feet in length and several feet thick, and they moved unlike anything else I had seen underwater. Ten to fifteen giants swam around me, and I spun around 360 degrees and looked around on all axes as I tried to follow their movements. As they passed by I watched them rocket up from the depths, turn on a dime while flashing colors, and then disappear back into the gloom. Mesmerized by this fluid scene, I forced myself out of the trance I was in and began making pictures but just kept repeating over and over in my head, "These are perfect oceanic creatures."

To be underwater with these magnificent animals is to witness the divine sense of nature. They are true thoroughbreds of the sea, with few, if any, equals. This is an animal that swims across entire oceans in the course of each year and is capable of generating heat that allows it to travel practically from the equator to the poles. With a streamlined design that naval

engineers have studied, they swim faster than a torpedo and likely possess physical endurance that we can hardly fathom. It is a warm-blooded fish that continues to grow its entire life—a 30-year-old bluefin can weigh more than a ton.

How I wish everyone could see a bluefin tuna the way I have! Having been underwater with bluefin tuna, I know of their greatness. It is no wonder to me that early man reverently painted pictures of bluefin tuna on cave walls or that Plato mused about their migrations, which once consisted of schools of unimaginable numbers. Unfortunately, most people only encounter tuna on their dinner plates as sushi or as the protein entrée next to vegetables and rice. When they think of tuna, by habit they think of seafood. They buy fish at markets and in restaurants with little, if any, information about how, where, or under what circumstances it was caught. Few consumers know anything about the incredible animal they are eating, and this is, I believe, the essence of the problem in the overfishing crisis facing our oceans.

Since the end of World War II, commercial fishing fleets have spread throughout the world's oceans and gathered up its wildlife for food at alarming rates. Scientists have determined that in just the last

Thresher shark in gill net. Mexico, 2005

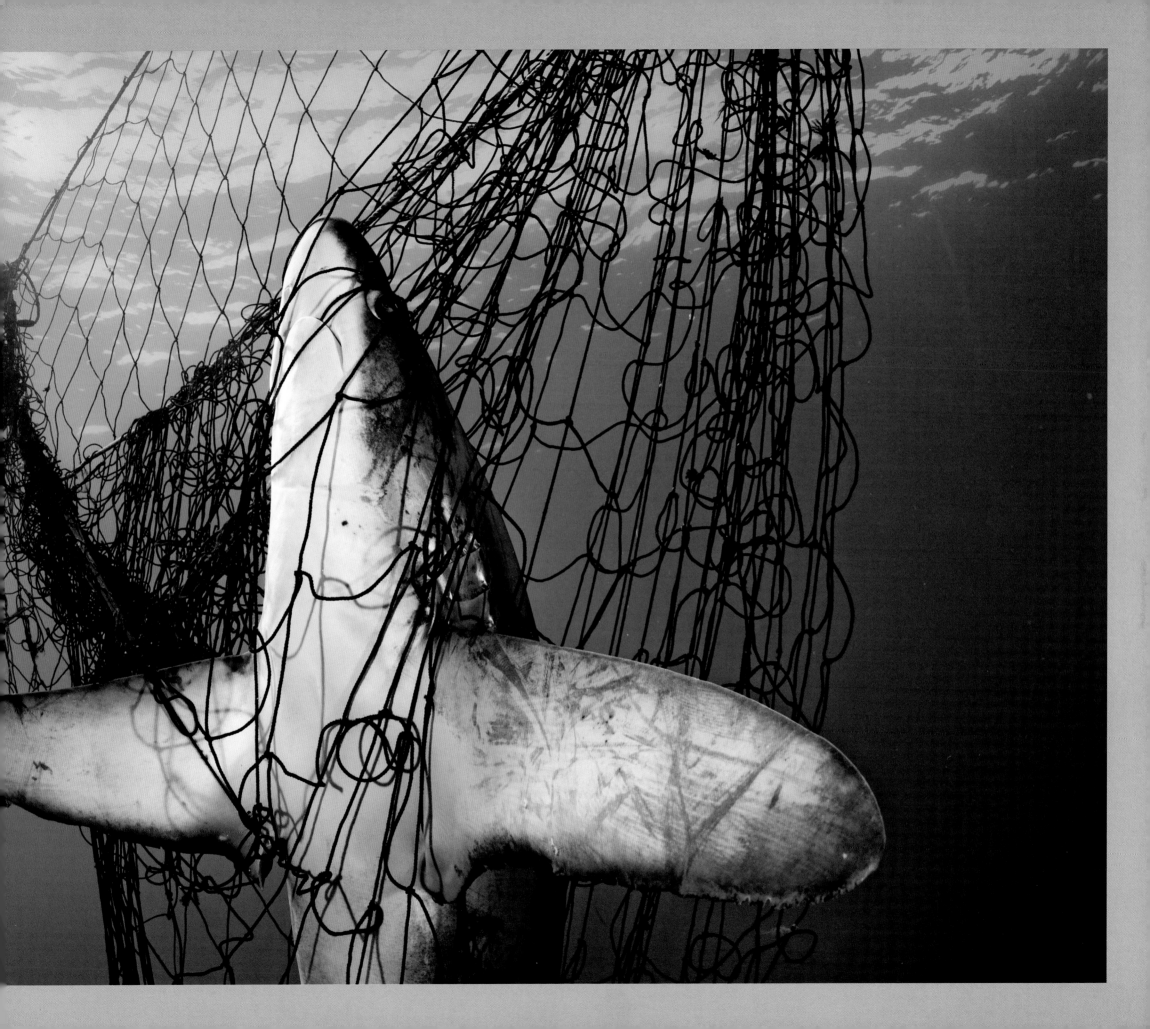

60 years, more than 90 percent of the ocean's large predatory fish have disappeared. These include tuna, billfish, and sharks—nearly all gone. Even if these statistics were only half accurate, it would be a tragic situation, but to lose this many important creatures is devastating. Yet it has happened, and few people have any idea, because so much of what happens in the ocean occurs out of sight.

Bluefin tuna and other large fish of the open ocean have been called the lions and tigers of the sea. Thinking about their terrestrial counterparts is useful, since it throws into relief how differently we think about wildlife on land versus wildlife in the sea. I don't believe that we would allow such a majestic creature as a bluefin tuna to perish from the planet if it lived on land. Nor would we think of eating the top land predators, such as lions or tigers. Catching fish, often referred to as harvesting, is not like cultivating agriculture or livestock for people to consume as food. Fishing fleets catch animals that are roaming freely in the ocean rather than being raised for our use and studiously replenished. Yet by virtue of their habitat, hidden from our immediate view, these animals are deemed less important and their status for our protection and care is diminished.

Granted, much of the current situation has to do with the fact that marine wildlife is more elusive—and harder for people to appreciate—than terrestrial wildlife. Fish are also perceived as cold and unattractive, compared to furry and familiar mammals on land. Yet I often wonder if the situation would be different if more people saw what I've seen underwater. This is a central reason why I strive to create compelling images that make people want to know more about these creatures. With knowledge and appreciation come awareness and the need for conservation. For this very reason, shedding much-needed light on ocean wildlife lies at the center of my work.

For instance, I have turned my camera on the devastating practice of bottom trawling—a common practice in the ocean that would never be tolerated on land. Imagine that a few hunters wanted to get some deer, but instead of using targeted hunting methods, they used a net. To do this, they pulled a net hundreds of feet wide through the forest to catch the deer. In the process, the net also caught birds, squirrels, raccoons, rabbits, mice, butterflies, bees, and dozens of other creatures. Pulling the net through the woods also ripped up and destroyed all the trees, bushes, ferns, and mushrooms on the forest floor. Later, when

the net was emptied, the hunters kept the deer but threw away all the other dead animals and plants as trash.

Absurd, you say. This would never happen. True, perhaps on land, but this happens every day in the ocean. Trawling is one of the most common commercial fishing methods in the world, and for decades these practices have devastated the ocean. Millions of pounds of unwanted species, called bycatch, are caught and thrown back into the sea in the pursuit of targeted species. Benthic regions across the planet have been reduced from lush habitats for animals to a wasteland of mud.

While photographing a cover story on the global fish crisis for *National Geographic* magazine, I spent time covering the issue of bycatch. I documented shrimp fishermen and swam under their boats as all the unwanted animals were being shoveled into the sea. Photographing scenes like that was disturbing, but I feel that they are crucial to help people understand what's really happening in our oceans.

Other methods used in commercial fishing are equally destructive. Every day, fleets deploy hundreds of miles of longlines with thousands of baited hooks in the oceans worldwide. Although technology has improved, this indiscriminate method of

fishing frequently catches undersized animals such as juvenile swordfish and sharks as well as unwanted species such as sea turtles. Gill nets pose grave threats to wildlife, too, as they drift like deadly curtains in mid-water and snare every organism that has the misfortune of swimming into them.

Longlines and gill nets are the predominant methods used to catch sharks, often targeted only for their fins, which fetch a high price in the fin soup trade. More than 100 million sharks are killed annually, a number that seems impossible but is sadly true. Every habitat in which sharks live—from coral reefs and pelagic zones to seamounts—depends on them for their overall health. Communicating these interdependencies is challenging, however, because to work effectively images must not only be technically great but also tell a powerful story in a single frame.

I was able to make a single frame that delivered such force while photographing another aspect of my overfishing story. I set off to document the problem of shark fishing, but I wrestled with how I would make a picture of a dead shark that would resonate with readers, since many people still believe the old adage, "The only good shark is a dead shark." After producing a number of compelling photographs of

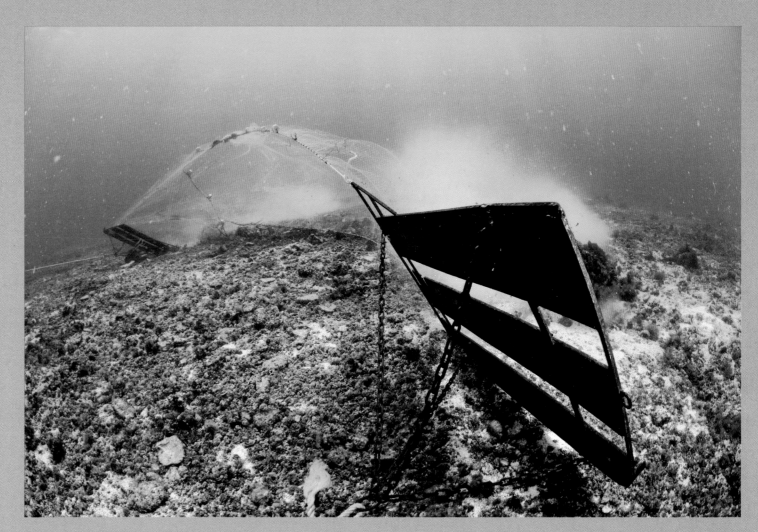

Shrimp trawl net. Mexico, 2005

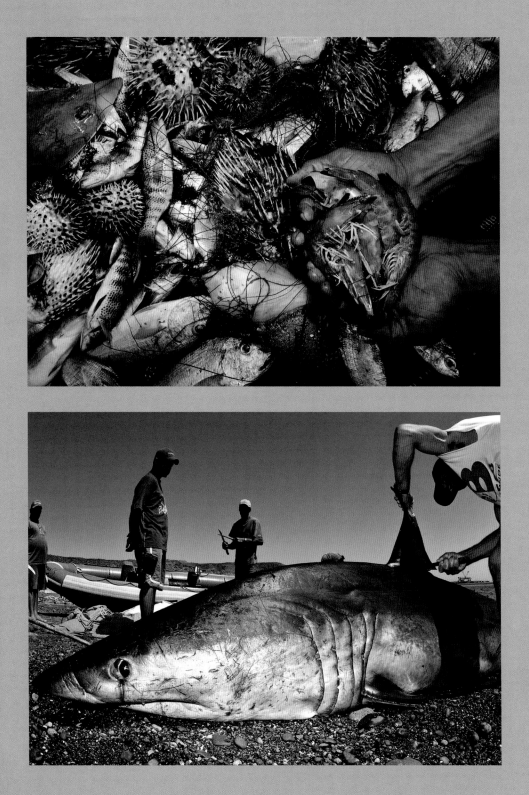

Fisherman holding shrimp with bycatch. Mexico, 2005 (top)

Mako shark being finned. Mexico, 2005 (above) ~ Shrimp bycatch. Mexico, 2005

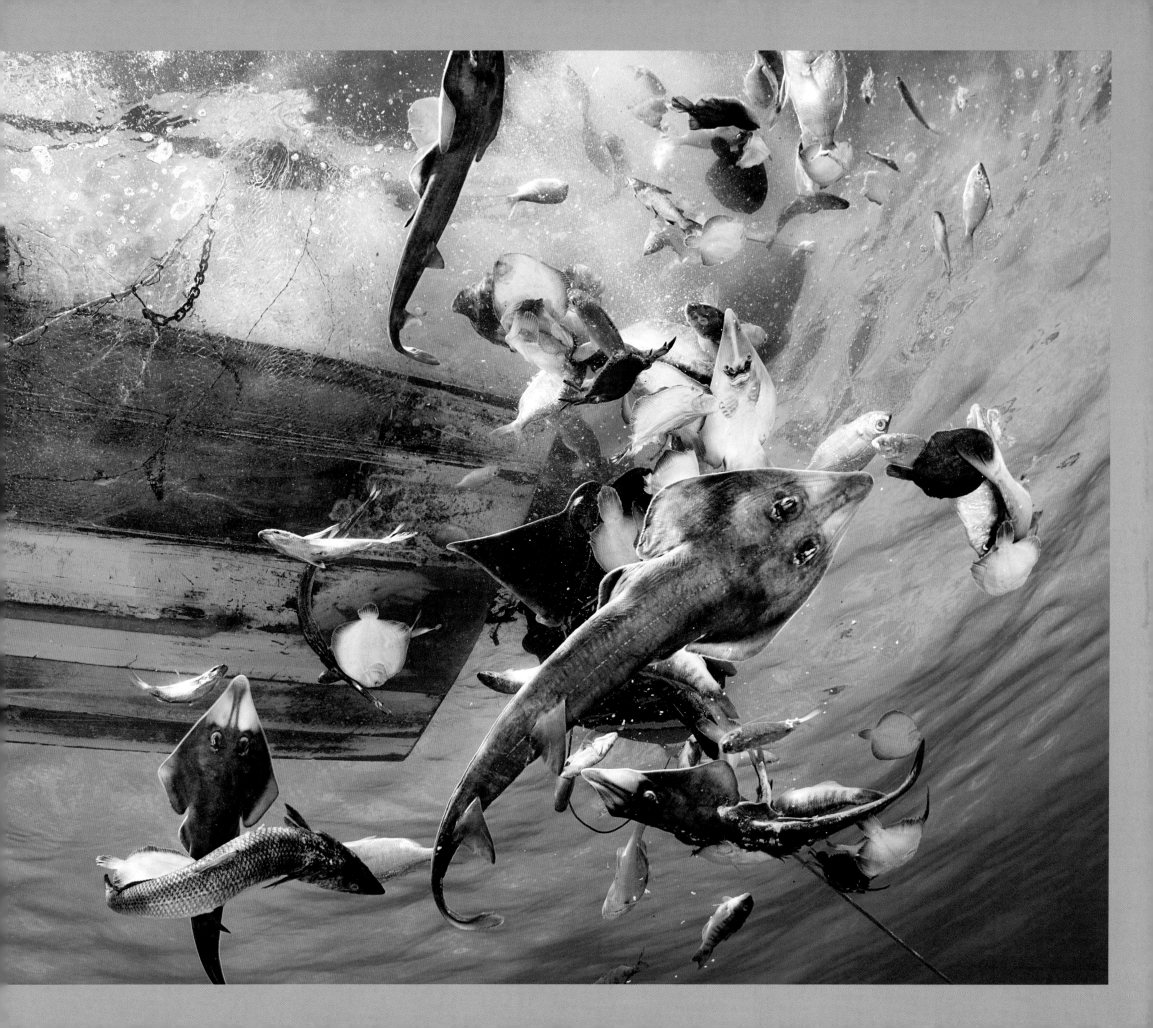

sharks being caught and finned, I still yearned for something more powerful—a picture that would really get noticed.

Swimming along a gill net in Mexico's Sea of Cortez one morning, I saw a large thresher shark that had died recently. Its eyes were open, and its long pectoral fins were outstretched in a pose that resembled a crucifixion. I photographed the scene from various angles and distances until I felt it was right. In the end, it came down to one frame that captured the essence of what I wanted to communicate. The photograph had the necessary elements of a technically good picture, but it was strong because it helped viewers see the animal in a new way and perhaps in some measure created a needed empathy for sharks.

Although this type of image is effective, even the most compelling photographs will not stop people from eating fish, and I recognize the demands of feeding the world's increasing population. But this reality further stresses the need for conservation and better custodianship of the oceans and their wildlife. Scientists tell us that there has never been a sustainable fishery. We simply deplete stocks until they are no longer commercially viable, and then we move on to another species. Clearly, this strategy cannot last for long.

Although the intricacies of global fisheries and geopolitical commerce are complex, certain solutions seem simple—for example, creating more protected places in the sea. Presently, only a tiny fraction—far less than one percent—of Earth's oceans is fully protected from commercial fishing. If we are to have healthy seas and thus a healthy planet in our future, we must create far more marine protected areas.

The concept is purely common sense. Create places in the ocean that are off-limits to any intrusion. To be most effective, these areas should be fully no-take, allowing ecosystems to function as they were designed. In protected zones like this, species grow to their maximum size and produce more and healthier offspring. Over time, habitats would be restored to their natural state, and we would have a clearer baseline for how they should function. Marine protected areas are investments in our future because these places will hark back to a long-ago time when seas were untouched and natural. They are replenishment zones where life spills over and repopulates the surrounding sea, thus benefiting everyone.

I have seen more than my share of anemic marine habitats that were once thriving undersea jungles. I have dived on burned-out reefs where algae chokes dying coral because the fish that keep the algae in check are gone. And I have drifted in pelagic deserts where once-mighty sharks, tuna, and billfish ruled. But I have also seen the ocean's ability to rebound. Around the world I have photographed marine protected areas that are alive and vibrant and speak volumes about the value of conservation. The Phoenix Islands in particular showed me the defenses that protected areas wield against environmental assaults, and New Zealand's abundant no-take zones showed me the sea's restorative powers.

The ocean is resilient—and tolerant—to a point, but we must listen, we must see, and we must act.

We are all connected to the sea and tied to her fate. The wounds suffered by Earth's oceans to date are not fatal. We can still turn the tide of past harm into a groundswell of future protection. Scientists have described what is happening to the heart of the sea. Images reveal her soul. With both as our guides, we can serve as vigilant guardians of the sea, and she will again thrive. I remain hopeful that her siren's song will echo loud and clear and continue to seduce men and women of future generations to leave the safety of the water's edge and explore. ~

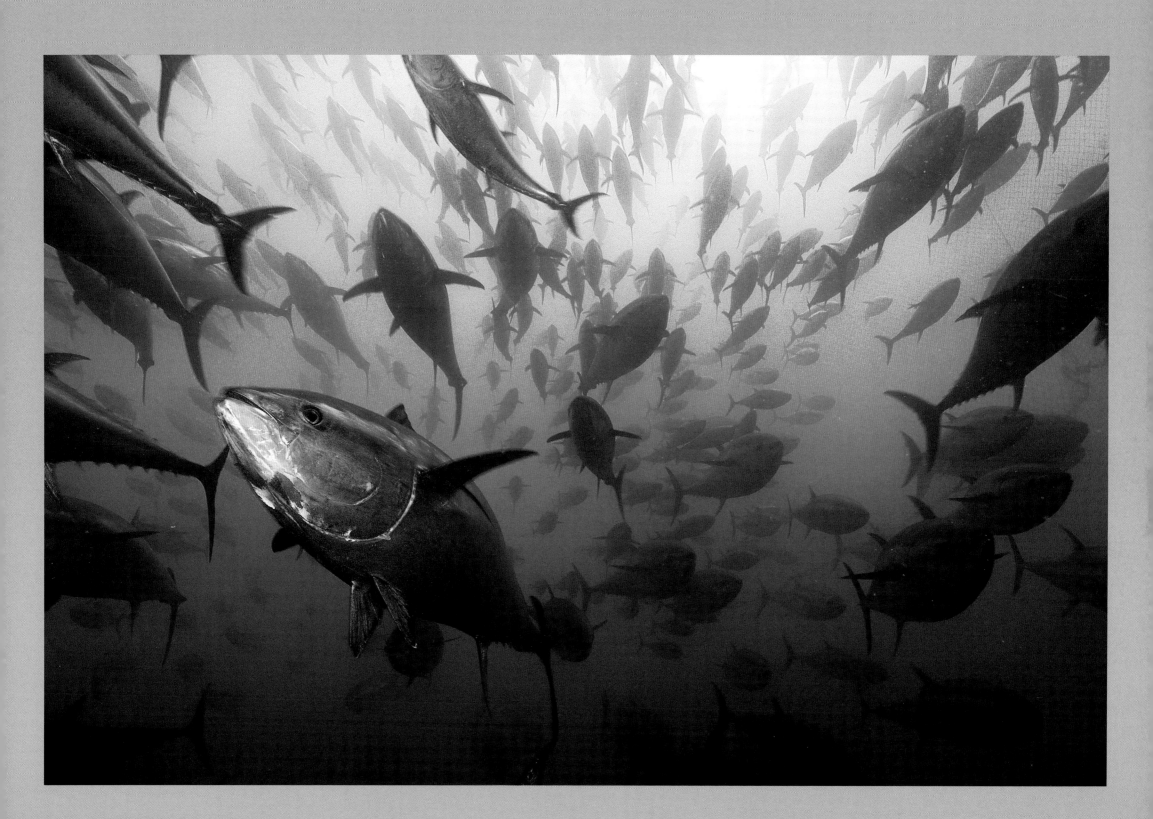

Bluefin tuna (captive). Spain, 2006

Mobula leaping. Mexico, 2005

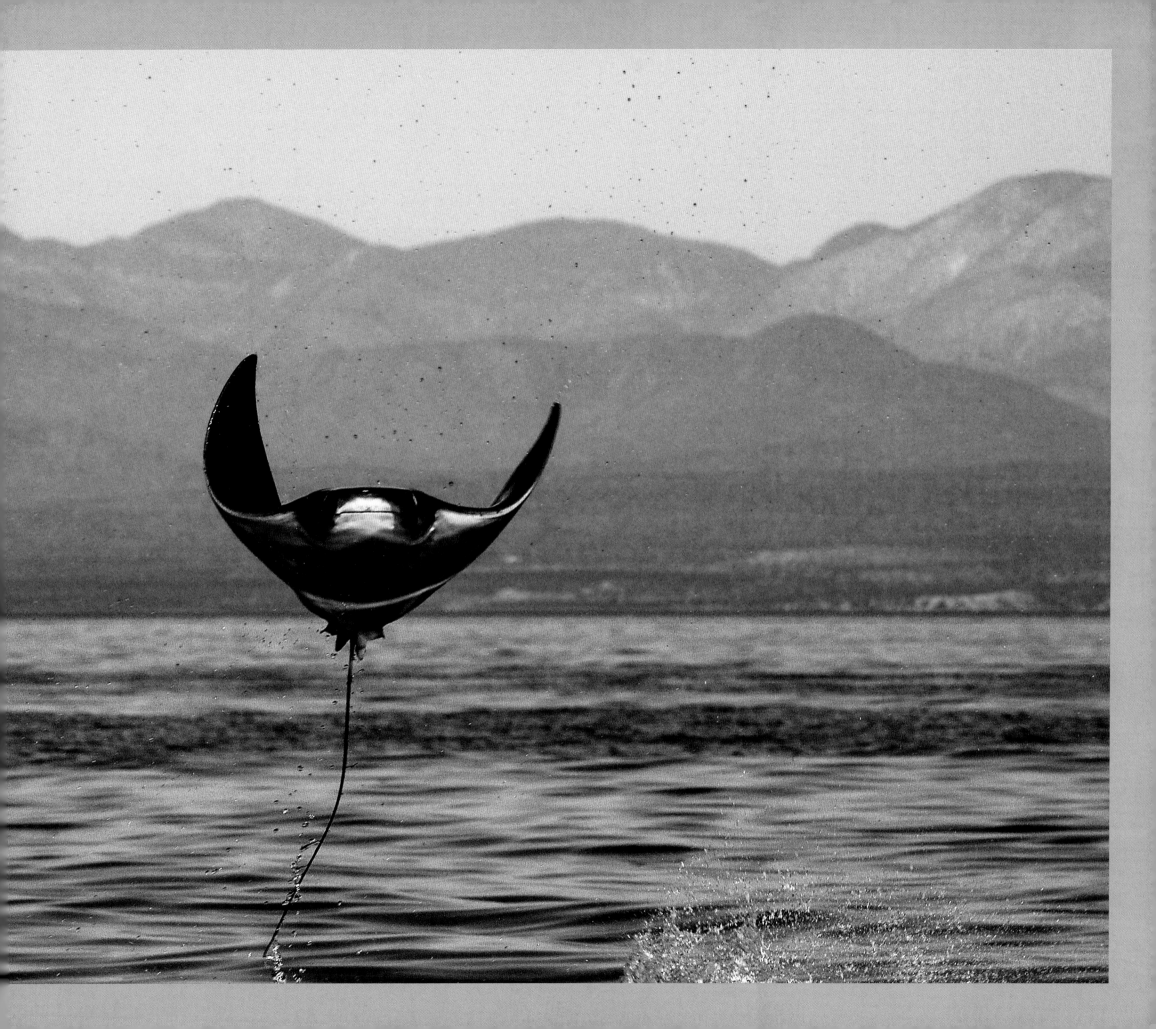

Acknowledgments

There are many people I want to thank who have helped in various ways with this book or in my work throughout the years. To begin, I thank my parents, Edwin and Jeannette Skerry, for creating a life for me in which I was allowed to dream and explore.

This book would not be possible without the support of Barbara Brownell Grogan, editor in chief of the National Geographic Book Division. I am deeply grateful for her vision and expertise to see it through from inception to completion and for her personal attention to every detail along the way. Also with NGS Books I wish to thank Editor Garrett Brown for his astute editing of my manuscript and Project Manager Marshall Kiker for keeping everything on track and on time. I am especially indebted to David Griffin, executive editor at National Geographic magazine, who served as picture editor and designer of this book. Having David involved in this project was a real coup, and I am thankful for his exceptional creativity, which contributed tremendously to this book.

Working for National Geographic magazine is a tremendous honor. Its historic reputation and the legendary content produced by this publication since 1888 are unparalleled. An assignment from NGM, therefore, comes with great responsibility, and I am grateful for the confidence Editor Chris Johns has placed in me through my many assignments over the years. As a world-class wildlife photographer, Chris understands the challenges of fieldwork, and as Editor in Chief of National Geographic magazine he has continually supported stories that make a difference.

With heartfelt appreciation I wish to thank Susan Smith, who as deputy director of photography for National Geographic magazine brought me in and made my dream a reality. She and Director of Photography Kent Kobersteen took the time to "develop" me as a regular NGM contributor, and I remain grateful to both. Equally important in developing and assigning my projects in more recent times has been Executive Editor for Photography Kurt Mutchler. I am especially appreciative for his guidance and direction in broadening the scope of my photography.

There are a handful of people who have made a real difference in my work, and as a result, in my life as well. At the top of this list is National Geographic magazine Senior Editor for Natural History Kathy Moran. As the picture editor with whom I have worked the most, Kathy has been a partner in every story, a mentor, and a friend. She has supported my work from the beginning, and with a careful eye to detail offered advice over the years that has made me a better photographer. Simply saying thank-you to Kathy will never seem to be enough.

The culture of excellence is evident throughout all of the National Geographic Society, and working alongside colleagues there for nearly a decade and a half has influenced my work in countless ways. With every project, day in and day out, the following people have also contributed and should be acknowledged: William Allen, Mark Bauman, Walter Boggs, Elaine Bradley, Dennis Dimick, Trish Dorsey, Bill Douthitt, Ken Geiger, Liz Grady, John Q. Griffin, Mike Lappin, Sarah Leen, Bill Marr, Dave Mathews, Nick Nichols, Victoria Pope, Sadie Quarrier, Leslie Rogers, Joe Stancampiano, Hans Weise, Susan Welchman, David Whitmore, and Kenji Yamaguchi.

I also wish to say a special thanks to Bill Curtsinger for years of inspiration and for opening the door for me. And to David Doubilet for allowing me to spend weeks in the field looking over his shoulder, garnering jewels of wisdom from a master.

Spending years in the field, working very long days, oftentimes in less than ideal conditions, can take a toll, and I am deeply grateful to those who have worked alongside me and have assisted in these endeavors. My photo/dive assistants have helped me deliver the goods time after time and have been wonderful companions with whom I have shared the adventure. To Mark Conlin, Mauricio Handler, Tom Mulloy, Sean Whelan, and Jeff Wildermuth I offer my sincere and profound thanks.

I am thankful also to the National Geographic Image Collection, who represent my work and look after the many details associated with the business of photography that my assignment schedule does not permit. Especially I want to thank Image Collection President Maura Mulvihill for her many years of support. Everyone at the Image Collection has been tremendously helpful, though I wish to thank those with whom I have worked the most, especially Marco DiPaul, Stacy Gold, Rob Henry, Alice Keating, Taylor Kennedy, Bill Perry, and Steve St. John.

There are other key professionals and organizations that have helped with my work that must be recognized as well. I am immensely grateful for the support of Conservation International, and especially wish to thank CEO Peter Seligmann. The accomplishments made by CI for our planet are substantial, and knowing that an organization like this is working day after day for conservation gives me great hope. Thank you also to the ILCP (International League of Conservation Photographers), particularly founder Cristina Mittermeier for her dedication to conservation and for promoting the value photographs have to this cause. I am grateful for the support of the New England Aquarium, especially President Bud Ris and Vice President Jane Wolfson, whose fabulous work has worldwide reach. I also wish to thank Fred Dion, formerly of Underwater Photo-Tech (now Backscatter), who has kept my equipment working for decades and spent many a late night with me building some new piece of gear that I needed in a hurry. Thanks also to Mark Doyle of Autumn Color for making my fine art prints and for the countless hours processing images. And to Bill Pekala and Anne Cahill with Nikon, John and Joe Stella of Scubapro, and Susan Long and Faith Ortins of Diving Unlimited International, I truly appreciate their many years of help and assistance.

My life of photography and exploring the oceans has introduced me to countless people from whom I have learned much and with whom I have enjoyed special friendships. Among the most special are Greg Stone, who graciously agreed to pen the foreword for this book. I thank Greg for his vision for ocean conservation and

for the adventures and friendship we share. I also want to thank my dear friend Steve Drogin, whom I miss deeply, and his wonderful wife Hiro, who have been travel companions and the very best of friends.

There are other colleagues and friends that have helped in my work, some scientists, some wildlife guides, some simply kindred spirits that have helped during my continuing voyage. Although the list is long, I would be remiss in not acknowledging the following people: Jim Abernethy, Scott Baker, Bill Ballantine, Scott Benson, Barbara Block, Bob Bonde, Moira Brown, Bill Buckley, Stuart Cove, Mario Cyr, Charlie Donilon, Mike Drainville, Alan Dynner, Sylvia Earle, Scott Eckert, Tony and Jenny Enderby, Dave Glowka, Rachel Graham, Howard and Michelle Hall, Roger Hanlon, Mike James, Grant Johnson and Katie Grudecki, Steve Kafka, Les Kaufman, Scott Kraus, Rod Mast, Mike McGettigan and Sherry Shaffer, Martin Moriarty, Nigel Motyer, Captain Mac Nagata, Sandra O'Connor, Shari Sant Plummer, Buddy Powell, Wes Pratt, Randi Rotjan, Enric Sala, Hela Shamash, Ruth and Lance Shaw, Chris Slay, Kelly Stewart, and Ted Waitt.

Finally, I want to thank my family. To my wife, Marcia, and daughters, Katherine and Caroline, I am forever thankful for your love and inspiration and for sharing my passion.

Maps Sources

Page 91: Appenzeller, Tim. "Leatherback Turtles." *National Geographic* (May 2009): 131.

Page 159: Chadwick, Douglas H. "Right Whale Watch." *National Geographic* (October 2008): 107; New England Aquarium.

Page 203: Warne, Kennedy. "Harp Seals." *National Geographic* (March 2004): 55.

Page 251: FAO capture database (electronic file), www.fao.org/fishery/en; FAO Fisheries and Aquaculture Department, *The State of World Fisheries and Aquaculture 2010*, accessed March 17, 2011, www.fao.org/docrep/013/i1820e/i1820e00.htm; Montaigne, Fen. "The Global Fish Crisis" (Special Report). *National Geographic* (April 2007): 49.

Ocean Soul ~ Brian Skerry

Published by the National Geographic Society
John M. Fahey, Jr., Chairman of the Board and
 Chief Executive Officer
Timothy T. Kelly, President
Declan Moore, Executive Vice President; President, Publishing
Merina Gerosa Bellows, Executive Vice President,
 Chief Creative Officer, Books, Kids, and Family

Prepared by the Book Division
Barbara Brownell Grogan, Vice President and Editor in Chief
Jonathan Halling, Design Director, Books and Children's Publishing
Marianne R. Koszorus, Director of Design
Carl Mehler, Director of Maps
R. Gary Colbert, Production Director
Jennifer A. Thornton, Managing Editor
Meredith C. Wilcox, Administrative Director, Illustrations

Staff for This Book
Marshall Kiker, Project Manager
Garrett Brown, Text Editor
David Griffin, Art Director
Trish Dorsey, Illustrations Coordinator
XNR Productions, Map Production
Judith Klein, Production Editor
Mike Horenstein, Production Project Manager

Manufacturing and Quality Management
Christopher A. Liedel, Chief Financial Officer
Phillip L. Schlosser, Senior Vice President
Chris Brown, Technical Director
Nicole Elliott, Manager
Rachel Faulise, Manager
Robert L. Barr, Manager

The National Geographic Society is one of the world's largest nonprofit scientific and educational organizations. Founded in 1888 to "increase and diffuse geographic knowledge," the Society's mission is to inspire people to care about the planet. It reaches more than 400 million people worldwide each month through its official journal, *National Geographic*, and other magazines; National Geographic Channel; television documentaries; music; radio; films; books; DVDs; maps; exhibitions; live events; school publishing programs; interactive media; and merchandise. National Geographic has funded more than 9,600 scientific research, conservation and exploration projects and supports an education program promoting geographic literacy. For more information, visit www.nationalgeographic.com.

Building upon a strong foundation of science, partnership and field demonstration, **Conservation International** empowers societies to responsibly and sustainably care for nature, our global biodiversity, for the well-being of humanity.

To license any images from this book or to obtain a print please contact Image Collection at www.nationalgeographicSTOCK.com. Telephone: 202-857-7537 or toll free 800-434-2244 Email:stock@ngs.org

Library of Congress Cataloging-in-Publication Data
Skerry, Brian.
 Ocean soul / Brian Skerry.
 p. cm.
 ISBN 978-1-4262-0816-4
 1. Marine photography. 2. Underwater photography. 3. Skerry, Brian--Travel. I. Title.

TR670.S58 2011
779.3--dc22

 2011009072

Printed in China
11/RRDS/1

Beluga whale. Canada, 1996